THE BRUSH OF INSIGHT

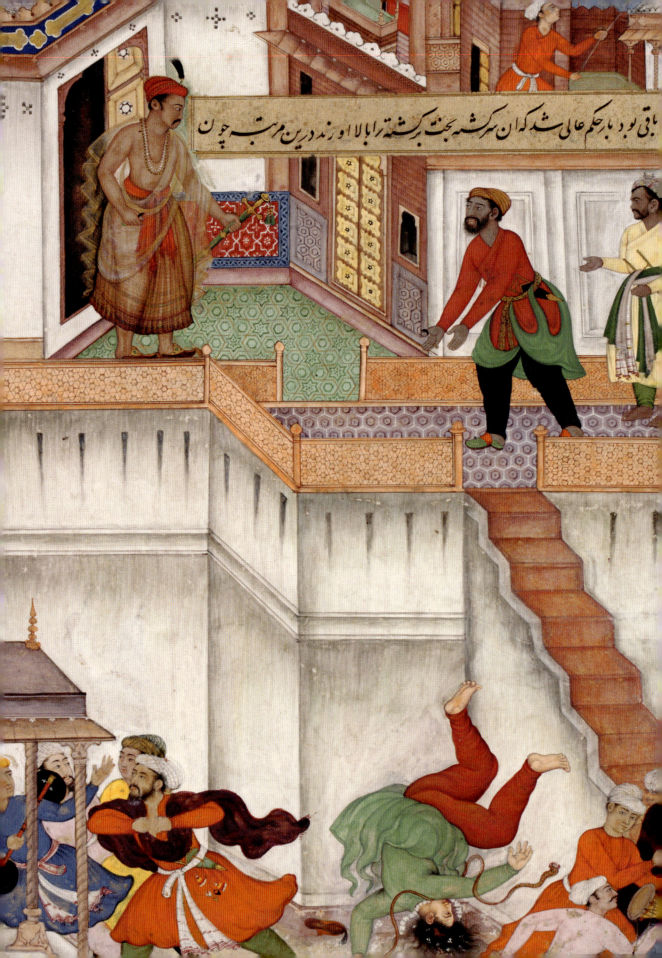

THE BRUSH *of* INSIGHT

Artists and Agency at the Mughal Court

YAEL RICE

University of Washington Press Seattle

Publication of this book has been aided by a grant from the Millard Meiss Publication Fund of CAA.

This book was made possible in part by a grant from Furthermore, a program of the J. M. Kaplan Fund.

Additional support was provided by Amherst College.

Copyright © 2023 by the University of Washington Press
Design by Mindy Basinger Hill
Composed in Adobe Caslon Pro

27 26 25 24 23 5 4 3 2 1

Printed and bound in the United States of America

All rights reserved. No part of this publication may be reproduced or transmitted in any form or by any means, electronic or mechanical, including photocopy, recording, or any information storage or retrieval system, without permission in writing from the publisher.

UNIVERSITY OF WASHINGTON PRESS *uwapress.uw.edu*

LIBRARY OF CONGRESS CATALOGING-IN-PUBLICATION DATA

Names: Rice, Yael, author.
Title: The brush of insight: artists and agency at the Mughal court / Yael Rice.
Description: Seattle: University of Washington Press, [2023]
Identifiers: LCCN 2022038480 | ISBN 9780295751092 (hardcover) | ISBN 9780295751085 (ebook)
Subjects: LCSH: Inner Visions: Fragments from the Unseen World—Workshop and Empire: The Invention of the Mughal Painter—Forms of Knowledge: The Emperor's Body and the Artist's Brush—World in a Book: Performance, Creation, and the Royal Album—Epilogue: From Copy to Trace. | Painting, Mogul Empire—Themes, motives. | Kings and rulers in art. | Painters—Mogul Empire—Social conditions. | Mogul Empire—Court and courtiers.
Classification: LCC ND1002. R53 2023 | DDC 759.95409/031—dc23/eng/20220922
LC record available at https://lccn.loc.gov/2022038480

♾ This paper meets the requirements of ANSI/NISO Z39.48-1992 (Permanence of Paper).

CONTENTS

Acknowledgments vii

Translation and Transliteration xi

Introduction 1

1. *Inner Visions* Fragments from the Unseen World 19
2. *Workshop and Empire* The Invention of the Mughal Painter 51
3. *Forms of Knowledge* The Emperor's Body and the Artist's Brush 97
4. *World in a Book* Performance, Creation, and the Royal Album 139

Epilogue From Copy to Trace 177

Notes 181

Bibliography 219

Index 247

ACKNOWLEDGMENTS

IN COMPLETING THIS BOOK, I have incurred a massive debt of gratitude. I am foremost grateful to Renata Holod and Michael Meister, who shepherded this project to its earliest crystallization. For their guidance and feedback in this initial phase, I also extend my sincere thanks to Darielle Mason, Larry Silver, Walter Denny, and Ebba Koch. At the University of Washington Press, I wish to express my gratitude profound gratitude to Lorri Hagman for her patience, support, and encouragement; Chad Attenborough for assisting with the monumental task of finalizing the book's image program; and Joeth Zucco for seeing this book through to its finished state. Special thanks go to Erika Bűky, copyeditor of the manuscript, for her sharp eye, keen suggestions, and forbearance. Finally, I am grateful to Jane Bragdon for her help acquiring images and image permissions, Zoë Woodbury High for her help proofing the final version of the text, and Eileen Allen for creating the index.

I am grateful, as well, to the Getty Research Institute, the Smithsonian Institution Freer Gallery of Art and Arthur M. Sackler Gallery, the University of Michigan, and Artl@s and Purdue Scholarly Publishing Service for allowing me to adapt and reproduce select portions of the following previously published works: "Workshop as Network: A Case Study from Mughal South Asia," *Artl@s Bulletin* 6, no. 3 (2017): 50–65; "'A Flower from Each Garden': Contradiction and Collaboration in the Canon of Mughal Painters," in *Canons and Values: Ancient to Modern*, ed. Larry Silver and Kevin Terraciano (Los Angeles: Getty Research Institute, 2019), 138–62; and "Painters, Albums, and Pandits: Agents of Image Reproduction in Early Modern South Asia," *Ars Orientalis* 51 (2022), 27–64.

None of the research on which this book draws would have been possible without the many curators, keepers, librarians, conservators, and art handlers

who generously made manuscript and print materials in their collections available to me. I am in particular indebted to the staff of the National Museum of India, New Delhi; the Bharat Kala Bhavan, Varanasi; the Raza Library, Rampur; the Khuda Bakhsh Library, Patna; the Chhatrapati Shivaji Maharaj Vastu Sangrahalaya, Mumbai; the Náprstek Museum, Prague; the Staatsbibliothek, Berlin; the Museum für Islamische Kunst, Berlin; the British Library, London; the British Museum, London; the Victoria and Albert Museum, London; the Royal Asiatic Society, London; the Royal Collection, Windsor Castle; the Fitzwilliam Museum, Cambridge; the Bodleian Library, Oxford; the Chester Beatty Library, Dublin; the Metropolitan Museum of Art, New York City; the Rare Book Department, Free Library of Philadelphia; the Philadelphia Museum of Art; the Walters Art Museum, Baltimore; the Smithsonian Institution Freer and Sackler Galleries, Washington, DC; the Virginia Museum of Fine Arts, Richmond; the Los Angeles County Museum of Art, Los Angeles; and the San Diego Museum of Art, San Diego. Generous financial support from the University of Pennsylvania, the Kress Foundation, the Social Science Research Council, Amherst College, the Rare Book School at the University of Virginia, the Mellon Foundation, and the Getty Foundation made possible my research travel and training in digital humanities methods. A grant from the College Art Association's Millard Meiss Publication Fund underwrote the reproduction of the many color images in this book.

I have benefited from the feedback of numerous colleagues, many of whom have shared their ideas about themes central to this project and offered comments and suggestions on chapters, talks, and other papers that have emerged from it. I wish to acknowledge, in particular, Pika Ghosh, Chanchal Dadlani, Laura Weinstein, Phillip B. Wagoner, Robert Skelton, Pushkar Sohoni, Christiane J. Gruber, Ben Anderson, Walt Hakala, Catherine Asher, Molly Emma Aitken, Kavita Singh, Susan Stronge, Deborah Hutton, Catherine Benkaim, Nancy Um, David J. Roxburgh, Persis Berlekamp, A. Azfar Moin, Audrey Truschke, Supriya Gandhi, Katherine Butler Schofield, Sonal Khullar, Debra Diamond, Fatima Qureshi, Murad Khan Mumtaz, Emily Neumeier, Malini Roy, Anna Seastrand, Holly Shaffer, Sussan Babaie, Dipti Khera, Purnima Dhavan, Jennifer Dubrow, Heidi Pauwels, Anand Yang, Padma Kaimal, Jamal Elias, and Daud Ali. I have been additionally fortunate to enjoy the support, guidance, and companionship of many colleagues in the Five College Consortium (Amherst College, Hampshire College, Mount Holyoke College, Smith College, and the University of Massachusetts, Amherst): Samuel Morse, Nicola Courtright, Monica Ringer,

Rowland Abiodun, Justin Kimball, Sonya Clark, Carol Keller, Betsey Garand, Natasha Staller, Trent Maxey, Tim Van Compernolle, Wako Tawa, Krupa Shandilya, Nusrat Chowdhury, Amrita Basu, Buffy Aries, Kiara Vigil, Vanessa Gordon, Adam Levine, Raphael Sigal, Niko Vicario, Alan and Nancy Babb, Dwaipayan Sen, Jeffrey Saletnik, Karen Koehler, Sura Levine, Ajay Sinha, Sonja Drimmer, Walter Denny, Gülru Çakmak, Karen Kurczynski, Bill Kaizen, Johan Mathew, Laura Kalba, Uditi Sen, Brigitte Buettner, and Dana Leibsohn. In the later stages of this project, during the height of the 2020–21 pandemic, I was buoyed by the virtual companionship of Stephennie Mulder, Margaret Graves, Jennifer Pruitt, Ladan Akbarnia, Wendy M. K. Shaw, Moya Carey, and Omniya Abdel Barr. Finally, I thank Ashley Moore for making the map that accompanies this book, and also for being a constant friend and a reliable source of good humor and quality cats.

Writing can be a solitary activity, but thanks to the companionship of Vanessa Mongey, Conny Aust, Miya Tokumitsu, Laura Kalba, Uditi Sen, Krupa Shandilya, Vanessa Gordon, Ingrid Nelson, Mary Hicks, Amelia Worsley, Marjorie Rubright, and Mira Xenia Schwerda, the process of completing this book has been much less lonely. I extend my gratitude to all of you for showing up and writing with me.

I wish to thank my family for helping me—in one way or another—bring this book into existence: Rosalind Rice; Gene and Georgina Rice; Barbara Robbins (z"l); Alan and Jen Rice; Raphael and Natalie Rice; Leigh and Danny Bar-Yakov; and my many nieces and nephews, who are scattered across three continents. I reserve my most heartfelt appreciation for Scott Allison, whose patience, humor, and endearment have made everything much easier and enjoyable than it would have otherwise been.

TRANSLATION & TRANSLITERATION

UNLESS OTHERWISE INDICATED, all translations from Arabic and Persian are my own. For the transliteration of Arabic and Persian words, I have adopted a simplified scheme without diacritics that draws from the *International Journal of Middle Eastern Studies* transliteration guide; F. J. Steingass, *Comprehensive Persian–English Dictionary;* and Hans Wehr, *Arabic–English Dictionary.* Arabic and Persian words, like *shaykh* and *Sufi*, that are commonly used in English have been left unitalicized in the text. Place names, for the most part, are indicated using their modern spellings.

All dates are rendered with reference to the Common Era (CE); for dates in Persian or Arabic texts, the Hijri date (AH) is included as well.

THE BRUSH OF INSIGHT

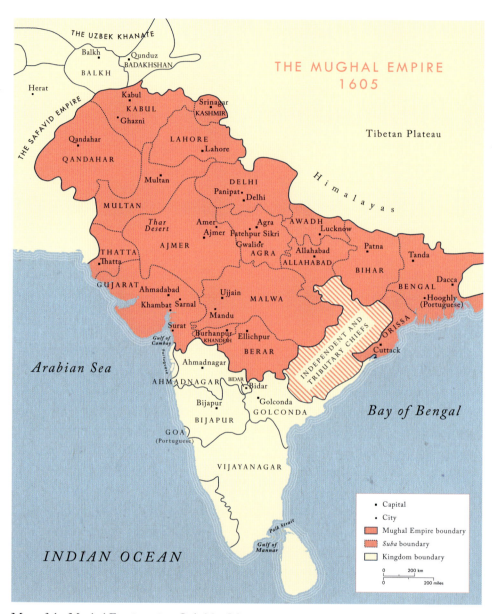

Map of the Mughal Empire, 1605. © Ashley Moore.

INTRODUCTION

THIS BOOK IS ABOUT THE CONSTELLATION of agents and institutions that shaped the perception of the Mughal emperors' preeminence in all spheres of dominion, temporal and sacred, during the reigns of Akbar (r. 1556–1605) and his son and successor, Jahangir (r. 1605–1627), and the fundamental role that manuscript painters, in particular, played in advancing it. The historical illustrations, physiognomic portraits, imperial dreams, and putatively documentary images that Mughal painters created came to be seen as both the evidence for and the instruments of sacred kingship. Their works challenged the status of writing as the primary medium for the transmission of knowledge and experience.

The appearance of these images in books made them doubly potent because books had long served as primary vehicles for the production and transmission of sacred and profane knowledge in the Muslim, Hindu, Jain, Christian, and Jewish communities that made up the Mughal Empire. In the Persianate world of the Mughal emperors, elites, and painters, books, and especially codices (stitched books), were also associated with both dynastic and mystical authority. That some of the most vivid and arresting visions of Mughal sacred kingship originated in the context of the codex was no accident.

A well-known painting of Jahangir seated on an hourglass throne underscores the currency of books by depicting the emperor presenting a manuscript to a turbaned and white-bearded figure, probably meant to represent a Sufi (Muslim mystic) of the Chishti lineage (fig. 1.1). This work was itself made for inclusion in a codex; its incorporation of an image of a manuscript, therefore, functioned as metapictorial commentary on the bookmaking contexts that were the royal painter's domain. The manuscript's decorated binding and clasps are finely detailed; even the fore-edge is crisply defined. Bichitra (fl. early seventeenth century), the court artist who created the work, extended this descriptive treatment to the rest of the painting, from the rep-

resentation of Jahangir's diaphanous *jama* (stitched coat) and curled sidelocks to the tiny feet of the cherubim inscribing a blessing on the hourglass below. The book, like the emperor, seems so palpably real that a contemporary viewer might have concluded that it portrays the very codex for which the painting was made.

In depicting his subject so comprehensively, Bichitra may persuade us that he witnessed this marvelous and impossible vision firsthand. But the Mughal manuscript painter's objective was not to depict exactly what he saw but to portray the earthly and cosmic realms as perceived through an investigative, heuristic lens that was, or appeared to be, the emperor's rather than his own. The vast quantity of Mughal portraits produced in the late sixteenth and early seventeenth centuries should be similarly understood as attempts to manifest the emperors' superior discernment as the primary mode of pictorial representation. These acts hinged on the notion that the Mughal dynasts alone possessed the perceptual and intellectual faculties to discern the truths about the phenomenal and metaphysical worlds and, ultimately, to bring order to them.

This project to reenvision the cosmos according to a distinctively Mughal imperial worldview was predicated on a legal doctrine, first articulated centuries prior, that identified independent inquiry (*tahqiq*), rather than imitation of tradition (*taqlid*), as the surest way to uncover divinity's truths. Conformity to established opinions had been the norm in legal and religious circles following Islam's emergence in the seventh century CE, with caliphs and sultans regarded not as spiritual or scholarly leaders, nor as sources of religious or political legitimacy, but as political figureheads for the *umma*, the larger community of Muslims. The catastrophic Mongol invasions of the thirteenth century, however, provided the conditions for the emergence of a universalist paradigm that drew instead upon Sufi, Shi'i, Mongol, and Hermetic bodies of thought and practice.[1] The new dispensation invested charismatic rulers—to whom their ideologues often attributed mystical knowledge, occult abilities, and genealogical connections to venerated figures like the Prophet Muhammad, 'Ali ibn Abi Talib, Jesus, and Alan Goa, the mythical female progenitor of the Chingizid line—with unconditional power and authority. Timur (d. 1405; also known as Tamerlane), the founder of a Sunni Turko-Mongol dynasty that dominated west and central Asia during the fifteenth century, was the exemplar of the saint-king. Taking the titles of Renewer (Mujaddid) and Lord of the Conjunction (Sahib Qiran), Timur styled himself as a cosmic, messianic ruler who would usher in Islam's new age.[2]

During the 1580s, Akbar's ideologues advanced similar claims about Mughal sovereignty. That Akbar was in fact descended from Timur on his

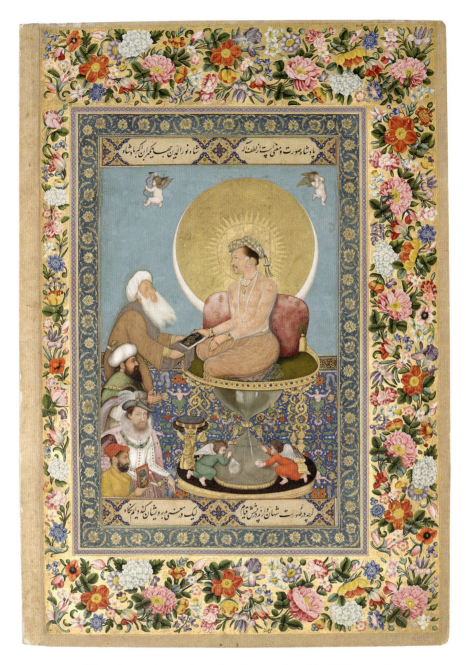

FIGURE 1.1. Jahangir seated on an hourglass throne, signed by Bichitra and completed circa 1615–18, northern India. Mounted on a dispersed page from the St. Petersburg Album, compiled eighteenth century, Iran, with decorated margins added by Muhammad Sadiq in AH 1160 (1747–48). Opaque watercolor, ink, and gold on paper. Folio 47.9 × 33 cm; painting 25.3 × 18.1 cm. Freer Gallery of Art, Smithsonian Institution, Washington, DC. Purchase—Charles Lang Freer Endowment, F1942.15a.

father's side, and from Chingiz Khan's on his mother's, made these declarations all the more resonant. Akbar took the title of Renewer of the Second Millennium (Mujaddid-i Alf-i Thani), a reference to the impending close of Islam's first one thousand years (AH 1000), which transpired in 1591–92.[3] A decree (*mazhar*) issued several years earlier, in 1579, heralded Akbar as a *mujtahid*, that is, one capable of formulating legal opinions independent of tradition.[4] Liberated from the constraints of precedent, the Mughal imperial machine pursued an ambitious truth-seeking agenda, foregrounding independent investigation, mystical matters, and novel subjects while identifying Akbar as a sacred sovereign in both body and intellect, and thus the ultimate unassailable authority.

Royal painters represented Akbar and his successor, Jahangir, as examiners of the natural and celestial realms, and thus as discoverers of truth, by depicting the objects of the imperial gaze in painstaking detail, as in Bichitra's painting. The formalistically descriptive idiom they employed made the case that empirical observation constituted a legitimate—even preferable—means of acquiring absolute knowledge. This emphasis on minute pictorial study was not wholly new, however; it can be traced to the later fourteenth century, and more specifically to the Mongol courts of Iran, when a host of factors—the expansion of royal patronage, the refinement of paper production and preparation, and the emergence of a historical consciousness about picture making—provided the conditions in which the manuscript image became increasingly autonomous from the text.[5] Over the next century and a half, the court painters of Iran and Central Asia rendered the patterns of nature and culture (architecture, costume, and utilitarian objects) in astounding, infinitesimal detail, and in a startling range of colors, to command the viewer's attention and thereby to produce temporalities and meanings that rivaled those of the textual narratives.[6] What distinguishes Mughal court painting from earlier and contemporary examples, however, is its use of a micrographic mode of representation to depict phenomena, from books and cherubim to courtiers and Ming cups, as if they had been observed from life. The Mughal painters' studies not only compel the viewer to linger on the page, to attempt to take in the abundance of minutiae, but they also invite her to contemplate the superior intellectual and corporeal powers—the emperors' own, of course—that made possible this profound perceptual apprehension of the subject.

Another significant departure from tradition is the Mughal painters' concentration on novel—indeed, often previously unrepresented—subjects and designs. In royal Persianate manuscript painting from the fifteenth

and sixteenth centuries, many of the same forms and compositional units reappear continually. Far from indicating a lack of originality, the adherence to visual precedent represented the painter's means of inserting himself into the chain of artistic tradition.[7] Only after having demonstrated his mastery in recalling and reproducing well-known configurations of lines and shapes did the court painter attempt to recast these compositional arrangements in subtle ways and thereby secure his position as a contributor to the history of picture making. Mughal manuscript painters broke with this pattern through the illustration of newly penned histories, such as the *Baburnama* (Book of Babur), the memoirs of the dynasty's founder who reigned from 1526 to 1530; the *Akbarnama* (Book of Akbar), a history of Akbar's reign that was composed and edited by his close advisor Abu'l Fazl (d. 1602); and the *Razmnama* (Book of War), an abridged Persian rendering of the *Mahabharata*. The demands placed upon Mughal painters to illustrate these texts echo the efforts of earlier Timurid *kitabkhana*s (library-ateliers, lit. "book houses") to produce numerous illustrated copies of revisionist histories of Timur's reign. The Timurid painters deliberately emulated both the style and subject matter of illustrated histories produced during the previous century at the Ilkhanid courts of Iran. Mughal painters, by contrast, dispensed with the close imitation of earlier models, although the imperial library possessed illustrated histories of Timurid provenance, which they could, and did, consult. Even when painters might have drawn on examples from illustrated manuscripts created at the Mughal court itself, they instead opted to create entirely novel pictorial cycles.[8]

To these new repertoires of subjects and motifs Mughal manuscript painters added compositional units and representational techniques drawn from European visual arts.[9] These include engravings and woodcuts, many depicting Christian and humanistic subjects. Such objects exemplified new modes of representation, such as the use of modeling, atmospheric perspective, and linear perspective. The three Jesuit missions to the Mughal court, the first inaugurated in 1580, were one important avenue of transmission of these materials. Merchants and imperial courtiers also acquired and circulated European prints and other objects, like paintings, glass vessels, and even a gilded silver drinking automaton. The emperors were not merely passive recipients of these materials from the West but actively and eagerly sought them out. Mughal manuscript painters, in turn, copied, recombined, altered, collaged, and interwove these novel images and modes of representation into their works. Their adaptation of foreign materials had an antecedent in earlier Persianate painters' use of *Chini* (Chinese) forms in manuscript illustrations,

but Mughal artists turned westward, rather than eastward, for their inspiration.[10] They regarded accommodating European with Persianate modes of representation as one of their primary tasks.[11] Although they had established their empire in South Asia, the Mughal emperors boasted Central Asian (specifically, Timurid-Chingizid) origins and had long looked to Ilkhanid, Timurid, Safavid, and even Shaybanid forms of cultural and political expression as exemplars. The elevation of European prints, paintings, and other media to equivalent status, precisely when Europeans were making themselves ever more present in South Asia and across the Indian Ocean, expressed the dynasty's self-conception as a cosmopolitan, world-ruling lineage.[12]

The profusion of new sources, subjects, and formats that Mughal manuscript painters produced during the reigns of Akbar and Jahangir resonated with a courtly ethos that prized novel forms of expression.[13] This turn is perhaps best exemplified by Mughal elites' burgeoning taste for "fresh-speaking" (*taza-gu'i*) poetry. This genre demonstrated a thorough knowledge of its literary precedents while emphasizing verbal ingenuity and newness of expression. This shift has been associated with a broader Indic (and perhaps global) preoccupation with historicity and renewal.[14] These developments should be viewed in light of the religious and political culture of the Mughal court, which celebrated the emperors as messianic bearers of a new era. According to both Akbar's and Jahangir's ideologues, the rulers would usher in a "fresh" age and proclaim an "oath of peace," which would make Hindus, Jews, and Christians the legal subjects of an empire ruled by Muslim (and monotheistic) sovereigns.[15]

Manuscript painters' contributions to these political and ideological enterprises took the form of paintings whose themes, compositions, and forms drew liberally from sources outside the canon of Persianate manuscript painting, and thus pointed to Mughal sovereignty's putatively universal applications. These shifts in image-making practice were more than iconographic. It is true that the members of Akbar's *tasvir-khana* (painting workshop, lit. "image house") turned increasingly to portraiture, and Jahangir's painters radically transformed the role of the manuscript artist by depicting their patron's dreams and visions. Mughal painters also introduced novel ways of representing their subjects that both absorb and beguile with their intricate detail and their construction of stylistically and formalistically heterogeneous worlds. Like Bichitra's painting of Jahangir on an hourglass throne, their works straddled the line between dream and material reality; they call into question the very ontology of the image in relation to painting, and in doing so they entangle artist, emperor, and the empyrean in the fiction of their

own making. Mughal artists elevated manuscript painting from mundane and material to sacred and transcendent.

The Agency of Artists, Paintings, and Books

The perception of Akbar and Jahangir as the ultimate sources of all Mughal pictorial expression—book painting, especially—has nevertheless long prevailed in both the popular and the scholarly imaginaries. The roots of this view can be traced in part to Orientalist writing of the nineteenth and early twentieth centuries, which saw powerful and long-reigning South Asian rulers like Akbar as precedents for colonial administrators and thus as historical protagonists whose empire building reflected the aspirations of the British Raj. By contrast, European and North American epistemological frameworks could not conceive of South Asian artists as anything more than craftspeople and artisans—that is, as subalterns devoid of originality and agency. The organizers of world expositions during this period exhibited contemporary works of South Asian art, many bearing the names of their makers, not in the fine arts halls but in venues dedicated to industrial arts.[16] Even Raja Ravi Varma (1848–1906), often hailed as India's first modern artist, was subjected to this treatment. The coordinators of the 1893 World's Columbian Exposition in Chicago, for which Varma had been selected to represent India, consigned the artist's contribution of ten oil paintings featuring depictions of Indian women to the fair's ethnographic section. The awards that his paintings received on this occasion underscored the subaltern status of their maker: one was given to Varma in commendation for mastering European academic artistic techniques, while another confirmed the works' value as strictly ethnological.[17]

Official Mughal texts fueled the perception of the emperors as the ultimate sources of all imperial pictorial expression.[18] The *A'in-i Akbari* (Regulations of Akbar), an accounting of the Mughal Empire and its offices completed by Akbar's chief ideologue, Abu'l Fazl, in 1596–97, emphasizes Akbar's close oversight of manuscript painting, even claiming that the emperor personally selected the scenes in each text that artists were to illustrate. According to the *A'in-i Akbari*, it was under Akbar's direction that "color has gained a new beauty" and royal painters' "delicacy of work, clarity of line, and boldness of execution, as well as other fine qualities have reached perfection."[19] These statements echo similar claims Abu'l Fazl makes about the emperor's influence in improving other royal institutions, from the imperial perfumery and kitchen to the cattle barns.[20] His hyperbolic assertions are, as one would

expect from an official royal text, rhetorical in function, the aim being to underscore the profound impact of Akbar's "penetrating foresight" (*dur-andish*) on all aspects of the Mughal Empire, large and small.[21] For Abu'l Fazl, the excellence of the imperial administration and its institutions constituted the primary evidence for the emperor's status as a saintly world ruler. Only under Akbar's supervision, Abu'l Fazl implies, could manuscript painting have achieved the heights that it did.

Reading Abu'l Fazl's text against the grain, we see the figure of the emperor recede into the background, while manuscript painters and other makers of books and related materials come to the fore. The first book of the text covers the regulation of such royal institutions as the *farash-khana* (carpet workshop), the *matbakh* (kitchen), and the *qur-khana* (arsenal). Of its ninety *a'in*s (regulations), *a'in* 34, the *a'in-i tasvir-khana* (regulation of the painting workshop), identifies the largest number of sixteenth-century Mughal workshop specialists by name, including the seventeen forerunners (*pish-ri-van*) of painting, the twenty-eight rare masters (*hunar-pardazan-i nadira*) of calligraphy, and fourteen subjects who translated texts into Persian (*bi-farsi avardand*).[22] By contrast, *a'in* 7, on refining gold alloys (*saf kardan-i tala-yi ghash-amiz*), identifies but one specialist, the engraver 'Ali Ahmad; *a'in* 10, on coins (*nuqud*), identifies two engravers—Mawlana Maqsud and 'Ali Ahmad.[23] *A'in* 20, on royal gems (*nagin-i shahinshahi*), names five engravers—Tamkin, Mir Dost, and Mawlana Ibrahim, and, once again, Mawlana Maqsud and 'Ali Ahmad.[24] And *a'in* 37, on the matchlock (*bunduq*), names the gunmakers Ustad Kabir and Husayn.[25] Although Abu'l Fazl elsewhere describes the numerous administrative positions, like *darugha*, *mushrif*, *faujdar*, and *mahavat*, that administered the royal workshops and other institutions, he does not identify the individuals who held them. The forty-two calligraphers, translators, and painters identified in the *a'in-i tasvir-khana* account for over 90 percent of the workshop specialists mentioned by name in book 1 of the *A'in-i Akbari*. If we include the coin and seal engravers—who would also have trained as calligraphers—mentioned in *a'in*s 7, 10, and 20, this proportion increases to 97 percent.

This cursory examination of naming practices in book 1 of Abu'l Fazl's text brings into sharper relief the outsized role that specialists of the book occupied in the Mughal imperial imaginary.[26] Where the author mentions many numerous other workers in the royal *karkhana*s (workshops), most remain unnamed, as if to suggest that they were, in effect, interchangeable, and the skills required to accomplish these tasks could be easily acquired. By contrast, Abu'l Fazl consistently lauds the practitioners of calligraphy, translation, and painting as masters (*sahib*), rare masters (*hunar-pardazan-*

i nadira), renowned (*namwar*), exemplars (*peshwa*), forerunners (*pish-rivan*), and pinnacles of the age (*sar amad-i ruzgar*), thereby characterizing their skills as unique and therefore ostensibly irreproducible.[27]

Scholars' mostly uncritical reception of the *A'in-i Akbari* has resulted in the near erasure of the instrumentality of Mughal imperial painters and other bookmaking specialists. This elision is particularly ironic since surviving inscriptions name scores of painters and identify their roles in the completion of manuscript paintings. The sheer number of painters employed in the imperial workshop and the rigorous attention that administrators paid to documenting their roles in creating individual manuscript illustrations—unprecedented in South Asia or the broader Islamic world—indicates the importance of the institution of manuscript painting. Art historians have made excellent uses of these epigraphic data, but mainly to identify the works of individual artists rather than to explore what these sources may tell us about the formation of a Mughal corporate artistic identity.[28]

Although Mughal illustrated manuscripts represent only a fraction of the books that Akbar and Jahangir commissioned and acquired, their production nevertheless required a monumental investment of capital, labor, and time as well as extensive collaboration and coordination among the atelier's painters and other book specialists. Akbar's atelier created at least three thousand (and probably many more) illustrated manuscript pages, some of them—such as a famous, now-dispersed manuscript of the *Hamzanama* (Tale of Hamza)—nearly two feet tall.[29] A number of these manuscripts originally contained more than sixty full-page paintings, and the marginal inscriptions penned by project or workshop managers reveal that as many as fifty or sixty painters collaborated on a single book project. Even though Jahangir reduced the size of the *tasvir-khana*'s painting staff on his accession to the throne, the members of this smaller atelier remained heavily occupied with the assemblage of an enormous album or *muraqqa'* (lit. "patched" or "mended")—a codex collection of discrete and heterogeneous paintings, calligraphies, and European prints—and the production and refurbishment of other illustrated manuscripts.

The tremendous size, scope, and complexity of these projects involved innumerable decisions, the physical traces of which inhere in the objects themselves. The illustration of poetic and prose manuscripts often entailed the coordination of distinct but contingent activities. These included planning the book's layout, from the number of lines of text per page to the number, selection, and placement of illustrations; the conception and execution of each illustration's foundational composition in transparent gray or brown ink; the filling in of these compositions with opaque watercolors and the subsequent

burnishing of the paper support; the illumination of select pages with metallic leaf and paint; and, in many cases, the decoration of the manuscript's written surfaces and page borders with figural, geometric, and botanical designs. The making of a *muraqqaʿ* required yet other kinds of skills. For each page, court painters had to first select and then arrange and mount the fragments on the album leaf's thick paper support. Royal artists painted over or gilded the joins on each page to create a continuous, conjoined surface and then ornamented the page borders in a rich array of designs, some adapted from Dutch and German engravings. All of these activities required constant collaboration between painters as well as negotiations with other specialists like paint mixers, gold beaters, paper preparers, and bookbinders, to name but a few.

Evidence indicates that painters followed directives that the project manager scrawled on the edges of the page to be illustrated.[30] In most cases, however, painters made decisions primarily through direct engagement with materials and other makers: these decisions—and the knowing entangled with them—were, in other words, tacit and dialectical.[31] Drawing on Pierre Bourdieu's concept of habitus, in chapter 2 I examine the role that these embodied processes played in the formation of the court artist—at once painter, bureaucrat, and disciple—around the end of the sixteenth century.[32] Bourdieu's insistence on the social, and ultimately collective, foundations of identity provides an entrée to perceiving Mughal workshop painters not as autonomous individuals but as constituent members of and thus contributors to a larger court society.[33] Although Mughal manuscript painters often minimized their own agency in the production of their works by characterizing themselves in their signatures as slaves of the court, this was, ultimately, a rhetorical move. In his depiction of Jahangir on the hourglass throne, for example, Bichitra's autograph identifies the artist as *banda ba-ikhlas* (devoted slave) (see fig. I.1); its placement on the emperor's footstool further underscores the painter's acknowledgment of his lowly status. These claims were not unique; Timurid, Turkman, and Safavid artists also styled themselves as royal slaves, using similar terminology, like *ghulam* and *banda*. What distinguishes the Mughal case is the painter's self-identification as an imperial disciple, in a clear evocation of the emperors' putative status as a Sufi saint, prophet, and sovereign and hence of the painter's own intimate, if also subservient, relation to the royal nexus of power.

In their capacities as artists and *murid*s (Sufi disciples), imperial painters conceived their central task as making manifest the metaphysical powers of their royal patrons and *pir*s (Sufi masters). They fulfilled this role by, for example, representing Jahangir's dreams and visions, a phenomenon I examine

in depth in chapter 1. Like prophets, *pir*s, and other Islamic rulers before him, the saintly king claimed to receive divine prognostications, but now it was court painters, rather than writers, as had been the tradition for centuries previously, who documented the emperor's dreams. Manuscript painters operated not simply as recorders of these events but as mediators between the material and spiritual worlds, and thus represented painting as an instrument of spiritual insight. These acts were not without their complications, however: in purporting to depict the empyrean, the Mughal painter straddled the line between a copyist and a creator of forms. In other words he risked the accusation of challenging the creative authority of God, an undertaking that, according to hadith (the verbal record of the deeds and sayings of the Prophet Muhammad), was not only futile but punishable in the afterlife. By identifying himself as a "devoted slave" on the emperor's footstool, Bichitra preempted such charges: his role in the making of the painting, his signature suggests, was strictly subservient and mechanical, not authorial.

Despite such claims, Mughal manuscript painters played a fundamental role in cultivating their patrons' earthly and spiritual authority. In addition to depicting imperial dreams, they produced iconic representations of Akbar and Jahangir that portrayed the father and son as cosmic rulers by virtue of their physical appearance. As I explain in chapter 3, imperial painters drew on the science of physiognomy (*'ilm al-firasa*), which posits that external form is an index of inner character. But these portraits did not exist only in books; they also enjoyed far more physically and socially enmeshed lives in the form of painted tokens that the emperors presented to courtiers to wear on their turbans and around their necks. Imperial portraits also provided the templates for wearable gold coins stamped with the emperors' portraits, known as *shast*s, which the emperors similarly distributed to their disciples. These acts were far-reaching: Sir Thomas Roe, the English ambassador in residence at Jahangir's court between 1615 and 1619, claimed to have received one of these portrait coins. The painters themselves, some of whom enjoyed membership in this royal cult, thus advanced a conception of the Mughal body as a source of spiritual knowledge and healing, a phenomenon with both local and global resonance.

The use of painted portrait designs for these purposes gave painters' works new and very public, tactile lives, but it also points to an association of painting—especially portraiture—with prophecy, revelation, and knowledge transmission that Persianate texts had long explored. The preface (*dibacha*) of an album that the calligrapher Dost Muhammad (fl. first half of the sixteenth century) compiled for the Safavid prince Bahram Mirza (d. 1549)

in Herat in 1544–45, for example, recounts the story of a celestial "chest of witnessing" (*sanduq al-shahada*) that was in the possession of the Byzantine emperor Heraclius (r. 610–644).³⁴ This massive, multicompartmented chest was said to have held painted portraits on silk depicting the prophets, from Adam to Muhammad. Muslim audiences interpreted the presence of Muhammad's portrait as proof that Christians knew that the final revelation of Islam was coming. According to the sixteenth-century text, the prophet Daniyal (Daniel) had painted the portraits as "copies after *acheiropoieta*, 'unmade' images fashioned by God, constituted at the beginning of time and encompassing all of God's creation and its prophetic lineage."³⁵ For Dost Muhammad, the tale of the *sanduq al-shahada* proved the divine and prophetic origins of painting and thus justified the vocation of the court painter. To drive home the point, Bahram Mirza's album contains numerous portraits of prophets, including Muhammad.

The same text also voices concern about painting's potential to deceive, here drawing on themes and ideas that the poet Nizami Ganjavi (1141–1209) had expressed centuries earlier in his *Khamsa* (Quintet). In the *Khamsa*'s final book, the *Iskandarnama* (Book of Alexander), Nizami relates that the emperor of China had invited Mani (c. 216–274), the founder of Manichaeism, to demonstrate his painting skills. Mani was celebrated as both a teacher and an artist. While en route to the emperor's court, Mani chanced upon a pool of water and, being thirsty, paused to fill his jug. His efforts, however, were thwarted: to prove the superiority of Chinese modes of depiction, the emperor had ordered his own painters to create an illusionistic representation of water on a rock crystal panel, and Mani had fallen for the deception. Not to be outdone, Mani then painted an extremely realistic image of a dog's corpse on top of the crystal pool, which so impressed his Chinese counterparts that they permitted him to proceed to his destination. The *Khamsa*'s frame story reveals Mani to be a master illusionist whose creations could deceive the most perceptive of observers.³⁶

In Dost Muhammad's text, it is the Artangi Tablet (*lawh-i artangi*), a painting on silk that Mani is said to have created in a cave over the course of a year, that performs the work of deceiving others, in this case potential converts to Manichaeism.³⁷ Dost Muhammad marshals this material to serve as a point of comparison with Islamic traditions of painting, which the Safavid text of course sanctions. According to this framework, non-Islamic artists, like those associated with Manichaeism and Christianity, employed illusionistic techniques to mislead viewers "into equating what they saw with the real thing."³⁸ By contrast, Islamic painters, as emblematized by the prophet Daniyal and the lineage (*silsila*) of acclaimed court artists who followed in

his path, dispensed with the superficiality of surface appearances in order to portray inner essences that are not immediately visible to the untrained eye. Thus Dost Muhammad not only made the case for Islamic painting's prophetic origins but also argued for the uses of figural representation beyond illusion and entertainment. Painting was an instrument for the production and transmission of visionary knowledge, and the painter a master depicter and decipherer of deeper, hidden meanings.

It is significant, and likely not coincidental, that in the century or so during which Dost Muhammad penned his preface, ideological and affective engagement with manuscript paintings escalated in both the Safavid and Ottoman realms, an effect of the sustained rivalries between the Shi'i and Sunni courts and their expanding contact with Europe.[39] These include depictions of the Prophet Muhammad's facial features in an early fifteenth-century Timurid copy of Hafiz-i Abru's *Kulliyat al-tavarikh* (Collection of histories), which a later, likely Ottoman, user of the book "veiled" with the addition of gold paint.[40] Another example, an illustrated page from a late sixteenth-century manuscript of Mir Khwand's *Rawzat al-safa* (Garden of purity) showing Muhammad and 'Ali, both veiled, destroying idols in the Ka'ba in Mecca, bears evidence of devotional rubbing. While the Prophet's white veil appears to be largely intact, 'Ali's has been rubbed completely away, an intervention that may be attributed to its use by a Shi'i adherent for pious, affective purposes.[41]

The same period saw the increased production of large-scale royal manuscripts of the *Falnama* (Book of divination), a text whose authorship is attributed to the ninth-century imam Ja'far al-Sadiq.[42] What is remarkable about these objects is the preeminence they give to painted representations of prophets and supernatural creatures. In the *Falnama*, these images represented auguries that the reader was to select at random while posing a query; a facing page of text gave the prognostication associated with the painting. Like the examples of the gold-veiled Prophet Muhammad and the effaced 'Ali, the *Falnama* manuscripts attest to the expanding roles of manuscript paintings as instruments of devotion and divination.

Given the Mughal dynasts' enthusiastic affiliation with Persianate cultural practices, it is unsurprising that Mughal manuscript paintings were similarly deployed as affective, epistemic objects. The court employed a large number of specialists—calligraphers, writers, and administrators, among others—from the Safavid sphere. The first directors of the royal *tasvir-khana*, 'Mir Sayyid 'Ali (fl. 1510–72) and 'Abd al-Samad (fl. 1535–1600), hailed from the Safavid courts of Iran, where Dost Muhammad had penned his defense of the Persianate painter's avocation in 1544–45.[43] Mughal notions about painting and images hardly map directly to Safavid ideas, however. Where Dost

Muhammad perceives the illusionistic paintings from Christendom as deceptive works devoid of deeper meanings, Abu'l Fazl praises "the experts of Europe [*karpardazan-i firang*]," who "succeed in drawing figures expressive of the conceptions which the artist has of any of the mental states."⁴⁴ For Abu'l Fazl, painting—regardless of its origins—can bring "truth" (*haqiqat*) to the "exoteric minded" (*zahir-nigahan*).⁴⁵

The painters of the Mughal manuscript workshop seem to have embraced the notion of painting as a heuristic and even quasi-divine medium. Laboring to complete hundreds of manuscript paintings over the course of Akbar's reign, they would in any case have perceived their work to be of critical importance, but some of them also illustrated texts, like Nizami's *Khamsa*, that engaged the very question of images' capacities to deceive and enlighten. Akbar's self-commissioned copy of the *Khamsa* contains a rare depiction of Mani's painting of the decomposing dog on the rock crystal slab, here credited in an inscription in the page's lower margin to the artist Sur Gujarati (fig. 1.2). In this rendering, Mani is shown painting the composition. The work is near completion—the dog's stiff form, complete with exposed entrails and pools of blood, has been rendered in full—but the brushstrokes are still watery and impressionistic, and so the painting still awaits the naturalistic touches that will lend it the illusionistic qualities about which Nizami wrote. But close inspection reveals that Mani's hands also appear unfinished. In the Mughal artist's rendering, painting is not only an artifice, and an exceedingly self-aware one at that; it is a craft that the painter—a master of forms—wields to elucidate the truths of God's creations.

In attending to the lure of images, one is liable to forget that these are physical entities—colors on paper—that were made for books. Many of these painted pages today exist as standalone objects, having been removed from the manuscripts or albums for which they were produced. Scholars have attempted to reconstruct whole codices from the scattered folios and gatherings.⁴⁶ Yet analysis has often centered on single illustrations and painters rather than the unique experiential aspects of creating and viewing paintings housed in books. The disassociation of book illustrations from the contexts for which they were made has resulted in the flattening and effective dematerialization of Mughal manuscript painting, a phenomenon compounded by the long-standing publishing and curatorial practices of cropping out and covering up borders and other nonpictorial components of illustrated pages.⁴⁷ Transmuted from objects into images, Mughal manuscript paintings have been denied the physical reality of their own making and perceived instead as the immediate, unadulterated products of imperial thought.

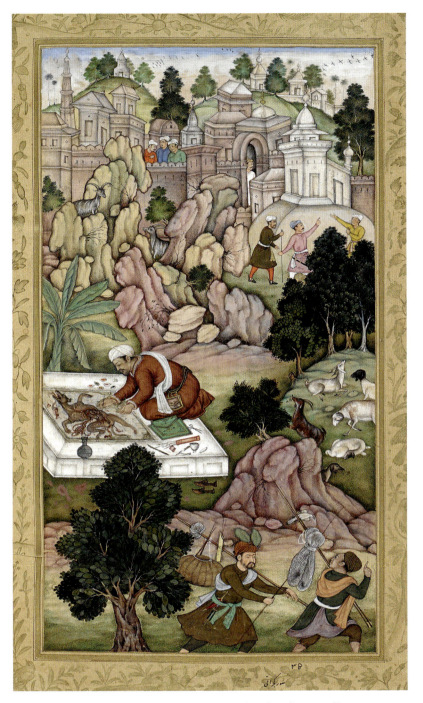

FIGURE 1.2. Mani painting a dead dog, ascribed to Sur Gujarati. From a partially dispersed manuscript of the *Khamsa* of Nizami Ganjavi, completed AH 1004 (1595–56), probably Lahore. Opaque watercolor, ink, and gold on paper. Folio 30 × 19.5 cm. British Library, London, Or. 12208, f. 262v. Photo: British Library / GRANGER.

Mughal manuscript painters recognized the potential that the codex, as both surface and structure, held for their larger enterprise. The recursive content of their images—as in Sur Gujarati's depiction of Mani painting the corpse of a dog—not only provided commentary on the nature of images and image making but also offered reflections on the physical medium, and hence potential instrumentality, of the painted page itself.[48] Bichitra's enigmatic pair of portraits of Jahangir and a Sufi shaykh (see figs. 1.3 and 1.4), both discussed in fuller detail in chapter 1, uses the architecture of the album opening—two facing pages—to bridge an encounter between the living emperor and his deceased spiritual master. The Persian inscriptions on the surfaces of both pages allude to a key (*kalid*) that will open the two worlds, earthly and celestial, that is "entrusted to your hand" (*ba-dast-i tust musallam*).[49] The epigraph may be understood to allude to Jahangir's hands, which are depicted on the right-hand page holding a celestial sphere, but it may also refer to the hands that hold the painted page. These double meanings reminded contemporaneous viewers of the physical reality of paintings, folios, and books and thus of their effective utility.

It was in the context of the *muraqqa'*, especially, that Mughal manuscript painting's multiple potentialities were most fully realized. A now-fragmentary album once holding well over 150 folios and known interchangeably as the Jahangir or Gulshan Album—assemblage of which began around 1599–1600, when Jahangir (then known by his given name, Salim) was still a prince—bears the material traces of these designs.[50] Containing portraits, calligraphic specimens, and European engravings, among many other types of works, the Jahangir Album also includes paintings with inscriptions that identify them as presentation pieces made for the occasion of Nawruz, the Persian New Year. As chapter 4 explains, these works functioned as the royal painters' contributions to the multiday celebrations, which also commemorated Jahangir's accession. These painterly gifts added to the Jahangir Album a critical temporal and ritual dimension. They also embedded the royal painter, and sometimes his family as well, in this momentous, multilayered codex collection.[51]

Manuscript painting and making offered the Mughal court artist a path to professional and social advancement, but these acts of figuration also threatened to trouble a cosmic and ideological paradigm that posited the emperors as the sole, ultimate, and infallible purveyors of divine truths. This was perhaps the primary reason that manuscript artists undercut their own agency as creators and instead foregrounded the emperor's vision (and visions). Even a painting bearing the artist's signature could accomplish this

end. In his painting of Jahangir seated on an hourglass throne, Bichitra uses his autograph to underscore his imperial servitude and contingent status as a creator. The problem is that Bichitra and his colleagues were too effective in their self-effacement, for they have left past and present viewers with the impression that neither their works nor their aspirations were their own.

Plan of the Book

The Brush of Insight examines one group of people (Mughal court painters), one location (the Mughal court), one medium (illustrated manuscripts, including albums), and one relatively brief span of time (c. 1544–1627). It does not aim to be comprehensive. But it is precisely this narrow focus that enables close examination of the formation of a new artistic, courtly agency, and of the ways that pictures and illustrated books became central to imperial modes of seeing and being in Mughal South Asia.

Rather than proceeding according to a strict chronology, the book begins with the years 1615–20, when Jahangir's court artists produced a significant corpus of manuscript paintings that purported to depict the emperor's dreams. The following chapter moves backward in time to the mid-sixteenth century to trace the earlier formation of the Mughal painter into a bureaucrat and disciple. Chapters 3 and 4 attend to the production, collection, and reception of illustrated manuscript materials associated with the reigns of both Akbar and Jahangir. By eschewing a strictly chronological structure, the book aims to identify and reinforce the multiple points of connection and continuity that existed between artists, other cultural producers, and their patrons.

The materials examined range from illustrated and unillustrated poetic and prose manuscripts to albums and coins. Here, again, it might seem logical to discuss the objects in chronological order of production. Yet because these objects are deeply layered, temporally and materially speaking, they defy such linear categorization. Court artists reportedly began to assemble the gargantuan Jahangir Album, for example, while Jahangir was still a prince. Construction of this *muraqqaʿ* continued into his reign as emperor, but its contents include drawings, paintings, and engravings that predate the codex itself. Because poetic and prose manuscripts were often refurbished, sometimes with significant material augmentations, dating them is complicated. The subsequent dispersal and fragmentation of these materials introduce yet further complexities. For these reasons, the book moves frequently among the various layers of these palimpsestic materials to bring into sharper relief the threads of association and affiliation that bind them.

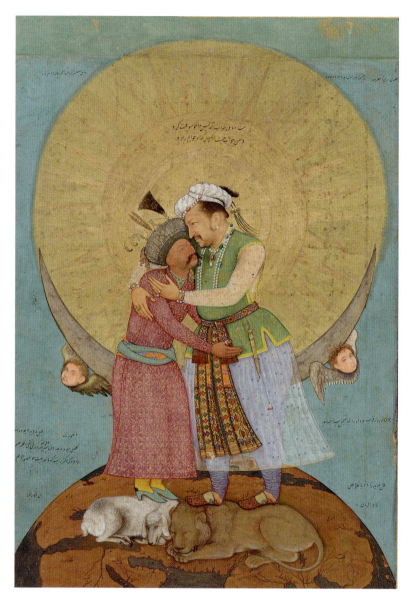

FIGURE 1.1. Jahangir meeting Shah 'Abbas I in a dream, signed by Abu'l Hasan and completed circa 1615, probably Ajmer. Mounted on a dispersed page from the St. Petersburg Album, compiled eighteenth century, Iran, with decorated margins (here cropped, though comparable to those reproduced in fig. 1.1) added by Muhammad Sadiq in AH 1160 (1747–48). Opaque watercolor, ink, and gold on paper. Folio 47.9 × 33 cm; painting 23.8 × 15.4 cm. Freer Gallery of Art, Smithsonian Institution, Washington, DC. Purchase—Charles Lang Freer Endowment, F.1945.9a.

INNER VISIONS

Fragments from the Unseen World

I

ONE EVENING AROUND 1615, while sleeping directly over a sacred spring on the outskirts of Ajmer, the Mughal emperor Jahangir (r. 1605–27) reportedly had a dream in which he encountered his rival, the Safavid ruler Shah 'Abbas I (r. 1588–29). Neither the experience of the dream nor its subsequent transmission in a book is unusual. Royalty, Jahangir's forebears included, often claimed to be visited by portentous dreams, which they or their servants recorded as textual accounts in chronicles and related works. In this case, however, it was a member of the Mughal manuscript atelier's staff of painters who documented the emperor's dream (fig. 1.1). Manuscript painters had long found employ at the Persianate courts of South Asia and Greater Iran, but whereas they had previously operated mainly as the illustrators of poems and chronicles, the artist Abu'l Hasan (1589–c. 1630) would now bring to life—in vivid colors and gold leaf—the "world of images" (*'alam al-mithal*), that intermediary zone between God and man, in which dreams took shape but not substance. The painter, in other words, materialized the Mughal emperor's nocturnal vision.

This painting belongs to a small group of highly unusual imperial portraits—all produced in the final fifteen years of Jahangir's reign and signed by or attributable to a handful of artists, Abu'l Hasan, Bishandas (fl. seventeenth century), and Bichitra (fl. early seventeenth century) among them—that purport to depict Jahangir's dreams and visions, and that represent the emperor as a spiritual sovereign who receives messages from God.[1] Unlike the depictions of events from the *Akbarnama* and in the other dynastic texts that imperial artists produced during the 1580s and 1590s, these paintings are set in ethereal environments replete with sun, moon, and angels. Their focus on the political and spiritual aspirations of their patron, Emperor Jahangir, further differentiates them from the kinds of works that Mughal artists had been creating for decades prior. Abu'l Hasan's painting shows Jahangir and Shah

'Abbas locked in an embrace while standing on a European terrestrial globe, each supported by an animal—Jahangir by a lion, Shah 'Abbas by a lamb. Abu'l Hasan made the important decision to place the lion's recumbent body over not only Mughal Hindustan, but Iran, too, including the Safavid capital of Isfahan. The beast's chest blankets the strategic zone between Qandahar and Kabul, over which the Safavids and Mughals fought for much of the sixteenth and seventeenth centuries. The artist effectively transmuted his patron's mundane territorial claims into cosmic prerogatives.

These paintings are further distinguished by their pairing of Persianate with European and Indic iconography and their incorporation of representational strategies historically associated with European art, including the use of modeling and tonal coloration to indicate volume, and the delineation of physiognomic details like idiosyncratic eyelid creases, mustache hairs, and sagging jawlines. Some of them even imitate European pictures wholesale. For example, Bichitra's depiction of Jahangir on an hourglass throne includes a representation of the English king James I (r. 1603–1625) in the lower left corner of the composition (see figs. 1.1 and 1.13). This was closely modeled after a portrait associated with John de Critz (c. 1551–1642), one of several painters active at the Stuart court. Also exceptional among this group of paintings are the calligraphic inscriptions that employ both the first- and third-person voices and the unconventional grouping of primary compositional components in the pictures' immediate foregrounds. Comparison with Mughal manuscript paintings from a slightly earlier period helps to elucidate the latter point. An illustration from an imperial manuscript of the *Akbarnama*, illustrated circa 1590–95, depicts the enthroned Emperor Akbar (r. 1556–1605), Jahangir's father, in the middle ground of the image and thereby contextualizes the dynast within the pictorial space (fig. 1.2). Abu'l Hasan's and Bichitra's paintings of Jahangir instead represent the Mughal sovereign in a zone that is flush with the picture plane.

These pictorial strategies, motifs, and formats distinguish this small group of works from other paintings that had been produced and collected at the Mughal court. They signal that Jahangir's dreams manifest not on the earthly plane but in the *'alam al-mithal*, a zone of archetypal forms from a realm between the corporeal and spiritual worlds. The representation of uncommon forms in the dream paintings—an English portrait of James I, a European terrestrial globe, and an owl, to name only a few—brought the extraordinary realm into the everyday reality of paint on paper, while the movement across the codex's gutter margin—from verso to recto page, and from one dream painting to the next—evoked the journey between the celestial and earthly

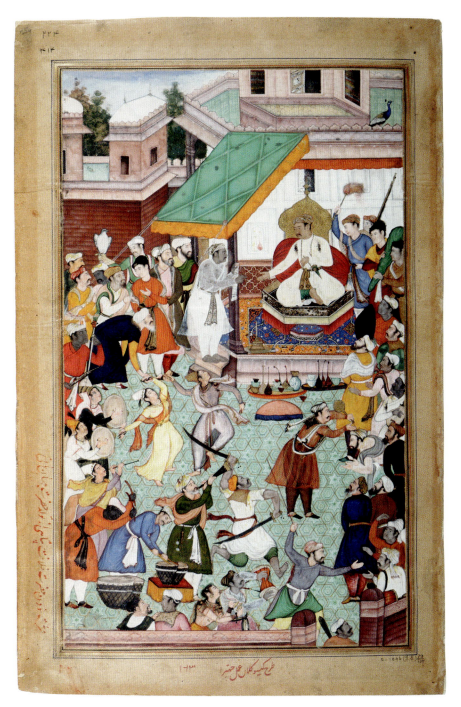

FIGURE 1.2. Emperor Akbar receiving news of the birth of his first son, Prince Salim, illustration ascribed to Keshava Kalan (*tarh* or "design") and Chitra (*'amal* or "coloring" or "work"). From a fragmentary manuscript of the *Akbarnama*, completed circa 1590–95, probably Lahore. Opaque watercolor, ink, and gold on paper. Painting 38.1 × 22.4 cm. Victoria and Albert Museum, London, IS.2:79–1896.

spheres. Interceding between God and Jahangir, the royal and divine kingdoms, and the earthly and celestial realms, the Mughal painter transcended the function of the court chronicler and the poet, becoming something more akin to the *mu'abbir* (dream interpreter) who connects the dream's sensory form (*surat*) to its inner meaning (*ma'ni*).

The royal artist nevertheless checked his ambitions. Mindful of the societal and religious conventions he might be perceived as transgressing, the painter portrays himself as the dutiful recorder, rather than the inventor, of the emperor's dreams. This self-effacing act—like that of the Mughal artist who paints to remind his audience of the artificiality of the entire pictorial enterprise—accorded with an imperial paradigm that framed the emperor as an enlightened spiritual as well as terrestrial master and his most intimate servants as his faithful disciples.

Jahangir's Dream

As if to forestall any question regarding its origins, Abu'l Hasan's painting of Jahangir embracing Shah 'Abbas tells us unambiguously that its source is a dream through a couplet of poetry voiced in the first person and inscribed in black ink above the two rulers' heads. It reads:

> Our shah came in a dream [*dar khwab*] and made me happy.
> He who woke me from my sleep is an enemy to my dream.[2]

An inscription copied in the upper left and right corners of the composition, written in the third person, additionally notes that Jahangir composed these lines after he witnessed (*mushahada numuda budand*) the content (*mazmun*) of the painting in a dream while sleeping near Chashma-yi Nur, a sacred spring located on the outskirts of Ajmer in today's Rajasthan.[3]

Epigraphs at the lower left explain that because Abu'l Hasan had not seen Shah 'Abbas in the flesh, "the blessed form of the shah was ascertained from a group who had seen him, and with the help of analogy [*qiyas*] and conjecture [*qarina*] of an artist [*hunarvar*], in short a likeness [*surat*] was made, which most believe to be like him. God [*huwa*] is the omniscient [*al-a'lam*] Form-giver [*al-musavvir*]."[4]

Additional inscriptions at the bottom of the painting identify the composition as "the work [*'amal*] of the disciple's devoted offspring [*muridzada-yi ba-ikhlas*] Nadir al-Zaman [Rarity of the Age, i.e., Abu'l Hasan], son of Aqa Riza." The adjoining statement claiming that "because Nawruz [the Persian New Year] was soon approaching, the painting was completed in haste" is

not to be taken at face value. Rather, as I discuss in chapter 4, this assertion strategically placed the painter's masterpiece beyond evaluation by the imperial bureaucracy, which both dictated and commodified the Mughal servant's every official function. Abu'l Hasan's presentation piece was thus transformed from a mundane exercise into a wondrous, temporally impossible performance. But by foregrounding this assertion, the artist simultaneously relinquished any claims to be the true inventor of the composition: his role in this enterprise amounted to completing its coloring (*'amal*, lit. "work"); credit for the design (*tarh*), the inscription suggests, belongs to someone else.

One sign that Abu'l Hasan's painting portrays an oneiric setting is the appearance of cherubs. Among the three types of dreams described by Ibn Khaldun (1332–1406) in the *Muqaddimah* (Introduction) are those that come from angels, which, unlike those dreams sent by Satan (*adghath al-ahlam al-kadhiba*), are considered to be true (*al-ru'ya al-saliha*).[5] In the *Ihya' 'ulum al-din* (Revival of religious sciences), the eleventh-century Sufi and theologian Abu Hamid al-Ghazali (1058–1111) asserts that dream visions come from the realm that one encounters after death, a "world of the angelic kingdom and the unseen" (*'alam al-malakut wa'l-ghayb*), which is distinguished from the "world of possession and [sense] perception" (*'alam al-mulk wa'l-shahada*).[6]

Additional signs that the painting depicts a dream are the crescent moon and the large sun, which suggest the subject's celestial context. A very early Islamic instance of the location of the dream world in the heavens appears in Qur'an 12:3, which cites the revelation of the Prophet Yusuf (the biblical Joseph) that he saw in a dream "eleven planets, and the sun, and the moon." Islamic dream-interpretation manuals from the medieval period list the various beings, objects, and phenomena one might encounter in a dream. These include God, angels, prophets (including the Prophet Muhammad), demons, sky and earth, day and night, stars, planets, rain, and so on.[7] The Prophet Muhammad's journey to the heavens (*mi'raj*), though technically a vision rather than a dream, served (and continues to serve) as the exemplar of the celestial peregrination.[8] As narrated in the Qur'an and hadith, it is said that the Prophet Muhammad met various prophets and witnessed numerous miracles during his ascent through the seven heavens.

The heavenly setting of Jahangir's vision also corresponds with the many descriptions of Sufi masters' dreams recorded in diaries, *malfuzat* (records of spoken words, lit. "utterances"), *tazkira*s (biographical anthologies), and histories (*nama*s, *tarikh*s) produced across Iran and South Asia during this period.[9] These accounts typically open with a dynastic progenitor experiencing a dream in a celestial setting containing the sun, the moon, and other

heavenly bodies.[10] Indeed, solar (as well as terrestrial) imagery appears frequently in the accounts of the dreams of Shaykh Safi al-Din Ishaq Ardabili (1252–1334), the founder of the Safaviyya *tariqa* (spiritual brotherhood) and the ancestor of Shah Isma'il, who established the Safavid Empire in Iran in 1501. The *Habib al-siyar* (Beloved of biographies) of Ghiyas al-Din Muhammad Khwandamir (1475–1535) describes a dream of Shaykh Safi, which, like Jahangir's vision, is set in the sky. It begins: "Among them, one night in the realm of dreams, he saw that he was sitting on the dome of the Friday mosque in Ardabil. Suddenly a sun arose that illumined all the regions of the earth with its light."[11] Later Khwandamir remarks: "As this writer was narrating the dream and its interpretation, it occurred to his feeble mind that already in the realm of dreams it must have clearly appeared to the divine Shaykh that from the horizon of his progeny, a sun was soon destined to arise, such that the crescent of the banner of his rule cast its rays, as a shining orb, upon the whole expanse of the earth."[12] Much of this description could apply equally to the painting of Jahangir's vision.

Abu'l Hasan's painting thus not only establishes the heavenly origins and oneiric nature of its subject, but it also equates Jahangir with other sanctified individuals who received dreams from on high. But heavenly dreams were vouchsafed to temporal leaders as well as prophets and Sufis. Abu Bakr (d. 634), the first of the Rashidun caliphs, was known for his celestial dreams; he was also celebrated as an expert interpreter of dreams. Oneiric narratives also figure in the numerous histories of the Abbasids, the Timurids, the Ottomans, and the Safavids, showing that the recounting of nocturnal visions was not only a royal prerogative but was fundamental to the form and structure of political discourses.[13] Accounts of dreams were judged in these texts to possess as much truth value, and thus rhetorical weight, as reports of real-life encounters.

The same was true of the Mughals. The memoirs of Babur (r. 1526–1530), the dynasty's founder, contain records of the author's dreams, including a dream in which he claimed a Sufi shaykh of the Naqshbandi lineage conferred blessings upon him. The *Akbarnama* and the *Jahangirnama* (Book of Jahangir), Jahangir's history of his own reign, also provide detailed accounts of imperial dreams as well as of dreams concerning the emperors recounted by family members and other intimates. These, according to A. Azfar Moin, "carried substantial symbolic capital and . . . constituted cosmological gifts in an exchange economy that created obligations for the sovereign."[14] Dreams, in short, played a fundamental part in the competitive social machinations that produced Mughal authority and power.

Despite the phantasmagoric appearance and celestial setting of Abu'l

Hasan's painting—as well as the presence of an inscription affirming that the image represents Jahangir's own dream—art historians have resisted interpreting it within an oneiric framework. Jeremiah P. Losty, for example, interprets the presence of the sun and moon in this painting solely as an allusion to Jahangir as "the light of the world," referring here to the emperor's title of Nur al-Din (Light of Faith).[15] Amina Okada, meanwhile, suggests that "this scene, completely devoid of historical fact, is the brilliant if naïve expression of Jahangir's anxiety and insecurity when confronted with the thorny question of Qandahar."[16] Jahangir's dream image, in other words, has psychological origins. While there may be some truth in this view, Jahangir and his contemporaries saw dreams as coming not from one's suppressed desires and concerns, but from other realms.

Art historians have furthermore identified the allegorical structure of Abu'l Hasan's painting, and of related contemporary works, as a borrowing from the European prints and other images that the Mughals collected so enthusiastically during the late sixteenth and early seventeenth centuries.[17] Allegory nevertheless also figures prominently in texts on Islamic oneirocriticism. The biographical dictionary of the blind, *Nakt al-himyan fi nukat al-'umyan* (Outpourings from the purse, anecdotes about the blind), by the Mamluk official al-Safadi (d. 1363), contrasts allegorical dreams with direct dreams: the latter, he explains, communicate future events exactly as they will happen.[18] According to Ibn Khaldun, those dreams that are "clear and distinct," meaning that "the ideas perceived in them may be very similar to the pictures by which they are represented," do not require interpretation.[19] Allegorical dreams, on the other hand, require interpretation (*ta'bir*) because of the gap between the dream images and the ideas that they signify. Both the allegorical dream, as it is understood in Islamic oneirocriticism, and the printed and painted European allegorical representations employ encoded imagery to convey an underlying meaning. Islamic dream allegories, however, are distinguished by their presumed source—the angels and the heavens, rather than the artist.

In this view, Jahangir's allegorical dream originated from neither the painter nor the emperor himself but rather from the divine. The oneiric narrative could thus make a political message appear to be preordained, or simply a matter of God's will.[20] Dream narratives, conceived in this way, could serve to bolster a ruler's political legitimacy (and that of his dynasty) while besmirching another's. A dream could also provide a ruler with justification for politically unpopular policies. Further, by laying claim to a visionary experience, a ruler could demonstrate his piety and proximity to God. Only the most virtuous and devout, after all, could receive visions from God.[21]

The oneiric framework transformed the political concerns and aspirations of Jahangir and his ideologues into heaven-sent declarations that could not be easily dismissed or challenged.

Seen in this light, Jahangir's dreams and his painters' depictions of them might best be understood as divine oracles, a proposition that Moin advances in his study of millennial sovereignty across the Timurid, Safavid, and Mughal empires. Moin suggests that rather than being memorialized in the *Jahangirnama*, a decidedly public text that enjoyed a broad readership, the emperor's dreams enjoyed a more limited, intimate audience as single-edition pictorial representations. The dream paintings hence echo a tradition of hagiographical writing in which the dreams of *pir*s (Sufi masters) were recorded and then transmitted only to their closest followers and progeny; but "instead of writing down his miracles, [Jahangir] had them painted."[22]

Nevertheless, here and in much of the art historical scholarship, the Mughal painter's part in depicting Jahangir's dreams remains little addressed. Even if, according to Islamic oneirocriticism, the painter's role was to depict—rather than invent—the dreams that his royal patron received from on high, this task would not have been taken lightly. In this capacity Abu'l Hasan enjoyed the important dual roles of witness to and mediator between the royal (i.e., temporal) and divine spheres. He both copied and gave material form to the intermediate zone of dreams. He traversed the earthly and the otherworldly, the prefigural and the phenomenal, the past and the present. He and Mughal painters like him were not only experts in designing and coloring; they were masters of a realm that bridged the world of the living and that of the dead.

Encountering the Dead

Just as dreams afforded the Mughal emperors the knowledge of future events, they enabled direct encounters with those who were no longer present. In his memoirs Babur describes an oneiric meeting with a fifteenth-century Naqshbandi saint, who apparently conferred on him a blessing that led to the Mughal upstart's temporary conquest of Samarqand.[23] Jahangir, in another instance, recorded a dream encounter with the deceased Akbar in or around Ajmer in 1614. In the dream, Akbar recommended clemency for 'Aziz Khan, the nobleman known as Khan A'zam, whom Jahangir, on the advice of his son Khurram (the future Shah Jahan), had imprisoned in Gwalior Fort. Jahangir recorded the meeting in his own memoirs.[24] Such visionary

testimony fulfilled multiple purposes. When Babur claimed to have met and received crucial strategic advice from a Naqshbandi shaykh in a dream, he ultimately credited a deceased spiritual being for his military victory while simultaneously depicting himself as uniquely sagacious. Jahangir's dream meeting with Akbar says as much about his gift of nocturnal insight as it does about the cultivation of Akbar's posthumous reputation as a mystic and sovereign. It is significant that Jahangir receives guidance not from a Sufi or a prophet, but from his father, who is here treated as a Sufi king possessing prophetic abilities.

In recording their dreams, Akbar and Jahangir participated in a tradition in which living persons claimed exclusive access to deceased luminaries—prophets, scholars, and shaykhs alike. Ibn 'Arabi claimed that his *Kitab al-futuhat al-makkiya* (Book of the Meccan revelations), a multivolume work dealing with a range of mystical topics, had been inspired by visions of the Prophet Muhammad he had received while on a pilgrimage to Mecca. Ibn 'Arabi was said to have been able to speak with prophets whenever he desired.[25] Dreamers also drew on their incontestable encounters with the dead to circumvent and expand on an established canon.[26] The Abbasid caliph al-Mam'un (r. 813–833), for example, claimed to have met the Greek philosopher Aristotle in a dream and to have received from him the inspiration to promote translations of Greek texts into Arabic.[27] The much later Muslim ruler of Mysore, Tipu Sultan (r. 1782–1799), also claimed to receive multiple visitors in dreams, from Sufi saints and the Imam 'Ali to the Persian poets Sa'di (d. 1291) and Jami (1414–1492).[28] Like al-Mam'un's dreams, Tipu Sultan's served to augment a deceased person's verbal record.

Sufis also claimed to receive esoteric instruction from deceased saints (*awliya'*) and prophets (*anbiya'*) in their dreams.[29] Many reported dream encounters with Khizr, a prophet-like figure believed to possess arcane knowledge of God. For the novice—whose goal was to achieve *kashf* (unveiling), a crucial step toward enlightenment—oneiric communication with Khizr and the saints provided direct access to the *'amal al-mithal*, the hidden realm that lies beyond phenomenal reality. Dreams, in other words, facilitated the seeker's apprehension of divine truth (*tajalli*).[30]

Departing from the strictly textual medium in which royal chroniclers and Sufi communities commonly represented such dream meetings, two seventeenth-century companion portraits—one of Jahangir, the other most likely of Mu'in al-Din Chishti (1141–1230), the Sufi shaykh who famously established the Chishtiyya *silsila* (lineage) in South Asia during the thirteenth century—employ the medium of painting and the architecture of the album

codex, known as a *muraqqa'* (lit. "patched" or "mended"), to record an encounter that could have occurred only in the Mughal sovereign's dreams (figs. 1.3 and 1.4; see also chapter 4). Because the pages' floral borders do not match, some have concluded that they could not have been originally bound side by side (i.e., as facing verso and recto pages).[31] It is nevertheless unclear whether the borders are contemporary with the paintings' production: the precise moment of compilation of the Minto Album, from which both folios come, remains unknown, and the current appearance of its contents, including the decorated borders, reflect interventions made at the very end of or shortly after Jahangir's reign. The depictions of both figures in strict profile—the portrait of Jahangir, mounted on a verso page, faces left, and the portrait of the shaykh, appearing on a recto, faces right—so that when viewed in a codex, they would have confronted each other squarely, and the inclusion of similar iconography certainly suggests that the two portraits were conceived as a pair. Both, for example, hold celestial orbs pierced with keyholes; the shaykh's is capped with a Timurid crown.[32] Gold inscriptions on the two paintings provide additional, compelling evidence that the two portraits were made to be viewed together, for not only are the epigraphs visually similar, but each also records the name of the Mughal court artist Bichitra.[33] Moreover, both images bear the inscriptions *kalid-i fath-i du 'alam ba-dast-i tust* (The key to the opening/ victory of the two worlds is entrusted to your hand), which appear in the upper left corner of the painting of Jahangir and on the orb in the portrait of Mu'in al-Din Chishti, and *banda-yi dargah* (slave of [your] threshold), presumably an allusion to the artist.[34] The suggestion here is that the long-deceased Sufi saint has bestowed upon Jahangir the key to the temporal and spiritual worlds. The paired portraits function as more than a depiction of a dream encounter; they instantiate it. The implied space between the two profiles, physically represented by the gutter margins that would have originally lain between the bound album pages—represents the metaphysical gap between their two worlds.[35] Bichitra's paintings effectively conjoin the realms of the waking and dreaming, living and deceased, and material and spiritual.

One of the central messages of this pairing of portraits is Jahangir's uniquely enlightened status. The emperor is depicted as the recipient of a visit and a gift of spiritual largesse from one of the most revered and sanctified South Asian Sufis. Following his father's example, Jahangir actively cultivated the appearance of being not only a temporal ruler but also a Sufi king.[36] His birth name, Salim—after Salim Chishti (d. 1572), the Sufi shaykh who had foretold his birth and in whose *khanqah* (lodge) the prince was reportedly born—broadcast his affiliation with Sufism, and with the Chishtiyya *silsila* in particular.[37] Jahangir even claims in his memoirs that Salim Chishti had

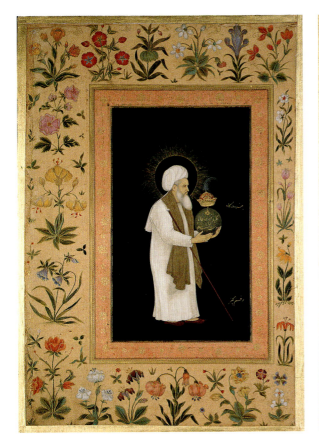 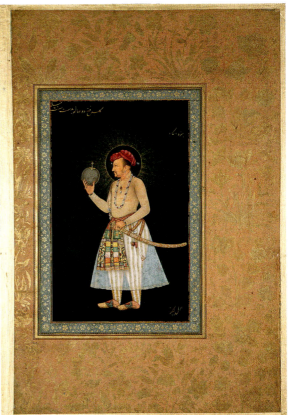

FIGURE 1.3. *left* Shaykh Muʻin al-Din Chishti holding an orb, signed by Bichitra and completed circa 1615–18, probably Ajmer. Mounted on a page from the divided Minto Album, with decorated margins added circa 1620–40. Opaque watercolor, ink, and gold on paper. Folio 38.9x 27.2 cm; painting 21.8 × 12.95 cm. © The Trustees of the Chester Beatty Library, Dublin, In 07A.14.

FIGURE 1.4. *right* Jahangir holding an orb, signed by Bichitra and completed circa 1615–18, probably Ajmer. Mounted on a page from the divided Minto Album, with decorated margins added circa 1620–40. Opaque watercolor, ink, and gold on paper. Folio: 38.9 × 27.2 cm; painting: 20.6 × 12.8 cm. © The Trustees of the Chester Beatty Library, Dublin, In 07A.5.

appointed him his spiritual successor by placing his turban on his namesake's head. Jahangir, then still known as Salim, would have been only two or three years old at the time.[38]

But the emperor reserved his most profound reverence for Muʻin al-Din Chishti. His displays of devotion escalated in AH 1022 (1613–14), the year that Jahangir transferred his court to Ajmer, where it remained until 1616. Though this move was almost certainly motivated by the need to counter a military rebellion mounted by Rana Amar Singh I of Mewar (r. 1597–1620), it also afforded the emperor proximity to Muʻin al-Din's *dargah* (shrine) in the center

FIGURE 1.5. Aerial view of the domed *dargah* (shrine) of Muʻin al-Din Chishti, Ajmer. Dinodia Photos / Alamy Stock Photo.

of that city (fig. 1.5). In fact, the *dargah* was Jahangir's first stop on entering Ajmer in 1613; his arrival on foot from Agra, not coincidentally, echoed the many pilgrimages his father had made to the same site. Jahangir made at least nine visits to the *dargah* during his three-year residency in Ajmer. On one of these occasions he donated a large *dig* (cauldron) to feed the many pilgrims that visited the complex.[39] Among his other material contributions to Muʻin al-Din's *dargah* was an elaborate gold rail to surround the Sufi's cenotaph.[40] While suffering from a prolonged illness, Jahangir not only prayed at and gave alms to the *dargah*; he also committed, on his recovery, to pierce his earlobes and wear pearl earrings as an external sign of his devotion. Many Mughal courtiers, in addition to *ahadi*s (foot soldiers), subsequently pierced their ears in emulation of the emperor.[41] This act—like the courtiers' donning of the emperor's painted portrait as pendants on their turbans and necklaces, discussed in chapter 2—cast royal subjects as *murid*s (disciples) and Jahangir as their *pir* (master), once again mirroring the Sufi *pir-murid* relationship.

Jahangir's visionary dreams seem to have flourished most vigorously while he was in residence in Ajmer, and thus in the vicinity of Muʻin al-Din's sanc-

tified body. Jahangir's dream of Akbar, for example, occurred in Ajmer four months after he pierced his ears in devotion to the shakyh. His dream of Shah 'Abbas also took place around this time, as indicated by the identification of Chashma-yi Nur as the site where it occurred. This pleasure palace, the construction of which was completed in 1614–15, lay less than three kilometers from Ajmer—far enough away from the city that Jahangir was able to visit it only on Tuesdays and Fridays (fig. 1.6).[42] The palace's location, near the top of a ravine that sits just below Taragarh, a twelfth-century fort, did not quite allow the emperor a view of the shaykh's tomb. In the Mughal imaginary, however, the two structures were closely linked, as evidenced by a painting showing Jahangir at the *dargah* of Mu'in al-Din (fig. 1.7). In the background is a small structure built alongside waterworks. This detail helps us to identify this complex with Chashma-yi Nur, for, as Jahangir notes in his memoirs,

 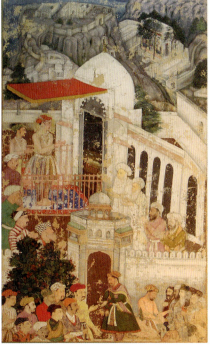

FIGURE 1.6. *left* Remains of a *pishtaq* (rectangular frame around a vault) and *ayvan* (vault) at Chashma-yi Nur, near Ajmer. Completed AH 1024 (1614–15). Photograph by author.

FIGURE 1.7. *right* Jahangir visiting the *dargah* (shrine) of Mu'in al-Din Chishti in Ajmer. From a dispersed and possibly unfinished manuscript of the *Jahangirnama*, compiled circa early 1620s, northern India. Opaque watercolor, ink, and gold on paper. Painting 33 × 20 cm. Raza Library, Rampur, Album 1, f. 3a. Photograph by author.

the palace featured a sophisticated hydraulic system that enabled water from the spring to be collected in a large reservoir below it.

Chashma-yi Nur's dramatic ravine setting, combined with its spring, fountain, reservoir, and "harmonious pavilions and delightful porticos and dwellings . . . some decorated and painted by expert masters and skilled painters," as Jahangir himself put it, provided aesthetic enjoyment, but it was also part of Ajmer's network of sacred Chishti geography, with the shrine of Muʿin al-Din at the center. Saints' bodies, according to Sufi traditions, emanate *baraka* (spiritual blessing); physical proximity to a shrine conveys some of this beneficent force. Sleeping near a *dargah* could facilitate the apprehension of dreams.[43] Jahangir's career as a visionary dreamer was owed, rather than merely incidental, to his tenure in Ajmer and to his closeness to the Chishti shrine in particular. Indeed, his proximity to Muʿin al-Din lent him the charismatic aura on which he based his identity as a mystical world ruler.

Springs and other natural water sources, of course, have their own potent associations with dreams, miracles, and healing powers. The Zamzam Well in Mecca, which Muslims have long associated with Ibrahim (the biblical Abraham), Ismaʿil, and the Prophet Muhammad's grandfather ʿAbd al-Muttalib, is perhaps the most famous example.[44] Numerous other *chashma*s abound, including the Chashma-yi ʿAyub (Fountain of Job) in Bukhara, around which lies a shrine whose original construction may date to the reign of Timur (d. 1405).[45] Babur's autobiography mentions a number of sacred springs, and Humayun (r. 1530–40, 1555–56), Babur's father, is known to have celebrated the circumcision of Akbar in 1546 at the *chashma* of Khwaja Seh Yaran, near Kabul.[46] Akbar shared his forefathers' interests in the political use of water features. In AH 1009 (1600–1601 CE) he added an inscription commemorating a military victory to an open-courtyard complex his commander Shah Budagh Khan had constructed in AH 982 (1574–75) around a sacred spring in Mandu.[47]

Jahangir's own patronage of sacred springs was unique to the extent that he resided, if only temporarily, next to Chashma-yi Nur. He not only slept by and drank the "the water of Immortality," as the spring is characterized in a contemporary inscription on the palace complex's *pishtaq* (rectangular frame around a vault), but also conducted business and dined near it.[48] Chashma-yi Nur provided Jahangir a crucial connection with Muʿin al-Din's Sufi daughter, Bibi Hafiz Jamal, after whom both the spring and the ravine had earlier been named, thereby extending the Mughal sovereign's association with the shaykh to include the shaykh's esteemed offspring.[49] The sacred

waters activated Jahangir's miraculous, visionary powers and also brought him closer to his *pir*.

It was during Jahangir's residency in and around Ajmer—and in particular through his close contact with Mu'in al-Din's *dargah* and Chashma-yi Nur— that he began to dream of Akbar, Shah 'Abbas, and the Chishti shaykh. It was also during this time that Jahangir pierced his ears in tribute to Mu'in al-Din and as a testament to his status as heir of the Sufi master's legacy. The imperial mint in Ajmer struck gold coins bearing the emperor's likeness along with inscriptions that identified him as *hazrat*, an honorific title usually reserved for prophets and Sufi *pir*s. Mughal artists produced the dream paintings, in other words, at precisely the time when Jahangir's claims to sacred authority and his cultivation of a coterie of disciples had reached a fever pitch.

Bichitra's paired portraits of Mu'in al-Din and Jahangir reinforced the notion that the Chishti saint had sanctioned Jahangir's promotion to lord of the spiritual and temporal realms. Bichitra's depiction of their meeting can be seen as visual documentation of the spiritual transformations Jahangir claimed to have achieved under the influence of his master.[50] Yet the paintings seem to have functioned as more than just records of the emperor's oneiric meeting. If we regard Bichitra's works primarily as physical objects, specifically as paintings created for use in a codex, it becomes clear that the original arrangement of the images and the inscriptions, on opposing verso and recto pages, encourages the viewer to experience them as representing a direct encounter between the two figures.[51] Moving from right to left, the direction in which Islamic books and Persian script are typically read, we move from the figure of Jahangir and its inscription ("The key to the opening of the two worlds is entrusted to your hand"), which trails off the page's upper left corner into the gutter margin, to appear again on the orb that the shaykh carries in his hands (see figs. 1.3 and 1.4). The repetition of the inscription underscores the fact that the two figures exist in separate realms. Even in a dream, an encounter between Jahangir and Mu'in al-Din Chishti requires bridging the separation between the living and the dead, and so the extradiegetic, or divine, address must ring twice.

The pendant portraits function as "mediational events," meaning that Bichitra's works, and those who view them, are agents in a process of transformation.[52] Put another way, the paintings do not merely record but instead instantiate the supernal conversation. They, as much as the dream, are a medium of insight. The narrative conclusion that the inscriptions appear to promise is thus foreclosed. The key is indeed in your hand: it is the paintings themselves.

The Light in the Shadows

The images of suns, halos, and luminescent auras that pervade Jahangir's dream paintings connote the Mughal sovereign's divinely illuminated state. They also suggest that the viewer may be edified through the act of physically holding and contemplating the portraits. Reproductions of these paintings in modern publications obscure the fact that one must manipulate the objects to apprehend their contents in full. The gold ground on which Jahangir's couplet of poetry appears, copied in black ink on Abu'l Hasan's depiction of Jahangir embracing Shah 'Abbas (fig. 1.8; see also fig. 1.1), in fact hinders the act of reading; illumination both obscures and reveals the words that, according to the inscription in the painting's upper right corner, the Supreme Majesty (*hazrat a'la*) had composed with his miraculous tongue (*zaban-i ma'jiz*). To reinforce the radiance and resplendence of his patron, the painter placed the emperor's head at the exact center of the sun's inner circle. The point of the compass with which he first sketched the orb would have rested on Jahangir's temple. He also inscribed the *a'la* (supreme) in gold, as if to suggest that the term *hazrat* (majesty) that immediately precedes it is its source of light. Here, as elsewhere in the dream paintings, Jahangir not only reflects light but is a wellspring of illumination.

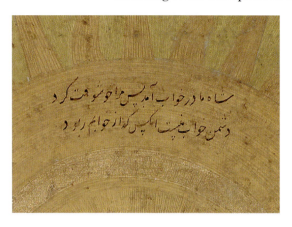

FIGURE 1.8. Detail from Jahangir meeting Shah 'Abbas I in a dream (fig. 1.1), Freer Gallery of Art, Smithsonian Institution, Washington, DC. Purchase—Charles Lang Freer Endowment, F.1945.9a.

Light is fundamental to accounts of the Mughals' divine origins and their conception of divine kingship.[53] According to the court chronicler Abu'l Fazl (1551–1602), the Mughals were descended from a female progenitor named Alan Goa, who had been impregnated by a "magnificent light" (*nur-i shigarf*).[54] Akbar inherited this light through his mother, Hamida Banu Begum, whose womb, like Alan Goa's, was said to have been penetrated by a ray from the sun. The Mughals likely promoted this origin tale in concert with Christological images as part of a campaign of messianic propaganda mounted, in part, as a response to the Safavids' 'Alid genealogical claims.[55] The light imagery in the dream paintings, therefore, could function as a shorthand reference to the dynasty's sacrosanct lineage, as well as to Jahangir's status as Islam's redeemer and savior.

The preponderance of light motifs also underscores Mughal imperial affinities with *ishraqi* (Illuminationist) philosophy, which deploys the vocabulary of light to articulate relationships with God, or the Nur al-Anwar (Light of Lights), who is, according to this paradigm, the ultimate source of illumination. The Levantine philosopher Shihab al-Din Suhrawardi (1154–1191), who developed this body of thought, drawing on and synthesizing much earlier Neoplatonic and Zoroastrian concepts, understood that an individual's distance from God lies on a spectrum, at one end of which is light, at the other darkness. He framed knowledge (*'ilm*) and wisdom (*hikmat*) in related terms, that is, as registers of the individual's closeness—here understood as a form of self-awareness—to the ultimate divine light. Suhrawardi's *ishraqi* philosophy provided a compelling model for kingship that grounded the exercise of authority and power in a discourse of wisdom and divinity.[56]

In his preface to the *A'in-i Akbari*, Abu'l Fazl characterizes kingship in distinctly Illuminationist terms, leaving little doubt of the influence of this philosophy on sixteenth-century Mughal court thinkers. He writes: "Royalty is a light emanating from God, and a ray from the sun, the illuminator of the universe the argument of the book of perfection, the receptacle of all virtues. Modern language calls this light *farr-i izadi* [the divine light], and the tongue of antiquity called it *kiyan kharra* [the sublime halo]. It is communicated by God to kings without the intermediate assistance of anyone, and men, in the presence of it, bend the forehead of praise towards the ground of submission."[57] Abu'l Fazl's references to *farr-i izadi* and *kiyan kharra*, both components of ancient Iranian notions of sacred kingship, signal his tacit awareness of Suhrawardi's tenets. That Suhrawardi's mystical philosophy also influenced the reign of Jahangir is attested by the emperor's *laqab* (epithet), Nur al-Din (Light of Faith), as well as by the pervasive presence of *shamsa*s (sunbursts) on his thrones and other royal accoutrements.[58] Whether Jahangir was familiar with Suhrawardi's philosophy of illumination specifically is unknown and perhaps irrelevant. *Ishraqi* thought was pervasive throughout South Asia at this time and was likely transmitted within and between courtly circles through the inheritors of Suhrawardi's doctrines, and possibly by the writings of the philosopher himself. The *Shariq al-ma'rifa* (The illuminator of gnosis), a treatise on the philosophical traditions of South Asia attributed to the Mughal poet Fayzi (1547–1595), the brother of Abu'l Fazl, bears the marks of *ishraqi* thought and so offers confirmation of the deep resonance of Suhrawardi's philosophy among the Mughal court's inner circles.[59]

The Mughals' attraction to Illuminationism may be explained, in part, by its overt political applications.[60] According to Suhrawardi, a ruler establishes

his political authority by performing miracles. To do this he must draw on an exclusive kingly intelligence that is illuminated by the divine aura known as *farr-i izadi* and *kiyan kharra*.[61] This will enable him to perform amazing feats, including predicting the future and ruling with justice. *Kiyan kharra* will, furthermore, enable him to "become courageous and dominant, have control, have people incline toward him, and have all nations obey and revere him."[62] With the divine light, the sage-king will be able to walk on water, fly, reach the celestial spheres, and travel the span of the earth. Suhrawardi continues: "Divine light will bestow upon him the robe of Royal Authority and of majesty. He will become the natural ruler of the world. He will receive aid from the lofty realm of heavens. Whatever he says will be heard in the Heavens. His dreams and his personal inspirations will reach perfection."[63]

These powers depend on the ruler's proximity to God, the ultimate source of *kiyan kharra*. This is signaled by distinctive physical signs of saintly status. But because God resides in the *'alam al-ghayb*, or hidden world, the illuminated king will also "live" in an elevated zone—known variously as the *al-aqlim al-thamin* (eighth clime), the *'alam al-mithal* (world of images), and the *'alam al-khayal* (world of imagination)—which lies between the earthly and the divine realms.[64] Sufi writers like Ibn 'Arabi would later adopt Suhrawardi's notion of an intermediary realm of formless images—identified by the former as the *'alam al-mithal*—in their own theorizations of a Hermetical world.[65]

The dream paintings' portrayal of Jahangir as a divinely inspired ruler draw so heavily upon *ishraqi* philosophies of kingship that they could almost be taken for illustrations of Suhrawardi's text. Jahangir is always shown with a golden halo and often framed by representations of the sun and the moon, both of which are objects of veneration in *ishraqi* thought.[66] In several cases the painters depict him subduing his rivals and commanding whole geographical regions, becoming in effect Suhrawardi's "natural ruler of the world." He is also consistently portrayed as residing in an intermediary space between the heavens and earth. This zone is not only the place of dreams, where images and imagination merge and visions take shape, but also, as Suhrawardi describes it, the realm of divinely inspired kings. Jahangir's dreams, in other words, are hardly mere terrestrial manifestations; they are rather the products, not to mention the signs, of his elevated physical and spiritual station.

Perhaps the most overt sign of *ishraqi* influence in the dream paintings is their emphasis on the emperor's uniquely illuminated status. This aspect of Jahangir's character is most fully elaborated in a painting showing Jahangir

triumphing over poverty, here represented symbolically as an ebony-skinned elderly man shrouded in an aura of darkness (fig. 1.9).⁶⁷ The work, which is today housed in the Los Angeles County Museum of Art (LACMA), depicts Jahangir standing on a lion that lies next to a lamb; the two animals, in turn, lie on a terrestrial globe. The emperor is shown aiming an arrow at the emaciated figure of poverty, from whose eye another arrow—presumably also launched by Jahangir—already protrudes. Perhaps anticipating the confusion that this painting was likely to generate among its viewers, an inscription located just above the horizon explains that this is "the blessed image [*surat-i mubarak*] of his exalted majesty, who, by the arrow of generosity [*tir-i karm*], cast out the sign [*nishan*] of poverty [*daliddar*] from the world [*'alam*] and constructed a new world [*jahan*] with his justice [*'adl*] and equity [*dad*]." Thus, *daliddar*, meaning "poverty," is the darkness that Jahangir's divine aura will have eradicated in the world to come. Like Suhrawardi's divinely inspired ruler, Jahangir receives aid in the form of an angel who offers him the arrows that will defeat the darkness; a pair of cherubs fly overhead holding a crown, presumably intended for him. The painting contains other concrete, visual signs of the justice and equity with which the enlightened ruler will build his new utopian realm: the depictions of the so-called chain of justice (*zanjir-i 'adl*), hanging from the hand of an angel at the upper left corner; Vaivasvata Manu, the Hindu progenitor of man and ancient lawgiver, shown resting on a fish that seems to be supporting the globe; and the lion and lamb who lie together peacefully.

Close inspection of the LACMA painting reveals a curious detail: *daliddar* appears to be speckled with small flecks of gold paint or leaf, as if to suggest that the act of eradicating him—even in a vision or dream—necessitated the use of light (fig. 1.10). Also puzzling is the fact that Jahangir abolishes this figure by blinding him.⁶⁸ Having already pierced one of the dark figure's eyes, the emperor stands poised to unleash another arrow at his other eye. If the objective is to eradicate poverty, why not deliver a mortal blow? Why does vision—or lack thereof—play such a key role in this depiction?

Suhrawardi's theory of optical perception is instructive here. He articulates his theory of vision in contradistinction to more mainstream theories of optics: "Theorem: [On Vision] You have now learnt that sight does not consist of the imprint of the form of the object in the eye, nor of something that goes out from the eye. Therefore, it can only take place when the luminous object (*al-mustansir*) encounters (*muqabala*) a sound [healthy] eye."⁶⁹ Diverging from Aristotle, Plato, Euclid, and Ibn al-Haytham, Suhrawardi rejects both extramission and intromission theories of vision: that vision occurs when

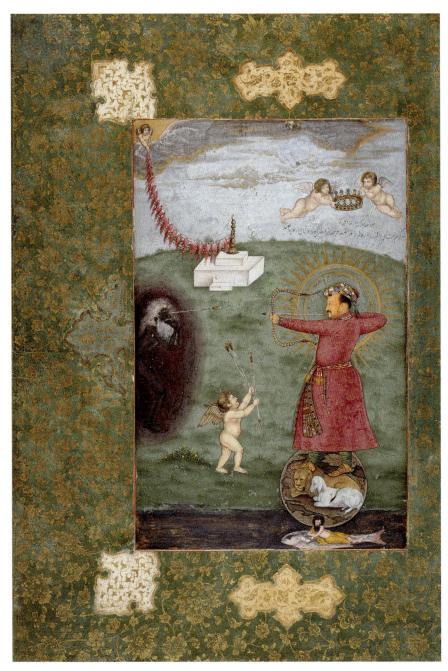

FIGURE 1.9. Jahangir vanquishing poverty, probably by Abu'l Hasan, completed circa 1620, northern India. Mounted on a page from a dispersed album, with margins decorated in the sixteenth or seventeenth century. Opaque watercolor, ink, and gold on paper. Folio 36.8 × 24.6 cm; painting 23.8 × 15.2 cm. Los Angeles County Museum of Art, from the Nasli and Alice Heeramaneck Collection, Museum Associates Purchase (M.75.4.28). Photo © Museum Associates/LACMA.

corporeal rays emitting from the eyes collide with an object, or, conversely, that sight is made possible by an action or substance entering the eye from the object that is seen. Suhrawardi's conception of sight (*ibsar*) is anchored by spatial parameters. The subject and the object must be coincident for sight to transpire.[70] Once these conditions have been met, vision can occur, but only with the presence of light and the absence of any obstacles in the line of sight.

Suhrawardi's theory of optics also considers the mechanisms of "internal" vision, or what Hossein Ziai characterizes in some cases as the illumination (*ishraq* or *mushahada*) of the subject. Unlike external sight, which is mediated through the instrument of the eye, internal vision is powered by the "creative acts of the illuminated subject's imagination."[71] The light that makes sight possible, moreover, is understood to be concrete and manifest (*al-nur*); the light upon which illumination is predicated, by contrast, is abstract and incorporeal (*al-nur al-mujarrad*). In either case, the presence of light is necessary for both vision and sight to occur.[72] This detail may explain why illumination, in the form of the gold flecks that cover *daliddar*'s emaciated body, is required even in the case of an internally generated vision.

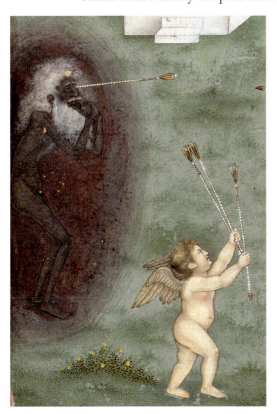

FIGURE 1.10. Detail from *Jahangir vanquishing poverty* (fig. 1.9). Los Angeles County Museum of Art, from the Nasli and Alice Heeramaneck Collection, Museum Associates Purchase (M.75.4.28). Photo © Museum Associates/LACMA.

At its core, Suhrawardi's philosophy of vision is relational: physical and spiritual sight can occur only where there exists an unobstructed path between the subject and the object. The epistemological implications of this notion are profound, for the Illuminationist theory of knowledge, rooted in perceptual and immediate experience, privileges intuition and "seeing" over reason (*'aql*) and discursive analysis.[73] As Ziai succinctly puts it, "The more 'seen' (sensed or intellectually perceived) a thing is, the better known it is."[74] For Suhrawardi, then, corporeal and mystical knowledge of an object

can occur instantaneously, in a single moment, prior to rational thought. Its presence, however, is crucial.[75] Whether the encounter between subject and object takes place in a physical space or within the imagination, a direct relationship between the two—unhindered by any obstacle (*hijab*)—must exist.

Suhrawardi's entwined theories of optics and knowledge help to elucidate the pronounced emphasis on visual apprehension—Jahangir's in particular—in the corpus of visionary paintings from this period. In the LACMA painting, for example, Jahangir must *see* the figure of poverty before destroying him. Significantly, the emperor's choice of weapon—the bow and arrow—requires precise optical focus. The small patches of gold leaf that hover over *daliddar*'s dark pall are perhaps suggestive of the light that is required for vision—and, by implication, for *knowing*—to be manifest. Jahangir defeats his foe not through physical might but through observation and apprehension. The emperor's vision—that is, the physical act of seeing (*ibsar*)—is more than just a sensory process: it is the means by which he obtains knowledge and hence exercises power. Seeing is an epistemological endeavor.

A related painting, probably completed around 1616 and showing Jahangir shooting the severed head of Malik 'Ambar (1548–1626), further expands on these themes of lightness, darkness, and vision (fig. 1.11). Bearing the signature of Abu'l Hasan, the work is today housed in the Chester Beatty Library, Dublin. Malik 'Ambar, who was of Ethiopian origins, rose in the ranks of the army of the Nizam Shahi Sultanate of Ahmadnagar to become a general; in the process he became one of Jahangir's most reviled political enemies. His head is shown mounted on a tall spike, with an arrow piercing his mouth and emerging from the back of his skull. As in the LACMA painting, Jahangir stands on a terrestrial globe, which is supported here by a bull and a fish, and holds a bow taut, ready to unleash another arrow at his decapitated foe. The imagery and the accompanying inscriptions bear a fascinating relationship with the *Jahangirnama*, which mentions the emperor's sighting not of Malik 'Ambar but of an omen in the form of an owl.[76] The owl appears twice in the painting: once perching on the head of Malik 'Ambar and again below it, apparently wounded by a mortal blow. The implication is that the two owls, which in the context of the *Jahangirnama* may be understood as portents of Malik 'Ambar, are one and the same; the painter has depicted the cause and the effect, a complicated interpolation of omen and dream. The cause, of course, is Jahangir. But as the artist makes clear, and as is also depicted in the LACMA composition, the emperor enacts defeat not with physical force, but with light, sight, and insight.

The Dublin painting's imagery and inscriptions play on the perceptual and

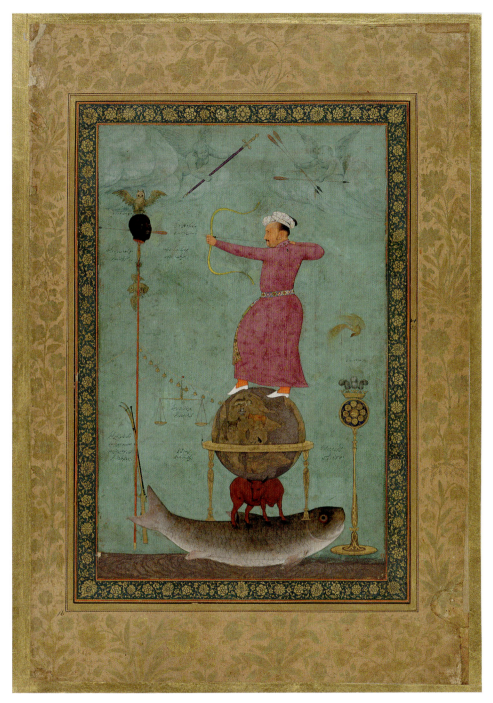

FIGURE 1.11. Jahangir shooting the head of Malik 'Ambar, signed by Abu'l Hasan and completed circa 1616, probably Ajmer. Mounted on a page from the divided Minto Album, with decorated margins added circa 1616–20. Opaque watercolor, ink, and gold on paper. Folio 38.9 × 27.2 cm; painting 25.9 × 16.4 cm. © The Trustees of the Chester Beatty Library, Dublin, In 07a.15.

metaphorical distinctions between light and darkness, thus challenging the viewer to account for its contradictions with the *ishraqi* hierarchy. Jahangir's pale visage emits golden light, while Malik 'Ambar's head is a dark spot on the page. The disc at the right side of the painting also shines bright—an effect, one may presume, of the luster of the Mughal genealogy inscribed on it. Yet elsewhere the image and text invoke the opposite associations: the emperor is associated with darkness, and Malik 'Ambar with color and light. The epigraph beneath the scales that hang from the chain of justice at the center left, for example, declares: "Through the felicity of the Divine Shadow's [*zill-illahi*] coming [*maqdam*], the earth is raised up on the Fish-bull."[77] The Divine Shadow, meaning God's representative on Earth, is of course Jahangir. The idea that the king was God's shadow drew from ancient Persian conceptions of kingship holding that the ruler, by virtue of his proximity to the divine, provided his subjects crucial protection—or shade—from the sun. Yet this proximity also grants the king the divine aura (*kiyan kharra*) that makes him a source of illumination.[78] The inscription between Jahangir's bow and Malik 'Ambar's head likewise inverts the *ishraqi* dichotomy, explaining that "whenever you [i.e., the arrow] come into the bow you steal the color from the cheeks of the enemies."[79] The irony of this statement is the fact that no matter how much Malik 'Ambar's face may pale in fear, it remains dark because, like any dark object, it absorbs rather than reflects light.

Decoding this work—and gaining access to the imaginal realm—requires sustained visual apprehension and inspection. Jahangir models these operations for us. Malik 'Ambar's head has been removed from his body and his skull already pierced, but the emperor still aims another arrow at him. By drawing and aiming his bow, he trains his—and our—eyes on the prize, and, as if by magic, the owl plummets to the ground. Abu'l Hasan's painting is at once a representation, a demonstration, and an instrument of mystical knowledge.

The *Mithal* Is the Message

Jahangir's visionary paintings operate as mediational objects that broker the relationship of viewer and subject, dreamer and dreamed, living and dead, earthly and divine. Their utility as instruments of ritual contact and spiritual edification derives as much from their manner of representation, the semiotic interplay of word and image, and their physical arrangement in the album codex as from their subject matter.

Most study of these works, however, has been iconographically oriented,

meaning that interpretation has rested exclusively on the decoding of each painting's component parts to arrive at a single overriding message.[80] Along these lines, the LACMA painting's representation of Jahangir using justice (*'adl*) and equity (*dad*) to destroy the indigence (*daliddar*) that threatens to undo the social order might be considered as a reference to ancient Persian— and, in turn, *ishraqi*—conceptions of kingship (see fig. 1.9). These maintain that a good king must uphold justice and social order or risk losing his *farr*— the luminosity that serves as a visual sign of legitimate rule. This fate befell Jamshid, a mythical early king of Persian history.[81] According to the Avesta, after Jamshid declared himself to be a divinity, the gods punished him by removing his *farr* for temporary storage in the sacred Lake Vourukasha until a right-ruling, divinely sanctioned ruler could reactivate it.[82] Here Jahangir is precisely that person: hovering over the water in the painting's foreground—a possible allusion to Vourukasha and its divine contents—he acts to preserve the cosmic order and receives his celestial crown.

The iconography of Vaivasvata Manu may be seen to add another layer of meaning to the painting. The seventh in the Manava lineage, Vaivasvata Manu was saved from a great flood by Matsya, the fish avatar of the Hindu god Vishnu and the first of his ten manifestations, who carried him on his back. Vaivasvata Manu became the progenitor of the race of people in the postdiluvian era (*manvantara*), which is the present age of humanity. Positioned above the body of Vaivasvata Manu, Jahangir can be identified with Savarni Manu, the eighth Manu, who will rule the future era. Like the Mughal emperor, Savarni Manu is said to be descended from the sun and to herald the dawn of a new age.

The painting also seems to draw from descriptions of the earth's creation, as imagined in Islamic texts like the *Qisas al-anbiya'* (Stories of the prophets) of Muhammad ibn 'Abd Allah al-Kisa'i (d. 805) and the *'Aja'ib al-makhluqat wa ghara'ib al-mawjudat* (Wonders of creation and oddities of existence) of Zakariya' al-Qazwini (d. 1283) and texts related to it. Both works explain that God stabilized the earth by placing it on an angel's shoulders, a conception of the cosmos that is clearly echoed in the representation of Jahangir in the LACMA painting.[83] The Dublin painting's representation of Jahangir shooting Malik 'Ambar, which depicts the emperor standing on a globe that rests on a bull and a fish, enjoys an even closer kinship with this cosmographic imagery. In both cases, Jahangir's stance suggests the status of creator of the cosmos. As one of the painting's epigraphs explains, it is Jahangir who will construct the new world and bring with it a "messianic peace."[84]

Although the strictly iconographic approach can thus shed much light on

the meaning and significance of these paintings, it neglects the meaning conveyed by the material and compositional aspects of these objects. How might the scale, medium, and style of the paintings factor into such an analysis? What is the significance of the contexts in which they were presented and then mounted and viewed? Is there an iconographical hierarchy at work in the paintings, and, if so, how does it manifest itself? Another limitation of the iconographical method is its assumption that analysis necessarily produces a single interpretation. The process of decoding iconography is potentially endless. It is not at all clear, furthermore, whether the work contains one unambiguous message, or whether it can yield an infinite number of meanings.[85] To put it more concretely, is Jahangir, as depicted in the LACMA painting, being compared to Jamshid, Savarni Manu, or God, or does he represent a combination of all three?

Bichitra's painting of Jahangir seated on the hourglass throne (see fig. 1.1) is likewise pregnant with signs and symbols, from the portrait of the emperor to the depictions of a Sufi, an Ottoman sultan or diplomat, James I, and a figure in yellow who may represent the artist holding in his hands a painting of a courtier, an elephant, and two horses. Two European-style cherubs soar above, and two more inscribe the bottom of the hourglass with the blessing "May your life last a thousand years." A carpet bearing a web of ornamentation, including European grotesques, lies parallel to the picture plane. Faced with this plethora of images and signs, scholars have tended to focus on elements of the composition, its iconography in particular, that support a single, cohesive interpretation. Richard Ettinghausen, for example, interprets the painting's contents as a declaration of Jahangir's preference for spiritual over earthly authority.[86] Yet the painting's abundance of signification precludes this totalizing treatment.[87] The iconographic approach presumes that visual images possess a discrete symbolic or narrative core meaning, which the viewer decodes. But what if the painting has no center? And what if the process of decoding is itself the means of making meaning?

The dream paintings' iconographic excess and interpretive slippage are central to the identification and function of the images as depictions of dreams that take place in the *'alam al-mithal*, the "world of images" that lies between the corporeal and incorporeal realms. It is precisely because the true nature of God is beyond human comprehension—indeed, is prefigural—that dreamers receive divine communications by means of encoded and embodied images. While they may exercise their imaginative faculties (*quwwat al-musawwara*) to perceive these celestial messages, they must draw on the rational faculty (*quwwat al-'aqliya*), which they use to comprehend the phenomenal

world when awake, to make sense of them. The imaginative faculty, more specifically, uses a mimetic capacity to envision the pictures created and stored by the rational faculty, meaning that the oneiric vision comes from God and occurs in a liminal realm, and yet it assumes only forms that the physical eye can perceive.

For the Mughal painter, the challenge of representing the emperor's dreams was twofold: he had to depict an unearthly realm that can be grasped only with the imaginative faculty, and he had to do so using images gleaned and manifested by the rational faculty. The iconographically dense nature of the dream paintings may thus represent the artists' attempts to approximate the semiotic phantasmagoria of the oneiric realm. The inclusion of distinctively mimetic components—such as Bichitra's faithful copy of the portrait of James I—follow in the same vein by explicitly replicating the sensory images on which the imaginative faculty draws (figs. 1.12 and 1.13). The artist does not exactly *represent* the dream and the dream world: he instead models the oneiric realm's own modes of figuration, namely mimesis and semiosis, to create the painting's dense field of encoded imagery.

To complete the dream painting, it must be decoded. But the viewer's (or dreamer's) fullest apprehension of the vision arises not from the translation of these symbols per se, but from the act of decoding. In her study of visionary practices among Sufi communities in South Asia, Marcia Hermansen argues that encoded dreams and visions function in effect as cognitive tools, but she underscores the importance of the process of interpretation—rather than the fact of the dream alone—in advancing spiritual illumination. For Hermansen, the process of thinking in symbolic systems "becomes a 'trigger' for visionary experience."[88] Unraveling the system of signification in the paintings of Jahangir's dream can thus produce a visionary experience on a par with the dream itself. The Islamic practice of dream interpretation is known as *taʿbir*, meaning to cross over. The crossing over may here refer to the dream's passage from its sensory form (*surat*) to its inner meaning (*maʿni*), but it may also connote the passage of translator (*muʿabbir*, lit. "one who crosses over") from a spiritually veiled to an unveiled state. The dream paintings' surplus of signification, in other words, may have been by design, the aim being to first confound and then elucidate. The point lies not only in the meaning of the images but also in the discerning of their meaning.

The dream paintings' dense symbolic programs accord with a larger epistemological turn that, according to Shahzad Bashir, viewed symbols as "mediators between the physical and the metaphysical."[89] Though he focuses on the emerging role of symbolic interpretation and materiality in Sufi

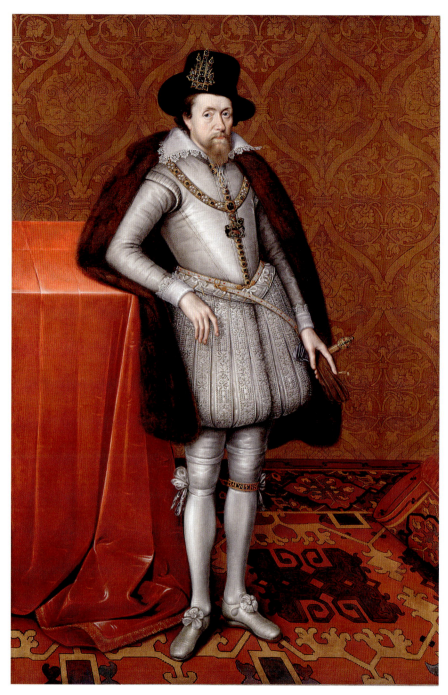

FIGURE 1.12. Portrait of James I of England, 1606, attributed to John de Critz the Elder. Oil on canvas. 200.5 × 129.5 cm. Dulwich Picture Gallery, London, UK, DPG548. © Dulwich Picture Gallery/Bridgeman Images.

literature produced in seventeenth-century Iran, Bashir's observation is equally applicable to the Mughals, who enjoyed innumerable contacts and connections with individuals, texts, and objects from the Safavid sphere.[90] In his examination of an autobiographical text that centers on the symbol of the Safavid turban, Bashir argues that the author composed the work by moving from the material surface of the headgear inward to the theological particularities, rather than the reverse. This proposal directly contradicts the modern scholarly consensus, which holds that religious practitioners articulate their agendas by proceeding "outward" from abstraction to object. The symbolic system thus remains entirely opaque to the practitioner and is revealed only by the scholar's rational analysis. According to Bashir's paradigm, however, the author's undertaking is wholly deliberate: far from being beholden to the regime of symbols with which he writes, the author instead makes a "self-conscious decision to become invested in the symbols" to encode his theology.[91]

FIGURE 1.13. Detail from Jahangir seated on an hourglass throne (fig. 1.1), showing the painter Bichitra (lower left). Freer Gallery of Art, Smithsonian Institution, Washington, DC. Purchase—Charles Lang Freer Endowment, F1942.15a.

In fashioning his own dense array of symbols, the Mughal painter of imperial dreams embraced a similar kind of symbolic thinking that, contrary to the assumptions inherent to iconographic analysis, is neither unconsciously nor intuitively educed but instead results from calculated consideration. Although God is the ultimate encoder of the emperor's dream, it is the artist who gives the dream material form. In doing so, the painter guides the viewer to perceive the oneiric vision as a beguiling display of disparate forms.

What the artist painted is as important as how he painted. In that regard, the dream paintings are distinguished by their compression of space and reduced number of figures. Comparison with the enthronement scene from the aforementioned *Akbarnama* manuscript, illustrated around the early 1590s (see fig. 1.2), shows how dramatically Jahangir's artists departed from the compositional formula canonized during Akbar's reign. Here, as in the depiction of Jahangir on the hourglass throne, Akbar is shown enthroned and receiving an audience. However, the painting of Akbar features many more

figures, including courtiers, musicians, dancers, and fly-whisk bearers. The architectural setting not only distinguishes imperial from nonimperial space but also creates the illusion of spatial recession. The trees visible in the upper left of the composition serve a similar function. Even absent these pictorial devices, the placement of figures along the composition's vertical axes, which makes those in the upper part of the painting appear to be behind and beyond those in the lower part, creates a sense of recessed space. The artists clearly delineate a foreground, a middle ground, and a background.

Bichitra, however, dispensed with this manner of rendering space in his depiction of Jahangir on the hourglass throne (see fig. 1.1). While the painting employs aerial perspective and overlapping to indicate spatial positions (we are meant to read the artist, for example, as standing in front of James I, James I in front of the Ottoman figure, and so on), it lacks a sense of deep spatial recession.[92] Indeed, the painting of Jahangir's dream seems flat, as if its contents lie flush with the picture plane. The carpet, the hourglass throne, the emperor, and the other figures appear to occupy the immediate foreground; they are also correspondingly larger than the figures in the more densely populated *Akbarnama* painting.

A similar effect is evidenced in Abu'l Hasan's depiction of Jahangir embracing Shah 'Abbas (see fig. 1.1), which shows the two world rulers looming large before the sun and the earth. Yet this pictorial strategy was not common to all of the paintings produced at Jahangir's court. A painting that was probably made around 1617–18 for an illustrated manuscript of the *Jahangirnama* attests to the diversity of Mughal artistic production during the early part of the seventeenth century (see fig. 4.8). The artist uses cues like the railings in the foreground and background to create the impression of spatial recession. The contents of the dream paintings are, in contrast, concentrated mainly in the foreground of the composition.

This new type of compositional scheme may have been inspired by European engravings that Jesuit priests and others had brought to the Mughal court decades prior. The presence and role of European art at the Mughal court has been the subject of numerous studies over the past century.[93] Ebba Koch, for one, argues convincingly that the engraved frontispieces of the multivolume Royal Polyglot Bible had an important influence on Mughal painting from the late sixteenth into the seventeenth century, and on Jahangir's dream paintings in particular. She points to the Dublin painting of Jahangir shooting Malik 'Ambar as one of several examples of Mughal paintings that were influenced "in concept as well as content" by the *Pietas Regis* image, the second engraved frontispiece from the first Bible volume.

Koch suggests that the imperial painter's invocation of European visual sources stemmed from his (and his patron's) desire to create "complex allegorical compositions, a concept that was thus far unknown in Indian and Persianate painting," and which the Mughals recognized as a salient means of communicating propagandistic political messages that had previously been transmitted in textual form only.[94]

Yet the Mughal painters' amplification of the compositional foreground and their incorporation of European objects and images, from a terrestrial globe to a portrait of James I, also identify the dream paintings as "other" and otherworldly, especially since the total effect of these elements departs so dramatically from Persianate manuscript painting convention. The seemingly paradoxical use of illusionistic modeling alongside representational strategies that emphasize abstraction and flatness furthermore serves to draw the eye into the composition.[95] This exercise does not lead to cathartic cognizance, however, but to wonder and then confusion. Questions follow: Where do these visions take place? Why does Jahangir stand on a lion? What is the meaning of the European hourglass's inclusion in Bichitra's work? And so the circuitous journey to divine meaning in form begins.

PRIOR TO JAHANGIR'S REIGN, records of imperial dreams—whether actual or potential—took textual rather than pictorial form.[96] Mughal artists may have modeled their paintings on literary precedents like the *Zafarnama* (Book of victory), by Sharaf al-Din 'Ali Yazdi (d. 1454), a history of Timur completed in 1425; biographical works like the *Nafahat al-Uns* (Breaths of fellowship) by Jami, which comprises biographical accounts of prominent Sufis; and *Fawa'id al-Fu'ad* (Morals for the heart), a record of the teachings and conversations of the Chishti master Nizam al-Din Awliya (1238–1325), compiled by Amir Hasan Chishti (d. 1336).[97] All three texts feature detailed descriptions of oneiric encounters and thus function as textual analogues to Jahangir's dream paintings. *Tarikh*s, *tazkira*s, and *malfuzat* very likely provided Mughal painters with the general typologies with which they formulated their depictions of Jahangir's dreams.[98]

Yet, in depicting their patron's dreams in colors on paper, Mughal artists made the case for painting's superiority for this enterprise.[99] Given its concern with the world of images ('*alam al-mithal*), painting provided an important means of documenting, gazing at, interpreting, and acting upon Jahangir's dreams. While they are records of past events, the dream paintings also reside

in the future, for their meaning derives from each viewer's unique decoding of the complicated web of imagery. The medium of painting facilitated the viewer's apprehension of Jahangir as a supremely enlightened mystical ruler—the epitome of Suhrawardi's philosopher-king and of the Sufi *pir*—who obtains divine messages by virtue of his proximity to the heavenly realms.

The power of these works lies not only in their visual excess and entangled temporalities but also in the status they confer on their creators. Mughal artists gained exclusive access to the most intimate of domains, Jahangir's dreams. The works center their makers as the innovators of a new type of instrumental painting that mediated between the realms of the image and the imagination while maintaining the pretense that the actual creators of the images are Jahangir and, ultimately, God. The Mughal emperor is ascribed a perspicacious (and, when necessary, deadly) way of seeing. The paintings encourage the viewer to attempt a similar kind of penetrating vision; external seeing, after all, can illuminate one's inner vision. The irony is that the painter, who fashions the entire picture, styles himself a mere copyist. He executes the work (*'amal*) of coloring God's design (*tarh*), as received by Jahangir, the true agent of insight.

The dream paintings thus afforded artists the opportunity to make bold proclamations about their dual roles as court servants and creators.[100] In his depiction of Jahangir seated on an hourglass throne, Bichitra placed his signature on the emperor's footstool—a humbling yet also self-promoting gesture. The epigraph identifying the artist as "the devoted slave" (*banda-yi ba-ikhlas*) of the court is also disingenuously self-denigrating. The figure in the yellow *jama* (stitched coat) at lower left, just below James I, very likely represents the painter (see fig. 1.13). He holds a painting of an elephant, two horses, and a man bowing submissively. The elephant may represent an imperial gift; the bowing man (who, like the ostensible artist, also wears a yellow *jama*), on the other hand, appears to stand in for the artist, who is too preoccupied with the presentation of the painting to make obeisance.[101] In depicting himself and his offering in this recursive, metapictorial way, Bichitra perhaps sought to ensure that the overall painting would be perceived not as an affront to the creative authority of the emperor or of God, but instead as a statement of devotion to his sovereign. Since all images ultimately come from God, the painting of images, the artist seems to suggest, is a divine gift.

WORKSHOP AND EMPIRE

The Invention of the Mughal Painter

2

AROUND 1610, SEVERAL YEARS INTO HIS TENURE as Mughal emperor, Jahangir (r. 1605–27) ordered a painting to be added to a prized manuscript that he had inherited from his father, Akbar (r. 1556–1605) (fig. 2.1). The work in question—a copy of the *Khamsa* (Quintet) of the Persian poet Nizami Ganjavi (1141–1209), completed at the Mughal court in AH 1004 (1595–96)—already boasted forty-two illustrations by twenty-two painters who had been active in Akbar's *tasvir-khana* (painting workshop, lit. "image house"). The addition, by the *khanazad* (court-born, lit. "born of the house") artist Dawlat (fl. late sixteenth–early seventeenth century), is distinguished from the rest by both its content and its placement in the codex. Rather than representing an episode from one of the text's five poems, Dawlat instead depicted himself sitting across from the manuscript's calligrapher, 'Abd al-Rahim 'Anbarin Qalam ("Pen of Ambergris"; fl. late sixteenth–early seventeenth century). Both figures are represented in minute detail, as if rendered from life, and as engaged in their respective artisanal pursuits.

The subject of Dawlat's study is striking, especially given its departure from the narrative of the manuscript's main text. The juxtaposition of the artist and the calligrapher conceals the fact that at the time of its creation, 'Abd al-Rahim was already deceased. This temporal confusion was likely an intentional strategy to affiliate the new emperor's cultural patronage with that of his father's. Operating like a scribal colophon, the dual portraits authorized Jahangir as the treasured manuscript's new and rightful owner.[1] Dawlat's work marks a watershed, as it established painting's capacity to function analogously with text: picture making could now support authorial claims that had hitherto been the purview of writing alone.

The manuscript addition is revolutionary in other ways as well. By depicting himself as an equal of 'Abd al-Rahim, Dawlat also communicated the

ascendancy of Mughal painters. He created the work at least five years before the Mughal artists Abu'l Hasan, Bichitra, and others invented the royal dream painting and thereby claimed the distinction of being the recorders of the emperor's visions (see chapter 1). The metamorphosis of the court painter into imperial intimate, in other words, was well under way early in Jahangir's reign. Jahangir's atelier was less than half the size of Akbar's and was thus more selective. Dawlat and other painters employed at Jahangir's court were no longer operating within a populous workshop apparatus; they worked increasingly autonomously and enjoyed greater proximity to the emperor and his coterie. This exclusive group still illustrated manuscripts, but they now also traveled with Jahangir, enjoyed membership in his cult of discipleship, and created the distinctively physiognomic brand of his painted and minted—and thus replicable—image.

Art historians have tended to view the artistic shifts during Jahangir's reign as marking a decisive break with the conventions associated with Akbar's reign.[2] More recent scholarship, however, has revealed just how many of Jahangir's artists also worked in Akbar's court and thus demonstrates the continuity between the two ateliers.[3] But Akbar's manuscript workshop, as different as it may seem from Jahangir's, also laid the foundations for the professional rise of Mughal painters during the early seventeenth century. Indeed, Dawlat's image of professional self-determination in the London *Khamsa*'s pictorial colophon would be inconceivable absent the teeming atelier in which he and many of his colleagues had trained.

Akbar's manuscript workshop was famously oversized. During his long reign it expanded from a staff of thirty or so painters to more than one hundred manuscript artists by the 1590s. The creation of the *Hamzanama* (Tale of Hamza), a now-fragmentary and dispersed manuscript that once contained as many as 1,400 full-page illustrations, each nearly two feet tall, played no small part in driving this boom. Production of this massive copy of the popular epic began around 1562 and reportedly took fifteen years to complete.[4] Beginning in the 1580s, the court called for a significant number of heavily illustrated dynastic histories and Sanskrit epics in Persian, some bearing as many as 150 full-page paintings. The atelier was hence enlarged and teams of fifty or more artists assembled to complete these projects.

The onus of producing so many unique manuscript paintings had a profound effect on the organization of the workshop. Much of the illustrative work was performed by teams consisting of a designer, a colorist, and, when needed, a portraitist. The copious illustration of the densely histories and epics, in particular, demanded close cooperation and frequent negotiation

FIGURE 2.1. The painter Dawlat (left) and the calligrapher 'Abd al-Rahim 'Anbarin Qalam (right), pictorial colophon signed by Dawlat and dated AH 1018 (1610). From a manuscript of the *Khamsa* of Nizami Ganjavi dated AH 1004 (1595–96). Opaque watercolor, ink, and gold on paper. Folio 30 × 19.5 cm; painting 13.5 × 10.9 cm. British Library, London, Or. 12208, f. 325b. Photo: British Library / GRANGER.

between designers and colorists, with the former often supervising the latter. Such transactions inculcated among the artists a sense of shared purpose and identity. Becoming a Mughal artist required not only the attainment of artistic skills but also the assumption of a courtly self, characterized by a certain kind of ethical disposition and agency. Artists who proved their mettle as teachers and overseers of the atelier's many newcomers, or who possessed the capacity to invent new compositions for manuscript illustrations, could rise to the ranks of administrators and titled subjects.

The histories and epics that the atelier was charged to illustrate, and which upon completion were accessible to select individuals at court, promulgated an imperial ideology in which Akbar's fitness to rule was based on his cosmopolitan and messianic status. This involved the creation of a visually consistent program of designs, each colored over weeks and months, that depicted the emperor's and his ancestors' exemplary royal lives. The atelier's production of these works was complicated by the fact that they had only recently been composed or translated into the court language of Persian, meaning that the manuscripts required entirely original and extensive sequences of illustrations. If the emphasis on textual and pictorial novelty underscored the uniquely fresh and worldly character of Akbar's age, it also placed enormous demands on the relatively small group of painters who designed the hundreds of new manuscript illustrations and oversaw their coloring. Some of these artists, not coincidentally, belonged to the emperor's cult of discipleship, an indication of how consequential this massive collective illustrating enterprise was to the materialization and conception of Mughal sacred kingship.

The distinctive status of the royal painter that was realized at the beginning of the seventeenth century, therefore, owes much to the workshop modus operandi that Akbar's artists had introduced earlier. This environment fostered the development of a collective subjectivity invested in illustrative, but also pedagogic, administrative, and, ultimately, ideological ends. Despite their conceptual innovations, Dawlat's colophon image and Abu'l Hasan's dream paintings bespeak the notion of the painter-bureaucrat-disciple that, through numerous collaborations and negotiations, had taken shape some decades prior.

The Origins of a Mughal Painting Style

To understand how the Mughal painter evolved from an illustrator of texts to the recorder of imperial dreams, we must go back to Akbar's manuscript workshop and its rapid development of a distinctively transcultural painting

style. The monumental *Hamzanama* manuscript looms especially large as an example because its illustrations bespeak a remarkable stylistic genesis. A folio from the earliest phases of the project shows the leave-taking of Khwaja Buzurjmihr, the Sasanian vizier who, in the *Hamzanama*, is also the father-in-law of the eponymous hero (fig. 2.2). The painting employs compositional devices that recall those used in Tabriz in the 1520s and 1530s for the paintings in a justly famous *Shahnama* (Book of kings) manuscript completed for the Safavid ruler Shah Tahmasp (r. 1524–1576) (fig. 2.3). These include the use of the large vaulted pavilion and garden setting and the profuse application of detailed geometrical and botanical designs throughout. The *Hamzanama* painting's squat proportions, selective use of bilateral symmetry, triple-domed roofs, and sparse cast of characters at the same time echo

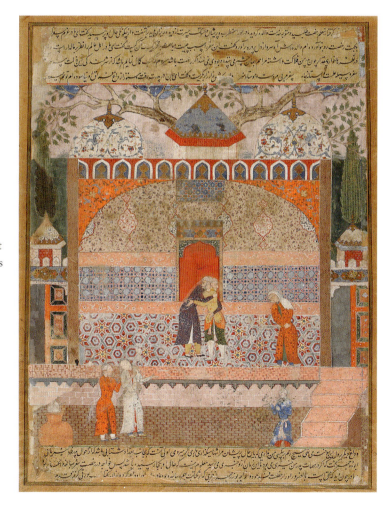

FIGURE 2.2. Khwaja Buzurjmihr taking leave of his mother, completed circa 1562–65. From a fragmentary and dispersed manuscript of the *Hamzanama*, completed circa 1562–77, Agra or Fatehpur Sikri. Opaque watercolor, ink, and gold on cloth mounted on paper. Folio 70.5 × 53.7 cm. Arthur M. Sackler Gallery, Smithsonian Institution, Washington, DC. Purchase—Smithsonian Unrestricted Trust Funds, Smithsonian Collections Acquisition Program, and Dr. Arthur M. Sackler, S1986.398.

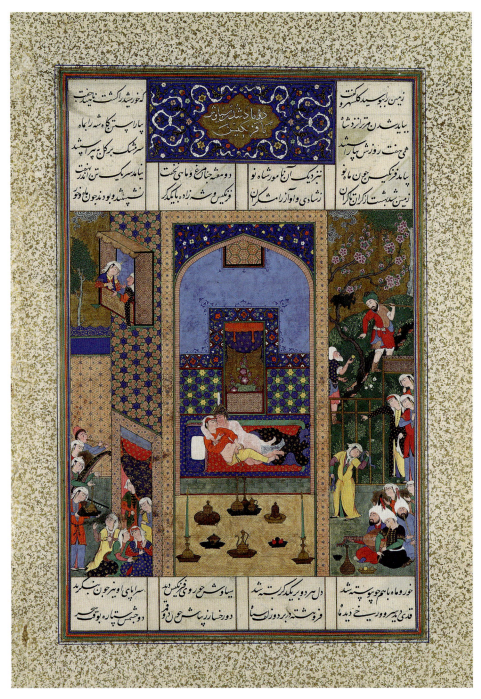

FIGURE 2.3. The wedding of Siyavash and Firangis, completed circa 1525–30. Detail of an illustrated page from a dispersed manuscript of the *Shahnama* of Abu'l Qasim Firdawsi, early 1520s–early 1540s, Tabriz. Opaque watercolor, ink, and gold on paper. Folio 47.3 × 32.1 cm; painting 28.9 × 18.4 cm. The Metropolitan Museum of Art, New York City, Gift of Arthur A. Houghton Jr. 1970.301.28.

FIGURE 2.4. Detail of an illustrated page from a manuscript of the *Chandayana* of Mulla Da'ud, completed circa 1525–40, Mandu. Opaque watercolor, ink, and gold on paper. Folio 25.5 × 20 cm; painting 19.7 × 14 cm. Cleveland Museum of Art, Gift of D. J. R. Ushikubo, The John Huntington Art and Polytechnic Trust, and Bequest of James Parmelee by exchange 1981.55.

illustrations in the more diminutive manuscripts of the *Chandayana* (Tale of Chanda), a poetic romance in Hindavi, that were produced in northern and central India during the first half of the sixteenth century (fig. 2.4).[5]

Other illustrated pages from the dispersed *Hamzanama* manuscript, however, eschew many of the representational devices and modes associated with earlier book painting from Iran and South Asia. A representation of a fisherman discovering Darab, Hamza's infant son, adrift at sea dispenses entirely with bilateral symmetry (fig. 2.5): instead the edges of the water, grass, and ground form diagonal lines that cut across the composition, lending it a sense of dynamism and spatial recession that is lacking in the scene with Khwaja Buzurjmihr. The highly detailed patterning is not restricted to the architectural ornamentation but extends to the depiction of the foliage and the surrounding landscape. What is most strikingly different about this illustration is its extensive use of modeling in the rendering of the textiles, the

large boulders, and the human figures, which recalls some of the European prints that were circulating at the Mughal court as early as the mid-1550s. Taken as a whole, the gargantuan *Hamzanama*'s roughly two hundred surviving paintings throw light on the multiple artistic traditions that underlay the rapidly formed new imperial style of the Mughal painting workshop.

The early Mughal atelier did not operate in an artistic vacuum; nor was it the first to employ artists or artistic techniques from beyond South Asia. The territories that Babur (r. 1526–30), the dynasty's founder, captured following his decisive victory at Panipat in 1526, and which his successor Humayun (r. 1530–40, 1555–56) reclaimed from Sikander Shah Suri (d. 1559) in 1555, were home to several highly active workshops whose output included illustrated books of the Sanskrit *Bhagavata Purana* (Story of Krishna) and the *Gita Govinda* (Song of Govinda), among other Hindu texts. Royal and commercial workshops in northern and central India had for centuries produced illustrated manuscripts of Persian texts like the *Shahnama*, the *Khamsa* of Nizami, the *Chandayana,* and the *Ni'matnama* (Book of delicacies) to cater to the region's numerous Persian-speaking communities of Turkic, Iranian, and Afghan origin.[6] Indeed, as several scholars have recently argued, in the fifteenth century, the literary, artistic, and political links connecting South Asia with Iran multiplied, giving rise to a deeply Persianate Indian Ocean world.[7] The steady migration of illustrated manuscripts, along with painters and other specialists of the book, from Iran, in particular Shiraz, to royal and mercantile centers in South Asia cemented these bonds.

In spite of the longtime presence of a Persianate ecumene on the Indian subcontinent, Humayun, the first dynast known to have sponsored the production of illustrated manuscripts, staffed his atelier with artists sourced directly from Iran. The few extant paintings associated with this period readily bespeak their makers' Safavid affiliations.[8] The first director of Akbar's manuscript workshop, Mir Sayyid 'Ali (fl. 1510–1572), came from this small pool of individuals. The son of the Safavid court artist Mir Musavvir (d. 1555), Mir Sayyid 'Ali likely contributed to the illustration of Shah Tahmasp's *Shahnama* and an equally impressive *Khamsa* of Nizami, dated 1539–43 (British Library, Or. 2265), both created in Tabriz. He reportedly supervised the initial phase of production of Akbar's *Hamzanama*. 'Abd al-Samad (fl. 1535–1600), another Safavid-trained artist, and calligrapher, who had joined Humayun's court years earlier at his capital in Kabul, became workshop director in 1572 when Mir Sayyid 'Ali embarked on a pilgrimage to Mecca. During this time, the workshop employed at least thirty painters, only a minority of whom were émigrés from Iran; the majority of its members were of South Asian origin—

FIGURE 2.5. The fisherman Iskandar rescuing the infant Darab, completed circa 1570. From a fragmentary and dispersed manuscript of the *Hamzanama*, completed circa 1562–77, Agra or Fatehpur Sikri. Opaque watercolor, ink, and gold on cloth mounted on paper. Folio 68.5 × 52 cm. Museum of Fine Arts, Boston, Horace G. Tucker Memorial Fund and Seth Augustus Fowle Fund 24.129.

both Muslim and Hindu—and likely hailed from northern Indian ateliers that predated or were contemporary with the Mughal conquest.

The stylistic disjunctions observed in the two *Hamzanama* paintings can be explained by the fact that the first of its illustrations reproduced here dates to an early phase of the manuscript's production (ca. 1562–65), whereas the second was probably made around five years later (cf. figs. 2.2 and 2.5).[9] The differences between these two illustrations, then, are not individual or idiosyncratic in nature but register broader shifts in painting practice that occurred as the imperial workshop expanded to accommodate contemporaneous projects like the illustration of the Cleveland *Tutinama* (Book of the parrot) and the School for Oriental and African Studies *Anvar-i Suhayli*, as well as the *Hamzanama*.[10] Between the 1570s and the 1590s, following the completion of the *Hamzanama* manuscript, the atelier staff not only increased in number but also diversified, employing artists from Iran, Central Asia, and the more recently vanquished territories of Gujarat, Bengal, and Kashmir.

While these historical and geographic circumstances clearly influenced the development of a new painting style during Akbar's reign, the precise mechanisms by which this style evolved have remained a subject of debate. Early twentieth-century studies characterized sixteenth-century Mughal painting as a synthesis of Persian and Indic (hence the label *Indo-Persian*), and, to a lesser extent, European styles.[11] Artists from Iran or of Iranian extraction were seen to share distinctive, fixed stylistic traits. The designations *Iranian* and *Indian* were hence perceived to connote categorical, unchanging attributes, no matter the circumstances or the location of the work's creation.[12] Even while accounting for the roles played by artists like Mir Sayyid 'Ali and 'Abd al-Samad in the process of style formation, these formulations reflected an essentialist understanding of style as geographically and culturally contingent. Percy Brown, for example, described the Mughal painting style as an offspring of the "union of the Persian and Rajput art" and identified Akbar as its catalyst. He further credited the "individuality" of the imperial style to "the fact that the art has absorbed the Indian atmosphere, it has become a part of India."[13] Ananda Kentish Coomaraswamy, in a similarly diagnostic vein, portrayed the Mughal painting style of the mid-sixteenth century as a synthesis of Indian and Iranian artistic traits. Even more than Brown, he emphasized Akbar's role as the enlightened steward who drove the evolution of Mughal painting into a new and unique artistic style.[14] Even though Coomaraswamy recognized that the majority of Akbar's artists were Hindu, Mughal painting could never shed the association of the dynasty's immigrant status.[15] In a landmark study published in 1916, Coomaraswamy characterized

Mughal painting as secular, individualistic, and courtly in nature—traits he associated with Akbar—and Rajput painting as "hieratic and popular, and often essentially mystic in its suggestion of the infinite significance of the most homely events."[16] Coomaraswamy's championing of Rajput painting accorded with his larger project to sanction the "native," and thus, for him, more authentic, artistic traditions of precolonial South Asia.

Although scholars have since refuted many of these early twentieth-century perceptions of the Mughal painting style as alien in origin and secular in function, the identification of Akbar as its progenitor nevertheless held considerable sway during the latter half of the twentieth century.[17] That these claims still resonate today is evidenced by one scholar's recent supposition that the emperor's creation of a syncretic painting style "anticipated his similar efforts to blend different religious ideologies into a unified whole later in his reign."[18] The formation of a Mughal painting style has long been viewed as a strictly top-down imperial project on the one hand, and as a testing ground for the empire's successful integration of different cultural and religious traditions on the other.

That Akbar played a defining role in the genesis of the Mughal manuscript painting style is corroborated by the *A'in-i Akbari* (Regulations of Akbar), whose author, Abu'l Fazl, observes that "since [painting] is an excellent source, both of seriousness [*jidd*] and entertainment [*bazi*], His Majesty . . . has taken a deep interest in it and sought its spread and development. Consequently, this magical art has gained in beauty. A very large number of painters has been set to work."[19] In the same text, Abu'l Fazl alleges that Akbar evaluated court artists' work on a weekly basis, was personally responsible for improvements in the quality of pigments, and, with his "transmuting glance," elevated the one-time workshop director 'Abd al-Samad's painting to a "more sublime level."[20] The Jesuit father Antonio Monserrate (1536–1600), who resided at Fatehpur Sikri between 1580 and 1582, attests to Akbar's involvement in the daily affairs of his royal workshops, including the painting atelier.[21] But, as John Seyller cogently observes, "Not even with Abu'l Fazl's eulogistic accounts of Akbar's 'transmuting glance' or weekly inspections of the atelier could the emperor personally determine the nuances of these hundreds of paintings produced on a rigorous schedule."[22] Noting that the *A'in-i Akbari* also credits Akbar with the supervision of the imperial kitchen, wardrobe, arsenal, and horse stables, Seyller contends that these improbable claims served a rhetorical rather than a descriptive function, namely, to depict Akbar as the sole architect of his empire. Given the political challenges Akbar faced from his younger brother and rival, Mirza Muhammad Hakim

(d. 1585), in Kabul during the early 1580s, not to mention the military campaigns the former launched in Punjab, Sind, and the Deccan in the 1590s, it has become increasingly difficult to sustain the notion of the emperor as the primary architect of the Mughal painting style.[23]

Seeking the origins of the Mughal style in sources other than geography or Akbar's personal intervention, other scholars have focused on the agency and impact of a few master artists. Stuart Cary Welch's 1961 study of the sixteenth-century court artist Basavana set the benchmark for this type of investigation.[24] Welch's study was followed in 1978 by Milo Cleveland Beach's *The Grand Mogul: Imperial Painting in India, 1600–1660*, whose catalogue raisonné entries for select artists provided the most comprehensive account of the activities of a number of manuscript painters at the Mughal court to date.[25] The ambitious *Masters of Indian Painting, 1100–1900*, a multiauthored study of virtuoso painters from India's royal courts, published in 2011, is a testimony to the enduring appeal of the master-artist paradigm.[26]

Contemporary sources would seem to corroborate this view. In fact, Abu'l Fazl's *A'in-i Akbari* lists four painters, including Basavana, whom he identified as "the forerunners on this high road of knowledge" (*pish-rivan-i in shahrah-i agahi*) and another thirteen whom he deemed worthy of commendation.[27] The criteria for artistic mastery are hinted at by Abu'l Fazl's characterization of Basavana as "incomparable in his age" (*yigana-yi zamana*) in designing (*tarahi*), portraiture (*chihra-gusha*), coloring (*rang-amizi*), and capturing likeness (*manand-nigari*).[28]

Yet Abu'l Fazl neglects to make clear that Basavana, along with the other sixteen artists he singles out, operated most often as a collaborator rather than as an autonomous agent. Fifteen of the 120 illustrated pages of the Patna *Tarikh-i Khandan-i Timuriyya* (History of the Family of Timur), completed around 1584–87, bear marginal inscriptions that credit Basavana with completing the *tarh* (design), while a second artist is identified as the colorist.[29] A similar pattern holds for the fragmentary Victoria and Albert *Akbarnama* (Book of Akbar), illustrated around 1590–95, in which Basavana is identified as the designer on fourteen of the manuscript's 116 extant illustrated pages; according to the marginal ascriptions, the artist played no part in the coloring (*rang-amizi* or *'amal*) of his own compositions.[30] Among these is a spectacular double-page representation of Emperor Akbar observing a battle between rival sects of *sanyasi*s (Hindu mendicants), designed by Basavana and colored by Asi and Tara Kalan (i.e., Tara "the Elder") (figs. 2.6 and 2.7).[31] Examination of several other manuscripts produced between 1580 and 1595 reveals that Basavana served more often as a designer than as a colorist of narrative

illustrations, although his talent as a colorist is evidenced by a small number of illustrations for which he is credited as sole creator.[32] This collaborative working style operated not only in the atelier as a whole but also within the manuscript project teams, whose membership could number in the dozens. To fulfil their mandates, designers—including the "master" artists—had to negotiate with their colorist colleagues, and vice versa.

The collaborative mode of production extended well beyond the designing and coloring of book paintings. The creation of illustrated manuscripts required the input and contributions of designers and colorists but also of accountants, project managers, paper makers, ink and paint mixers, and binders. In addition to mastering design and coloring, Abu'l Fazl's "forerunners" had to partner with and supervise numerous colleagues.

The Workshop as a Whole

To understand the role of manuscript painters not only as image makers but also as collaborators and administrators, we must shift perspective to examine the workshop as a whole. Abu'l Fazl's brief, though significant, exposition on the workshop in the *A'in-i Akbari* is of limited utility: focusing on calligraphers and painters, it accounts for only seventeen of the hundred-plus artists who worked in the Mughal atelier during the final decades of Akbar's reign. Marginal ascriptions in black and red ink that record numerous artists' names along with crucial prosopographical information, and often also identify the tasks that each fulfilled in completing manuscript illustrations, can help to fill this lacuna (see figs. 2.6 and 2.7). These scribal marks began to appear in illustrated manuscripts with some frequency in the early 1580s. During this time the court relocated twice—from Fatehpur Sikri to Lahore around 1585 and then from Lahore to Agra around 1598—and the workshop expanded dramatically in size. The regular appearance of such ascriptions in the lower margins of illustrated pages registers the increasingly bureaucratized nature of the large manuscript workshop and the need for a record of the activities of its many painters.

Drawing on a different, though functionally related, set of inscriptions, Seyller has brought to light some of the complex methods of collaboration that artists and others used to create manuscript paintings. He has shown, for example, that painters relied on marginal notations in black ink, likely penned by a supervisor at the very edges of the folios, to guide their creation of manuscript illustrations. These directives sometimes indicated the composition's scope (whether it should span two pages rather than one, for example) and

FIGURE 2.6. Battle between rival sects of *sanyasis* (Hindu mendicants), ascribed in the lower margin to Basavana (*tarh* or "design") and Asi "brother of Miskina" (*'amal* or "coloring" or "work"). From a fragmentary manuscript of the *Akbarnama*, completed circa 1590–95, probably Lahore. Victoria and Albert Museum, London, IS.2:62–1896.

FIGURE 2.7. Akbar watching a battle between rival sects of *sanyasi*s (Hindu mendicants), ascribed in the lower margin to Basavana (*tarh* or "design") and Tara Kalan (*'amal* or "coloring" or "work"). From a fragmentary manuscript of the *Akbarnama*, completed circa 1590–95, probably Lahore. Opaque watercolor, ink, and gold on paper. Painting 32.9 × 18.7 cm. Victoria and Albert Museum, London, IS.2:61–1896.

subject matter, suggesting that artists did not rely exclusively on their own interpretations of the manuscript's main text. Seyller also identifies marginal inscriptions that enumerate the number of days allowed for completion of paintings, a figure that a workshop director probably tallied in order to ensure that the workshop's many projects would run efficiently and to budget.[33] This rare evidence of textual workshop directives survives only because a small number of folios were, for one reason or another, incompletely trimmed when the leaves were prepared for stitching into a codex. Presumably every folio would once have borne marginal instructions like these, parts and traces of the workshop's coordinated production apparatus. To be sure, administrators like the *khan-i saman* (lord of the household) and the *darugha* (superintendent) regulated the *tasvir-khana* by reporting its activities up the chains of command, but Seyller's analyses of marginal inscriptions demonstrate that many other individuals had a hand in the management of the workshop. Many of its operations, we may assume, were independent of the emperor's oversight.

But for the most part scholars have neglected to consider what the hundreds of artist ascriptions may tell us about how large teams of painters executed heavily illustrated manuscripts.[34] One of the earliest known Mughal manuscripts to bear extensive ascriptions of this type is the British Library copy of the *Darabnama* (Book of Darab), a Persian prose romance about the legendary King Darab composed by Muhammad ibn Hasan Abu Tahir Tarsusi in the twelfth century (fig. 2.8).[35] Completed around 1580–83, the manuscript originally contained more than two hundred paintings. In its current, fragmentary state, the manuscript contains 157, of which 131 are accompanied by scribal notations that credit the works to forty-seven artists. With few exceptions, each painting is credited to a single artist.[36] Of the *Darabnama* manuscript's 130 extant folios, 120 are illustrated on one or both sides, and the overwhelming majority of folios that have illustrations on both recto and verso ascribe credit for these paintings to one artist.[37] Since the *Darabnama* has been rebound, and thus trimmed, it is impossible to determine its original sixteenth-century collation. However, assuming that the manuscript was collated as quaternions (eight leaves per gathering), as was customary for Persianate manuscripts produced in South Asia during this time, a pattern does emerge: for any single quire (i.e., four folded sheets with sixteen pages), there is a great probability that no more than eight artists—a maximum of two per bifolium (i.e., a folded sheet of paper producing two leaves with four pages)—were involved in creating the requisite illustrations.[38] This arrangement would have ensured that the completion of paintings within a single bifolium or quire necessitated coordination among only a small group of artists.

FIGURE 2.8. Shapur and Tamrusiya, Darab's lover, arrive on the island of Nigar ascribed in the lower margin to Basavana ('amal or "coloring" or "work"). From a fragmentary manuscript of the *Darabnama*, completed circa 1580–83, probably Fatehpur Sikri. Ascribed to Basavana, British Library, London, Or. 6810, f. 34r. Opaque watercolor, ink, and gold on paper. Folio 35.5 × 23 cm; painting 24.8 × 19.2 cm. Photo: British Library / GRANGER.

Even with artists organized into relatively small teams, the overall management of a manuscript project would have required supervision and standardization. Although the *Darabnama* is missing at least forty-three of its original paintings, and many of those that are extant lack authorial ascriptions, the distribution of works among the artists is telling. Of the 131 ascribed paintings, 70—or more than half—are ascribed to thirteen artists, while the remaining 61 are ascribed to thirty-four artists; nineteen artists' names, meanwhile, appear only once. These figures indicate that a limited number of artists were responsible for producing the bulk of the manuscript's illustrations. The artist Bhagwan, for example, is credited with executing ten paintings. Another three artists (Mithra, Mukhlis, and Nanha) are each credited with producing seven paintings, while three other artists (Bhura, Ibrahim Kahhar, and Sanvala) are credited with six.

From what can be discerned from the extant portions of the manuscript, the allocation of work on the *Darabnama* seems to have been organized according to a fairly regular scheme. This system would have allowed for some degree of collective self-management, with the artists who executed the bulk of the illustrations likely overseeing other artists' work to ensure a degree of stylistic unity throughout the manuscript. An ascription on one folio credits 'Abd al-Samad (referred to as *khwaja*, or master), one of the workshop's most senior artists, with "correcting" (*islah*) the work of the relatively minor painter Bihzad.[39] That the experienced artist Basavana is associated with only one of the extant *Darabnama* illustrations is puzzling (see fig. 2.8), but he might have been operating in a more supervisory role. It is equally possible that Basavana was minimally engaged with the enterprise because of other commitments: the *Darabnama*, after all, was not the only heavily illustrated manuscript that the Mughal workshop was producing at this time.

The approach taken in the production of the *Darabnama* manuscript, wherein each painting was executed by a single artist, seems to have been a short-lived experiment.[40] While a few poetic manuscripts, each containing a small number of individually authored illustrations, were produced or refurbished in the late 1580s and the 1590s, the bulk of the workshop's commissions during this time consisted of historical texts or epics, each bearing more than one hundred paintings executed by teams of two to three painters. Among these were the *Akbarnama*, Abu'l Fazl's history of the emperor's own reign, completed in the mid-1590s; the *Baburnama* (Book of Babur), or Babur's memoirs, which the courtier 'Abd al-Rahim (1556–1627) translated from Chagatai Turki into Persian around 1589–90; and a number of older and contemporaneously authored histories—including the *Tarikh-i Khandan-i Timuriyya* (History

of the Family of Timur), the *Jamiʿ al-tavarikh* (Compendium of chronicles) of Rashid al-Din (d. 1318), and the *Tarikh-i alfi* (Millennial history)—that celebrate the Mughals' Timurid and Mongol ancestors and the dynasty's place in Islamic history. Akbar's painters were simultaneously illustrating manuscripts of Sanskrit epics like the *Mahabharata*—rendered in Persian as the *Razmnama* (Book of war)— and the *Ramayana* (Story of Rama).[41] Both texts had been only recently translated into Persian by Muslim court scholars from conversation, in Hindi, with Hindu Brahmans in the imperial *maktab-khana* (scriptorium, lit. "writing house").[42]

The sheer volume of artist ascriptions in manuscripts of historical and epic texts offers crucial evidence for the preponderance of the collaborative mode of illustration. The majority of these inscriptions identify two artists, the one who completed the painting's design (*tarh*) and the one who filled in the colors (*ʿamal* or *rang-amizi*), in that sequence not only because of the necessary order of the tasks but also because of the greater esteem that design was accorded. Ascriptions occasionally also record the name of a third artist, a portraitist who completed or refined the faces of the emperor and other important figures (*chihra-yi nami*, lit. "illustrious faces"). The inscriptions on a Victoria and Albert *Akbarnama* page showing Emperor Akbar supervising construction of the imperial city of Fatehpur Sikri in 1571 ascribe the *tarh* to Tulsi, the *ʿamal* to Bandi, and the *chihra-yi nami* to Madhava Khurd (i.e., Madhava "the Younger") (fig. 2.9).[43] Close inspection of the painting reveals that Akbar's face is indeed rendered in a more delicate and attentive manner than those of other figures. The same artist probably also painted the face of the nearby courtier in the maroon-colored *jama* (stitched coat), who shares Akbar's heavy-lidded eyes, upturned brows, and narrow, straight nose. The division of artistic labor among several individuals almost certainly helped to expedite the completion of the many copiously illustrated manuscripts undertaken at Akbar's court.

Computational analysis measuring the incidence of ascriptions for individual artists reveals that heavily illustrated manuscripts include ascriptions for a correspondingly large number of artists.[44] Graphs shown here reveal the extent of each artist's participation in the Jaipur *Razmnama*, the Jaipur *Ramayana*, and the Patna *Tarikh-i Khandan-i Timuriyya* based on the number of times his name appears in marginal ascriptions (figs. 2.10–2.12). The Jaipur *Razmnama*, for example, bears nearly sixty artists' names alongside 150 of its 168 illustrations; the remaining eighteen either lost theirs as a result of the trimming of the folios or never bore a name at all. The ascriptions in the Patna *Tarikh-i Khandan-i Timuriyya* of circa 1584–87 credit fifty-eight

FIGURE 2.9. Akbar supervising construction of his new capital, Fatehpur Sikri, ascribed to Tulsi (*tarh* or "design"), Bandi (*'amal* or "coloring" or "work"), and Madhava Khurd (*chihra-yi nami* or "portraits"). From a fragmentary manuscript of the *Akbarnama*, completed circa 1590–95, probably Lahore. Opaque watercolor, ink, and gold on paper. Painting 32.7 × 19.5 cm. Victoria and Albert Museum, London, IS.2:91–1896.

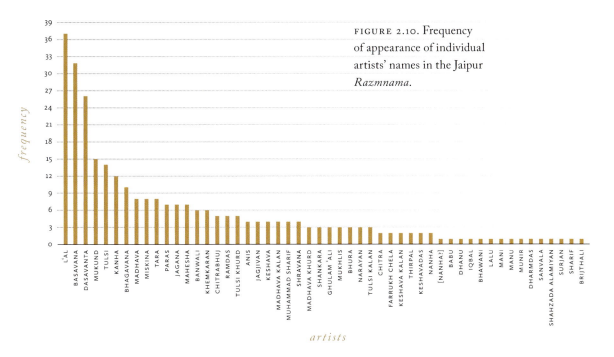

FIGURE 2.10. Frequency of appearance of individual artists' names in the Jaipur *Razmnama*.

artists for its 118 illustrations, and ascriptions appended to 168 of the 178 illustrations in the manuscript of the Jaipur *Ramayana* of circa 1585–88 identify fifty-nine artists in total. Many of these manuscript production teams comprised a small number of very active artists (i.e., artists whose names appear frequently in the marginal ascriptions) and a large number of minimally active artists (whose names appear infrequently or only once). This pattern, as is made plainly evident by the shape of the slopes in all three graphs, holds regardless of the number or size of the paintings in the manuscript: the marginal inscriptions in the so-called Keir *Khamsa* of Nizami, whose illustrations were completed around 1585, attribute the manuscript's thirty-four minuscule illustrations to twenty-six artists, sixteen of whose names appear only once (fig. 2.13). The structural consistencies observed here suggest that the workshop operated according to a judicious and deliberate scheme of allocating illustration work that brought many different artists together on multiple occasions and in a variety of capacities.

Examination of instances of artistic collaboration in the Jaipur *Ramayana* and *Razmnama* and the Patna *Tarikh-i Khandan-i Timuriyya*, using network graphs to chart which artists worked together, and how frequently, provides further insights about the Mughal *tasvir-khana*'s working methods (figs.

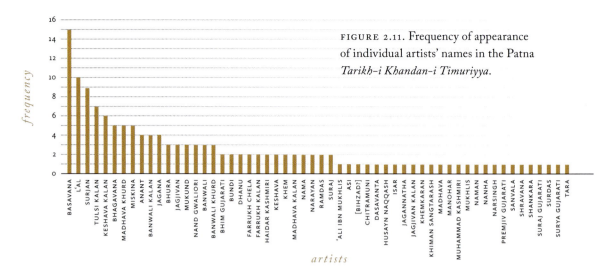

FIGURE 2.11. Frequency of appearance of individual artists' names in the Patna *Tarikh-i Khandan-i Timuriyya*.

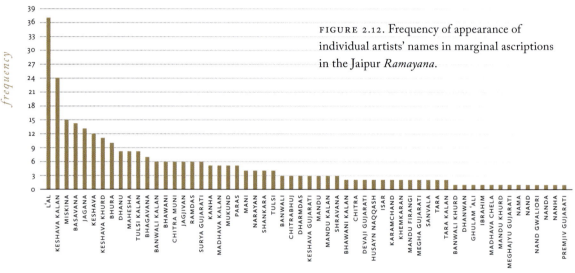

FIGURE 2.12. Frequency of appearance of individual artists' names in marginal ascriptions in the Jaipur *Ramayana*.

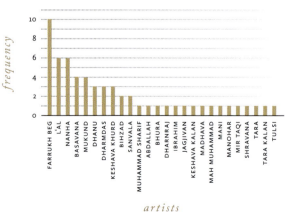

FIGURE 2.13. Frequency of appearance of individual artists' names in marginal ascriptions in the Keir *Khamsa*.

2.14–16).⁴⁵ Measuring each artist's betweenness centrality—that is, the number of times an individual serves as a bridge on the shortest path connecting two others—these graphs show which painters (here represented as a small number of larger, more saturated nodes) enjoyed the greatest influence as pathways of knowledge transmission. The network graphs also reveal that the composition of the groups of artists who worked together varied with each new manuscript project, and collaborations between designers and colorists changed regularly. The artist Miskina, operating in the capacity of a colorist, collaborated with three different designers (Dasavanta, Basavana, and Keshava Kalan) on seven different illustrations in the Jaipur *Razmnama*. Miskina then worked mainly as a designer, and with an entirely different cast of collaborators (Chitrabhuj, Keshava Khurd, Mandu Firangi, Narayan, Bhura, Sarwan, and Jagjivan), on the Jaipur *Ramayana* manuscript. Miskina worked once again with Jagjivan, Bhura, and a new associate, Anant, to com-

FIGURE 2.14. Network graph showing betweenness centrality of designers and colorists who collaborated on the Jaipur *Ramayana* manuscript illustrations, completed 1582/83–86. The larger and more highly saturated a node, the higher its betweenness centrality. Thicker and more highly saturated edges (connecting links) indicate a greater number of collaborations between two nodes.

FIGURE 2.15. Network graph showing betweenness centrality of designers and colorists who collaborated on the Patna *Tarikh-i Khandan-i Timuriyya* manuscript illustrations, completed circa 1584–87.

FIGURE 2.16. Network graph showing betweenness centrality of designers and colorists who collaborated on the Jaipur *Razmnama* manuscript illustrations, completed circa 1585–88.

plete illustrations in the Patna *Tarikh-i Khandan-i Timuriyya*; his previous collaborators Basavana, Keshava Kalan, Keshava Khurd, Narayan, and Sarwan also contributed to the manuscript's illustrations but were partnered with other painters. The steady rotation of production team membership across multiple manuscript projects would have ensured that the responsibility of educating and overseeing novice painters was distributed among a relatively small group of established artists. Abu'l Fazl alludes to the managerial and pedagogical dimensions of the court artist's profession in the *A'in-i Akbari*, where he writes: "under ['Abd al-Samad's] instruction [*amuzish*] many students [*shagirdan*] have become masters [*ustad*]."[46] But the paintings and the ascriptions provide much more granular evidence for this phenomenon.

These arrangements presumably facilitated the efficient training of novice workshop members by more experienced artists. They would also have introduced both junior and senior artists to a wide range of artistic styles and working methods. Maximizing the diversity of collaborations among the atelier's designers and colorists created connections, or ties, between large numbers of artists, but since the collaborations were temporary and not often repeated, these were what social network analysis defines as "weak" ties. Weak ties establish acquaintanceship, whereas strong ties inculcate closer, more intimate relationships. Yet maintaining weak ties fosters a wider flow of information and skills.[47] In a workshop that employed over one hundred painters from various parts of South Asia as well as Central Asia and Iran, a network of weak ties would have promoted the broad dissemination of different modes of making. The structure and system of Akbar's imperial atelier did not merely encourage stylistic diffusion: it made it possible—even unavoidable.

Learning Style, Learning Self

The workshop protocol of the 1580s through the 1590s, involving the frequent rotation of collaborators, necessitated regular negotiations among designers and colorists. This mode of production furthered the formation of a shared sense of an artist-servant self that was centered, in part, on negotiating shared learning, teaching, and making within a large imperial bureaucratic institution.

To understand what the processes of designing and coloring entailed, let us take a closer look at a double-page composition from the Victoria and Albert *Akbarnama*, which depicts Akbar commanding his army at the battle of Sarnal, Gujarat, in 1572 (figs. 2.17 and 2.18).[48] The inscriptions in the lower margins indicate that L'al completed the designs for both paintings, while

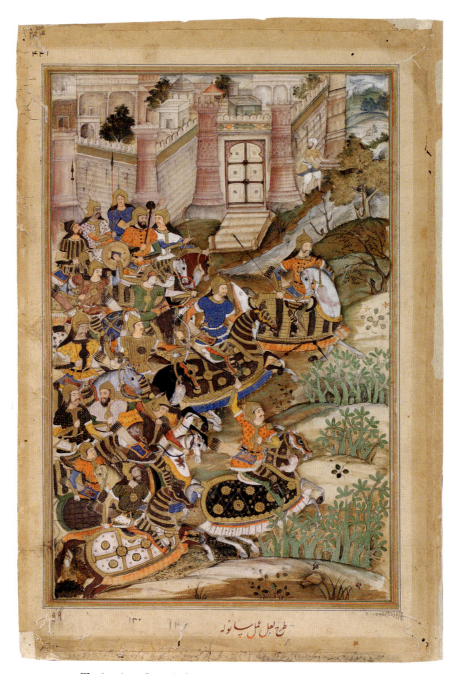

FIGURE 2.17. The battle at Sarnal, Gujarat, in 1572, ascribed to Lʻal (*tarh* or "design") and Sanvala (*ʻamal* or "coloring" or "work"). From a fragmentary manuscript of the *Akbarnama*, completed circa 1590–95, probably Lahore. Opaque watercolor, ink, and gold on paper. Painting 30.6 × 19.7 cm. Victoria and Albert Museum, London, IS.2:107–1896.

FIGURE 2.18. The battle at Sarnal, Gujarat, in 1572, ascribed to Lʻal (*tarh* or "design") and Babu Naqqash (*ʻamal* or "coloring" or "work"). From a fragmentary manuscript of the *Akbarnama*, completed circa 1590–95, probably Lahore. Opaque watercolor, ink, and gold on paper. Painting 31.8 × 18.8 cm. Victoria and Albert Museum, London, IS.2:106–1896.

Babu Naqqash colored the right-hand side and Sanvala the left. Although the contributions of Babu Naqqash and Sanvala are more readily apparent, the general shape and structure of L'al's foundational design, or *tarh*, is still discernible. The artist's manner of stacking lines to indicate hilly ground, for example, is common to both parts of the composition, as are the clusters of plants on the hillcrests.[49] L'al designed a number of similarly complicated, action-filled battle scenes in the *Akbarnama* manuscript.[50] He evidently also had a penchant for depicting small, multispired city views in the upper registers of his compositions. These appear in both panels of the double-page composition. L'al's hand is further evident in the spray of flowers and the cluster of green plants located near the gutter of the left-hand page, where Sanvala apparently applied the colors hastily and unevenly. The *tarh* is also exposed in the outlines of arrow slits in the city walls that show through the transparent wash. Just below the unfinished arrow slits is a soldier in a blue and gold polka-dot coat, whose bow—another fragment of L'al's *tarh*—Sanvala left conspicuously unpainted. Paint loss on the face of an archer nearby provides another glimpse of L'al's foundational design.

These traces and palimpsests reveal L'al's *tarh* to be more like a preparatory drawing than a finished, unalterable template. This fact should come as little surprise, since the colorist's multiple layers of paint usually—though not always completely—concealed the designer's monochromatic sketch. The colorist would begin by covering the *tarh* with a transparent white wash, to which he would then apply multiple layers of opaque paint, each burnished in turn. In the final stage of the process, he filled the design's compositional units with finely rendered details: eyes, mustaches, tufts of grass, armor, and architectural and textile designs. The laborious, accretive process accounts for the jewel-like finish of many Mughal manuscript paintings; it also shows that the "work" of *'amal* amounted to more than coloring in the lines. The colorist had also to possess precise hand-eye coordination, familiarity with a diverse assortment of ornamental patterns, and knowledge of the chemistry of pigments and color mixing. Coloring, like designing, required considerable expertise and time.[51]

The twofold mode of production may point to a twofold mode of reception, whereby paintings were appraised according to their narrative clarity and compositional ingenuity (*tarh*) on the one hand, and their variety, combination, and precision of coloring and patterning (*'amal*) on the other.[52] The connoisseur's appreciation for the latter would account for the great latitude that the colorist enjoyed in selecting the hues and patterns to fill in the other artist's design. The distinction between designing and coloring, however,

could be complicated by the production process itself, which required that the designer and colorist collaborate with and thereby learn from one another.

What was the nature of contact and collusion between the designer and the colorist when completing a manuscript illustration? While the royal histories and marginal inscriptions say little on this score, the paintings themselves tell a story. For Sanvala and Babu Naqqash, L'al's foundational drawings provided instruction in the organization of complex battle scene illustrations. L'al's composition for the double-page *Akbarnama* battle scene, for example, contains numerous overlapping soldiers and horses embedded in a landscape dense with vegetation, landforms, and architecture. Sanvala and Babu Naqqash did not merely color but traced, negotiated, and thereby modeled L'al's compositional choices. The *tarh* guided the colorists' hands as they filled in and defined the outlines of horses, helmets, and crenellations. Coloring was a means of learning.

Sanvala seems to have enjoyed an especially productive relationship with L'al. In each of the five illustrations in the *Akbarnama* to which Sanvala contributed coloring, L'al served as the designer. Likewise, in the Keir *Khamsa* of Nizami and the Jaipur *Razmnama* and *Ramayana*, Sanvala is identified as the colorist of five illustrations in total, all designed by L'al.[53] But L'al, in his capacity as a designer, worked with a large number of painters: in the Jaipur *Razmnama* alone, he collaborated on thirty-four illustrations with twenty-one colorists. By contrast, Sanvala contributed to only one illustration for this manuscript, designed by L'al. Analyzing network graphs showing instances of collaboration among painters reveals a similar pattern of production, with a small number of designers working with a larger pool of colorists across the many illustrated manuscripts created at Akbar's court from the 1580s onward (see graphs 2.14–16).[54] This arrangement cast designers, who are represented by large, color-saturated nodes in the three graphs illustrated here, as the disseminators of artisanal know-how.

The roles of designer and colorist were not always fixed. The marginal ascriptions indicate that designers frequently colored illustrations as well. Indeed, seventeen of the twenty artists identified as designers in the Jaipur *Razmnama*'s ascriptions also served as colorists.[55] The painter Mukund is credited with producing the *tarh* for five of the manuscript's illustrations and for coloring eleven compositions, all of which were likely designed by other artists. Mukund collaborated with L'al on two different illustrations, each artist serving as designer for one and colorist for the other.[56] L'al, the most active artist in this manuscript, created twenty-seven of the *Razmnama* designs and provided coloring for three. Basavana served as designer for

twenty-six paintings in the *Razmnama* and as colorist for eight. Working as colorists, designers collaborated with (and thus stood to learn from) artists of lesser stature.

These examples show that artistic collaboration contributed to the production of a shared style and professional identity. Collaborations functioned much like apprenticeships, with senior and junior painters establishing collective practices together through the imitation of patterns, gestures, postures, and dispositions. Artists, in this sense, inculcated rather than acquired skill. Even more, they contributed to, shared, internalized, and embodied a mode of conduct, or what Pierre Bourdieu calls *habitus*, that served an important social function.[57]

Bourdieu's theory of practice elucidates the tacit, constructed, and somatic nature of learning and producing style in communities like the Mughal manuscript atelier. Style, in this sense, is a process, not a product; it is involuntary and situated; and all participants contribute to the production of knowledge. Style, moreover, is never "finished"; it does not follow set rules, nor is it static and unchanging, but it is constituted and reconstituted through interactions among community participants, who are themselves constituted through myriad social, material, and spatial relationships.[58] Cognition is thus not only embodied but extended to the larger environment.

To learn style, then, means to participate in the creation of a social world. Learning is integral to identity formation, as it "involves the whole person; it implies not only a relation to specific activities, but a relation to social communities—it implies becoming a full participant, a member, a kind of person."[59] Becoming a painter in the sixteenth-century Mughal manuscript workshop meant becoming a certain kind of person, one defined by collaborative learning, teaching, and making within a sprawling bureaucratic institution. It entailed not only participation in the formulation of an artisanal practice, but also the adoption of a shared habitus and, by extension, a collective identity. Studies that have focused on individual artists as the workshop's catalysts—stylistic, professional, or otherwise— fail to account for the degree to which knowledge production was situated, as opposed to internalized, and they neglect the intrinsic part that the community of practice played in the constitution of the artist as a social category. The idea of the Mughal artist that emerged in the early seventeenth century would be inconceivable without the interplay of the network of court artists. If the artists constituted the workshop community, it is equally true that the workshop community created the artists.

The term *community* may conjure an image of equality and harmony. But

communities of practice are not necessarily egalitarian. The Mughal manuscript workshop was a highly centralized and hierarchical institution. Its system of operation cast some individuals as junior staff and others as senior. Age and experience were factors in this hierarchy, but some workshop members enjoyed advantages by virtue of their positions as the sons, nephews, or brothers of more established artists or court servants. Conflict likely erupted on a regular basis, and competition was fierce, if we judge by Abu'l Fazl's claims that Akbar regularly evaluated artists' work and determined salaries accordingly. Even if the emperor did not take a panoptic view of the atelier's goings-on, it was a regulated system in which experienced artists supervised, reviewed, and corrected the work of their less experienced colleagues. Cultivating certain skills—artisanal, but also pedagogical, managerial, and political—could elevate the artist to a position of greater standing. The workshop produced a kind of collective agency that nevertheless manifested social and professional inequalities.

The Artists of Invention

According to marginal ascriptions, only three artists—Bhura, Mahesha, and Khemkaran—served as both designers and colorists in the production of the Victoria and Albert *Akbarnama* of circa 1590–95.[60] Why had the division between *tarh* and *'amal* intensified by this time? One possible explanation is that the greater fluidity of roles evidenced in the Jaipur *Razmnama* and the other illustrated manuscripts produced in the 1580s had served to train artists in the full spectrum of artisanal skills and also offered a testing ground for the many artists the atelier now employed. By the time the Victoria and Albert *Akbarnama* manuscript was in production, the majority of Akbar's artists had spent a decade or more in the court workshop; they would have been evaluated on multiple occasions and ranked accordingly. The addition of artist ascriptions in the margins of illustrated manuscript pages would have facilitated this process.

By what criteria were manuscript painters judged? Those tasked with coloring an illustration's design would have had to demonstrate familiarity with various forms of ornament—botanical, geometric, and otherwise—and color combinations, and precision in their depiction. Two examples from the Victoria and Albert *Akbarnama*, both ascribed to the colorist Sarwan, attest to these skills (figs. 2.19 and 2.20). Colorists needed to know how to mix, layer, and burnish paints of different mineral and organic compositions, and to possess a tacit understanding of color theory.[61] Striking juxtapositions of colors could

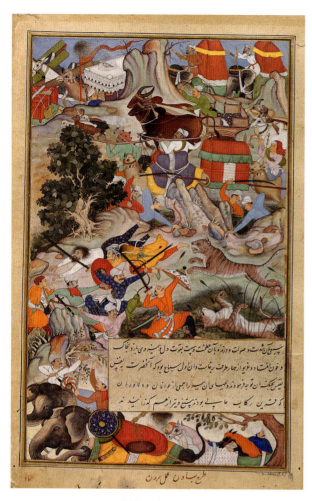

FIGURE 2.19. Akbar slays a tiger that had attacked the royal entourage, ascribed to Basavana (*tarh* or "design") and Sarwan (*'amal* or "coloring" or "work"). From a fragmentary manuscript of the *Akbarnama*, completed circa 1590–95, probably Lahore. Opaque watercolor, ink, and gold on paper. Painting 33 × 20 cm. Victoria and Albert Museum, London, IS.2:18–1896.

animate an illustration's design while also drawing attention to key subjects and events. It is clear that colorists drew on a body of stock patterns to fill areas of the design; this archive likely expanded and contracted as artists joined and left the workshop. The minuteness of the colorists' schemes of pattern and ornament—what David J. Roxburgh refers to as "micrographia"—played the important role of extending the temporality of the narrative moment by absorbing the beholder's attention.[62] Color was integral to the creation of a rich tapestry of manuscript embellishments.

Designing drew on a different body of knowledge and conventions. Working in monochromatic ink, the designer stitched together modular design units—distant city views, human and animal groups, rocky outcrops—to create the foundation of the illustration. The colorist later covered these with layers of patterning. The designer's enterprise, like that of the colorist, required precision, but it also demanded compositional and narrative inventiveness. It is important to understand what precisely *invention* means in this context. In the painting traditions associated with Timurid and Safavid Iran, it was the design—and specifically the *tarh*'s contoured line—and not the coloring that denoted artistic authorship. By emulating earlier designs, the painter invoked an inherited "corpus of subjects, motifs, designs, and themes" so as to insert himself into a recognized artistic genealogy; and by "subtly recasting . . . [these] pre-established archetypes," he sought to confirm his own status as an author.[63]

Those artists who excelled at both coloring and designing enjoyed responsibilities different from those of their less experienced or skilled colleagues.

These included pedagogical and supervisory duties, and from the mid-1580s until the end of Akbar's reign, they also entailed the solo production of illustrations in de luxe manuscripts.⁶⁴ The majority of these works were made to accompany Persian poetic texts like the *Khamsa*s of Nizami and Amir Khusraw Dihlavi (1253–1325) and the *Baharistan* (Spring garden) of Jami (1414–92), which were connected with canons of narrative illustrations formulated in the Persianate sphere during the fifteenth century. In these paintings artists could demonstrate their accomplishments as both designers and colorists.⁶⁵ The artists included Basavana, L'al, Madhava, Miskina, Mukund, and Sanvala, who had been some of the most active designers for the highly illustrated chronicles and epics of the 1580s and 1590s. Others, like Dharmdas, whose name appears in three de luxe manuscripts dated between 1595 and 1598, had perhaps been only recently recruited to the workshop.

The artists who contributed illustrations to these manuscripts had to demonstrate not only their familiarity with the paradigmatic pictorial compositions associated with manuscript copies of these texts but also their ability to improve on them in subtly inventive ways. The *Khamsa* of Nizami of 1595–96,

FIGURE 2.20. Akbar greeting Rajput royals and other nobles at court, probably in 1577, ascribed to Miskina (*tarh* or "design"), Sarwan (*'amal* or "coloring" or "work"), and Madhava (*chihra-yi nami* or "portraits"). From a fragmentary manuscript of the *Akbarnama*, completed circa 1590–95, probably Lahore. Opaque watercolor, ink, and gold on paper. Folio 37.9 × 24.3 cm; painting 32 × 19.2 cm. Victoria and Albert Museum, London, IS.2:114–1896.

which bears forty-two illustrations associated with Akbar's patronage, exemplifies this principle.⁶⁶ Manohar's painting of the Sasanian King Anushirvan (r. 531–579), also known as Khusraw I, from the *Khamsa*'s first book, the *Makhzan al-asrar* (Treasury of secrets), invokes a long Persianate tradition of depicting this subject (fig. 2.21). The scene illustrates one of the book's parables, about a vizier who brings King Anushirvan to a ruined village in the

FIGURE 2.21. King Anushirvan and his vizier ascribed to Manohar ('*amal* or "coloring" or "work"). From a partially dispersed manuscript of the *Khamsa* of Nizami Ganjavi, completed AH 1004 (1595–96), probably Lahore. Opaque watercolor, ink, and gold on paper. Folio 30 × 19.5 cm. British Library, London, Or. 12208, f. 13v. Photo: British Library / GRANGER.

kingdom to impart a lesson about the ruler's responsibilities to his own subjects. Like the illustration of the same subject in a Safavid royal copy of Nizami's *Khamsa* from 1539–43 (fig. 2.22), Manohar shows the king and his vizier on horseback, both making gestures similar to those in the earlier painting; both paintings also include depictions of building ruins at the left center. As was customary for the iconography of this pictorial narrative, the Mughal and Safavid works also include pairs of owls, whose conversation the vizier interprets for his patron as an indictment of Anushirvan's policies. Where the Safavid artist painted a rivulet in the right-hand side of the composition, however, the Mughal artist instead depicted a well; the former painting also includes a foreground vignette of two lumberjacks felling a tree as a donkey feeds on grass nearby, while the latter shows a gnarled tree with a figure controlling a leaping dog on a leash. One of Manohar's noticeable departures from the archetype is his portrayal of the decaying architecture in the distance. In contrast with the Safavid painting, in which the buildings are rendered as elaborate vaulted brick

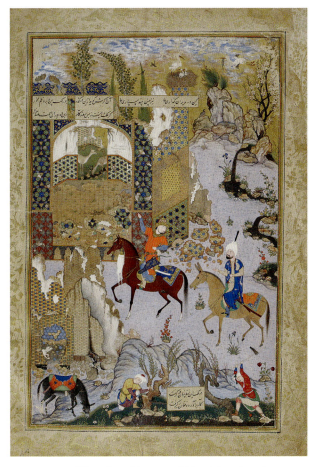

FIGURE 2.22. King Anushirvan and his vizier, signed by Mirak and dated AH 946 (1539–40). Detail of a page from a manuscript of the *Khamsa* of Nizami Ganjavi, completed 1539–43, Tabriz. Opaque watercolor, ink, and gold on paper. Folio approx. 36 × 25 cm. British Library, London, Or. 2265, f. 15v. Photo: British Library / GRANGER.

structures studded with colorful geometric tiles, the Mughal illustration includes both brick and masonry structures, some of them reminiscent of European and pre-Mughal South Asian architecture. It was precisely these kinds of minor adjustments (or innovations) that manuscript painters were expected to make while simultaneously establishing their familiarity with the pictorial formulas associated with the canon.

Novelty, however, bore distinctive valences at Akbar's court. During the late 1570s, a small group of scholars, including Abu'l Fazl, had established

the imperial ideology of *sulh-i kull* (total peace), which drew on Neoplatonic doctrines on the unity of existence (*wahdat al-wujud*) advanced by the Andalusian Sufi scholar Ibn 'Arabi (d. 1240), as well as centuries-old discourses on political ethics (*akhlaq*). At its core, the doctrine held that Akbar's reign would ring in a new age of social harmony.[67] *Sulh-i kull*'s emphasis on respect for cultural diversity registered a broader awareness of the Mughals' cosmopolitan status in the early modern world. Akbar's court was remarkably heterogeneous, and the exchange of commodities and the flow of knowledge had quickened through increased contact with merchants, diplomats, and sectarian groups from across South Asia, Africa, Europe, and elsewhere. Akbar's ideologues contended that he alone could negotiate and harmonize these linguistic, cultural, and religious differences and thereby introduce an era of peaceful accommodation and social order. The establishment of the *ibadat-khana* (worship house) at the imperial city of Fatehpur Sikri in 1575 provided a physical space in which Akbar performed these functions.[68] It was in this relatively public forum that Akbar invited the *'ulama'* (Muslim scholars) and members of the Shi'i, Hindu, Jain, and Catholic communities to debate sectarian matters. Related to these developments was the 1579 decree (*mazhar*) that proclaimed Akbar to be the *mujtahid*—that is, one who could formulate legal opinions independent of established religious doctrine—and imam of the era.[69] That this argument rested on the emperor's capacity to formulate sound opinions through direct apperception (*tahqiq*, "reality"), rather than according to precedent (*taqlid*, "imitation"), made clear Akbar's unique qualifications as the bringer of *sulh-i kull*.

But the idea of Akbar as the ruler of a new age also resonated with a courtly—and Islamicate—fixation on the coming of the second Islamic millennium (AH 1000/1591) and the belief that it would introduce profound societal transformation. For the Mughals, this millenarian preoccupation evolved into the identification of Akbar as the Mujaddid-i Alf-i Thani (Renewer of the Second Millennium), a prophet-like figure who would usher in epochal change.[70] The evidence marshaled to support this claim appears in the *Tarikh-i alfi*, a multiauthored text commissioned in 1582 that relays the history of the first one thousand years of Islam, from the Prophet Muhammad's death to Akbar's reign, albeit couched in a global framework that includes the histories of Europe and China alongside those of Iran, South Asia, Central Asia, and North Africa.[71] The text asserts that Akbar's status as the Mujaddid-i Alf-i Thani had been confirmed by "an occult calculation based on the letters of the emperor's name and the apocalyptic science of *jafr* [divination]." These emphatically messianic connotations are confirmed

by texts like the *A'in-i Akbari* and the *Akbarnama*, which celebrate Akbar's supreme status as a temporal and spiritual ruler.[72]

During this period and in the early decades of the second Islamic millennium, there was, as Rajeev Kinra describes, "a heightened sense of newness in the air" at the Mughal court. This extended to the production of texts: the later sixteenth and early seventeenth centuries saw the manifestation of a taste for "fresh-speaking" (*taza-gu'i*) poetry, a movement whose practitioners—including 'Urfi (1555–91) and Abu'l Fazl's brother Fayzi (1547–95)—possessed a self-conscious awareness of the newness of the moment and sought to "refresh" and "rejuvenate" the inherited Persianate literary traditions.[73]

The creation of new kinds of texts took a programmatic turn with the establishment in the mid-1570s of an initiative to produce Persian translations of Hindu sacred texts, including the *Mahabharata* (in Persian, the *Razmnama*) and the *Ramayana*.[74] These projects, according to Audrey Truschke, underscore "how the Mughals understood their evolving imperial identity as cutting across literary and political realms." Her analysis of the *Razmnama* confirms the deep concern with the linguistic, aesthetic, and literary aspects of the translation enterprise and, by association, the *sulh-i kull* ideology. The text served less to legitimize Mughal imperial rule among its largely non-Muslim subjects, as other scholars have argued, than to "make the Sanskrit tradition a living part of Indo-Persian culture." The team of translators—led by a group of Muslim scholars working in cooperation with Hindu Brahmans—accomplished this task by assimilating the *Mahabharata* with Islamicate royal preoccupations with *tarikh* (history), *aja'ib* (wonders), and ethics manuals, while simultaneously signaling skepticism of the epic's truth value in their extradiegetic characterizations of it as merely "alleged" history.[75] The translators also aimed to highlight Akbar's unique role as the great accommodator of religious, linguistic, and cultural difference, as contrasted with the *'ulama'*, who maintained that the production of knowledge should be rooted solely in Islamic tradition. The commissioning of other newly composed or translated historical texts like the *Baburnama*, the *Tarikh-i alfi*, the *Tarikh-i Khandan-i Timuriyya*, and the *Akbarnama* during the 1580s and 1590s served comparable ends.

These works seem to have enjoyed broad reception beyond the emperor's own limited quarters. According to Abu'l Fazl, Akbar demanded that manuscripts held in the imperial collections be read aloud during royal assemblies (*mahfil-i humayun*), at which any number of bureaucrats and servants would have been present.[76] Some members of the court, meanwhile, may have had access to copies of these newly composed texts in the royal libraries at the

court.⁷⁷ Others, like Hamida Banu Begum, Akbar's mother, commissioned their own illustrated manuscripts of the *Akbarnama* and the *Ramayana*.⁷⁸ Artists trained in Akbar's atelier also produced a well-known dispersed copy of the *Razmnama* dated 1598–99 likely intended for nonimperial consumption. Thus some of these works circulated beyond the emperor's own personal collections.

Mughal painters, like their literary counterparts, also engaged in acts of translation. The *tasvir-khana*'s diverse staff—comprising mainly Iranian, Central Asian, and South Asian artists—may have been assembled precisely to support the challenges of accommodating newly composed Persian texts to a pictorial medium. There is reason to believe that the widespread practice of ascribing authorship to manuscript illustrations may have served not only as a form of recordkeeping, but also as a means of indexing the workshop's heterogeneous membership. In addition to sectarian affiliations, the names in the marginal ascriptions include *nisba*s, like *Kashmiri, Lahori, Gwaliori,* and *Gujarati*, that identify the artists' places of origin.⁷⁹ The abundance of recognizably Hindu names in the ascriptions would have appeared all the more pertinent given the workshop's mandate to illustrate Hindu texts. The appearance of names like Mandu Firangi (Mandu the Frank), which occurs in the margins of several illustrated pages of the Jaipur *Ramayana*, would have further broadcast the cosmopolitan and ecumenical nature of image and manuscript making at Akbar's court.

The manuscript workshop played integral roles in the court's translation projects and ideological aims. As its calligraphers copied new texts like the *Razmnama*, the *Ramayana*, and the *Tarikh-i alfi*, its painters produced hundreds of illustrations to accompany these works.⁸⁰ Beyond the visually striking effect of the manuscripts as a whole, the strategic design and placement of specific paintings could advance certain ideologies that did not necessarily inhere in the main text. The fragmentary Victoria and Albert *Akbarnama* manuscript, thought to be the presentation copy made for the emperor himself, is a case in point. Among its 116 extant illustrations are numerous battle scenes and depictions of courtly rituals (marriages, births, and hunts), political intrigues, diplomatic meetings, and events related to the emperor's spiritual pursuits, which present Akbar as the mystical Persianate king par excellence.⁸¹

It is tempting to imagine that the manuscript's illustrations informed Abu'l Fazl's editing of the *Akbarnama* text, especially since it appears that at least some of the paintings were completed before the text.⁸² Close examination of the text and image relationships indeed suggests that its makers conceived

of the book as a holistic program of historical writing and painting. One painting shows the aftermath of the violent state execution of Akbar's *koka* (milk brother), Adham Khan (1531–1562), for the murder of the Mughal general Ataga Khan (fig. 2.23). According to Abu'l Fazl, Akbar had issued the official decree that Adham Khan be thrown headfirst from a palace balcony, but those who carried out the order out did so incorrectly and, as a result, the act had to be performed a second time. The text and illustration of the scene, however, invite the viewer of the manuscript recto page to perceive the narrative event as a cyclical phenomenon. The fall of Adham Khan's twisted, upside-down body, his red-clad legs contrasting with the white stucco wall, combined with the diagonal thrusts of the surrounding figures' arms, draw the eyes to Ataga Khan's blood-splattered body at the lower left. The single line of text that dramatically intrudes into the chaos begins to elucidate the scene: "When he was dragged up by his hair, they obeyed orders and turned him upside down and threw him down so that his neck was broken and his brains were dashed."[83]

Moving from Ataga Khan's body back to Adham Khan's grotesque form, the viewer's eyes are guided upward from the sandstone steps to the balcony and the line of text near the top of the page, which explains: "He was still half alive. Once again it was ordered that the unfortunate wretch be brought back up. This time . . ."[84] The break in the sentence prompts the viewer to reread the lower line of text and review the pictorial representation of events—thus, like Adham Khan, experience the execution once again. This strategy not only obviates the painters' need to illustrate the repetition of the act but also implicates the viewer in Akbar's administration of justice.

The positioning of Akbar alone in the illustration's upper left quadrant is programmatic. The *Akbarnama* makes it clear that throughout the episode, the emperor remained on the palace balcony. His location in the composition, however, aligns him with the line of Abu'l Fazl's text, underscoring the point that it was Akbar who ordered "that the unfortunate wretch be brought back up." But the placement also contrasts Akbar's upright posture with Adham Khan's twisted body. The emperor is shown bare-chested, draped with diaphanous textiles that reveal his left arm and shoulder. The emphasis on Akbar's ideal physique is a central feature of Mughal manuscript painting of this period (a subject explored in chapter 3).[85] For a court culture that subscribed to the tenets of physiognomic science, holding that external appearances reflect internal character and moral state, portraits of the Mughal sovereigns constituted indisputable evidence of the dynasty's singularity.

The coordination of text and image in illustrated manuscripts was chal-

FIGURE 2.23. Adham Khan, Akbar's *koka* (milk brother), being thrown from the palace walls in 1562, ascribed to Miskina (*tarh* or "design"; *chihra-yi nami* or "portraits") and Sangha ('*amal* or "coloring" or "work"). From a fragmentary manuscript of the *Akbarnama*, completed circa 1590–95, probably Lahore. Opaque watercolor, ink, and gold on paper. Painting 33 × 19.5 cm. Victoria and Albert Museum, London, IS.2:29–1896.

lenging enough, particularly for those charged with designing paintings to accompany new (and, in some cases, incomplete) texts and translations like the *Ramayana*, the *Razmnama*, the *Baburnama,* and the *Akbarnama*. Because none of these texts was associated with an existing set of manuscript illustrations, designers had to invent pictorial cycles and compositional units. Even when they had access to codicological exemplars, artists still elected to diverge from precedent. The illustrations in a Mughal manuscript of the *Razmnama*, created around 1598–99, are almost entirely different in content from the illustrations in the imperial copy of the same text produced between 1582 and 1586; where the subject matter did overlap, the later painters invented entirely new designs, even though they would have certainly had access to the older, more lavishly painted imperial codex.[86] The preference for new designs may speak to the atelier members' consciousness that they, like all of Akbar's court, were participants in an epochal transition.

Nevertheless, the workshop's designers did draw selective inspiration from older manuscripts in the imperial collections. The library's collection of Ilkhanid, Timurid, and Shaybanid illustrated manuscripts, for example, served a practical purpose in the production of paintings for texts like the *Tarikh-i Khandan-i Timuriyya*, the *Jamiʿ al-tavarikh*, and the *Tarikh-i alfi*, which situate the Mughals' dynastic past in the Islamic—and specifically the Turco-Mongol—world. Some of the means by which artists adapted and responded to these earlier manuscripts are evident in a late fourteenth- or early fifteenth-century copy of the *Jamiʿ al-tavarikh* from Iran or Central Asia, which members of the Mughal atelier refurbished in the 1590s.[87] Royal artists added entirely new paintings to the manuscript, sometimes incorporating fragments of the earlier illustrations to communicate stylistically the fact of the Mughals' descent, but also temporal distance, from their Mongol forebears.[88]

European prints also provided artistic inspiration for Mughal designers. A painting from a dispersed copy of the *Baburnama*, circa 1593, shows the inhabitants of Osh, in present-day Kyrgyzstan, repelling invaders. The image includes a depiction of a boat near the horizon at the top center whose reduced scale recalls strategies used in European painting to create the illusion of spatial recession (fig. 2.24). The Mughal artist also utilized cool hues like blue and green in the upper register of the composition, bringing to mind sixteenth-century Dutch and Flemish techniques for using atmospheric effects to convey the impression of distance.[89] Numerous such adaptations from European sources figure in the many heavily illustrated manuscripts produced during the final decades of Akbar's reign. By adapting European

FIGURE 2.24. The inhabitants of Osh repelling invaders. From a dispersed manuscript of the *Baburnama*, completed circa 1593, probably Lahore. Opaque watercolor, ink, and gold on paper. Folio 32 × 21 cm. The Walters Art Museum, Baltimore, W.596.25B.

techniques to the illustration of dynastic texts, the royal designers of the atelier participated in the very kind of cosmopolitan accommodation and innovation that Akbar's rule promised to introduce. Mughal artists' use of European iconography and formal strategies accorded with an imperial ideological program to which poets and historiographers likewise contributed.[90]

The taste for inventive images that engaged with the cosmopolitan, messianic currents at Akbar's court is manifested in the paintings produced for de luxe manuscripts as well. These include an illustration of debating philosophers in the *Makhzan al-asrar* (Treasury of secrets) from the first book of the 1595–96 *Khamsa* of Nizami. This illustration, ascribed to Miskina alone, incorporates depictions of two wall paintings that clearly borrow from European prints (fig. 2.25). The precise sources that Miskina consulted have yet to be identified, but at least one of the composition's details, showing a man with an open book kneeling beside an angel, was very likely Christian in theme; the figure recalls Saint Matthew the Evangelist.[91] A nearby painting of naked children, rendered confusingly as either part of or inhabiting the architecture, seems to take its inspiration from a European engraving of a bacchanal. Although the precise meaning of these interventions remains a matter of debate, the inventive incorporation of distinctively European compositions and motifs into the paradigmatic repertoire of images associated with Nizami's *Khamsa* would have fit with the long-standing practice of emulating and recasting an established illustrative tradition. But Miskina's painting does more than recast: it radically reconceives the Persian poet's tale by placing it in a European—or a contemporary Mughal—setting, thus communicating the cosmopolitan standing of the Mughal court, and especially Akbar.

FIGURE 2.25. Debating philosophers, ascribed to Miskina (*kar* or "work"). From a partially dispersed manuscript of the *Khamsa* of Nizami Ganjavi, completed AH 1004 (1595–96), probably Lahore. Opaque watercolor, ink, and gold on paper. British Library, London, Or. 12208, f.23v. Folio 30 × 19.5 cm. Photo: British Library / GRANGER.

THE STUDY OF THE MUGHAL MANUSCRIPT workshop during Akbar's reign has often centered on questions of stylistic origins and, more specifically, who or what brought the ostensibly syncretic illustrative mode of painting into existence. Analysis of the ways that manuscript project teams functioned reveals, however, that the atelier's organization into groups of artists with frequently interchanging members catalyzed the development of a collective artistic style and a collective professional identity centered on collaboration and negotiation, all within a large workshop and a sprawling imperial bureaucracy. Learning to color manuscript illustrations in this collaborative workshop setting, in other words, also involved learning to embody ways of being and identifying as both an artist and a court servant.

The workshop was not only a space of collaboration but also one of hierarchy, where certain skills, abilities, and associations could elevate one painter over another. Miskina had been active at Akbar's court for over a decade when he completed the illustration of the disputing philosophers for the 1595–96 *Khamsa* of Nizami. He is credited as a colorist in the Jaipur *Razmnama* and as both a colorist and a designer in the Jaipur *Ramayana*. Marginal ascriptions in the Patna *Tarikh-i Khandan-i Timuriyya*, the Victoria and Albert *Akbarnama* (in which he is also identified as a portraitist), and the Chester Beatty Library and British Library *Akbarnama* of circa 1602–3 indicate that Miskina worked solely as a designer or operated entirely alone, suggesting that his earlier work on the *Razmnama* and *Ramayana* manuscripts had warranted his advancement to the status of designer.[92] That Miskina was the son of Mahesha, who was already an established member of Akbar's manuscript atelier, probably also helped to advance his career.[93] Miskina further contributed paintings to some of the most celebrated de luxe manuscripts connected with Akbar's patronage: the *Khamsa* of Nizami discussed above, the Bharat Kala Bhavan *Anvar-i Suhayli* (Lights of Canopus), dated 1596; and the Walters Art Museum and Metropolitan Museum of Art *Khamsa* of Amir Khusraw Dihlavi, dated 1597–98. He also appears on Abu'l Fazl's list of the seventeen forerunners of Mughal painting.

Miskina no doubt earned this esteemed position because he was a very good artist. But to excel professionally at the Mughal court, an artist needed also to invent new designs that could advance claims about Akbar's aptitude to rule during an age of unprecedented change and multicultural encounters. Like the scholars, translators, poets, musicians, and other servants at the Mughal court, select manuscript painters came to function as participants in

and producers of the imperial credo of absolute civility. A few even enjoyed membership in Akbar's Tawhid-i Ilahi (Divine Oneness), an exclusive discipleship established in 1582, which modeled itself on the Sufi *shaykh–murid* (master–pupil) relationship.

The emergence of this new kind of painter-bureaucrat-disciple during the 1590s would be inconceivable outside the context of the Mughal manuscript atelier. The enormous staff of painters that had been assembled in the early 1580s demanded considerable administration and regulation—responsibilities that fell to the atelier's *darugha* (superintendent) and the *tahvildar* (cashier) but were also increasingly undertaken by a small corps of artists. Basavana, for example, worked with thirty different artists on the Jaipur *Razmnama*, Jaipur *Ramayana*, and Victoria and Albert *Akbarnama* manuscripts. According to marginal inscriptions, his colleague L'al collaborated with forty-four artists on these three projects. Both artists served mainly as designers and thus assumed instructional, and even supervisory, responsibilities. For painters like Miskina, Basavana, and L'al, the tasks of designing and supervising would have gone hand in hand.

Some of the most active designers and inventors in Akbar's workshop also found employment in Jahangir's much smaller manuscript atelier during the early seventeenth century. Those who had contributed several singly authored paintings for de luxe manuscripts possessed the training and know-how to advance new claims about the Mughal dynasty and, in particular, the new emperor's capacity to rule. Joined by a small group of émigrés from Iran, some of whom Jahangir had recruited to his atelier prior to his accession to the throne in 1605, painters like Dawlat, Manohar, Bishandas, Govardhan, and Abu'l Hasan would become more than members of an artistic workshop collective.[94] Charged with depicting the emperor as well as the realm's grandees, they would become increasingly implicated with the machinations of empire.

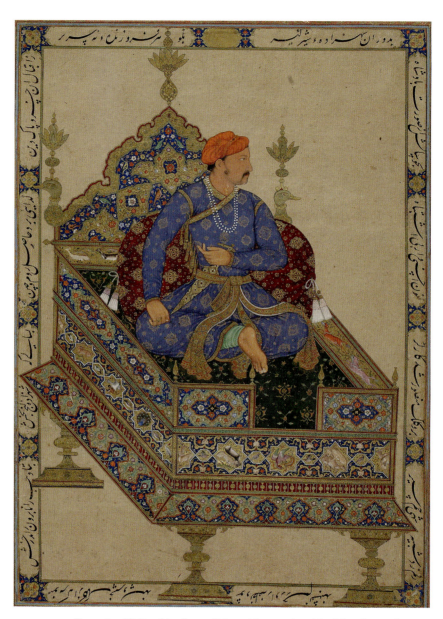

FIGURE 3.1. Portrait of Salim (the future Jahangir), completed by Manohar and Mansur and dated AH 1009 (1600–1601), probably Allahabad. Mounted on a page from the St. Petersburg Album, compiled and margins (here cropped) designed mid-eighteenth century, Iran. Opaque watercolor, ink, and gold on paper. Painting 27.2 × 19.5 cm. Institute of Oriental Manuscripts, Russian Academy of Sciences, St. Petersburg, Ms. E-14, f. 3a.

FORMS OF KNOWLEDGE

The Emperor's Body and the Artist's Brush

3

IN JULY 1600, Emperor Akbar's son Prince Salim (the future Jahangir, r. 1605–27) proclaimed himself *padshah* (emperor) and established a rival court in Allahabad, around three hundred miles southeast of Akbar's imperial residence in Agra. The father and son reconciled some four years later—time enough for the seditious Salim to patronize a number of gardens and tombs and establish a manuscript workshop in his fledgling capital. The latter endeavor was among his chief priorities, if a portrait of him dated AH 1009 (1600–1601 CE)—the inaugural year of his rebellion—is any indication (fig. 3.1). The portrait shows the rebel prince seated cross-legged on a golden platform throne (*takht*). The profusely ornamented throne and bolster—both likely the handiwork of Mansur (fl. 1590–1624), who also worked as an illuminator (*mudhahhib*)—threaten to envelop Salim's diminutive figure, but the rich colors of his lapis-colored stitched coat (*jama*), orange turban, and mint drawstring trousers (*pajama*) draw our eyes back to him. Unlike the throne, which is depicted at an oblique angle, thereby creating a series of dramatic diagonals across the page, Salim's body faces directly forward at the center of the composition. These visual contrasts lend it a composure befitting his regal status. The representation of the prince's face in strict side profile adds to the portrait's overall sense of stasis. (This is one of the earliest Mughal paintings to use what would become in the seventeenth century the preferred portrait orientation.) This effect is contrasted by the many images of animals that decorate the throne, whose dynamism functions as a foil to Salim's static form. Although the painting bears a date of completion, thus anchoring it to a particular moment and place, the artists rendered their subject as if he exceeded the confines of earthly time and space.

Inscribed with the names of the artists Mansur and Manohar (fl. 1580–1620), both of whom had worked at Akbar's court, the painting provides

definitive evidence for the presence of imperial servants at Salim's court in Allahabad.¹ Among these were some of the longest-serving members of Akbar's atelier, including L'al, 'Abd al-Samad, and the much-celebrated calligrapher Mir 'Abdullah, also known by the honorific title Mushkin Qalam (Musky Pen). Manohar himself had long enjoyed imperial patronage; that he was the son of Basavana, one of the most active and celebrated painters at the Mughal court during the sixteenth century, likely played some part in securing his good standing in Akbar's workshop. Yet he and a number of other Mughal servants joined Salim in Allahabad, suggesting that the ties of loyalty that had once bound Akbar to his subjects were fraying. When Salim proclaimed himself *padshah* in 1600, Akbar was nearly fifty-eight years old and had ruled as emperor for over four decades. The exodus of artists from Akbar's court to Salim's, then, might have been motivated by the anticipation of the emperor's death and his son's succession. But the rebel court in Allahabad offered artists other compelling inducements, including Salim himself, whose physique and physiognomy came to serve as the benchmark against which all other bodies would be measured.

The portrait illustrates the integral role of painters and painting in engendering the Mughal preoccupation with Salim's physical form, as do the six rhyming Persian couplets in the surrounding cartouches. The final distich provides the date for the painting's completion in the chronogram "form of the emperor" (*surat-i padshah*; AH 1009/1600–1601).² The inscription employs the term *surat*—which means "portrait," but can also be translated as "image," "form," "figure," or "appearance"—rather than the Persian word *shabih*, which has the narrower definition of "portrait" or "representation."³ *Surat* possessed a mystical valence in Mughal South Asia and the Persianate sphere, where it was glossed as "external form" and often juxtaposed with *ma'ni*, meaning "inner essence."⁴ The date of the inaugural painting of the upstart emperor, the chronogram seems to suggest, is revealed not merely in Salim's portrait but in his form or body, his physical being.

The fourth and fifth distiches underscore the role of Manohar and Mansur as the image makers. According to the couplet, Manohar, "who with a stroke of his princely-approved pen would cause sperm to take shape in the womb, drew a portrait [*shabih*] of a king as glorious as Jamshid," and "Mansur's pen [*kilk*] worked on it [i.e., the painting]."⁵ Jamshid was a legendary Persian king who is said to have owned a divination cup (*jam*) that allowed him to observe the entire universe and provided him with the elixir of immortality. The use of *shabih* in this context underscores the distinction between the portraits made by the artists and Salim's own form, *surat*, which is God's creation.

Despite underscoring this important difference, the epigraphs emphasize the artists' roles as creators in their own right.

The painting is emblematic of a new kind of imperial portraiture that emerged during the latter part of Akbar's reign. It drew heavily from the science of physiognomy (*'ilm al-firasa*), whose central premise is that facial and other external bodily features are an index of inner character.[6] With the approach of the second Islamic millennium, in 1591, the Mughal enthrallment with portraiture, and physiognomy in particular, intensified.[7] This concern is consistent with the claims advanced by ideologues at the court about the Mughal sovereign's status as both the Mujaddid-i Alf-i Thani (Renewer of the Second Millennium), a bringer of paradigmatic change, and the *insan-i kamil* or *al-insan al-kamil* (perfect man), an infallible sovereign who regulated the cosmos. By depicting their patrons as possessing ideal physical forms, the imperial painters provided vital evidence for the Mughal emperors' innate, irrefutable status as cosmic rulers.

By contrast, the many detailed and seemingly naturalistic studies of animals and royal elites that Mughal painters produced during the reigns of Akbar and Jahangir instantiated in paint their royal patrons' penetrating and discerning gazes, thereby establishing the sovereigns' authority as investigators and judges of external signs. In these works, however, the artist depicted human subjects not exactly as they appeared but rather as individualized specimens who nevertheless belong to a specifically Mughal typology. Portraiture regulated the emperors' subjects by subsuming them into an imperial taxonomy. Painted portraits and animal studies thus accrued value as epistemic objects, while their makers—the painters themselves—enjoyed the sometimes precarious position of knowledge producers.

The Emperor's Form

The seeds of the Mughal preoccupation with the imperial visage can be found in illustrated manuscripts of dynastic texts created during the last two decades of Akbar's reign. In the illustrations of two dispersed manuscripts of the *Akbarnama* (Book of Akbar) produced at the Mughal court during this period, Akbar is distinguished not only by his elaborate wardrobe, royal accoutrements, and placement in the compositions but also by his distinctively and consistently rendered facial features (figs. 3.2 and 3.3).[8] The portrayals of his ancestor Timur in fifteenth-century manuscripts of the *Zafarnama* (Book of victory) of Sharaf al-Din Yazdi (d. 1454), produced mainly in Shiraz and Herat, by contrast, identify the ruler by sumptuary details and royal trappings

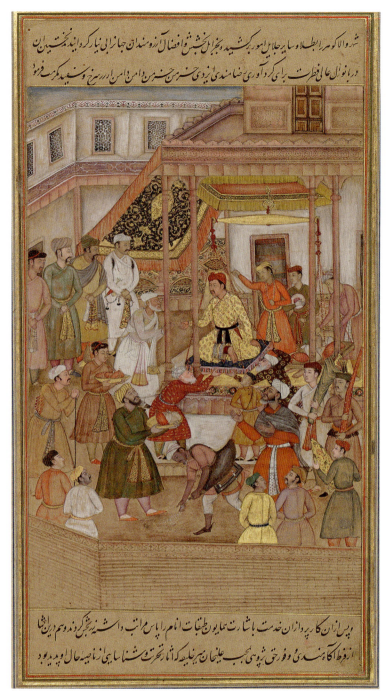

FIGURE 3.2. Akbar being weighed on his lunar birthday in 1577, ascribed in the lower margin (here cropped) to Mukund. Detail of a page from a dispersed manuscript of the *Akbarnama*, completed circa 1602–3, probably Agra. Opaque watercolor, ink, and gold on paper. Folio 43.5 × 26.8 cm; painting 19.6 × 12.4 cm. © The Trustees of the Chester Beatty Library, In 03.245.

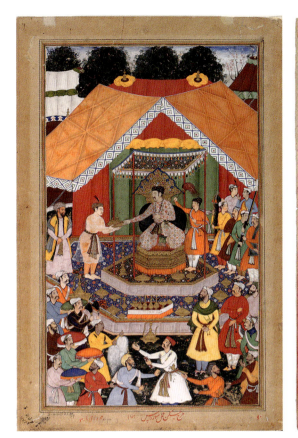
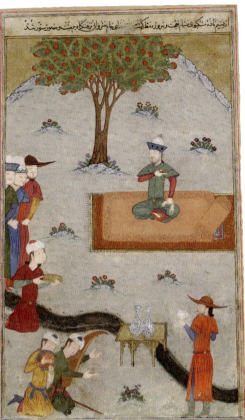

FIGURE 3.3. Akbar receiving his foster brother Azim Khan at Dipalpur in the Punjab in 1571, ascribed to Jagana (*tarh* or "design"), Sur Das (*'amal* or "coloring" or "work"), and Madhava (*chihra-yi nami* or "portraits"). From a fragmentary manuscript of the *Akbarnama*, completed circa 1590–95, probably Lahore. Opaque watercolor, ink, and gold on paper. Painting 32.4 × 18.6 cm. Victoria and Albert Museum, London, IS.2:94–1896.

FIGURE 3.4. Timur celebrating his conquest of Delhi. From a dispersed manuscript of the *Zafarnama* of Sharif al-Din 'Ali Yazdi, completed AH 839 (1436), Shiraz. Opaque watercolor and ink on paper. Folio 28 × 16.8 cm. Harvard Art Museums/Arthur M. Sackler Museum, bequest of Abby Aldrich Rockefeller, Photo © President and Fellows of Harvard College, 1960.198.

(fig. 3.4). The individuating details in the representations of Akbar's face in the *Akbarnama* manuscripts should not come as a surprise, since a small number of the contemporary inscriptions in the margins identify the artists who painted the portraits of important individuals (a task termed variously *chihra-yi kashi*, *chihra-yi gusha'i*, and *chihra-yi nami*)—namely, the emperor as well as members of the royal family (see, e.g., fig. 3.3). But this practice seems to have been far more pervasive than the marginal inscriptions suggest.

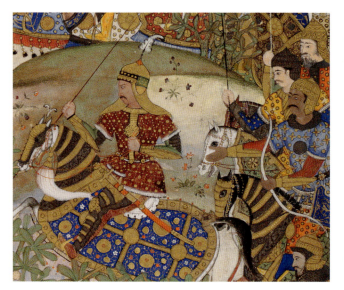

FIGURE 3.5. Detail from fig. 2.18, showing Akbar and his soldiers, in a manuscript of the *Akbarnama*, completed circa 1590–95, probably Lahore. Victoria and Albert Museum, London, IS.2:106–1896.

Examination of the physical evidence reveals that the designers of the Victoria and Albert *Akbarnama* illustrations (c. 1590–95) consistently refined and corrected the colorists' work, although the majority of these interventions go unmentioned in the inscriptions in red ink located in the pages' lower margins. L'al frequently repainted the portraits of the emperor in illustrations that he had designed and that other artists colored. In the right-hand side of the double-page battle scene discussed at length in chapter 2, for example, the faces of the soldiers share a visual kinship with one another: their eyebrows are thick and arched, their irises lie in the center of almond-shaped eyes, and their noses are long and sometimes hooked (see fig. 2.11). The visage of the emperor, depicted on horseback near the center of the composition, is distinguished by its less rounded eye, slender and defined nose, and higher cheekbones (fig. 3.5)—all indications that an artist other than Babu Naqqash, the composition's colorist, completed the portrait. Similar instances of retouching appear in most representations of Akbar in the Victoria and Albert *Akbarnama*. Their frequency and the absence of ascriptions referring to repainting suggest that later interventions by designers were common and even unplanned.[9]

Senior painters' revisions of the depictions of Akbar ensured that he was consistently and recognizably portrayed throughout the manuscript. In its present, fragmentary state, the Victoria and Albert *Akbarnama* manuscript bears ascriptions to sixty-six artists for more than one hundred illustrated pages. Assigning the task of completing the emperor's portrait to a smaller pool of painters would have minimized the number of stylistic idiosyncrasies.[10] But this pronounced attention to the representation of the emperor's face and body is also indicative of the preoccupation with imperial physiognomy and physiognomic analysis that emerged during the final decades of Akbar's reign.

Mughal histories and memoirs of the sixteenth and early seventeenth cen-

turies reflect a deep interest in the study of physiognomy, known in Persian and Arabic as *'ilm al-firasa* (the science of discernment) and *'ilm al-qiyafat al-bashar* (the science of divination by genealogical lines).[11] The *Akbarnama*, for example, privileges the observations and interpretations of corporeal features as tools for prognostication, a key component of physiognomic analysis. According to Abu'l Fazl's text, on opening his eyes for the first time, the newborn Akbar had smiled—a sign that "clever persons of perspicacity [*mutafarrisan*] recognized . . . as an initial portent [*tafa'ul*] of the spring of fortune and a preface to the blossoming of the bud of hopes."[12] The science of physiognomy regards external form (*surat*) and inner essence or meaning (*ma'ni*) as mutually dependent: physical form provides a gauge of internal temperament and character, while inner essence determines the appearance of the exterior self. The smiling face of the prince thus provided proof of the future Emperor Akbar's greatness.

Physiognomic prognostication was widespread in the early modern world. As at the Mughal court, interest in physiognomic analysis spiked in the sixteenth-century Ottoman court, as indicated by the number of surviving royal manuscripts on the topic, such as the *Qiyafatname* (Book of physiognomy) and the *Qiyafat al-insaniyya fi ṣama'il al-'Osmaniye* (Human physiognomy and the disposition of the Ottomans).[13] Physiognomy was popular in Europe as well, thanks in no small part to the publication of the Neapolitan polymath Giambattista della Porta's *De humana physiognomonia* in 1586. As practiced in both Christendom and the Islamic world, the discipline has roots in antiquity: among the earliest documented texts on the subject is a work from around the fourth century BCE, titled *Physiognomy* and attributed to Aristotle, although its authorship remains in dispute.[14]

The Islamicate discipline of *'ilm al-firasa*, however, enjoyed a distinctive historical and philosophical trajectory, starting with a treatise written by the Smyrna scholar Antonius Polemon (c. 88–145) and translated into Arabic in the ninth century CE.[15] Subsequent Arabic and Persian texts on *'ilm al-firasa* included the *Kitab al-firasa* (Book of physiognomy) by Fakhr al-Din al-Razi (d. 1209), which identifies physical features, such as height, eye color, and vocal characteristics, as signs of intrinsic temperament.[16] The *Kitab al-futuhat al-makkiyya* (Book of the Meccan revelations) by Ibn 'Arabi (d. 1240), a foundational mystical text whose main premise is the integral relationship between inner (*batin*) essence and outer (*zahir*) form, contains sections on both divine (*ilayihha*) and natural (*tabi'iyya*) physiognomy, the former being a specialized skill that only those endowed with God's luminescence were able to perform.[17] According to this text, one who possessed the ideal physical

characteristics (and thus model temperament)—what Ibn ʿArabi termed the "perfect man" (*al-insan al-kamil*)—was also deemed to be especially hallowed. First among such figures was of course the Prophet Muhammad, and descriptions of the latter's facial and bodily features, known as *hilya* (external appearance, lit. "adornment"), circulated in a diverse range of texts.

Whether Akbar and Jahangir were familiar with Ibn ʿArabi's discourses on physiognomy or Fakhr al-Din al-Razi's *Kitab al-firasa* is a matter of speculation, but knowledge of physiognomic analysis, from whatever sources, nevertheless figured centrally at the Mughal court, as Abu'l Fazl's description of the infant Akbar attests. Jahangir's memoirs, the *Jahangirnama* (Book of Jahangir), include a brief report on Akbar's physical appearance that speaks similarly to this preoccupation:

> External appearance [*hilya*] of the blessed one: In stature he was of medium height. He had a wheaten complexion and black eyes and eyebrows. His countenance was radiant, and he had the build of a lion, broad of chest with long hands and arms. On his left nostril he had a very beautiful fleshy mole [*khal-i gushtin*], about the size of half a chickpea. Among those who have some expertise in the science of physiognomy [*ʿilm-i qiyafa*] such a mole is considered a sign of great good fortune. His august voice was very loud, and he had a particularly nice way of speaking. In his conduct and manners there was no comparison between him and the people of the world—a divine aura [*farr-i izadi*] was apparent around him.[18]

The structure of this section of the *Jahangirnama*—opening with the description of Akbar's physical traits and closing with the commentary on his "conduct and manners"—makes the correlation between his physical splendor and exemplary moral character seem self-evident and suggests that his success as a ruler was a foregone conclusion. By identifying these virtues in his father, Jahangir simultaneously pointed to his own aptitude as a judge of physiognomy.

Jahangir took this rhetorical strategy one step further by characterizing his description of Akbar's countenance as a *hilya*. This term, hitherto applied almost exclusively to the textual description of the Prophet Muhammad's physical appearance, carried mystical resonances because of its occurrence in the *Hilyat al-awliya' wa tabaqat al-asfiya'* (The adornment of the saints and the ranks of the elite), an influential compendium (*tabaqat*) of biographies of important religious authorities from the first three centuries of Islam.[19] The presumed author, the hadith authority Abu Nuʿaym al-Isfahani (d. 1038), conceived of the work as a Sufi *tabaqat*, although the text also covers such

figures as the Rashidun caliphs and the first six Shi'i imams, in addition to select Sufis of the ninth through the eleventh centuries CE. By identifying the text as a *hilya*, Jahangir very deliberately couched his description of his father's appearance in language usually reserved for the Prophet and other saintly luminaries.

If these resonances were lost on the reader, Jahangir's reference to Akbar's "very beautiful fleshy mole . . . a sign of great good fortune," offered another external sign of his predecessor's sanctity. The Prophet had borne a similar mark, as had a number of other consequential individuals. Known as the *khatam al-nubuwwa* (sign of prophecy), the Prophet's mole was located between his shoulders. The sixth Shi'i imam Ja'far al-Sadiq (d. 745) reportedly had a black mole on his cheek. The mole became so closely associated with distinction that authors from the period use the expression *sahib al-khal* (one with a mole) as shorthand for those who bore it. It is also said that the Mahdi, a savior who will redeem Islam to its true state, restore justice, and usher in a golden age just prior to the end of the world, or Day of Judgment, will bear the same portent on his face. This detail would have had particular relevance to Jahangir's description, given the claims that Akbar and members of his court had made about his identification as the Mujaddid-i Alf-i Thani. Jahangir's description of his father's physical appearance thus sought to substantiate earlier assertions while also underscoring his own corporeal and inner merits by virtue of his descent from Akbar.[20]

A painting of Jahangir and Akbar ascribed to the court artists Abu'l Hasan and Hashim makes similar claims about their shared physique (fig. 3.6).[21] The work is unusual in that it represents Akbar in mise-en-abîme fashion, as a painting within the painting.[22] Jahangir is shown before a textile-draped balcony holding a portrait of this father. Akbar is depicted, in turn, holding a celestial sphere that bears the inscription *arsh-ashyani* (one who nestles in paradise) and thus makes clear that the image is a posthumous representation. Another, indistinct inscription, on the dark green ground situated just below Jahangir's left hand, states that Jahangir is here depicted at the age of thirty—that is, right around the time of his rebellion in Allahabad, in 1599 or 1600, while Akbar was still alive. To complicate matters further, Abu'l Hasan and Hashim likely completed the painting around 1614, some ten years after Akbar's death. The subject matter and confusion of dates suggest that the double portrait may depict Jahangir's nocturnal dream encounter with his deceased father, a portentous event that the emperor recorded in the *Jahangirnama* in the same year.[23]

More than just a projection of fictive harmony between father and son,

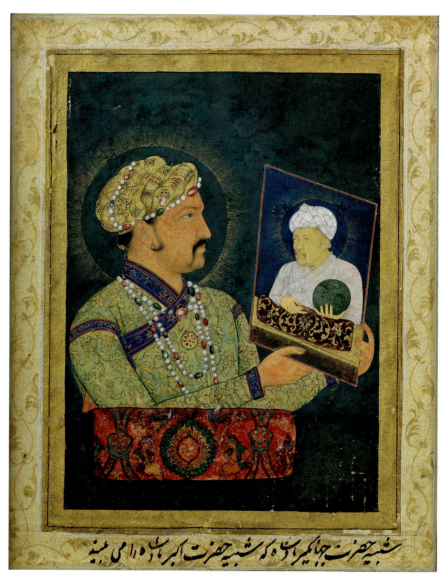

FIGURE 3.6. Jahangir holding a portrait of his father, Akbar, ascribed to Abu'l Hasan and Hashim and completed circa 1615, possibly Ajmer. From a dispersed album page with margins (here cropped) decorated eighteenth century, India. Opaque watercolor, ink, and gold on paper. Painting 18.3 × 11.6 cm. Musée Guimet, Paris, n. 3676B. Photo: Christophel Fine Art.

the painting invites the viewer to compare the two emperors' physiognomies and their respective representational modes. While the inscriptions are temporally disorienting—they place Jahangir in different periods of time, both before and after his father's passing—the portraits are specific to their own moments. Each emperor is depicted in the canonical portrait mode (three-quarter or strict side profile) associated with his reign.[24] The father and son assume the same chest-forward posture, wear wispy mustaches, and exhibit similarities in their facial structure, as if to suggest that in spite of their political (and representational) differences, the two royals were physically—and, therefore, innately—alike, a point reinforced by the twin nimbi around their heads.[25] Akbar's mole, also visible in this double portrait, offers further proof of his sanctified nature and, by association, his son's.

The relationship between external form and inner essence implied and expressed in these imperial portraits accords with Islamic esoteric philosophies and practices.[26] According to such luminaries as Ibn ʿArabi and the Sufi poet Fakhr al-Din Ibrahim ʿIraqi (1213–1289), meaning (*maʿni*), or the hidden (*batin*), is formless. Hence, it is only through physical form (*surat*), or the manifest (*zahir*), that one can perceive meaning.[27] Thus vision ranks among the primary instruments of perception of the divine (*tajalli*).[28] It also figures centrally in the relationship between the Sufi master (*pir*, *shaykh*, or *murshid*) and disciple (*murid*), in which the disciple's direct observation of his guide enabled spiritual progress. Among the Naqshbandis, a Sufi order that enjoyed prominence and popularity across South Asia during the late sixteenth and seventeenth centuries, careful observation was a core element of the disciple's practice.[29] The early sixteenth-century *Rashahat-i ʿayn al-hayat* (Dewdrops from the elixir of life), a Naqshbandi hagiography penned by ʿAli ibn Husayn Kashifi "Safi" (d. 1532–33), for example, describes a spiritual exercise that involves visualizing the body of one's master. The text instructs the disciple to use the physical senses to "absorb" the image of his *pir* and then to draw on the internal senses to implant that image on his heart.[30] The *murid*'s apprehension of form—or *surat*—was a vehicle for inner transformation.[31]

In the double portrait of Jahangir and Akbar, the son, like the *murid*, attains esoteric wisdom through his physical resemblance to his father. Moreover, in modeling the action of beholding a portrait, the painting appeals to the viewer to contemplate the forms of the two emperors and thereby gain awareness of the meaning of God's creations. The joining of the imperial and the mystical here is not at all coincidental. The figure of the charismatic Sufi master, combined with motifs associated with Central Asian dynastic

cults, provided Akbar and his ideologues with the template for a new kind of messianic sovereignty, which they advanced during the final quarter of the sixteenth century.[32] Integral to these developments was the emergence of *sulh-i kull* (total peace), a Mughal ethos of religious tolerance and civility. As the harbinger of a multicultural utopian epoch and the "saint of the age," Akbar embodied sacredness. He was, according to Abu'l Fazl, a "divine talisman" (*ilahi tilism*), who could restore the sick to health better than any expert physician.[33] Beholding his portrait not only offered spiritual edification; it promised to cure the body, too.

The Face of Discipleship

These political and ideological shifts were codified by the formation in 1582 of a practice of discipleship, known as the Tawhid-i Ilahi (Divine Oneness), centered on the body of the emperor.[34] This "devotional cult" was modeled directly on the Sufi *silsila* (lineage, lit. "chain"), though it also drew on the solar rituals and motifs of sacred kingship in Zoroastrian and Hindu traditions.[35] According to Abu'l Fazl, who counted himself among Emperor Akbar's disciples, discipleship involved first taking an oath of loyalty and then prostrating before the emperor, a practice that recalls the Chishti *murid*'s habit of ritually prostrating before his *pir* as a demonstration of deference.[36] Akbar then presented to the initiate a seal or signet (*shast*) engraved (*naqsh karda-hand*) with the proclamation *Allahu Akbar* (God is the greatest). Disciples were advised to greet each another with this address and to say in response *Jalla Jalaluhu* (may His glory be sanctified), in order, Abu'l Fazl explains, to "keep the Divine [*ilahi*] in fresh, lively, and grateful remembrance."[37] That both phrases also contained the names of the emperor, Jalal al-Din Akbar, lent these exchanges a powerful, if also potentially heretical, double meaning.[38] Abu'l Fazl's characterization of *Allahu Akbar* as the "greatest of names" (*ism-i a'zam*) and the "holiest of talismans" (*tilism-i aqdas*) applied equally well to the Mughal *padshah*.[39] Indeed, Abu'l Fazl even casts Akbar as the divine talisman (*ilahi tilism*), whose body and breath can cure others' ills.[40]

According to the *Muntakhab al-tavarikh* (Selection of chronicles), the surreptitious history of Akbar's reign written by the courtier and scholar 'Abd al-Qadir Bada'uni (1540–1605), the inductees into the discipleship also received the emperor's portrait (*shabih*), which they wore enclosed in jeweled cases on their turbans.[41] Bada'uni explains that the portrait took the "place of a tree" (*ba-ja shajara*), an allusion to the alphabetic genealogical lineages that Sufi initiates recite, memorize, and copy as a means of inserting themselves

into their *silsila*'s long chain of descent. By equating the emperor's portrait to the *shajara*, Bada'uni implies that the image functioned as a metonym to connect the master and the disciple across time and space. The Mughal disciple's placement of the emperor's portrait on his turban further echoes the Sufi rite of succession known as *dastar-bandi* (turban tying), in which the *pir* ties his intended successor's turban as a public demonstration of his investment as heir. Through the invocation of Sufi customs and rituals like the *shajara* and the *dastar-bandi*, Akbar's imperial discipleship functioned as a mystical cult with the emperor rather than a Sufi *pir* as its self-appointed spiritual leader.

Whether the *shast*s that Akbar presented to his devotees were stamped with the salutation *Allahu Akbar*, as Abu'l Fazl claimed, or with the imperial portrait (*shabih*), as in Bada'uni's account—or possibly both—is unknown, since no example is known to be extant. A portrait of Akbar stamped on a gold coin that was issued after his death does survive, however (fig. 3.7). This object, which was likely intended as a presentation piece to be worn rather than as currency, was issued in AH 1014 (1605), "year 1 of the accession" (*sana 1 julus*), at the start of Jahangir's tenure as emperor, and offers a clear indication of the new emperor's intent to sustain the cult of discipleship that his father had inaugurated.[42] In the coin portrait, Akbar is depicted in three-quarter profile, as was the custom during his lifetime. He is shown seated before a balcony, a portrait type that clearly references a ritual practice initiated during Akbar's reign that involved the Mughal emperor presenting his visage to his subjects from an elevated gallery, known as a *jharoka-yi darshan* (viewing balcony).[43] This metal image is a reminder that the Mughal emperor's face is not only exemplary but worthy of veneration. The representation of the sun on the coin's reverse probably alludes to the divine aura (*farr-i izadi*) emanating, according to both Abu'l Fazl's and Jahangir's accounts, from the Mughal emperors' faces.[44] To the holder of the coin, the golden images of the sun and the emperor might seem to have been formed of the very same substance. Although the issuing of the coin might rightly be perceived as a son's memorial tribute to his father, it served equally to promote Jahangir's own station. For those in the know, the appearance of the epigraph *Allahu Akbar*, located on the roundel's obverse alongside the deceased ruler's visage, could also bring to mind Akbar's imperial discipleship, especially the *shast* that bore the same proclamation.

In AH 1020 (1611), six years after the issue of Akbar's posthumous portrait coin, the imperial mints issued the first gold coins bearing the image of Jahangir.[45] Four variations of this coin type were struck, each showing Jahangir

resting his left hand on a balcony; two show the emperor holding in his right hand a cup of wine or a piece of fruit. The *jharoka-yi darshan* setting and the portrait bust format drew a direct connection with the coin bearing Akbar's portrait in order to illuminate the corporeal, and thus metaphysical, links that affirmed their membership in the same imperial *silsila* (figs. 3.7 and 3.8). Other details, such as the distinctive grid pattern on the parapet on all the coins, point to the possibility that the artist who designed the 1605 coin may have worked on, or been involved with, the creation of the 1611 coins.

The differences between the earlier and later imperial portrait coins are nevertheless telling. In the place of *Allahu Akbar*, Jahangir's portrait coins bear an inscription that reads "A likeness [*shabih*] of Jahangir Shah, [son of] Akbar." They also dispense with the three-quarter profile, which came to be associated with the portraiture of Akbar's reign, in favor of a strict side profile. Perhaps most notably, the Jahangir coins show a halo around the emperor's head. The latter change played on Jahangir's *laqab*, Nur al-Din (Light of Faith). It also spoke to the increasingly acute imperial fixation with pre-Islamic Persian and Illuminationist (*ishraqi*) notions about the light-filled aura signifying divine kingship. As if seeking to drive home that point, the engraver of the 1611 roundel replaced the sun on the reverse of the 1605 Akbar portrait coin with an image of the sun placed behind a rearing lion (fig. 3.8). The *shir-u-khurshid* (lion and sun) had long served as a monarchical symbol in Iran, Anatolia, and Central Asia, both before and after the advent of Islam. Along with the image of the wine cup—a motif that carried associations with the *jam-i jam*, the vessel of divination with which the ancient Persian kings, most famously Jamshid, were said to have made prognostications—the *shir-u-khurshid* would have resonated as a fitting symbol for the spiritual master of a coterie of imperial disciples.

A related group of gold portrait coins produced in Ajmer several years later, in AH 1023 (1614–15), made further claims about Jahangir's physical majesty. In these portraits, Jahangir is seated cross-legged with wine cup in hand, a composition that clearly draws from painted portraits of the emperor (fig. 3.9).[46] The Persian *nasta'liq* inscriptions that accompany the ruler's portrait explain that the image (*tasvir*)—or form—of the likeness (*shabih*) of the esteemed (*hazrat*) Jahangir Shah on the gold coin (*sikka-yi zar*) was created not by a particular artist but by destiny (*qaza*), underscoring the point that the emperors' physiognomies were the creations of the Divine. The inscription on the coin's reverse, which reads "The words *Jahangir* and *Allahu Akbar* have been equal in value since pre-Eternity [*ruz-i azal*, the period before the creation]," made the additional point that the father and son coexisted,

FIGURE 3.7. Obverse (left) and reverse (right) of a gold coin bearing a portrait of Akbar, dated AH 1014 (1605). British Museum, London, 1930,0607.1

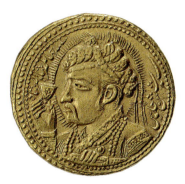

FIGURE 3.8. Obverse (left) and reverse (right) of a gold coin bearing a portrait of Jahangir, dated AH 1020 (1611). British Museum, London, OR.7432.

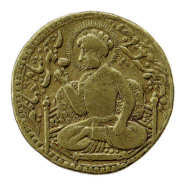

FIGURE 3.9. Obverse (left) and reverse (right) of a gold coin bearing a portrait of Jahangir, dated AH 1023 (1614). Diameter 21 mm. British Museum, London, OR.7180.

both corporeally and cosmically. The painting by Abu'l Hasan and Hashim of Jahangir holding his father's portrait, completed around the same time as these gold portrait coins, advanced a very similar argument.

The inclusion of a wine cup on Jahangir's portrait coins, an accoutrement reserved mainly for more familiar settings, was likely meant to evoke the private audiences that were held daily at the Mughal court. A contemporary painting showing Jahangir receiving his son Prince Parviz—with wine cups in evidence—conveys the intimacy of these encounters (fig. 3.10). Coins referencing these settings may have represented an attempt to bridge the gulf that separated the emperor from disciples who resided far from the imperial court. Similar to Akbar's use of the *shast* "in place of the *shajara*," or Sufi genealogical tree, Jahangir's bestowal of portrait coins far and wide created a physical chain—a series of virtual private audiences—that spanned the Mughal empire.

The Mughal emperor's presentation of the gold portrait coins cemented the ties of loyalty between himself and his followers.[47] In this way, it echoed the ceremonial presentation of *khila'* (robes of honor), a practice widespread across the Islamic world by which rulers, including the Mughals, sought to transmit their charisma and thereby forge an unequal social bond—one centered on obligatory reciprocity—with the recipient.[48] The gifting of the coins also recalls the public performance of *tula-dana*, the ritual weighing of the emperor and the royal princes against gold on their lunar and solar birthdays, which equated the imperial body with the precious metal.[49] During these weighing ceremonies, the imperial body *became* gold. Both the metal and the emperors owed their existence to the sun: the Mughals' progenitor, Alan Goa, was said to have been impregnated by a shaft of light, while, according to a line attributed by Abu'l Fazl to his brother, the court poet Fayzi (1547–1595), "The mines get their gold from [the sun's] fostering glance [*nazar-i tarbiyat*]."[50] The portrait roundels therefore served as not just symbolic but also material substitutes for Akbar and Jahangir.

The very technology of minting—the striking of a gold blank with an engraved image—established a close physical relationship between coin and emperor. That some of the extant portrait coins evidence significant abrasion, seemingly from rubbing, suggests that their recipients venerated them as relics—that is, as objects that had come into direct contact with, and therefore possessed some of the essence of, their archetype, Jahangir (fig. 3.11).[51] The belief that the portrait coin possessed protective power is also suggested by the later historian Muhammad Hashim Khafi Khan (c. 1663–c. 1731), who mentions in his early eighteenth-century *Muntakhab al-lubab* (Selection of

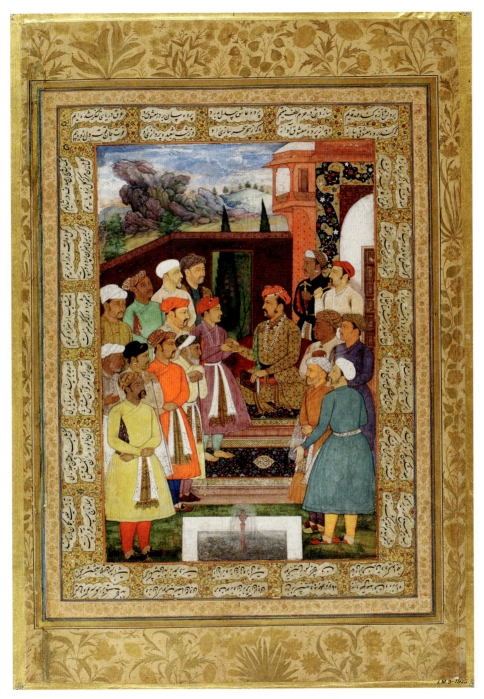

FIGURE 3.10. Jahangir seated cross-legged with a cup of wine while receiving Prince Parviz and giving a private audience, ascribed to Manohar and completed circa 1610–15, possibly Agra or Ajmer. Mounted on a page from the divided Minto Album, with decorated margins added circa 1620–40. Opaque watercolor, ink, and gold on paper. Folio 39 × 26.4 cm; painting 23.7 × 15.6 cm. Victoria and Albert Museum, London, IM.9–1925.

essential matters) Jahangir's directive that the portrait coin should be worn by its recipients "on the sash of the turban or on the breast as a life-preserving amulet [ḥirz-i jan]."[52] Serving as an official to Emperor Aurangzeb (r. 1658–1707) and his successors, Khafi Khan drew on the testimonies of royal insiders to compose his history of the Mughal dynasty, beginning with Timur. His description of the portrait coin illustrates the central importance of its talismanic function in collective memory, even a century after the fact.

The long-standing salience of the imperial portrait coins may also be attributed to their resemblance to legal tender. Though they are not, technically speaking, currency, they nevertheless *look* like money, sharing roughly the same dimensions and produced with the same technology as the Mughal *mohur*s, *rupee*s, *dam*s, and *paisa*s that circulated across the empire.[53] The roundels' associations with the empire's robust, cash-based economy thus marked the wearers of these devices as participants in global political systems of exchange. The Mughal revenue and pay systems and the imperial mandate to expand trade and commerce required a significant investment—figuratively and literally—in the production, collection, and circulation of money. Coins were minted in abundance—John F. Richards estimated that "the number of silver rupees in existence must have run into tens of millions"—and cash flowed freely across the empire.[54] Gold played a particularly important role. Much of the gold that entered Mughal South Asia through official channels during the seventeenth century was converted to royal currency, Mughal specie being the only legal tender that was widely accepted in the empire. But lacking stores of gold, silver, and copper, imperial moneyers in some regions obtained them through commercial transactions with European trading companies. Both imperial coins and the gold portrait roundels were emblematic of the empire's locally entrenched yet globally connected character at the beginning of the seventeenth century.

The critical role of the imperial portrait coins on the world stage is illustrated by Jahangir's presentation of one of these objects, encased in gold and accompanied by a chain from which it could hang, to Sir Thomas Roe, the English ambassador to the court between 1615 and 1619.[55] According to 'Abd al-Sattar ibn Qasim Lahori's *Majalis-i Jahangiri* (Conversations with Jahangir) of 1608–11, the imperial discipleship included immigrants, foreign diplomats, Jews, Jesuit

FIGURE 3.11. Gold coin (obverse) bearing portrait of Jahangir and adapted for use on a chain, dated AH 1020 (1611). British Museum, London, Or. 7280.

FIGURE 3.12. Obverse (left) and reverse (right) of a silver coronation medallion bearing the portrait of James I (obverse) and a rampant lion (reverse). Dated 1603. Diameter: 28.6 mm. British Museum, London, G3,EM.316.

priests, Hindu priests, Muslim scholars, and others.[56] Since Roe seems not to have been among them, however, it seems that presentation of the portrait coins was not restricted to disciples. The increasing identification of the imperial likeness as proof of Jahangir's corporeal singularity likely provided the impetus for its wider circulation.

The imperial portrait coin would have struck the European visitor to the Mughal court as a familiar, and thus uncanny, object. European royalty and elites, after all, had been distributing stamped, cast, and painted medallions bearing their own portraits since the fifteenth century.[57] One example, a 1603 silver coronation medal adorned with the likeness of the Stuart king James I of England (fig. 3.12), bears a blazon of a rampant lion on its reverse—a clear, if unexplained, parallel to the lion that appears on Jahangir's slightly later coinage. James is also reported to have gifted portrait medals to foreign ambassadors, along with chains on which to suspend them.[58] At least one similarly sized portrait, though rendered in paint rather than in cast or stamped metal, was presented to Jahangir by Roe himself.[59] The striking similarity between the two miniature portrait traditions speaks to the degree to which Mughals and Europeans had become constellations within overlapping orbits.[60] Portrait coins, because of their portability, served as tools of communication and competition in the early modern world. Moreover, by fashioning visually and functionally similar objects—creating what Sanjay Subrahmanyam has likened to "a roomful of mirrors"—agents in Mughal South Asia and Stuart England "produced commensurability" and thereby facilitated the translation of each party's interests.[61]

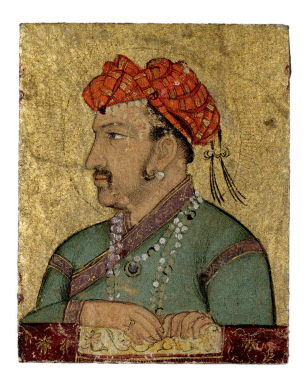

FIGURE 3.13. Portrait of Jahangir, completed early seventeenth century, possibly Agra. Opaque watercolor and gold on paper. Painting 4.8 × 3.2 cm. Cleveland Museum of Art, Purchase from the J. H. Wade Fund 1944.496.

The Painter's Apperception

The models for the portrait coins and all other representations of the imperial likeness almost certainly came from the painters employed in the imperial *tasvir-khana* (painting workshop, lit. "image house"). One example, probably created after 1614—when the emperor began to wear pearl earrings as an indication of his affiliation with the Chishti Sufi *silsila* (fig. 3.13)—measures 4.8 × 3.2 cm, but the dimensions of the emperor's face are roughly the same as those on the portrait coins. Another depiction of Jahangir distributing alms at the *dargah* (shrine) of Muʻin al-Din Chishti in Ajmer (fig. 3.14) closely matches the proportions of the images from the gold coins. This illustration, which a royal artist most likely made around the early 1620s for a now-dispersed and possibly never-completed manuscript of the *Jahangirnama*, also includes images of courtiers wearing gold portrait coins around their necks and on their headgear. One figure at the right of the image, dressed in a green *jama* and standing close to the emperor, is depicted wearing a painted portrait pendant instead.

Because they provided the line-based design or template (*tarh*) for the emperor's image—whether materialized in opaque watercolor or stamped

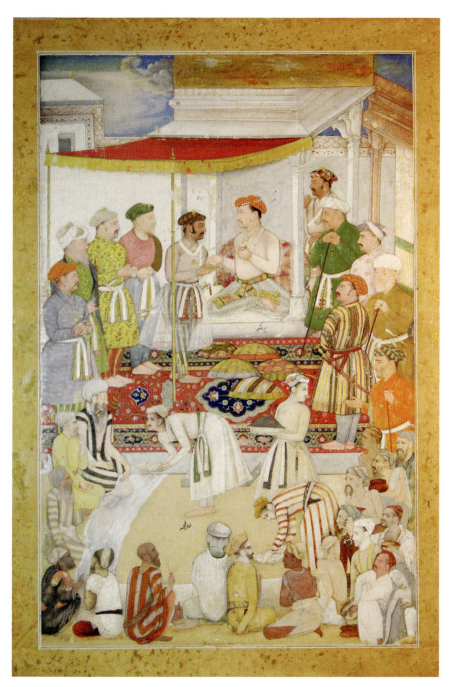

FIGURE 3.14. Jahangir distributing alms at the *dargah* (shrine) of Muʻin al-Din Chishti in Ajmer, ascribed to Fatehchand (*ʻamal* or "coloring" or "work"). From a dispersed and possibly unfinished manuscript of the *Jahangirnama*, assembled early 1620s, northern India. Opaque watercolor, ink, and gold on paper. Painting 31 × 20 cm. Raza Library, Rampur, Album 1, f. 4a. Photograph by author.

in gold—artists in the *tasvir-khana* assumed a principal role in the analysis, codification, and sanctification of the imperial form.[62] A Mughal genealogical chart, today housed in the Aga Khan Museum, Toronto, shows how royal painters used pictorial representation to make claims about the dynastic likeness and the place of Jahangir's portrait within it (fig. 3.15). Mounted as an album page, complete with three illuminated headpieces (*sarlawh*s), the tree bears portraits of Jahangir along with his sons, grandsons, and, below them, his ancestor Miran Shah (d. 1408), son of Timur and great-great-grandfather of Babur (the Mughal dynasty's founder, r. 1526–30), and Miran Shah's issue.[63] Set in gilded roundels, the royal portraits, especially Jahangir's, resemble the gold and painted portrait roundels discussed above. The chart's overall format draws from fifteenth- and sixteenth-century Turco-Mongol royal genealogical trees, in both codex and scroll formats.[64] Like these, the Mughal genealogical tree depicts the figures' affinities through the shared poses, postures, gestures, costumes, facial hair, and accoutrements. Both Jahangir and Miran Shah are shown holding falcons, for example. But unlike the Turco-Mongol precedents, the Mughal chart portrays the emperor and his sons as both individuated and characteristic. They share an overall physiognomic—and by implication inner—profile, but each is also granted his own distinctive physical appearance.

The Toronto genealogical tree provides additional visual distinctions by juxtaposing two paintings that were executed at different times and in different idioms, thus establishing the integral relationship between historical time and painting style. The upper panel, showing Jahangir with his sons and grandsons, was likely completed around the early 1620s; the lower panel, showing Miran Shah and his issue, probably dates to a decade or two earlier. These differences serve as intentional marks of temporal distance, distinction, and exclusion.[65] The uses of the fully saturated versus less saturated colors, the strict side versus three-quarter profile portraits, and the distinctive versus generalized depictions of facial features communicate the temporal separation of the two groups, despite their genetic linkage. The Timurid lineage is rendered in an archaizing style that recalls Timurid book painting of the fifteenth century.[66] It is curious, too, that Miran Shah's portrait is positioned below Jahangir's, as if Miran Shah were Jahangir's descendant. It is a portrait of Prince Khurram (the future Shah Jahan, r. 1627–58) that should appear where Miran Shah's is placed, but it was probably removed or left incomplete when Khurram rebelled against his father in 1623. Yet the physical arrangement of the page, with Jahangir and his descendants at the top and Miran

FIGURE 3.15. Mughal genealogical tree showing Jahangir with his progeny and ancestors, signed by Dhanraj and completed circa 1605–27, northern India, possibly Agra. Opaque watercolor, ink, and gold on paper. Folio 36.2 × 24.2 cm. © Aga Khan Museum, Toronto, AKM 151.

Shah and his at the bottom, could not have been an afterthought. Rather it echoes the argument about Jahangir's matchless physiognomy that is asserted by the contrasting painting styles in the two panels. In juxtaposing the different painting idioms, the genealogical tree advances the case for Jahangir's status as the supreme culmination of the Timurid lineage.[67]

The idea that a portrait's painting style possessed historical truth value is suggested by an entry in Jahangir's own memoirs, the *Jahangirnama*, in which the emperor questions the authenticity of an alleged early fifteenth-century European portrait of Timur. On the sixth of Dhu'l Hijja, AH 1017 (3 March 1609), Muqarrab Khan "sent a picture [*surat*] the Europeans [*firangan*] believe to be a likeness [*surat-i shabih*] of His Majesty the Sahib-Qiran [Timur]."[68] Jahangir explains that when the first Ottoman sultan, Bayezid I (r. 1389–1402), "was captured by [Timur's] victorious forces, a Christian who was governor of Istanbul at the time sent an emissary with rarities and gifts to show his obedience and servitude, and an artist who had been sent along with the emissary drew a picture of His Majesty [i.e., Timur]. If this claim has any basis in fact, there will never be a better gift for me." Ultimately, however, the emperor remained skeptical of the portrait's authenticity "since [Timur's] descendants bear no resemblance to the features in the picture."[69] This passage speaks to the importance of the resemblance between portrait and person in establishing genealogical connections. Since the emperor does not recognize a resemblance, he doubts the genuineness of the image. And yet, if an authentic portrait is one that bears a resemblance to its subject (and the subject's descendants), how could Timurid-era portraits of Timur, which always eschew mimetic representation, ever be judged to be physiognomically accurate? Rather, as the London tree shows, genealogy and painting style were integrally bound. A true portrait of Timur had to look Timurid.[70]

Firsthand witness statements offered another means of judging the trustworthiness of portraiture. The *Khatirat-i Mutribi Samarqandi* (Memoirs of Mutribi Samarqandi), which contains records of twenty-four conversations between the poet-scholar Sultan Muhammad Mutribi Samarqandi (1558–1630/31) and Jahangir at the Mughal court in Lahore in late 1626 and early 1627, provides an example.[71] Mutribi recounts that Jahangir handed him a depiction of the Shaybanid *khan*s of Samarqand, 'Abdullah Khan Uzbek (1533–1598) and his son 'Abd al-Mu'min Khan (d. 1598/99), and asked: "Are these good likenesses [*shabih*]. . . or do you have some comments to make? If you do, then tell me."[72] Jahangir had not met either in person, but Mutribi had. The conversation continued:

"The portrait [*surat*] of 'Abdullah Khan is too fleshy, and his chin was not as straight as it's shown here," I replied. "In fact he was rather thin, and he had a crooked chin."

"Was it crooked on the right side, or the left?" he asked.

"On the left," I said.

A painter [*musavvir*] was called out to correct the portrait, and whatever I said he was ordered to make the appropriate changes. Then the Emperor asked, "What about the portrait [*shabih*] of 'Abd al-Mu'min Khan?"

"He's painted very greenish here," I said. "He wasn't like that; in fact he was more white than green, and he wore his turban a little more to the front, as neatly as possible."

"Take off your turban," he said, "and show me how he did it."

I took off my turban and showed him. The Emperor said to the painter [*musavvir*], "Paint it this way."[73]

Art historians have interpreted this passage as evidence for Jahangir's interest in the "accuracy of visual description."[74] But Mutribi's record of this exchange also speaks to the status of the image as a historically contingent object, one that could be used for "empirical verification."[75] That is to say, a portrait's authentication required the testimony of someone who had seen the subject at first hand. One imagines that Jahangir would not have been satisfied had Mutribi said he had *heard* 'Abdullah Khan and his son looked this way or that. It was important that he had seen the two Uzbek rulers with his own eyes.

Like Mutribi, Mughal painters were tasked to provide visual testimony. Two portraits of Jahangir's rivals, the rulers Ibrahim 'Adil Shah II of Bijapur (r. 1580–1627) and Muhammad Qutb Shah of Golconda (r. 1611–25), both painted by Hashim, attest to this practice (figs. 3.16 and 3.17).[76] The emperor personally inscribed both portraits with the statement *shabih-i khub* (a good likeness), even though he had never met either man in person.[77] It was the painter, Hashim, who filled the role of the expert witness. Before Hashim entered Jahangir's employ around 1620, he had worked as a painter at the royal courts of the Deccan and in that capacity would have seen the two rulers or could have consulted those who had.

As painted portraits gained value as historically and physically contingent objects of analysis, painting—and painters—came to operate in increasingly diplomatic capacities. In 1613, for example, Jahangir sent Bishandas, "who was without equal in drawing likenesses [*shabih kashi*]," with the ambassador Khan 'Alam to the court of Shah 'Abbas I (r. 1587–1629) in Isfahan in order "to

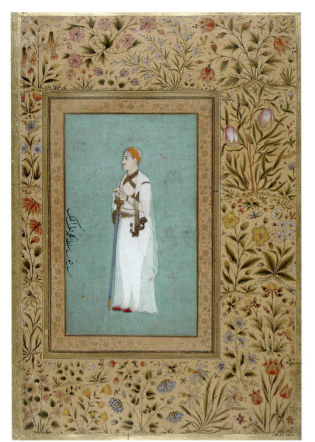 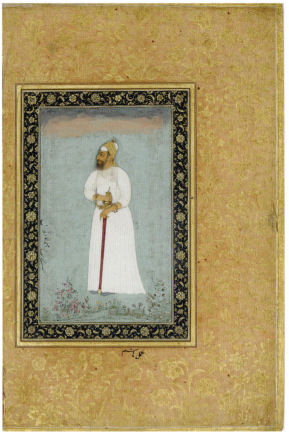

FIGURE 3.16. *left* Portrait of Muhammad Qutb Shah of Golconda, ascribed to Hashim and completed circa 1623–25, northern India. Mounted on a page from the divided Minto Album, with decorated margins added circa 1625–30. Opaque watercolor, ink, and gold on paper. Folio 38.6 × 26.5 cm; painting 19.7 × 11.7 cm. Victoria and Albert Museum, London, I.M.22–1925.

FIGURE 3.17. *right* Portrait of Ibrahim 'Adil Shah II of Bijapur, ascribed in the lower margin to Hashim and completed circa 1620, northern India. Mounted on a page from the dispersed Shah Jahan Album, with decorated margins added circa 1625–30. Opaque watercolor, ink, and gold on paper. Folio 38.9 × 25.4 cm. The Metropolitan Museum of Art, New York City. Purchase, Rogers Fund and the Kevorkian Foundation Gift 1955.121.10.33v.

take the likeness [*shabih*] of the shah and his chief statesmen."[78] The portrait and the artist would serve as Jahangir's surrogates on the mission.[79] On his return, Bishandas brought the portraits to the emperor for inspection. To gauge the accuracy of the shah's portrait, Jahangir again relied on the testimony of those who had seen the subject in the flesh: he showed it to a number of Safavid servants in residence at the Mughal court, and "everyone . . . said that

he had drawn him very well." Jahangir concluded that Bishandas "had drawn the portrait of my brother the shah in particular very, very well [*bisyar khub kashida bud*]."[80] Through its physical connection with the painting's subject, or with an individual who had seen the subject, the painted portrait gained currency as a truth-bearing, epistemic object.

The Mughal court portraitist could draw not only on his own and others' visual memories but also on the *tasvir-khana*'s archive of images. Bishandas's studies of Shah 'Abbas, for example, served as the basis for Abu'l Hasan's representations in the famous double portrait of Jahangir embracing his Safavid rival (see fig. 1.1). Two Mughal portraits of Zayn Khan Koka (d. 1601), Akbar's foster brother, meanwhile, echo one another. One is a painting now in the Victoria and Albert Museum and the second a painting in the British Library, to which a depiction of pigeons and a dovecote was added in the seventeenth century (figs. 3.18 and 3.19). In these late sixteenth-century portraits, the royal painters drew from a catalogue of compositional units that could have been part of a workshop collection, which artists could trace using transparent paper or animal skin and charcoal powder.[81] Alternatively, the artists could have drawn on their memories of these works. Given the close formalistic similarities between the two portraits, it seems likely that one of these is a copy of the other. An early seventeenth-century portrait of the same subject, this one associated with the workshop of the Mughal vizier 'Abd al-Rahim Khan-i Khanan (1556–1627) in Burhanpur, differs in several important respects from the earlier portraits, including the rendition of Zayn Khan Koka's *jama* as red rather than white and the placement of the subject's folded hands at his chest rather than his waist (fig. 3.20). These adjustments suggest that this later study may have been executed from the recollection rather than the tracing or direct examination of an earlier work.[82]

Whether informed by his own apprehension of the subject or by another artist's rendition, the Mughal painter possessed the unique mechanical skills, visual memory, and materials to produce portraits that were ascribed epistemic value. The juxtaposition of dynastic portraits could articulate important genealogical connections while also attesting to the historical specificity of painting and painting styles. Portraits acquired a truth value because they attested to a physical proximity between the artist (or, as in the case of Mutribi, of the royal informant) and the subject. It was only by establishing the reliability of a likeness's source that the image in question could be deemed fit for physiognomic analysis. Whatever the portrait's function, the royal *tasvir-khana* was the basis of its production, from which imperial painters crafted the *tarh* for portraits that would be rendered in paint and later in metal and other media.

FIGURE 3.18. *left* Portrait of Zayn Khan Koka, completed late sixteenth century, Lahore or Agra. Opaque watercolor, ink, and gold on paper. Painting 10 × 6.6 cm. Victoria and Albert Museum, London, IS.91–1965.

FIGURE 3.19. *right* Portrait of Zayn Khan Koka, completed circa 1595, probably Lahore. Detail from a later assembled and now dispersed album. British Library, London, Johnson Album 18, 18. Opaque watercolor, ink, and gold on paper. Painting 10.2 × 6.9 cm. Photo: British Library / GRANGER.

FIGURE 3.20. Portrait of Zayn Khan Koka, completed early seventeenth century, northern India. Detail of a page from the Laud *Ragamala* Album. Opaque watercolor, ink, and gold on paper. Painting 9.4 × 6 cm. Oxford University, Bodleian Libraries, MS. Laud Or. 149, f. 18a.

Type and Typology

Just as Mughal portraiture shed light on the natures of those who were absent, geographically distant, or deceased, it also provided insight into the condition and character of the emperor's physically present and living subjects. The goal of this enterprise was not, however, to elucidate the unique qualities of every Mughal royal and courtier. Court portraits served instead to mold individual subjects into a canon of types. This idea runs counter to the individuated, mimetic character of late sixteenth- and early seventeenth-century Mughal portraiture, a topic that has long been a focus of art-historical scholarship.[83] Part of the problem is that art history has long correlated naturalistic portraiture with the rise of the unique, autonomous individual,

a product of the modern era.⁸⁴ Critiquing this position, Hans Belting argues that an image's degree of likeness is irrelevant for the premodern period; the more pertinent question, he suggests, is a "likeness to what?" That an image bears a resemblance to a body tells us only so much, for bodies are themselves socially constituted.⁸⁵ Indeed, in Mughal portraiture, the likeness—however mimetic it may seem—was more a representation of an ideal than of a discrete, sui generis specimen. The science of physiognomy, after all, sought not to uncover the singular qualities of every individual but rather to correlate each person's particular combination of biographical and physical characteristics—location and time of birth, facial appearance, quality of voice, and so on—with a limited set of characteristics and dispositions.⁸⁶ While Mughal portraiture sought to express a subject's inner essence, it did so through an analogical process that fitted each subject into an established type.⁸⁷

The protocols of conduct for Mughal court subjects, which drew explicit connections between decorum, bodily practices, and inner character, represent yet another effort to mold the individual to accord with an archetype. Male behavior and corporeal habits were dictated by conventions centered on the concept of the "perfect man." These rules, drawn from both Islamicate and Indic traditions, emphasized corporeal self-discipline, improvement of one's innate disposition (*akhlaq*), and spiritual devotion. These codes of comportment fostered loyalty and deference among the Mughal emperor's subjects, but they also equipped courtiers with the ethical and bodily knowledge that they needed in order to foster professional ties.⁸⁸ Male members of the Mughal administration affiliated themselves with rigidly regulated hierarchical cohorts of officers. In the context of the royal audience (*darbar*), they organized themselves according to personal (*zat*) and troop (*suvar*) ranks and conformed to an imperial canon of gestures and poses.⁸⁹ The arrangement of noble bodies in clusters, columns, and rows in effect materialized the Mughal imperium's internal hierarchy and rule of order.

The strict side-profile portrait, which largely replaced the three-quarter profile at the beginning of the seventeenth century, reinforced this standardizing program by distilling physiognomic and ethnic differences into a single outline. Ebba Koch argues that the side-profile portrait, which sought to minimize both natural and representational aberrations, likely drew its inspiration from the Platonic preference for ideal forms. It thus portrayed courtly subjects as components of a larger, homogeneous unit.⁹⁰ But the portraitist's particular treatment of the face also allied the subject with Mughal behavioral and bodily ideals. For example, the portraits of the court servants Kishan Das Tunwar and Raisal Darbari in the so-called Salim Album, a dispersed manuscript

of late-sixteenth and early seventeenth-century paintings probably compiled for Jahangir around the time of his accession to the throne in 1605, depict the men with wispy mustaches; beards, if present, are groomed and sparse (figs. 3.21 and 3.22).[91] The clean-shaven look came to be linked with increased masculinity and was thus a subversion of Islamic custom, which associated beards with piety.[92] The sparse facial hair also visually linked the servant with the Mughal sovereign. Akbar had ceased to wear a beard and sported shorter hair after experiencing a spiritual epiphany during a hunt in 1578.[93]

Another distinctive characteristic in Mughal portraiture is the narrow waist, which, according to the seventeenth-century courtier Muhammad Baqir Najm-i Sani's *Maw'iza-yi Jahangiri* (Admonitions of Jahangir), denotes a man who was "*kamar-band*, 'waist bound up,' [signifying] one ready for action, service and battle."[94] This feature is evident in numerous Mughal portraits, including one of Prince Daniyal (d. 1605), the brother of Jahangir, and another of Madhava Singh (d. 1610), brother of the Kachhwaha raja of Amer (figs. 3.23 and 3.24), both bearing ascriptions identifying the court artist Manohar and today mounted in a nineteenth-century album in the Walters Art Museum, Baltimore.[95] The men are represented with broad hips that emphasize their narrow waists; they are also clean-shaven, except for their thin mustaches. Despite their different backgrounds—Daniyal was the son of the Mughal emperor and Madhava Singh the son of a Rajput king—the similarities in their portraits can be explained in part by the paintings' shared authorship and by the fact that the subjects' families were related through marriage. But these corporeal commonalities also reflect an intention to depict all imperial subjects as belonging to a limited set of courtly types.[96]

The gestures and the poses in the portraits of Madhava Singh and Daniyal signal adherence to a royal code of behavior. Daniyal is shown performing the *kurnish*, a manner of saluting the emperor and his written decrees (*farmans*) and gifts by placing the palm of the right hand on the forehead while bowing the head.[97] According to the *A'in-i Akbari* (Regulations of Akbar), the imperial subject should then fold his arms across the chest, a gesture that appears frequently in contemporary portraits.[98] The portrait of Madhava Singh represents another stock mannerism, showing the subject standing in attention while holding a long staff. Paintings of royal audience scenes show numerous members of the court in this posture (see fig. 3.21). Again, the painter foregrounds Madhava Singh's identity as a royal type, rather than a wholly unique individual.

Mughal painting's emphasis on the *tarh* as the primary locus of artistic authorship allowed the royal painter an enormous degree of agency in defin-

FIGURE 3.21. Portrait of Kishan Das Tunwar, ascribed to Kanha and completed circa 1595, Lahore or Agra. From the dispersed Salim Album, compiled circa 1600–1605. Opaque watercolor, ink, and gold on paper. Folio 23.5 × 15.2 cm. Virginia Museum of Fine Arts, Richmond, Nasli and Alice Heeramaneck Collection, Gift of Paul Mellon 68.8.59. Photo: Katherine Wetzel. © Virginia Museum of Fine Arts

FIGURE 3.22. Portrait of Raisal Darbari, attributed to Bishandas and completed circa 1600–1604, probably Allahabad or Agra. From the dispersed Salim Album, compiled circa 1600–1605. Opaque watercolor, ink, and gold on paper. Folio 23.3 × 14.9 cm. © The Trustees of the Chester Beatty Library, Dublin, In 44.2.

ing the subject's character. Using a codified set of outlines and postures, the painter could render the subject as a legible and easily reproducible combination of representational marks. This system allowed artists to transfer the gist, or outline, of a portrait from one artistic medium to another, but it also granted the members of the *tasvir-khana* a prominent role in the creation of a typological universe that instantiated in royal manuscripts and albums, not to mention courtly codes of corporeal protocol. Manohar's likeness of Madhava Singh found its way onto one of the pages of the Jahangir Album

FIGURE 3.23. Portrait of Prince Daniyal, ascribed to Manohar and completed early seventeenth century, northern India. Detail of a page from an album compiled in the nineteenth century, Iran. Opaque watercolor, ink, and gold on paper. Folio 29.5 × 19 cm. The Walters Art Museum, Baltimore, W.668.28b.

FIGURE 3.24. Portrait of Madhava Singh Kachhwaha, scribed to Manohar and completed early seventeenth century, northern India. Ascribed to Manohar. Detail of a page from an album compiled in the nineteenth century, Iran. Opaque watercolor, ink, and gold on paper. Folio 29.5 × 19 cm. The Walters Art Museum, Baltimore, W.668.29a.

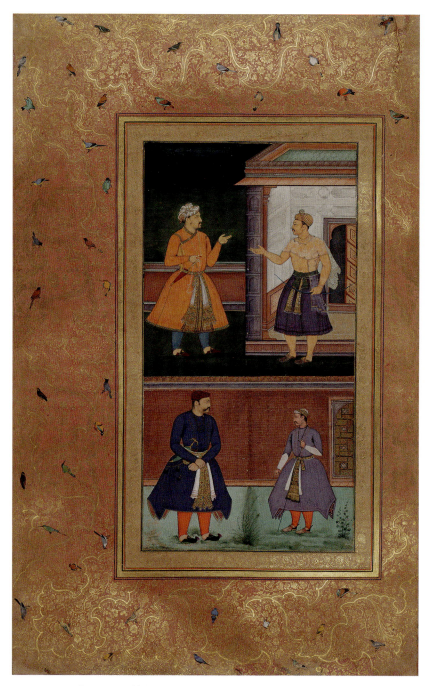

FIGURE 3.25. Portraits of (clockwise from upper left corner) Jahangir, Akbar, Madhava Singh Kachhwaha, and Prince Daniyal (?), completed early seventeenth century, northern India. From the dispersed Jahangir/Gulshan Album, compiled circa 1599–1618 and later. Opaque watercolor, ink, and gold on paper. Folio 42.2 × 26.5 cm; painting 25.5 × 13 cm. Staatsbibliothek zu Berlin, Preussischer Kulturbesitz, Orientabteilung, Libri picturati A 117, f. 18v.

(known also as the Gulshan Album), where he is accompanied by portraits of Jahangir, the deceased emperor Akbar, and another figure who resembles Prince Daniyal (fig. 3.25). Comparison of the two portraits of Madhava Singh reveals that the Jahangir Album image, which must have been reproduced during the early seventeenth century, was copied directly, or traced, from the earlier painting. Not only are the representations of similar size—both measure around eight centimeters in height—but both also show Madhava Singh with *mala*s (prayer beads), staffs, and similar *jama*s, even down to the *bandhani* (tie-dye) linings. Mughal portraiture's reductive and easily replicable typology facilitated the straightforward transfer of the court subject's likeness from one context to another. In some cases, subjects were transported into a collective audience setting; Madhava Singh Kachhwaha, instead, was made the eternal companion of a Mughal emperor and his son.[99]

Mughal portraits were the products and instruments of an imperial regime. While the painter represented his subject in accordance with the imperial codes of comportment, the subject shaped his body and inner self to conform to a royal typology. The responsibility for maintaining the empire's cosmic order and harmony lay, nevertheless, with its "chief physician," the emperor himself.[100] Mughal bodies demanded the *padshah*'s expert—and literal—supervision, an end that portraiture helped to fulfill by extending and making manifest the emperor's penetrating gaze.

The Discerning Eye

One of Jahangir's first orders on his accession to the throne was the installation of a "chain of justice." One end of the chain, which bore golden bells along its length, was placed at the Shah Burj, an octagonal tower at Agra Fort; the other end was attached to a stone post next to the Yamuna River.[101] Ringing the bells would draw Jahangir's attention to any perceived injustice. The chain thus provided all imperial subjects, no matter what their station, direct access to the emperor; it was also a visual reminder of the emperor's vow to uphold the law and guarantee that justice prevail.[102] The Mughal sovereign's duty was to maintain equilibrium among all of his diverse subjects, lest the empire fall into complete disarray.[103]

If subjects communicated their grievances through the medium of sound, Jahangir then executed his judicial functions by using his sense of sight. An illustration from a dispersed or never-completed *Jahangirnama* manuscript shows Jahangir holding a public audience at Agra Fort (fig. 3.26). The chain of justice is visible in the upper left quadrant of the composition. The crowd

below includes courtiers of high rank as well as commoners. A squabble appears to have broken out in the crowd, and a man in a purple *jama* at the left has motioned to strike (or has already struck) the bells to alert the emperor. Jahangir is as still and stoic as an icon, gazing downward. The only part of his body that seems at all kinetically engaged is his hand, which clasps a pendant on a strand of pearls. This stasis suggests that Jahangir's capacity as a judge comes from his discerning gaze and mental acuity.[104] Yet the emperor is himself an object of the crowd's, and the viewer's, gaze.[105] Like the portrait coin, this representation of the imperial profile constitutes the proof of Jahangir's exemplary—even saintly—inner character. For this reason, Jahangir's reputation as a dispenser of justice rested heavily on his physical appearance.

If the emperor's face was the visible indication of what lay in his heart and mind, the same applied to his subjects. According to Abu'l Fazl, Emperor Akbar relied on his ability to assess inner character through outer appearances in his role as adjudicator: "In the investigation into the cases of the oppressed, [Akbar] places no reliance on testimony or on oaths, which are the resource of the crafty, but draws his conclusion from the contradictions in the narratives, the physiognomy, and from sublime researches, and noble conjectures."[106]

Among the advice Akbar gave to his son Prince Murad (d. 1599) on Murad's departure for Malwa was "Be not satisfied in the administration of justice with oaths and witnesses."[107] Rather, one should "make various inquiries and study the book of the forehead [the science of physiognomy]." The skillful and perceptive physiognomist (*sahib al-firasa*) could accurately determine a defendant's guilt or innocence.[108] Thus the ability to assess outer appearances was viewed as essential to the ruler's capacity to administer justice.

The identification of Akbar as a *mujtahid* in AH 987 (1579) lent legal weight to the emperor's capacity to make sound and reasonable judgments. Typically such a designation was reserved for a scholar of *fiqh* (Islamic jurisprudence), which Akbar, whom Abu'l Fazl described as the "pacifier of disturbed hearts," was not.[109] As the *mujtahid*, Akbar was the final arbiter in all matters pertaining to Sharia (Islamic religious law), a position that elevated him above the *'ulama'* (Islamic scholars), whose interests were often at odds with his own.[110] A *mahzar* (decree) issued in the same year, which declared Akbar to be the Sultan-i 'Adil (Just Ruler), effectively secured the emperor's position as a judge superior to any jurist or doctor of law.[111]

In this role, Akbar's demonstration of his attention to and correct interpretation of external signs (*al-amarat*) was all the more important. The admissibility of this type of evidence in Sunni courts of law was legitimized only in the thirteenth and fourteenth centuries through the writings of Damascene

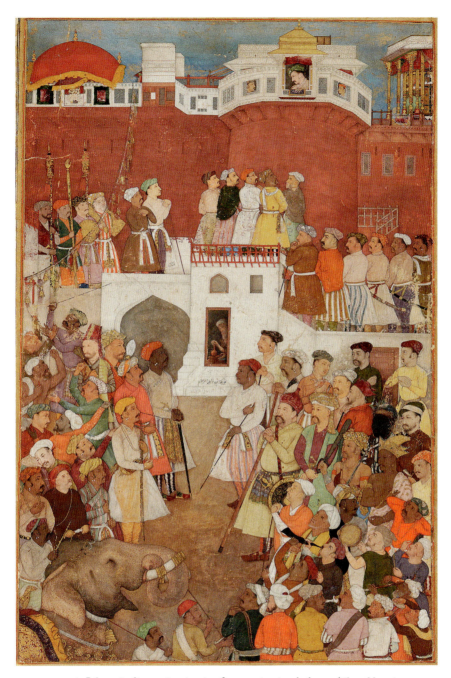

FIGURE 3.26. Jahangir dispensing justice from a viewing balcony (*jharokha-yi darshan*), signed by Abu'l Hasan and completed circa 1620, northern India. Detail of a page (with margins cropped) from a dispersed album compiled in the eighteenth century, India. Opaque watercolor, ink, and gold on paper. Folio 56 × 35.2 cm; painting 31.4 × 20.4 cm. © Aga Khan Museum, Toronto, AKM 136.

jurists such as Ibn Taymiyya (1263–1328) and Ibn Qayyim al-Jawziyya (d. 1351). Prior to this time, the privileging of verbal testimony was the norm. Ibn Qayyim argued that the freedom from reliance on verbal testimonies would advance justice because physical manifestations and processes do not lie, whereas witnesses do.[112] For Akbar, whose political platform rested largely on the supposition that as Sultan-i 'Adil he was Islam's renewer, it was important to exhibit an aptitude for observation and rational reasoning.

Central to Akbar's self-cultivated role as an investigator of signs (and later to Jahangir's as well) is the contemporary meaning of *tahqiq*, a method of examination that can be translated as the "pursuit of truth" or "independent inquiry."[113] Often understood in opposition to *taqlid* (imitation), the proponents of *tahqiq* argued for the salience of intellectual judgment, rather than conformity to scriptural and historical tradition, in the interpretation of religious texts and phenomena. The tenets of *tahqiq* drew in large part from Platonic ideas that saw the refined intellect as a tool to disclose truths that were inaccessible to the human sensory faculties. The success of independent examination, therefore, depended on the investigator's capacity to hone his mind "to the point of cosmic perfection" rather than indiscriminately following precedent and the literal word of the Qur'an. The *tahqiqi* mode of inquiry first took root in the Islamic world during the post-Mongol era, when one of its primary proponents, Nasir al-Din Tusi (1201–1274), advanced an ethical-humanist position that drew on both wisdom literature and occult or hidden (*batini*) and Hermetic thought. By the late sixteenth century, when Abu'l Fazl made his own impassioned argument for the superiority of the independent pursuit of truth, *tahqiq* had influenced popular genres of self-cultivation literature like *adab* and *akhlaq*.[114] The monarch, furthermore, had been identified as its ultimate agent. For Abu'l Fazl, it was Akbar who held the key to uncovering God's truths.

That Jahangir also perceived visual discernment and judgment to be closely connected is evinced by his claims about his abilities to identify the various hands of artists. He writes in the *Jahangirnama*:

> I derive such enjoyment [*zawq*] from painting [*tasvir*] and have such expertise [*maharat*] in judging [*tamiz*] it that, even without the artist's name being mentioned, no work of past or present masters [*ustadan*] can be shown to me that I do not instantly recognize who did it. Even if it is a scene of several figures and each face is by a different master, I can tell who did which face. If in a single painting [*surat*] different persons have done the eyes and eyebrows, I can determine who drew the face and who made the eyes and eyebrows.[115]

While art historians have pointed to this passage as evidence for Jahangir's status as a connoisseur of painting, it can also be read as an assertion of his remarkable visual acuity and, by extension, his superior judgment.[116] By claiming to be able to identify the hands of his many artists, Jahangir suggests that his mastery of the interpretation of representational marks extends likewise to the science of physiognomy.[117] Connoisseurship of art was more than a neutral, academic enterprise.

Jahangir's fascination with natural sciences and oddities, many examples of which are recorded in his memoirs, served similarly to underscore his powers of observation and reasoning and his discerning taste, and thus to support his singular fitness to judge and rule.[118] Jahangir nevertheless acknowledged that his interest in nature was not unique. His grandfather, Babur, "wrote in his memoirs of the shapes and forms of some animals," though, as Jahangir notes, "he did not order the artists to depict them."[119] When Muqarrab Khan presented Jahangir with a gift of "several very strange and unusual animals," including a North American turkey, Jahangir "both wrote of [these animals] and ordered his artists to draw their likenesses in the *Jahangirnama* so that the astonishment [*sayrat*] one has at hearing of them would increase by seeing [*az didan ziyada*] them."[120] This passage is significant not only for what it tells us of Jahangir's use of pictorial representations as records of visual experience, a function previously satisfied in large part by verbal texts, but also for its identification of the artist as the faithful court servant who reproduces and thus sustains the object of the emperor's wonder, intellectual curiosity, and judgment. During Jahangir's reign, both paintings and painters came to be recognized as vital agents of *tahqiqi* investigation.

As a text that was intended to be copied widely, the *Jahangirnama*, with its commentaries on natural wonders, Timurid antiquities, and painters' hands, was a public expression of the emperor's self.[121] Each of its chapters opens with the celebrations of Nawruz (the Persian New Year), which coincided, by design, with the anniversary of Jahangir's accession. The very organization of the *Jahangirnama* thus presents the "outer (*surat*) and material (*zahir*) world . . . [and the emperor's] public life and profane life" as constituting, and constitutive of, the Mughal imperium.[122] The text operated as an instrument of propaganda by reasserting the Mughals' Timurid lineage, in the wake of competing claims from the Safavids, while its personal observations of people, plants, minerals, and objects in the imperial collections represented Jahangir as a universal ruler who held the world in his hands.[123]

A number of the early seventeenth-century Mughal paintings thought to have been made for a now-dispersed and possibly never-completed manuscript copy of the *Jahangirnama* attest to the role of Mughal painters and

FIGURE 3.27. Portrait of the zebra presented by Mir Ja'far to Jahangir on the occasion of Nawruz in 1621 (AH 1030), ascribed to Mansur and probably completed 1621, northern India. Mounted on a page from the divided Minto Album, with decorated margins added circa 1630–40. Opaque watercolor, ink, and gold on paper. Folio 26.9 × 38.7 cm; painting 18.3 × 24 cm. The Victoria and Albert Museum, London, IM.23–1925.

their images in bolstering the reputation of the emperor as both world ruler and keen observer.[124] A depiction of a zebra, likely made for a copy of the *Jahangirnama*, materializes in vivid, graphic detail the animal, described in the memoirs as a *gur khari* (wild ass), that the emperor first witnessed around 19 March 1621 (9 Farvardin AH 1030) and subsequently gifted to Shah 'Abbas (fig. 3.27). In his memoirs, Jahangir described the zebra: "It was extremely strange, for it was for all the world exactly like a tiger. Tigers have black and yellow stripes, but this one was black and white. There were black stripes, large and small in proportion to where they were, from the tip of its nose to the end of its tail and from the tip of its ear to the top of its hoof. Around its eyes were black stripes of great fineness."[125]

The painting closely accords with the emperor's description. Yet Jahangir's own voice also activated the artist's work. An inscription that Jahangir appended to the painting of the zebra provides vital information about the animal that does not appear in the *Jahangirnama*, namely that Europeans or Turks (*rumiyan*) in the company of Mir Ja'far had brought the zebra (*ushtur*, meaning camel or mule) from Ethiopia (Habsha).[126]

The imperial inscription also identifies the artist as the master (*ustad*) Mansur, Nadir al-'Asr (Rarity of the Age). This information appears to play on commentary in the *Jahangirnama* that addresses the creation of the animal itself. Jahangir states that the zebra "was so strange some thought it might have been painted, but after inspection [*tahqiq*] it was clear that that was how God had made it."[127] He also opines that "the painter of destiny [*naqqash-i taqdir*] had produced a tour de force on the page of time [*safha-yi ruzgar*] with his wonder-working brush." The court painter is secondary to "the painter of destiny" who created the zebra. Mansur could depict only what God had already fashioned.

As a royal painter, Mansur thus functions as an accessory to the emperor, who, employing his full arsenal of *tahqiqi* inquiry, takes credit for recognizing the zebra as a creature worthy of examination and description. In depicting the wonders of nature that the emperor documents in writing, Mansur, in other words, merely substantiates Jahangir's observations. But the emperor, in turn, endorses Mansur's painting, in effect authorizing it as supporting evidence for his own extraordinary vision and judgment. This interplay of image and text reflects the complex matrix of optics, observation, and judgment at the Mughal court, where the painter's brush and the emperor's pen operated in tandem to make the latter's visual experiences manifest.

THE PORTRAIT COINS AND ILLUSTRATED MANUSCRIPTS like the Victoria and Albert *Akbarnama* showcase the physical characteristics that differentiated the emperors from all others and identified them as belonging to a corporeally and spiritually distinguished lineage. The imperial portrait served not only as the proof of the Mughal dynasts' capacities as sacred kings but also became the focus of ritual practices. Portraiture was a locus for epistemological investigation. The images of Madhava Singh and the royal family show how the Mughal portrait sought to reveal the inner essence of the subject and thereby functioned as an object holding truth and knowledge. The association of certain paintings with individual painters—such as the Walters portraits of Prince Daniyal and Madhava Singh, both ascribed to Manohar—and historical styles further underscored the epistemic value of these works by anchoring them to specific individuals, events, and places in time.

Jahangir's artists also made manifest the emperor's capacity for visual discernment and so provided proof of their patron's status as the bringer of a

new, more harmonious age. Their endeavors complemented textual projects like the *Jahangirnama*, an official, public record that portrayed the dynast as an enlightened, observant judge of man and nature. The material image can be understood as the coloring in of the text's design, although Jahangir also recognized that paintings intensified the "astonishment one has at hearing of [the subject]," a clear acknowledgement of the positive contributions that picture making could bring to the text of the *Jahangirnama*.[128] While the author of the verbal description, and thus the catalyst for painting, is Jahangir, both the emperor and his painters acknowledged that the ultimate creator is God. Imperial painters did not attempt to mask the fact that they operated as authors twice removed; rather, their very livelihoods rested on their capacities to further the fiction that their works, their vision and visions, were the emperor's own.

WORLD IN A BOOK 4

Performance, Creation, and the Royal Album

ABU'L HASAN'S PAINTING OF JAHANGIR'S DREAM, discussed in chapter 1, leaves little to the imagination. The portrayals of the emperor and his rival, the Safavid ruler Shah 'Abbas I (r. 1588–1629) of Iran, are so detailed in their execution, with every eyelid crease and moustache hair illustrated by fine colored lines, that they reward close and sustained observation (see fig. 1.1). The representation of costume—from Shah 'Abbas's feather-capped turban to Jahangir's tie-dyed sash (*patka*) and diaphanous cotton undershirt—is similarly meticulous; magnification reveals even finer patterns and textures.[1] One might suppose that the court artist labored for months on this painting, yet one of its several Persian epigraphs states: "Since Nawruz was near, it [i.e., the painting] was made in haste." This inscription emphasizes the swiftness, no doubt exaggerated, with which Abu'l Hasan completed his masterpiece. It also tells us that the artist made the painting for one of the most important events of the Mughal calendar: Nawruz, the Persian New Year, which falls on the vernal equinox. In 1584, Akbar had adjusted the royal calendar so that the first day of the Nawruz celebrations would thereafter coincide with the imperial accession anniversary (*julus*) and thereby herald the start of a new, divine era. The Nawruz-*julus* festivities were, bar none, the most resplendent and ritually efficacious of the Mughal annual cycle.[2]

Contemporary scholarship has largely glossed over the ritual and rhetorical significance of Abu'l Hasan's claim about the execution of this phenomenal painting, for reasons that are not entirely clear. Scholars have treated this painting, among others, as an autonomous image removed entirely from the contexts of imperial life. Yet Abu'l Hasan's epigraph makes clear that it was made for presentation at the most important dynastic ritual enacted at the court. Gift exchange, because of its function in constituting social ties, is integral to most political economies, and the Mughal Empire was no exception. The presentation of tributes in public ceremonial settings was an

expression of the Mughal servant's loyalty and hope of reciprocation. If the emperor was pleased with his subject's offering, he might proffer a boon or promotion, thereby extending the cycle of mutual obligation.

Royal painters' contributions to these displays of largesse differed from those of high-ranking Mughal courtiers. Governors, ministers, and generals were expected to spend large sums showering gifts on the emperor, especially during the celebration of Nawruz. The painter's gift was his labor, and his reward, should the emperor deem his efforts worthy, a cash bonus or an honorific title.[3] With the vernal equinox fast approaching, Abu'l Hasan no doubt wished to have something spectacular to present to Jahangir for the occasion. But his claim to have executed his depiction of Jahangir's dream in haste was specious: the painting, which incorporates numerous details applied in multiple, burnished layers of color and gold, must have taken months to finish. His assertion paradoxically underscores the amount of time and labor that he had invested in the production of his masterpiece, and it thus invites viewers to draw comparisons between painting and more temporally based art forms like music and poetry. Painting too was a performance.

In addition to receiving titles and promotions, painters might be honored by having their work featured in a royal album (*muraqqa'*).[4] The Mughal album took the form of a codex (stitched book) in which prized works from the imperial collections were mounted, mainly on paper. These included Persianate paintings, early sixteenth-century calligraphic specimens from Central Asia, and European prints. The production and circulation of *muraqqa'*s solidified a canon of forms, styles, makers, and subjects. Though lacking a clear narrative arc, these collections of heterogeneous objects invited viewers to draw connections between fathers and sons, emperors and nobles, thereby creating, from one page to the next, influential networks of affiliation. The appearance of a painter's work in this royally sanctioned context thus ensured him imperial recognition and increased social capital, which could extend to his family members and followers. Although Abu'l Hasan's painting of Jahangir and Shah 'Abbas is today mounted on a page that bears mid-eighteenth-century borders that were decorated in Iran, it was very likely once part of an album originally assembled for Jahangir.[5] Paintings associated with Nawruz seem to have been prominent in this royal *muraqqa'*, likely because of their evocation of the most important event of the imperial calendar, but also for their ability to give a second life to the individuals, objects, and incidents associated with and depicted in them.

At the royal gatherings (*majlis*es) where the emperor and his companions viewed these materials, albums would have functioned as deftly curated mi-

crocosms of the court itself. The painter's presence in the album was evident, and often self-reflexively so. Included among the numerous contributions of Jahangir's artists are a number of recursive images that entreat the royal viewer to reimagine pictorial representation as an epistemic enterprise and painters as knowledge producers. The imperial *muraqqaʿ* was thus not only about the Mughal court and the emperor's ambitions; it was also about the role of the imperial artist in fashioning that cosmopolitan, world-owning vision.

Nawruz and Gift Exchange

The celebration of Nawruz (lit., "New Day") can be traced to pre-Islamic Iran, where the ritual drew from Zoroastrian and other ancient Iranian traditions. Its emphasis on the triumph of good over evil and verdant renewal was also often combined with a fixation on the figure of the king as the agent of regeneration and the earthly representative of the divine. The mythical ruler Jamshid—whose story is elaborated in Firdawsi's *Shahnama* (Book of kings), a poetic account of the legendary and historical kings of Iran completed around 1010—is said to have introduced the observance of Nawruz to the Persian people. The earliest recorded celebrations of Nawruz, which date to the Achaemenid and Sasanian periods, reveal that gift exchanges between courtiers and ruler played a central role in the ceremony.[6] For court nobles, the event afforded the opportunity and obligation to submit payment (*pishkash*) as recompense for promotions, reappointments, and other professional advances, with the offerings couched in elaborate and quasi-public ceremonies, banquets, and performances.[7]

Compared to the extravagant festivities at Jahangir's court, Nawruz celebrations during the reigns of the first Mughal emperor, Babur (r. 1526–1530), and his successor, Humayun (r. 1530–1540, 1555–1556), were modest. Although Babur wrote a poem commemorating the occurrence of Nawruz and ʿId al-Fitr on the same day in 1505, it is unclear whether he ever celebrated the Persian New Year.[8] On at least one occasion he refused to do so.[9] His ostensible purpose was to demonstrate his stricter orthodoxy, but this act may also have been intended as a rebuff to his political rival, the Safavid Shah Ismaʿil (r. 1501–1524), who had compelled Babur to wear Ismaʿili Shiʿi garb, among other humiliations, in exchange for military assistance.[10]

Humayun, Babur's son and successor, may also have been reluctant to observe Nawruz because of its association with his own subjugation to the Safavids. During his exile in Iran in 1543 and 1544, Humayun was forced

to don sectarian accoutrements and participate in Nawruz celebrations in the Safavid-controlled city of Herat as payment for his protection by Shah Tahmasp (r. 1524–1576).[11] Nevertheless, the Nawruz festivities at Humayun's court following his successful retaking of Kabul in 1546 were, according to the *Humayunnama* (Book of Humayun)—an account of Humayun's reign written by his half-sister Gulbadan Begum—quite exuberant: "After the New Year they kept splendid festivity for seventeen days. People dressed in green, and thirty or forty girls were ordered to wear green and come out to the hills. . . . All the sultans and amirs brought gifts to the Audience Hall Garden. There were many elegant festivities and grand entertainments, and costly khi'lats and head-to-foot dresses were bestowed."[12] The extravagance of that year's celebrations may be partly explained by the fact that Nawruz coincided with the young prince Akbar's circumcision. But Humayun probably also recognized the political and economic advantages, not to mention the ritual and symbolic efficacy, of staging Nawruz festivities at his fledgling court.

Such festivities only increased in size and extravagance during Akbar's long reign. At the festivities of 1574, which took place in Ajmer, Akbar "distributed the sum of a lac [100,000] of rupees to every class of person present at the assembly."[13] The Nawruz celebrations of 1584 were similarly grandiose.[14] That year Akbar also introduced the Ilahi (Divine) Era, which involved the conversion of the Mughal calendar from a lunar to a solar cycle and reset the anniversary of the emperor's *julus* to coincide with Nawruz.[15] Birthdays and other ritual observances associated with the Islamic and Persian calendars continued to be occasions for revelry, but none approached the resplendence and pageantry of the combined celebrations of Nawruz and the *julus*.

The Nawruz obligations imposed on Mughal nobles could be burdensome, although they also held the enticing possibility of reciprocation. As Jahangir reports, it became a custom "for one of the great amirs to give a party every day and arrange rare offerings [*pishkash-ha-yi nadir*] of all sorts of jewels, gem-studded vessels, precious textiles, elephants, and horses and persuade His Majesty to attend their parties. In order to do honor to his servants the emperor would take the trouble to attend the gathering, inspect the gifts, choose what he liked, and give [*bakhshidand*] the rest to the host."[16]

Gifts offered to the royal patron provided the emperor an opportunity to assess his servants' allegiance, sometimes with immediate consequences. According to Jahangir's memoirs, at the AH 1024 (1615) Nawruz festivities, Asaf Khan—the brother of his wife Nur Jahan and son of 'Itimad al-Daula, his grand vizier—made an "offering of gems, jewel-studded utensils, and textiles of every sort and description that were inspected in detail. What I

liked was worth 85,000 rupees."[17] Three days later, on 5 Farvardin, Jahangir increased Asaf Khan's *mansab* (rank) by 1,000, making his total *zat* (personal ranking) 4,000 and his *suvar* (troop ranking) 2,000.[18] As a point of comparison, 'Itimad al-Daula received an increase of 1,000 *zat* and *suvar* that same Nawruz, for a total *zat* of 6,000 and *suvar* of 3,000.[19] The emperor also gifted his subjects horses, robes of honor (*khilaʿ*), turban ornaments, and, in very special cases, gold-stamped and painted portraits of his own likeness (described in chapter 3). Enacted during large assemblies staged at court over many days, these public gestures of bestowal allowed the emperor to redistribute his wealth and reinscribe his superior status.[20]

Imperial servants who were unable to attend the festivities at court were not exempt from the obligation of gift giving. For the Nawruz celebration of AH 1021 (1612), for example, Afzal Khan—the governor of the *suba* (province) of Bihar and the son of Abu'l Fazl, who had been the chief ideologue at Akbar's court—sent to Jahangir a *pishkash* of "thirty elephants, eighteen *ghunt* ponies, some Bengal textiles, sandalwood, musk bags, aloeswood, and all sorts of other things." At the same *majlis*, Shah Beg Khan—to whom, in AH 1016 (1607–8), Jahangir had awarded the governorship of Kabul, the rank of 5,000, and the title Khan-i Dawran (Lord of the Age)—sent from abroad "forty-five horses, two camels, Chinese porcelain [*chini khatayi*], ermine pelts, and other rarities he had gathered in Kabul and vicinity."[21] These extensive lists suggest that Nawruz gifts served the additional purpose of showcasing specialties from the *suba*s governed by these absent courtiers. They might also have assured the emperor of the *suba*'s—and thus the noble's—productivity while underscoring the fact that everything was, in essence and in form, the property of the Mughal crown.[22] Gifts from abroad affirmed the emperor's and the courtier's patronage relationship while ensuring that the imperial subject was once again placed in the emperor's debt. The onus was always on the servant to "repay" his patron with his unbending loyalty.

The Artist's Time

For the Mughal artist, who had neither coins nor camels to bestow on his imperial patron, the Nawruz painting afforded the opportunity to demonstrate the aesthetic, commemorative, and historiographic value of his labor. Artful expressions of loyalty and devotion—whether poetic, musical, or painted—carried their own weight, even if their monetary value was demonstrably less than that of jeweled turban ornaments and Arabian horses.[23] References to and records of panegyric poems and songs composed for other

Muslim rulers on the occasion of Nawruz attest to the less tangible value of some New Year's gifts.[24] Abbasid court poets, for example, recited *qasida*s (laudatory poems) at royal Nawruz festivities, a public act that affirmed the poets' loyalty and called attention to the caliphs' responsibilities as rulers.[25] A well-crafted panegyric poem might carry greater symbolic worth than a precious gem or woven textile if it could attest to a royal patron's political authority. Gifts were measured not only against gold but also in terms of their ceremonial and rhetorical weight.[26]

An enigmatic painting associated with Humayun's reign may represent the earliest extant example of a Nawruz painting fashioned for a Mughal patron (fig. 4.1).[27] The painting probably depicts one of the many celebrations connected to the *tuy* (circumcision) of Akbar, which took place near the shrine of Khwaja Seh Yaran in Kabul during the Nawruz celebrations of 1546; its maker, the artist Dost Muhammad, may have prepared the work for presentation at the Nawruz festivities the following year, in 1547. Dost Muhammad's painting thus commemorates the young prince's circumcision while also celebrating Akbar's father, Emperor Humayun, who had recently reconquered Kabul. His portrayal of Humayun holding court in a mountainous setting evokes Kayumars, the legendary first king of Iran, who is often depicted in a similar setting in illustrated manuscripts of the *Shahnama*. The painting invites the viewer to imagine the Mughal emperor, like Kayumars, as one who can harness and manipulate the natural environment.[28] The painting has particular associations with Nawruz because Kayumars's ascension to the throne, according to some accounts, occurred just when the sun entered the sign of Aries, marking the beginning of Nawruz.

Another theme that this vibrant composition engages is painting itself. Dost Muhammad depicted Abu'l Nasir Muhammad "Hindal" (1519–51), Humayun's younger half-brother—here shown seated next to Humayun in a light pink *jama* (stitched coat)—proffering what may be a portrait of the young prince Akbar to the emperor. By making a painting the centerpiece of his own composition, Dost Muhammad in effect reminds his patron and other viewers that painting is fundamental to Mughal ritual and gift exchange. This metapictorial detail—the painting inside a painting—also communicates the capacity of painting to both commemorate and reenact ritual events through its exploration of recursive themes.[29]

Among the earliest extant Mughal paintings whose inscriptions identify them as Nawruz works specifically is a depiction of a musician and a princely scribe completed by 'Abd al-Samad in AH 958 (1551), presumably for his patron, Humayun (fig. 4.2; see also fig. 4.4). Compared with Abu'l

FIGURE 4.1. Nawruz celebration following the circumcision of Akbar in 1546 in Kabul, attributed to Dost Muhammad and completed circa 1547, Afghanistan. From the dispersed Jahangir/Gulshan Album, compiled circa 1599–1618 and later. Opaque watercolor and gold on paper. Folio 41 × 25.5 cm; painting 40 × 22 cm. Staatsbibliothek zu Berlin, Preussischer Kulturbesitz, Orientabteilung, Libri picturati A 117, f. 15r.

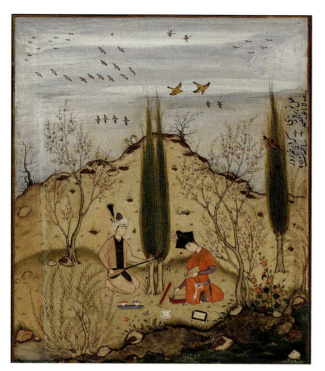

FIGURE 4.2. Detail of figure 4.4 showing a musician and scribe (or painter) seated outside, ascribed to ʿAbd al-Samad and completed AH 958 (1551), probably Afghanistan. From the dispersed Jahangir/Gulshan Album, compiled circa 1599–1618 and later. Opaque watercolor, ink, and gold on paper. Golestan Palace Library, Tehran, Ms. 1663, f. 158.

Hasan's painting of Jahangir and Shah ʿAbbas, ʿAbd al-Samad's study is more economical in its handling of space, color, and line. The sparseness of the composition may have been intended to show off the artist's extraordinary skill and swiftness of execution.[30] A Persian inscription on the painting's right-hand edge, probably added in the early seventeenth century, seems to support this interpretation. It reads: "Nawruz work [*ʿamal-i Nawruz*] of master ʿAbd al-Samad, which was made in half a day in the year [AH] 958 [1551]."[31] Another notation, this one embedded more firmly in the composition itself, intimates that the painter produced the exercise expressly for the emperor.[32] Taken together, the two epigraphs provide evidence that the execution of paintings for Nawruz and their presentation in imperial settings had been codified at the Mughal court by the mid-sixteenth century.[33] The primary inscription is also significant for its specificity: the painting was made in *half a day*. One is left to ponder whether ʿAbd al-Samad might have created the study on the occasion of Nawruz itself.

Another Nawruz work credited to ʿAbd al-Samad, this one depicting a horse and groom, bears even more precise information about the time frame of the painting's execution (fig. 4.3; see also fig. 4.4). It, too, is formalistically spare, drawing on a limited color palette and vocabulary of motifs. The inscription states that the *ʿamal-i Nawruz* was executed "in half a day, from dawn till the time when the sun was at its zenith [i.e., midday]" in AH 965 (1558), presumably for his new patron, Emperor Akbar.[34] The suggestion that the painter completed the composition just when the sun had entered Aries implies that the creation of the painting, like the vernal equinox itself, is an event worthy of recognition.

The claims of the inscriptions on 'Abd al-Samad's two Nawruz paintings warrant further examination. Though both compositions are fairly modest in scope, the artist would have likely needed more than half a day to complete them. Mughal paintings required considerable time to produce. The artist had first to lay the foundational design onto paper and then apply layers of opaque watercolor paint, burnishing each layer in turn. By minimizing the labor and time required to complete these works, the inscriptions argue for placing the painting outside the court's normal scheme of evaluation. Marginal inscriptions in illustrated Mughal manuscripts dating from the late sixteenth century attest that painters received specific directives from workshop or project managers as to the number of days they were to spend on any given illustration.[35] When Mughal librarians periodically assessed the monetary value of these manuscripts, along with other works housed in the royal treasury, they usually assigned the highest values to those that contained the most labor-intensive

FIGURE 4.3. Detail of figure 4.4 showing a horse and groom, ascribed to 'Abd al-Samad and completed AH 965 (1558), probably Lahore. From the dispersed Jahangir/Gulshan Album, compiled circa 1599–1618 and later. Opaque watercolor, ink, and gold on paper. Golestan Palace Library, Tehran, Ms. 1663, f. 159.

paintings.³⁶ By upending this evaluative paradigm, 'Abd al-Samad's half-day Nawruz paintings attempt to transcend the mundane physical fact of their making. The artist, like Abu'l Hasan more than six decades later, claimed to have made the paintings in practically no time at all.

The Nawruz paintings and the inscriptions that accompanied them may have served to link the painter's work to the court and its calendar, much as Timurid and Safavid poets composed works to immortalize events at court.³⁷ "Occasional poetry," as David J. Roxburgh terms it, was paralleled by "occasional art," which likewise evoked specific events and ritual occasions.³⁸ Other examples may be found in the work of early modern Italian court painters who capitalized on the temporal dimensions of their craft, for example by making quickly executed portraits from life, to compete with other court entertainers, like poets and musicians.³⁹ Mughal painters, like their Italian counterparts, had to contend with a sometimes antagonistic professional environment in which competition was keen and salaries and promotions were by no means guaranteed.

Despite the Mughal painter's lack of access to material riches, the Nawruz festivities provided him with opportunities to advance his station and assert the value of painting. In claiming to have completed his paintings on the day, or even at the very moment, of the vernal equinox, 'Abd al-Samad in effect inserted his workshop enterprise into a ritual chronology and domain. At the same time, the inscriptions demanded that the work be seen to transcend the material and temporal contingencies of the bureaucratic machine. It is something of an irony that the painter sought to increase the value of his artistic production by downplaying the labor that it required.

Whereas the production of illustrations in narrative manuscripts was almost always a collaborative effort, the creation of a Nawruz painting provided the individual artist with the chance to compete for his patron's favor on his own terms. There was no guarantee of a positive return, but if 'Abd al-Samad's career is any indication, his efforts were rewarded. From around 1572 he served as director of the imperial manuscript workshop; in 1576 he was promoted to head of the mint in Fatehpur Sikri; and in 1584 he was made the *divan* (chief official) of Multan.

The Paper Thickens

If it is difficult to reconstruct the precise social context in which Dost Muhammad and 'Abd al-Samad created their Nawruz paintings and Humayun and Akbar appreciated them, it is at least possible to point to the significant

afterlife these works enjoyed in the royal album (*muraqqa'*) in which they were later mounted. Known today as both the Gulshan Album and the Jahangir Album, after its putative original patron, this codex combined Mughal, Deccani, Uzbek, and Safavid paintings with early sixteenth-century calligraphic specimens from Herat and Bukhara and artful collages of European prints.[40] It alternated openings, or facing pages, that showed paintings with openings that showed calligraphies, thereby inviting the viewer to compare the contributions and forge new meanings, values, and associations.[41] The semiosis of the album opening was, like the physical construction of the folio itself, deeply layered, the deposits of time thick and encrusted.

Although the Jahangir Album was rearranged and repaginated in Iran during the nineteenth century, and portions of it are today dispersed to various collections around the world, there is still good reason to believe that 'Abd al-Samad's musician-and-scribe and horse-and-groom paintings were, in the *muraqqa'*'s early seventeenth-century arrangement, mounted as opposing pairs on facing verso (right-hand) and recto (left-hand) pages (fig. 4.4). One clue is the fact that at the bottom of each page appears an illustration of the same literary subject: Majnun, whose tragic tale of unrequited love the poet Nizami Ganjavi (1141–1209) had popularized in Persian rhyming verse in his *Khamsa* (Quintet) centuries prior. The painting at the bottom of the recto album page bears the inscription "Shah Salim," indicating that it was made during the period of Jahangir's rebellion in Allahabad between 1600 and 1604, when he was still known by his birth name, Salim. The corresponding work on the facing verso was probably executed at least a century earlier in Herat, in today's Afghanistan. Viewing the two album pages from right to left, the typical orientation for reading Islamic texts and books, the two Majnun compositions appear as chronological variations on a single theme.

The earlier painting almost certainly served as a model for the one opposite. The copying of masterful renditions of favorite subjects was central to the Mughal painter's practice, one that enabled him to insert himself into the long chain of artistic tradition. By emulating, as well as recasting, the early sixteenth-century artist's version of this commonly illustrated scene, the Mughal artist effectively "performed" the canon.[42] Abd al-Samad's musician-and-scribe and horse-and-groom paintings, mounted in the registers above, likewise rehearse a larger corpus of subjects, styles, and forms.

The performative potentialities of the individual and paired paintings are also in evidence in the codex as a whole. The textual *dibacha*s (prefaces) of Timurid and Safavid *muraqqa'*s frame artistic practice as both performance and self-expression.[43] The creation of these objects could be conceived, like

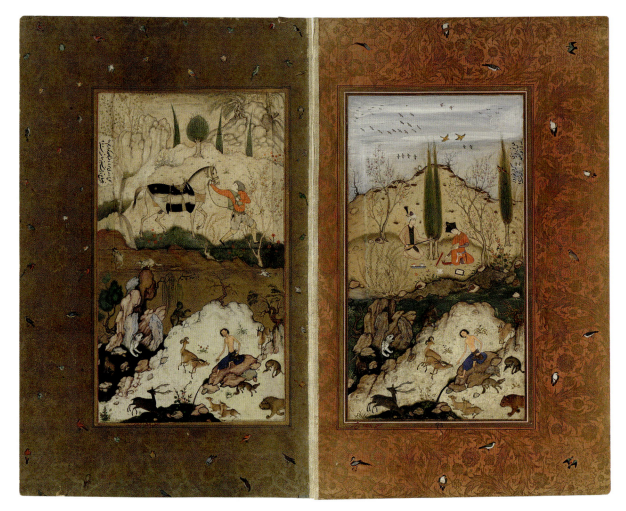

FIGURE 4.4. Facing verso (right-hand) and recto (left-hand) pages bearing in their upper registers paintings ascribed to 'Abd al-Samad, dated AH 958 (1551) and AH 965 (1558), respectively. From the dispersed Jahangir/Gulshan Album, compiled circa 1599–1618 and later. Opaque watercolor, ink, and gold on paper. Folios: each approx. 41.5 × 27.5 cm. Golestan Palace Library, Tehran, Ms. 1663, ff. 158, 159.

the poet's recitation, as both a performative and an authorial enterprise. The composition of the albums encouraged users to pore over and make sense of the elements' original contexts, making the albums, in Roxburgh's words, "socially self-reflexive objects."[44] One of the Persianate album's primary schemes of signification lay in calling attention to its makers, the contexts for its own production, and the operation of signifying. In this sense, the album was neither a closed book, so to speak, nor in possession of a single theme or narrative arc; rather, it was something more akin to the ourobo-

ros, the pre-Islamic mythological serpent that undergoes transmutation by consuming its own tail.

The Jahangir Album, in parallel fashion, thematized the temporal and referential nature of the creative act. Its format, including the collage-like structure of the page and the alternating sequence of image and text, invited users to grade compositions against one another while also drawing other connections—historical, dynastic, and genealogical, among others—between them and across the *muraqqa*'s gathering of objects. The fragments of calligraphic poetry that the workshop's staff artfully pasted around the paintings and the prints on the album's pages presented yet another layer of signification.

The album also encouraged its users to generate their own creative responses to it. Although we have no documentation attesting to how exactly albums were used at the early seventeenth-century Mughal court, they were likely shared at intimate gatherings that included family members, high-ranking courtiers, and ambassadors.[45] In these settings, the contents of the *muraqqa'* would have prompted extemporaneous responses that augmented its already abundant resonances. The album thus intertwined multiple events in time: the creation of its individual components, the compilation of the album, and the occasions of its viewing.

Nawruz paintings were integral to the Jahangir Album's rhetorical operations precisely because they treated depiction as a singular, ephemeral performance. They demonstrated the durability of paintings and drawings and the potential of those objects to mark historical events related to the celebrations of Nawruz. But through their physical association with individual artists, patrons, and collectors, they also produced new, and sometimes fictionalized, genealogies of affiliation and affection. 'Abd al-Samad's mid-sixteenth-century half-day Nawruz paintings, which had been made for Humayun and Akbar, sit alongside a work that had been produced for Jahangir decades later. The latter painting was evidently made after the early sixteenth-century Herati painting of Majnun mounted on the facing page. This pair of paintings performs versions of a canonical composition, but the inclusion of 'Abd al-Samad's paintings above it also provided a material link to prior Nawruz celebrations, as well as to the patronage of Jahangir's grandfather Humayun and his father, Akbar. In short, the mounting of these objects into an album produced an image of seamless dynastic succession by indexing events, exchanges, and individuals associated with the previous reign. Never mind that Jahangir actually rebelled against his father and in 1602 ordered the execution of Akbar's close confidante, vizier, and chief ideologue, Abu'l Fazl.

FIGURE 4.5. Prince on horseback hunting in a forest, signed by Muhammad Sharif and dated AH 999 (1591), probably Lahore. From the dispersed Jahangir/Gulshan Album, compiled circa 1599–1618 and later. Opaque watercolor, ink, and gold on paper. Folio 42.2 × 26.7 cm; painting 26 × 18.4 cm. Los Angeles County Museum of Art, from the Nasli and Alice Heeramaneck Collection, Museum Associates Purchase (M.78.9.11). Photo © Museum Associates/LACMA.

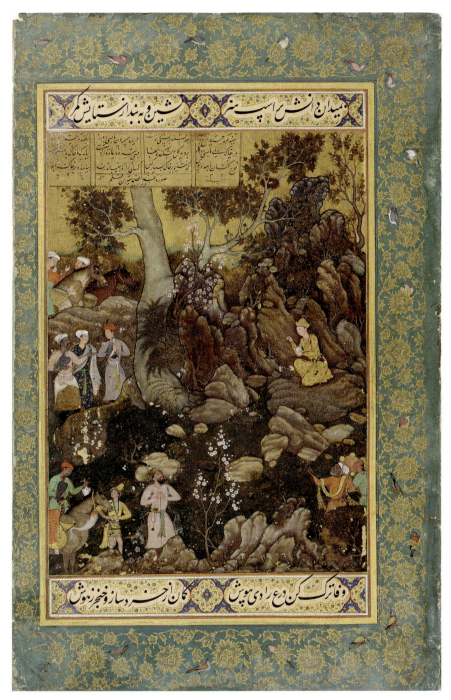

FIGURE 4.6. Jamshid writing on a rock, signed by 'Abd al-Samad and dated AH 996 (1587–1588). From the dispersed Jahangir/Gulshan Album, compiled circa 1599–1618 and later. Opaque watercolor, ink, and gold on paper. Folio 42 × 26.5 cm. Freer Gallery of Art, Smithsonian Institution, Washington, DC. Purchase––Charles Lang Freer Endowment, F1963.4b.

Artists used the pages of the Jahangir Album, and Nawruz paintings in particular, to make yet other claims about the Mughal's dynastic lineage. Muhammad Sharif, the son of 'Abd al-Samad, enjoyed the status of a *khanazad*, that is, a house-born member of court. Like his father, he trained as a painter; and like 'Abd al-Samad, he produced a Nawruz work that was eventually mounted in the Jahangir Album (fig. 4.5). Departing somewhat from the canonical practices exemplified by 'Abd al-Samad's compositions, Muhammad Sharif's painting does not so much emulate as it updates—and thus attempts to improve on—an older work. Muhammad Sharif's painting is a royal hunt scene that bears the Nawruz date of 9 Farvardin AH 999 (20 March 1591) and an inscription identifying him as the artist. Recent scientific and stylistic analyses have revealed that this painting lies on top of an earlier work, possibly executed by 'Abd al-Samad for an illustrated—though incomplete or damaged—*Shahnama* manuscript commissioned by Humayun during the mid-1550s.[46] The younger artist replaced the face of the rider at the center, originally the young Prince Akbar, with a likeness of Prince Salim (the future Jahangir), who would have been twenty-one years old in 1591. Sometime later—probably in the early seventeenth century, when the painting was being prepared for inclusion in the Jahangir Album—Muhammad Sharif or another artist extended the bottom and left edges of the composition to fit the *muraqqa*'s dimensions. These numerous painterly interventions forged a visible, material link between three generations of Mughal dynasts (Humayun, Akbar, and Jahangir).

The palimpsestic painting evokes another important association: the professional and familial relationship between Muhammad Sharif and 'Abd al-Samad. That the son chose to leave some of 'Abd al-Samad's work uncovered suggests that he intended to showcase his skills as a painter alongside his father's. This painting may have even been paired in an opening in the Jahangir Album with 'Abd al-Samad's painting of the mythical Jamshid (fig. 4.6), further reinforcing these filial resonances.[47] 'Abd al-Samad's painting is dated AH 996 and bears the number 32, a reference to the thirty-second year of Akbar's reign, meaning that it was made between December 1587 and March 1588, perhaps even on or for Nawruz.[48] The subject is suggestive of Nawruz because of Jamshid's association with the inauguration of the holiday.[49] The juxtaposition of the two Nawruz works in the album made the nexus of associations between the father and son all the more evident.

Muhammad Sharif not only repainted the hunt scene but may also have penned the three couplets of poetry on the golden panels within the painting. Invoking the familiar image of Majnun—the crazed lover who wanders the

desert tortured by the estrangement from his beloved, Layla—the rhyming verses can be read as an intimate appeal to the painter's imperial patron.[50] The subtext of the poem is the devotee's pain from being separated from God, but the couplets also evoke the ties of discipleship that bound servants to their imperial master, especially *khanazad*s like Muhammad Sharif. A minute *Allahu Akbar* inscription, located just above the verses located in the upper calligraphic panel, adds weight to this theory, for while the phrase means "God is the greatest," during Akbar's reign—and especially after the early 1580s—it was also construed to mean "God is Akbar."

The function of Muhammad Sharif's Nawruz painting as a material statement of his devotion to Akbar is underscored by the inscription at the bottom right, which characterizes the artist as "the disciple in the four stages of sincerity, with foot in place."[51] This curious turn of phrase was linked specifically with the members of the so-called Tawhid-i Ilahi (Divine Oneness), the exclusive, Sufi-like cult of discipleship that Akbar had established in 1582 (discussed in chapter 3).[52] Its members publicly expressed their devotion to Akbar, for example by professing an oath of loyalty and prostrating themselves before him.[53] The declaration of loyalty could also take the form of a painting.

This deeply layered and historically resonant work prefigured, and perhaps propelled, the artist's elevation to the highest standing at Jahangir's court a decade later. A mere two weeks after his accession to the throne, Jahangir granted Muhammad Sharif the title of Amir al-Umara' (Amir of Amirs), and would later, in the *Jahangirnama* (Book of Jahangir), his memoirs, describe his attachment to him as "so great that I consider him as a son, brother, friend, and comrade."[54] Muhammad Sharif appears among the attendees of Jahangir's first Nawruz *darbar* as emperor in a painting produced in the later 1610s—possibly by Manohar, another *khanazad* painter—as an illustration for the *Jahangirnama* (fig. 4.8). Shown wearing a pink *jama*, the artist is given pride of place near the emperor. The red pouch that hangs from his neck may contain Jahangir's personal seal.[55] The emperor concludes his commentary on Muhammad Sharif in the *Jahangirnama* by discussing the *khanazad*'s father, Khwaja (Master) 'Abd al-Samad, who was "without equal in his time in the arts of depiction" and had enjoyed the intimate companionship of Humayun and the "honor and dignity" of Akbar.[56] Mounted in the Jahangir Album some years after its execution, the artist's Nawruz painting from 1591 functioned as the material record of contact and commemoration bridging emperor and subject, master and disciple, and father and son.

Epistemic Images

The visibility of imperial subjects and luxury objects was an essential aspect of Nawruz celebrations at the Mughal court, enhanced by the royal painters and the works they created for inclusion in imperial albums and manuscripts. These compositions reflected the painter's role as a performer of pictorial representation and style.[57] But the works they created in association with Nawruz also made the case for the historical function of painting. As 'Abd al-Samad and Muhammad Sharif attempted to establish storied lineages through the production, retouching, and recontextualization of the *'amal-i Nawruz*, artists like Manohar, Abu'l Hasan, and Bishandas staked new claims about painting as a means of documentation and knowledge transmission.

While court records offer ample descriptions of the Nawruz celebrations, we must turn to contemporary accounts from visitors to the Mughal court to gauge the visual impact of the festivities. One rich source is the journal of Sir Thomas Roe, the English ambassador to the Mughal court from 1615 to 1619, who recorded his impressions of the royal Nawruz celebrations of 1616 and 1617 in lavish detail. I quote here only a short passage from his description of Nawruz of 1616:

> Ther is erected a Throne fower foote from the ground, in the Durbar court, from the back whereof to the place wher the King comes out, a square of 56 paces long and 43 broad was rayled in, and covered over with faire Semianes or Canopyes of cloth of goulde, silke, or veluett, joyned together and susteyned with canes so covered. At the end were sett out the pictures of the King of England, the Queene, my lady Elizabeth, the Countesse[s] of Sommersett and Salisbury, and of a Cittizens wife of London; below them another of Sir Thomas Smyth, governer of the East India Company.[58]

Roe's text reveals just how integral the act of being seen was to the Nawruz celebrations at Jahangir's court.

Paintings depicting Nawruz events not only attest to the importance of visibility at royal ceremonial functions; they also re-create (or, more accurately, invent) and thus make visible these momentous ritual performances.[59] The representation of the *darbar* at the first Nawruz celebrations of Jahangir's reign, on 10 March 1606, illustrates this point (see fig. 4.8). The painting depicts rows of courtiers standing in attendance, all of whom are identified by contemporary inscriptions on their turbans and collars. Jahangir is seated on an elaborate throne in the center of the composition. The rows of figures not only create the image of a corporate imperial body but also offer a diverse

catalogue of gazes.⁶⁰ Surprisingly, few of the courtiers are portrayed watching Jahangir, with the exception of Prince Khurram (the future emperor Shah Jahan), to whom Jahangir extends his right hand, and several attendants and nobles standing adjacent to the emperor. The majority of the nobles assembled instead gaze at each other, implying that seeing and being seen were integral to the *darbar* ritual. Even the women of the court take part in the spectacle. Following the protocols of modesty, the doors to their round tents are covered with screens, so that neither the men assembled below nor the viewer of the painting can see them inside, but the royal women can see out.

To watch also meant to be watched, though this principle did not necessarily apply to all. A painting by the imperial artist Abu'l Hasan, intended to be paired with Manohar's to produce a double-page composition, illustrates the politics of courtly spectatorship (fig. 4.7). Here a great crowd, including a European priest, has gathered to watch the assembly depicted in the scene on the facing verso (right-hand) page (fig. 4.8). Those whose gazes are not directed toward the Nawruz assembly are engaged in activities like playing music, bowing in reverence, and dispensing gold coins, but they do not watch each other. The double-page composition's neat division of the Nawruz attendants into observer and observed instantiates in paint the Mughal court's investment in the politics and phenomena of visibility.

Both paintings portray things not as they actually were, but rather as the painters and their patron wished them to be. This point applies not only to the individuals, objects, and spaces depicted but also to the manner of their depiction. Some scholars have attempted to identify the two large-scale paintings displayed on either side of Jahangir's throne in Manohar's work as objective documentation of European objects, both paintings and prints, in the possession of the Mughal court.⁶¹ The most pertinent of these objects is Georg Pencz's engraving, circa 1543, of Tobias and the archangel Raphael (fig. 4.9), which has been proposed as the likely model for the painting of the two angels in the upper left background of Manohar's work.⁶² Attempts to identify this painting's "original" sources, however, neglect a more important point: that Manohar's portrayal of the European work is itself a kind of performance. The artist, for example, depicted Tobias with a pair of wings, an addition that has no connection with Pencz's print or with the tale as it is expounded in the Book of Tobit. If Manohar was referencing the European paintings or prints that had been collected at the Mughal court, he was at the same time demonstrating his capacity to operate in distinctively different (in this case *firangi* or European) representational and stylistic modes.

Of course, the entire painting is also a performance of sorts. Though it

FIGURES 4.7 (left) AND 4.8 (right). Nawruz *darbar* of Jahangir, signed by Abu'l Hasan (left) and attributed to Manohar (right), completed circa 1617–18, northern India. Mounted on pages from the St. Petersburg Album, compiled and margins designed mid-eighteenth century, Iran. Opaque watercolor, ink, silver, and gold on paper. Left-hand painting 37.8 × 22 cm; right-hand painting 37.9 × 22.7 cm. Russian Academy of Sciences, Institute of Oriental Manuscripts, St. Petersburg, E-14, ff. 21r and 22r. (Although the images were likely originally placed on facing pages, in the compilation of the eighteenth-century St. Petersburg Album, they were bound as consecutive recto pages.)

FIGURE 4.9. Georg Pencz, *Tobias and the Angel*, plate 5 from the Tobias and the Angel series, completed circa 1543, Germany. Engraving on paper. Sheet 6.7 × 9.7 cm. Minneapolis Institute of Art, Gift of Elizabeth, Julie, and Catherine Andrus in memory of John and Marion Andrus, 2015.93.141.

purports to depict the events of the 1606 Nawruz celebrations, the painting was executed over a decade later, around 1617–18. In rendering the work, Manohar presumably relied on institutional memory, but he also drew on his own imagination. Artists' reenactments of royal assemblies, like this one, provided Jahangir with a view of the imperial audience and setting that was unavailable to him from his position on the throne. Pictorial representation could make manifest courtly ceremonies, and in particular the politics of seeing that they entailed, in a way that poetic and prose texts could not.⁶³

Jahangir's painters used this mode of performative representation to mimetically depict some of the luxury objects that circulated at the Nawruz celebrations, a phenomenon that demonstrates parallels with European artists' production of "epistemic images" at precisely the same time.⁶⁴ Although the procurement of these items was well beyond the means of most Mughal court painters, masterful depictions of them were not. Artists' depictions of precious goods were deliberate and calculated: they attended in particular to those objects that appealed to their patron the most. The *Jahangirnama* revels

in the unique and unusual gifts that the emperor's subjects presented to him.[65] Exotic objects seem to have made a greater impression on him than those of more local origin. At the Nawruz festivities of 1610, the courtier Muqarrab Khan, having just arrived from the ports of Khambhat and Surat, offered Jahangir "gems, jeweled utensils, containers, gold and silver vessels of European manufacture, and other unusual rarities ... so many Abyssinian slaves, Arabian horses, and every other sort of thing he could think of." During the 1613 celebrations, he presented to Jahangir more prized rarities from Europe, including "a jewel-studded saddle of European manufacture."[66]

A painting of an imaginary meeting between Jahangir and Shah 'Abbas I that the court artist Bishandas completed around 1620, possibly for presentation as an *'amal-i Nawruz* (fig. 4.10), functions as a kind of analogue to these lists of rare and impressive objects.[67] Although the ostensible focal points of the painting are the two emperors, they share center stage with objects of European, Iranian, Indian, and Chinese origin. On a low Italian table in front of the seated rulers is an array of precious items: a Venetian (or imitation Venetian) glass, a Chinese porcelain cup, an Italian ewer made from metal (or perhaps marble), and Iranian vessels. The two opulent braziers in the foreground appear to be of Near Eastern origin. Jahangir's brother-in-law, Asaf Khan, is pictured standing at left holding a gilded cup in one hand and a bottle in the other. On the right, Kham 'Alam, who led a Mughal embassy to the Safavid court in 1613, holds in his left hand a drinking automaton in the shape of Diana and a stag. Perching on his right arm is a falcon, which may reference a specific gift of Russian origin. Platters in the foreground are laden with fruit. While much of this is of South Asian origin, some—including the melons—hails from Central Asia. On the tray at the right is a pineapple, a fruit from the Americas that the Portuguese introduced to South Asia around the mid-sixteenth century.

The objects that Bishandas portrayed resemble real things that likely made their way to the Mughal court. The porcelain cup, for example, is of a particular type produced in Ming China during the late sixteenth and early seventeenth centuries.[68] The automaton is depicted so precisely as to suggest that the artist painted it from an actual model.[69] By referencing specific objects that Jahangir had likely received as gifts, Bishandas framed his own painting as another kind of offering—one on a par with the rare items the artist had represented, for the painting functioned as documentation of the objects that the emperor had received. Bishandas's beguiling composition seeks to prove that pictorial representation is equivalent in value to the precious metal automaton and the succulent pineapple. But painting, being a

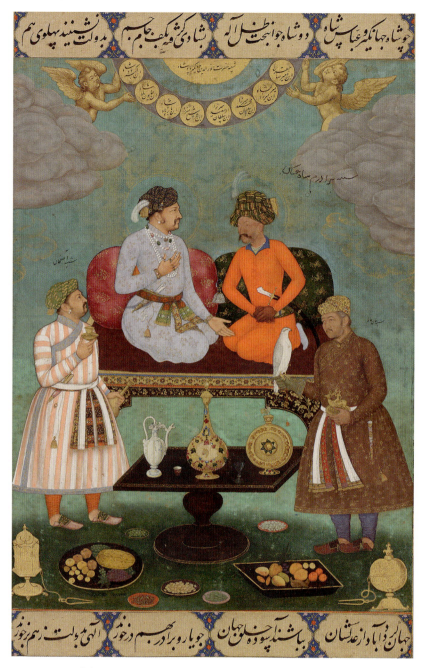

FIGURE 4.10. Jahangir entertaining Shah 'Abbas I, attributed to Bishandas and completed circa 1618, northern India. From a dispersed page of the St. Petersburg Album, compiled eighteenth century, Iran, with decorated margins (here cropped, though comparable to those reproduced in fig. 1.1) added by Muhammad Sadiq in AH 1160 (1747–48). Opaque watercolor, ink, and gold on paper. Folio 47.9 × 33 cm; painting 25 × 18.3 cm. Freer Gallery of Art, Smithsonian Institution, Washington, DC. Purchase—Charles Lang Freer Endowment, F1942.16a.

creative art, could even exceed its referent; Jahangir and Shah 'Abbas, after all, never met in person.

In the section of the *A'in-i Akbari* (Regulations of Akbar) that addresses the imperial painting, or form-making, workshop (*tasvir-khana*), Abu'l Fazl provides a lengthy disquisition on the utility of writing and painting. He asserts that writing (*khatt*) can bring forth the experiences (*tajarib*) of those now past (*pishiniyan*); for, among other reasons, writing brings wisdom (*agahi*) to those far (*dur*) and near (*nazdik*).[70] Were it not for the letter, he continues, speech (*sukhun*) would cease to have life (*zindagi nadashti*), and we would be left with no offering (*armaghani*) from those who have passed (*guzashtagan*). Abu'l Fazl claims, in other words, that writing is fundamental to the transmission of prior knowledge, because its system of signs can effectively convey the sounds of speech. Image making (*tasvir*), he suggests, is not without its own virtues, for it can bring truth (*haqiqat*) to the exoteric-minded (*zahir-nigahan*) and thus is a source of study (*jidd*). In other words, pictures or pictorial forms can, like writing, transmit historical facts; and they can even transcend the value of writing by offering a reliable, even superior, substitute for the object of study. But image making's semiotic regime can also be a source of play (*bazi*) and, in the case of the illusionistic art of the Europeans (*ahl-i firang*), of magic making (*sihr-pardazi*) and deception.[71] It was painting's illusionistic capabilities that gave Mughal painters the greatest pause.

All the World's a Page

The role that royal artists played as the inventors of newfangled images and infeasible worlds was another salient theme that they advanced in their own works. In his portrayal of the encounter between Jahangir and Shah 'Abbas, Bishandas employed a mimetic mode of representation to portray a fictive meeting, thus bringing the role of the painter into question.[72] Does he depict that which comes before him, meaning both the phenomenal world and the long chain of artistic tradition that he has inherited through his training? Or does he create ex nihilo? This question applies to the preparation of album pages as well. The combining and reframing of 'Abd al-Samad's Nawruz works with the two Majnun compositions, discussed earlier in this chapter, created a new, if also impossible, whole. Like the manuscript illustration, this new composition was constructed by copying and stitching together discrete canonical design units. But unlike the manuscript illustration, the tableaux that constitute the two album pages make little narrative sense. The consolidation of these disparate materials instead invokes the possi-

bility that the Mughal artist could rethink convention to create something radically novel.

Combining pictures in a bricolage can also be understood as a meta-commentary on the album's production and the Mughal artists' role in that process. This point is crystallized in another amalgamated page from the Jahangir Album, also created through the joining together of discrete compositions (fig. 4.11). This page combines four paintings. Their edges are masked by landscape embellishments, likely added by a court artist around the early seventeenth century, when the emperor's atelier prepared the works for inclusion in the Jahangir Album. The design units are organized into a grid, with one pair stacked atop the other. The upper right cell contains a depiction of an unidentified elderly, bearded man leaning on a walking stick, a standard trapping associated with imperial elites. To his left appears a strikingly similar-looking man, leaning slightly forward and holding a portrait. The figures in the lower half of the page are clearly artists; the one on the left may even be identified as the painter Keshava Das, who was among the most active artists at Akbar's court.[73] Each of these figures is accompanied by the tools of his trade: tubular pen and brush containers, convex shells for holding paints, and leaves of paper on which the artists appear to be engaged in the act of depiction. The figure on the left is shown creating an image of the Virgin Mary—an apt detail, for Keshava Das is known for his many compositions with European, and specifically Christian, themes. The figure on the right paints a hunting scene, which resembles the illustrations in the narrative manuscripts that the Mughal atelier produced during the 1580s and 1590s.

Taken as a whole, the album page at first creates the illusion of a unified painting rendered on a single paper support. The green ground, the trees, the undulating horizon, and the arrangement of the figures create a sense of spatial cohesion, as if the artists are seated in front of the older, standing men who hover above them on the page. This sense of unity is, however, soon belied by the realization that the figures vary significantly in size. Were the figure at the lower right to stand up, he would tower over the colleague seated opposite him. Close examination also reveals subtle differences in painting styles, indicative of the multiple hands that were likely involved in the creation of the four works.

Although the amalgamated composition seems to fall apart, so to speak, with sustained viewing, its cellular logic nevertheless makes sense within the framework of the Mughal album. The page both draws from and recasts a four-part grid layout that appears frequently in the Jahangir Album and which was also used in Persianate albums of the sixteenth century. Another page from the Jahangir Album bearing four paintings of standing men, all

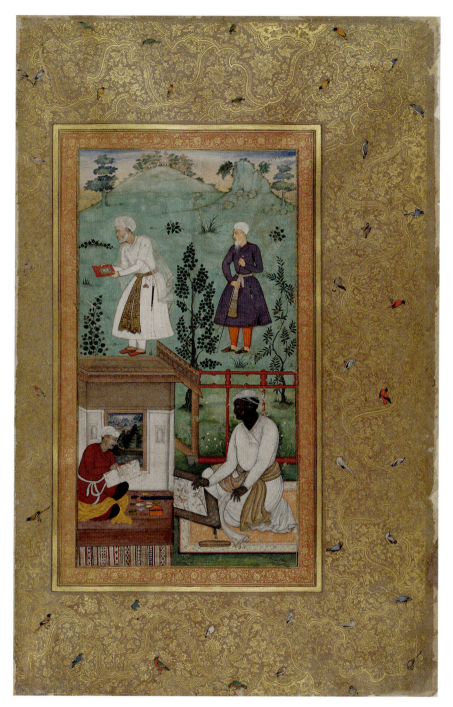

FIGURE 4.11. Collaged page bearing portraits of courtiers and artists, possibly including, at lower left, the painter Keshava Das, completed late sixteenth century–early seventeenth century, northern India. From the dispersed Jahangir/Gulshan Album, compiled circa 1599–1618 and later. Opaque watercolor, ink, and gold on paper. Folio approx. 42.2 × 26.5 cm. Staatsbibliothek zu Berlin, Preussischer Kulturbesitz, Orientabteilung, Libri picturati A 117, f. 21r.

FIGURE 4.12. Collaged page bearing portraits of (counterclockwise from top right) Rana Karan Singh II of Mewar, Suraj Singh Rathor of Marwar (ascribed to Bishandas and dated AH 1017 [1608–9]), Bahadur Khan Uzbek, and the Mughal general Zamana Beg (ascribed to Bishandas), known as Mahabat Khan, completed early seventeenth century, northern India. From the dispersed Jahangir/Gulshan Album, compiled circa 1599–1618 and later. Opaque watercolor, ink, and gold on paper. Folio approx. 42.2 × 26.5 cm. Staatsbibliothek zu Berlin, Preussischer Kulturbesitz, Orientabteilung, Libri picturati A 117, f. 22v.

mounted on a single support, employs the same format (fig. 4.12). The similar green backgrounds of the discrete units, combined with the cursory horizon at the top of the page, lend the composite image a degree of coherence; this is undermined, however, by the gold ruling at the joins of the collage that actually amplifies the fragmentary state of the album page.

Although the portraits of the four men accord with an imperial typology, sharing a similar stature and build, these are not generic representations. Each depicts an individual identified by a nearby inscription, probably copied in Jahangir's own hand. Moving counterclockwise from the top right, the portraits show Rana Karan Singh II of Mewar; Suraj Singh Rathor of Marwar; Bahadur Khan Uzbek, commander of Qandahar; and the Mughal general Zamana Beg, known as Mahabat Khan.[74] The collage created the conditions for visual comparison. It also, however, had the effect of diminishing difference—of making each individual appear to be but part of a larger whole. It is not a coincidence that all the figures also assume the same codified gesture of subservience, with one hand crossed over the other: the presence of the emperor, as the intended recipient of the portraits' gazes and gestures, was always inferred. The court subject's portrait, in other words, always operated in relation to and was contingent on the emperor's gaze. As distinctive as any of these individuals might seem, each could be identified with—and, in this context, illustrated as—the generic type of the compliant subject.

The contrasting emphasis on the artist's active, laboring body on the other album page calls into question the nature of artistic representation itself (see fig. 4.11). Its assemblage of paintings makes the case that the image is but the product of the coordination of eye, hand, and brush, not the fruit of a representational act that might be seen as a challenge to the creative authority of God, as a few hadith (traditions of the Prophet) caution.[75] Some of these traditions predict that on the Day of Judgment, God will ask the painter who has imitated His creative activity to breathe life into his images, and he will fail. The album page's circumspect treatment of image making may seem odd, nevertheless, given the abundance of paintings that Mughal artists produced during the later sixteenth and early seventeenth centuries. Surely the court had reconciled any lingering anxiety around the production of images? The *A'in-i Akbari* suggests otherwise. Its author, Abu'l Fazl, mounts a defense of the production and use of pictures: "It is indeed amazing that from a cultivation of reflection [*abadi-yi andisha*] on observing images [*surat-bini*] and making pictures [*tamthal-arayi*]—which is by itself a source of indolence—came the elixir of wisdom [*jandarad-i agahi*] and a cure for the incurable sickness of

ignorance, and those many haters of painting who blindly followed their predecessors had their eyes opened to seeing the Truth [*haqiqat-bin*]."[76]

With his reliance on painters and paintings to record the likenesses of imperial servants and rivals, Jahangir reaffirmed his predecessor's beneficent views on images and their makers. He had, after all, appointed Bishandas as the Mughal embassy's official portraitist at the Safavid court in 1613. Public texts like the *A'in-i Akbari* and the *Jahangirnama* argued in favor of pictures, but imperial painters also sought to justify their vocation and thereby improve their court standing, and they expressed these aims in their paintings.

The album's mise-en-page offered painters another framework in which to articulate the epistemic value of their creative labors.[77] They drew on convention to delineate the page's design units; the album's viewers were thus primed to take heed of departures from that type. The album page bearing the portraits of the two seated artists, which constitutes an adaptation of the normative four-portrait grid, can be interpreted as a metacommentary on the pretense of painting, if not of the album itself. Viewers of the album would have begun in the upper right quadrant of the page—the natural starting point for most Persian-language codices—with its stock portrait, and then moved to the upper left, where the portrait is doubly represented by the bowing figure and by the work that he holds—a portrait of the same individual grasping the same portrait. This mise-en-abîme creates what Roland Barthes calls a *punctum*, the "sting, speck, cut, little hole" that "pricks" the viewer. For Barthes a punctum is a small detail whose presence utterly alters the meaning of a picture. It is, he elaborates further, "an addition . . . [that] is nonetheless already there," meaning that it is not only a referent but also the thing itself.[78] The Mughal painting inside a painting signifies the objects and acts of painting, but it is also the realization that *all* is representation.

This meditation on pictorial representation is extended in the two lower images, where all depiction is shown to be mere contrivance (fig. 4.13). The image on the right depicts the artist painting a narrative illustration of a hunt, with a figure on horseback who is felling a lion. Below him in the composition is another figure. The illusion of the painting within a painting is, however, undercut by the truncation of the topmost edge of the painting and the board on which it rests (at left). The illustration's unfinished appearance only affirms its constructed nature and also points to image making as durational and processual. The mussel shells resting on the board are empty of the bright paints that they are meant to hold. Their lack of color contrasts with the colorful scene of the artist and his surroundings and again calls attention to the artificiality of the painting process.

The image at bottom left of the album page concludes the metapictorial sequence by juxtaposing an image of a Christian icon with that of a distant and wholly fanciful landscape. Like his counterpart, Keshava Das is depicted (or, more likely, depicted himself) seated with his *qalam-i mu* (paintbrush, lit. "pen made of hair") in his right hand. The small shells on the floor beside him are filled with pigments—red, orange, pink, green, blue, and yellow—yet the image he is working on contains only blue wash and flesh tones. The warmer and more vivid colors held by the shells, however, match the artist's costume and the striped woven rug (*dhurri*) in the immediate foreground, as if to suggest that the subject of the work has painted the very composition in which he appears. He focuses his attention on the task at hand: the completion of what may be, based on the telltale appearance of the blue mantle, an image of the Virgin Mary. Keshava Das is known for his extensive treatment of European and Christian subjects, but this detail seems more than mere happenstance.

FIGURE 4.13. Detail of lower portion of figure 4.11, showing two Mughal painters at work. Staatsbibliothek zu Berlin, Preussischer Kulturbesitz, Orientabteilung, Libri picturati A 117, f. 21r.

Judging by the abundance of Marian imagery in standalone album paintings and illustrated manuscripts, the Virgin—whom Muslims also revere as an exemplar among women—seems to have enjoyed a particular resonance at the courts of Akbar and Jahangir.[79] Her appearance alongside the other three studies mounted on the album page may have served to provide additional grounds for reflection on the nature of painting and the painter's vocation, for here too the depiction is revealed to be but a picture made by human hands. In other words, the painter does not fashion a miraculous image, akin to the Salus Populi Romani, a venerated image of the Virgin Mary and Christ Child today housed in Rome, which (as the Jesuits in residence at the Mughal court would have explained) Saint Luke was believed to have rendered himself.

The incomplete Marian painting is counterposed with—in fact, it literally cuts through—the representation of the deeply recessed landscape. The illusionism of this landscape is rendered void by its framing within the album page. If all four figures are presented as residing in the same space,

in proximity to one another, the viewer must accept that the landscape in the window belongs to some other spatial order altogether. Is it a figment of the artist's imagination—in which case, which artist exactly? Is it instead meant to be a depiction of a mural? Or is it, as the neighboring paintings so insistently affirm with regard to their own status, just paint on a page?

The metapictorial themes taken up here are raised elsewhere in the Jahangir Album. A depiction of a young Prince Akbar presenting a painting to his father, Humayun, draws attention to the role that pictorial figuration played in royal rituals and economies of gift exchange (fig. 4.14).[80] It also illustrates the capacity for painting to reflect on its status as a heuristic, if also hazardous, medium. Probably produced around 1555–56, the painting depicts a royal festivity—possibly associated with Nawruz—in a two-story garden pavilion. As attendants carry porcelain and metal vessels, entertainers perform music. A hunting party is shown returning with its kill in the foreground. Seated on an elaborate platform nestled in a tree next to the pavilion, Akbar is shown handing a painting to Humayun, who is enthroned opposite him. The gift is also ours to enjoy, for the young prince tilts the paper support outward to reveal that it bears a copy of the album painting itself. The artificiality of representation is once again laid bare.

The artist's presence is as salient here as it was in the previous example. Inscriptions in the cartouches above and below the painting identify 'Abd al-Samad as the author of both the album painting and its miniature likeness.[81] These were likely added in the early seventeenth century when the work was prepared for inclusion in the Jahangir Album. The painter's signature appears within the painting, on a golden bifolio lying on the green tiles in the forecourt of the pavilion, and reads *Allahu Akbar, al-'abd 'Abd al-Samad Shirin Qalam* (God is great. The slave 'Abd al-Samad "Sweet Pen").[82] Scholars have generally accepted the hypothesis, posed some time ago, that the turban-capped figure seated on the tiles, with a *qalamdan* (pen case) and inkpot beside him, must be a self-portrait of the artist.[83] The inclusion of this self-portrait may be explained by the fact that 'Abd al-Samad and his fellow artist Mir Sayyid 'Ali apparently schooled Akbar in the arts of painting.[84] The work may allude to their master-student relationship, for the emulation of masters' works was among the primary ways that students learned to paint.[85] But Akbar, of course, did not execute the painting; rather, 'Abd al-Samad did. Thus the album painting can be seen as a tribute to the painter's status as both court artist and instructor to the heir apparent.

At the same time, the work shows off 'Abd al-Samad's abilities as a painter in minuscule, for which he was celebrated during his own lifetime. According

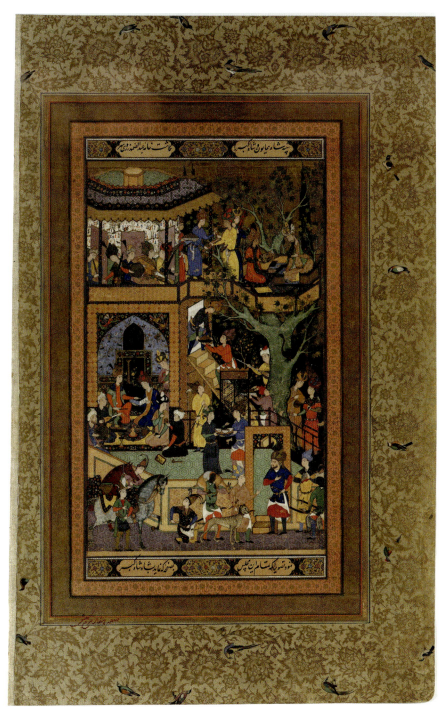

FIGURE 4.14. Festivities at the court of Humayun, signed by 'Abd al-Samad and completed circa 1555–56, probably Delhi. From the dispersed Jahangir/Gulshan Album, compiled circa 1599–1618 and later. Opaque watercolor, ink, and gold on paper. Folio approx. 41.5 × 27.5 cm. Golestan Palace Library, Tehran, Ms. 1663, f. 70.

to a letter attributed to Humayun, 'Abd al-Samad is said to have "stolen the ball of precedence from his peers. On one grain of rice he has made a vast field wherein some people are playing polo.... Also on a grain of rice he has made a hall.... He has also drawn a rider on a poppy seed."[86] The painter aimed to impress his royal patron, the prince, and the other members of the court by reproducing an existing painting on a tiny scale. One wonders whether and how this potentially infinite recursive sequence continues—does the painting of the painting contain yet another painting of a painting?

'Abd al-Samad's ventures into the infinitesimally small draw comparison with calligraphers' practices of writing Qur'anic verses on grains of rice and poppy seeds. According to the Mughal courtier 'Abd al-Qadir Bada'uni, 'Abd al-Samad had accomplished this as well.[87] The copying of Qur'anic inscriptions on this scale is not only a feat of wonder: it makes possible the attachment of the text to the user's body, like an amulet, to serve as a material reminder of the devotee's investment in the text and, by implication, in God.[88] In the *A'in-i Akbari*, Abu'l Fazl ascribes to the act of painting an important mnemonic value that puts it on par with devotional acts. He couches his assessment of painting and the painter's vocation within a series of remarks attributed to Akbar:

> One day in an intimate assembly, when the fortunate few had gained his proximity, His Majesty remarked: "I cannot tolerate those who make the slightest criticism of this profession [*pisha*]. It seems to me that a painter [*musavvir*] is better than most in gaining knowledge of God [*khuda-shinasi*]. Each time he draws a living being he must draw each and every limb of it, but seeing that he cannot bring it to life must perforce give thought to the miracle wrought by the Creator [*ba-nirangi-yi jan-afrin*] and thus obtain an awareness [*shinasayi*] of Him."[89]

The emperor's apologia here inverts the hadith that cautions the artist against the depiction of humans and animals, lest he be called upon to breathe life into his creations. In Abu'l Fazl's account, it is the artist's recognition of the insentient nature of his representations that enables him to gain "knowledge of God." Like the calligrapher's minute copying of the Qur'anic text, the painter's replication of objects at multiple scales calls attention to the artificiality of the pictorial enterprise. It does so in part by drawing painter and viewer into close proximity with the object of scrutiny. These enterprises thus share a revelatory, if also contradictory, function: both engage the eye to reveal a hidden truth, yet in doing so they underscore humankind's cognitive and creative limitations.

The Mughal painter's meditations on the benefits and pitfalls of his vocation might seem misplaced in the context of the imperial album. Jahangir's *muraqqaʻ* was probably viewed by only a very select group of royals, diplomats, painters, calligraphers, bookmaking professionals, and librarians. In spite of the album's size—the folios average forty-one centimeters in height and twenty-eight centimeters in width—its format meant that only a handful of people could view it at once. In general, painting (and painters) enjoyed a far more public profile through media such as mural painting. Pictures of animals, humans, and celestial creatures abound on the walls of the palace structures in Fatehpur Sikri and Lahore; garden pavilions associated with the patronage of Nur Jahan, Jahangir's favorite wife, in Agra also bear traces of figural paintings.[90] If the depictions of Mughal architecture in sixteenth- and seventeenth-century manuscript and album paintings are any indication of historical practice, mural paintings were far more numerous than the current state of the materials would suggest. As Abu'l Fazl, Akbar, and Jahangir attest through their defenses of the pictorial arts, the licitness of figural painting had not been firmly established. The court painter's status remained fraught and open to contestation.

In spite of its intimate nature, especially as compared with the mural, the album painting became the primary locus for the artist's defense of his craft. This choice may be explained by the codex's long-standing association with the production and dissemination of knowledge in the Islamic world. Embedding in a book his most extended ruminations on the ontology of depiction, the artist aimed to establish that painting, like the codex, was a means of knowledge production. In their pursuit of this objective, Mughal artists utilized metapictorial techniques—such as restaging canonical compositional formulas and replicating images inside images—to illustrate the insurmountable creative limitations of paintings and painters. In exposing the artificiality of representational figuration, the imperial painter at once conceded that God's demiurgic agency reigned supreme while asserting painting's uniquely epistemic status.[91]

THE JAHANGIRNAMA'S VOLUMINOUS ACCOUNTS of the robes, coins, and other objects of value that the emperor bestowed and received leave one with the impression that little else transpired at court. Gift exchange played a central part in the constitution of Mughal sovereignty throughout the year.[92] Nawruz, however, was the most important occasion for the presentation of

gifts. The orchestration of the audiences enabled royal and servant alike to witness these displays of largesse. One of the key functions of the Nawruz-*julus* celebrations, after all, was to showcase the emperor's munificence and the imperial courtiers' status and wealth. The constitution of Mughal court society—from the emperor's sovereignty to the subject's rank—depended on the visibility of these materially and symbolically loaded transactions, which the presence of an audience helped to establish. By training court members' eyes on these constitutive interchanges, the *darbar* primed attendees to take account of their own and others' actions.

Court painters as well as nobles had to contend for royal favor. In this they competed not only with fellow members of the imperial manuscript workshop but also with other courtly entertainers. As Mughal chronicles show, poets and musicians could garner royal rewards greater than any that painters apparently collected.[93] According to one official text, for example, the legendary musician Tansen received two hundred thousand rupees for his first performance at Akbar's court.[94] During the Nawruz festivities of 1608, verses likening the emperor to the sun earned a poet the reward of an elephant. And in 1615, a poem composed by the *hakim* (doctor) Masih al-Zaman elicited a reward of one thousand *mohur*s—an amount that, as Seyller observes, exceeded the valuation of "almost every manuscript of the highest quality."[95] Royal painters must have understood that their advancement at court depended on their ability to create works that were, like poetry and music, both enduring and temporally contingent. By invoking the ceremonies, gifts, and other events associated with Nawruz cerebrations, imperial paintings invited viewers to reflect on past, present, and future ritual occasions.

By focusing on his labor—or lack thereof, as exemplified by the *'amal-i Nawruz* compositions—the painter asserted that his works were as performative and thus as valuable as those of poets, musicians, and other court entertainers. The major difference, of course, was that poets and musicians actually performed their works in courtly gatherings; the painter's performance inhered in the object itself. But painting, unlike poetry, and to a far greater extent than music, was a fraught vocation in the Islamic world, where image making could be perceived as a challenge to the creative authority of God. Mughal artists' claims regarding the epistemic status of their works produced a similar paradox, whereby paintings would be understood as rivaling the documentary functions of writing but could also represent a threat to a cosmological order that identified the Divine as the "supreme giver of form [*musavvir*]," as described in an inscription penned on the work that Abu'l Hasan made "in haste" for Nawruz.

In downplaying the labor and originality involved in their work, Abu'l Hasan and 'Abd al-Samad hence sought to abnegate any claims to having actually invented their compositions. (Abu'l Hasan's source material was an imperial dream, while 'Abd al-Samad drew from canonical, oft-repeated designs for both his Nawruz works.) In the Jahangir Album—one of the primary repositories for artistic performances like these, as well as a context that invited transactional polemics about the artist's vocation and picture making itself—the focus on the industry of the painter could serve similar ends by self-reflexively calling attention to the creation of the images and of the codex itself. Both moves—simultaneously affirming and denying the creative agency of the painter—paradoxically absolved the artist of any perceived transgression. Painting, in these terms, could be construed as mere lines and color on a page, and the artist as a mere copyist.

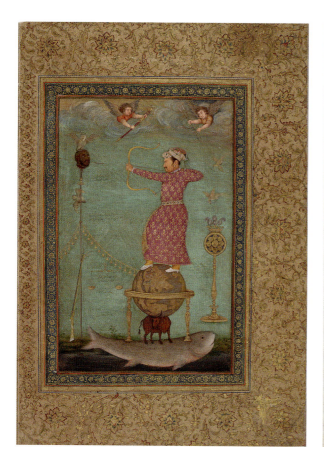

FIGURE E.1. Jahangir shooting the head of Malik 'Ambar, ascribed (in homage to) Abu'l Hasan and completed early nineteenth century, probably Delhi. Opaque watercolor, ink, and gold on paper. Folio 38 × 26 cm; painting 23.3 × 15 cm. Freer Gallery of Art, Smithsonian Institution, Washington, DC. Purchase––Charles Lang Freer Endowment, F1948.19a.

FIGURE E.2. Jahangir shooting the head of Malik 'Ambar, attributed to Ghulam 'Ali Khan and completed circa 1825, probably Delhi. Opaque watercolor and gold on paper. Painting 27.7 × 18 cm. San Diego Museum of Art, Edwin Binney 3rd Collection, 1990.409.

EPILOGUE
From Copy to Trace

WITH ITS GRUESOME AND BEGUILING IMAGERY, Abu'l Hasan's painting of Jahangir shooting the head of Malik 'Ambar is an image that one does not soon forget (see fig. 1.11). That it continued to engage artists and collectors centuries after its production is suggested by an early nineteenth-century copy, probably made in the Mughal capital of Delhi, now in the Freer Gallery of Art in Washington, DC (fig. E.1). Although this is not an exact replica of the early seventeenth-century painting, the similarities are striking. The copy echoes the original's composition and coloring, from the detailed renderings of the mother cat and kittens on the globe to the pink hue of the emperor's costume. The later artist even reproduced Abu'l Hasan's inscriptions, including his signature. Another nineteenth-century rendition of the same subject, this one probably executed by the late Mughal painter Ghulam 'Ali Khan, is embedded inside a series of genealogical portraits depicting Babur, Humayun, and Akbar with their Timurid ancestors (fig. E.2). Abu'l Hasan's painting clearly left a lasting impression.

These two works are not isolated phenomena. Numerous paintings created in South Asian centers of power, from Delhi and Lucknow to Hyderabad and Jaipur, during the eighteenth and nineteenth centuries reference or copy Mughal paintings from the first half of the seventeenth century. Although the Mughals' political power had begun to wane following the death of Jahangir's grandson, the long-reigning Emperor Aurangzeb 'Alamgir (r. 1658–1707), the work of earlier Mughal imperial artists like Abu'l Hasan retained its currency. Indeed, it seems to have been precisely during the eighteenth century—just as the empire's power was declining—that seventeenth-century Mughal painting became fully canonized, in large part through its circulation and copying elsewhere.[1] The political instability that plagued the empire encouraged the movement of royal artists to other courts

in search of opportunities, and a series of invasions of the Mughal capital in the eighteenth century also led to looting and thus to the dispersal of Mughal manuscript materials to far-flung destinations.

The inherent mobility of Mughal paintings, drawings, codices, and painters expedited this dispersal. One important avenue of transmission was the Hindu Rajput rulers and princes whom Akbar and Jahangir had required to serve in their imperial administrations. On returning to their dynastic abodes, the Rajput princes took with them not only imperial affects and codes of behavior but also a preference for Mughal modes of pictorial representation and the painters who created them.[2] In addition, Mughal royals and elites established their own libraries and manuscript workshops that facilitated the transfer and collection of illustrated books, whether made on site, purchased, or received as gifts or booty.

Other Mughal paintings and albums found a generative reception beyond South Asia. Abu'l Hasan's painting of Jahangir's dream of his rival Shah 'Abbas I (see fig. 1.1) was probably among the many objects—including the Jahangir Album—that the Afsharid ruler Nadir Shah (r. 1736–1747) likely carried to Iran following his invasion of Delhi in March 1739. This and other Mughal paintings were shortly thereafter recontextualized in a royal album that may have been made for Nadir Shah's grandson, Shahrukh Shah (r. 1748–1750, 1750–1796).[3] At some point during the rule of Ahmad Shah Qajar (r. 1909–1925), Abu'l Hasan's painting, mounted on the Afsharid album page (as it is still today), was removed from the royal collections in Tehran. The Freer Gallery of Art acquired the work in 1945. The rest of the Afsharid album, including a number of other seventeenth-century Mughal paintings, was purchased by Tsar Nicholas II (r. 1894–1917) in 1910. The album was subsequently known as the Leningrad Album and later the St. Petersburg Album after its new home, where it, for the most part, remains.

Abu'l Hasan's painting of Jahangir shooting Malik 'Ambar traveled a different path to reach its current home in the Chester Beatty Library, Dublin. It was sold at a London auction in 1925 as part of an album containing seventeenth-century Mughal paintings and calligraphies whose eighteenth- and nineteenth-century provenance remains obscured. Although the identity of the consigner, a Lord Minto, is known, scholars have not yet been able to establish just how this English noble came into possession of these works. In any event, the American-born industrialist and collector Alfred Chester Beatty, in collaboration with the Victoria and Albert Museum, made a successful bid for the lot, and the album—thereafter known as the Minto Album—was subsequently divided between Dublin and London.

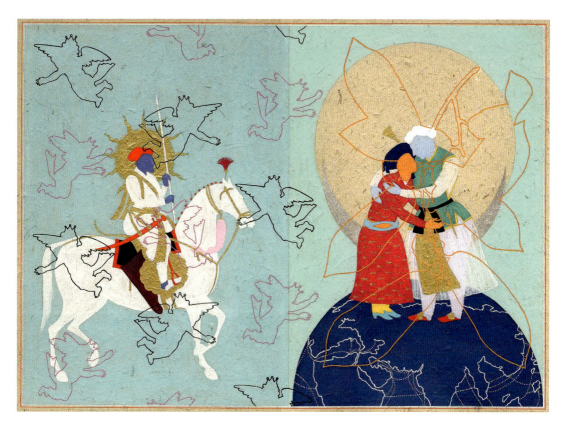

FIGURE E.3. Nusra Latif Qureshi, *Considerate Flying Objects I*, 2002. Gouache and acrylic on wasli. Painting 26.5 × 36.5 cm. Copyright © Nusra Latif Qureshi. Image courtesy the artist and Sutton Gallery, Melbourne.

The pages of the Minto Album share a complicated relationship with two other albums—the Kevorkian and the Wantage Albums, today housed in the Metropolitan Museum of Art and the Victoria and Albert Museum, respectively—that contain early nineteenth-century copies of seventeenth-century Mughal works.

These examples attest to the signal role of the album—as a rhetorical device, a cultural frame, and a material device—in advancing sixteenth- and seventeenth-century Mughal painting's circulation and canonization from the eighteenth century onward. Many of these works may owe their survival to their preservation in albums, which protected them from exposure to light and indiscriminate touching. The irony, of course, is that it is precisely the format of the album that spurred the frequent translocation of Mughal court paintings and their copies.

Today, the phantasmagoric productions of Abu'l Hasan and his colleagues are readily accessible through print and digital media. Combining modern

reproductive technologies with traditional manuscript painting methods, a number of artists from South Asia have laid claim to the complicated legacies of Mughal painting and its makers. Among these, the Pakistani-Australian artist Nusra Latif Qureshi's *Considerate Flying Objects I*, completed in 2002, stands out for its creative appropriation of Abu'l Hasan's depiction of Jahangir's dream of Shah 'Abbas, discussed in chapter 1 (fig. E.3). In Qureshi's rendering, the Mughal and Safavid rulers enjoy the company of Jahangir's son and successor, Emperor Shah Jahan (r. 1628–1658), mounted on horseback, and multiple cherubim. The golden outline of a tamarind branch, or some other botanical specimen, floats over the images of Jahangir, Shah 'Abbas, and the terrestrial globe on which they stand. Defying expectations, Qureshi dispenses with the intricate detail that fills the seventeenth-century album page and instead distills Abu'l Hasan's work into an assemblage of layered lines and blocks of color. In doing so, she returns to the fundamentals of the Mughal painter's practice, in line and contour. If Qureshi's work is about the multiple and many-layered predicaments of the postcolonial citizens of Pakistan, for whom the Mughal and colonial forms of rule linger as indelible traces, it is also a testament to the lasting power of Abu'l Hasan's iconic image. It is, in the end, a reminder that the Mughal painter gave form not only to his royal patron's dreams but also to his own; and by returning to his traces, Qureshi can make this world of images her own, too.

NOTES

Introduction

1. Melvin-Koushki, "Early Modern Islamicate Empire," 353. See also Moin, "Sulh-i Kull."

2. Chann, "Lord of the Auspicious Conjunction."

3. Similar references also appear in the *Tarikh-i Alfi* (Millennial history), a history of the first one thousand years of Islam that Akbar commissioned in 1582 (Moin, *The Millennial Sovereign,*" 133–34).

4. Bada'uni, *Muntakhab-ut-Tawarikh*, trans. Elliot and Dowson, 532.

5. Roxburgh, "Micrographia."

6. As Roxburgh and, more recently, Balafrej have proposed, the wealth of detail evinced by late fourteenth- through sixteenth-century illustrated Iranian manuscripts represents one of the avenues by which royal artists staked new claims about the utility and status of painted images (Roxburgh, "Micrographia"; Balafrej, *The Making of the Artist*).

7. Poetry and calligraphy likewise privilege adherence to and mastery of precedent. See, for example, Losensky, *Welcoming Fighānī*; and Roxburgh, "The Eye is Favored," 283.

8. Seyller, "Model and Copy."

9. The relationship of early Mughal painting to European images and objects has been the subject of numerous studies. For the most recent examinations of this topic, see Botchkareva, "Representational Realism"; Rice, "Lines of Perception"; Gonzalez, *Aesthetic Hybridity*; Natif, *Mughal Occidentalism*; K. Singh, *Real Birds in Imagined Gardens.*

The *firangi* (i.e., European) mode of representation also flourished at the court of the Safavid ruler Shah Sulayman I (r. 1666–1694), under the aegis of the imperial painter Muhammad Zaman. For a study of this artist's work, including a critique of twentieth-century art historians' inadequate appreciation of the complexity and diversity of Persian painting, see Landau, "From Poet to Painter." For an examination of the artist's Europeanizing oeuvre as exoticizing and unstable rather than realistic in intent and function, see Botchkareva, "Representational Realism," 123–33.

10. Necipoğlu argues that by 1600 the European mode (which she terms "Frankish") had supplanted the Chinese as the primary exemplar of naturalism in the Persianate sphere ("Persianate Images between Europe and China").

11. K. Singh characterizes this phenomenon as a tense, if also ultimately productive, process of accommodating allusion with illusion (*Real Birds in Imagined Gardens*, esp. 71–79), while Botchkareva interprets it as a part of a larger project to marry highly descriptive representational techniques drawn from European sources with Persianate conventions of serialized depiction ("Representational Realism," 323–28). For a foundational study on artists' selective—and thus highly deliberate—adaptation of European representational strategies in the time of Shah Jahan, see Koch, "Hierarchical Principles."

12. On the cosmopolitanism of European images and representational techniques, especially in the context of the Mughal album, see Rice, "Global Aspirations."

13. The emphasis on the knowledge, synthesis, and generation of novel forms of expression at the Mughal court was not an entirely new phenomenon. On court agents' earlier impetus to reconcile two cultural traditions (namely the Persian and Sanskrit cosmopolises) at the early modern royal centers of the Deccan, see Flatt, *The Courts of the Deccan Sultanates*, 19–22.

14. Kinra, "Fresh Words."

15. Moin, "Sulh-i Kull."

16. Bean, "The Unfired Clay Sculpture of Bengal," 621–22.

17. Mitter, *Art and Nationalism*, 198–99.

18. The Mughal emphasis on the imperial patron as the *kitabkhana*'s key taste maker echoes earlier, mainly Timurid, royal exemplars. On Prince Baysunghur of Herat (1397–1433) as one such active patron-practitioner, see Roxburgh, "Baysunghur's Library."

19. Abu'l Fazl, *A'in-i Akbari*, trans. Naim, 1:183.

20. On the rhetorical thrust of Abu'l Fazl's text, and the *a'in-i tasvir-khana* (regulation on the painting workshop) especially, see Seyller, *Pearls of the Parrot*, 30–31; and Rice, "'One Flower from Each Garden,'" 142–43.

21. Abu'l Fazl, *A'in-i Akbari*, ed. Blochmann, 1:52. Abu'l Fazl claims that Akbar's "penetrating insight" extends even to his oversight of the imperial kitchen (*matbakh*).

22. I exclude from the count the mentions of governors and ministers. The painters listed include Mir Sayyid 'Ali, 'Abd al-Samad, Dasavanta, Basavana, L'al, Mukund, Miskina, Farrukh, Madhava, Jagana, Mahesha, Khemkaran, Tara, Sanvala, Haribans, and Ram (Abu'l Fazl, *A'in-i Akbari*, trans. Blochmann, 1:114; Abu'l Fazl, *A'in-i Akbari*, ed. Blochmann, 1:117); the calligraphers Muhammad Husayn, Mawlana Baqir, Muhammad Amin, Mir Husayn-i Kulanki, Mawlana 'Abd al-Hayy, Mawlana Dawri, Mawlana 'Abd al-Rahim, Mir 'Abdullah, Nizami, 'Ali Chaman, and Nurallah Qasim Arsalan (Abu'l Fazl, *A'in-i Akbari*, trans. Blochmann, 1:109; Abu'l Fazl, *A'in-i Akbari*, ed. Blochmann, 1:115); and the translators Amir Fathullah, Naqib Khan, 'Abd al-Qadir, Shaykh Sultan, Hajji Ibrahim, Shaykh Fayzi, Mukammal Khan, 'Abd al-Rahim Khan, Mawlana Shah Muhammad, Mullah Ahmad, Qasim Beg, Shaykh Munawwar, Mawlana Sheri, Nasrullah-i Mustawfi, and Mawlana Husayn-i Wa'iz (Abu'l Fazl, *A'in-i Akbari*, trans. Blochmann, 1:110–12; Abu'l Fazl, *A'in-i Akbari*, ed. Blochmann, 1:115–16).

23. Abu'l Fazl, *A'in-i Akbari*, trans. Blochmann, 1:22; Abu'l Fazl, *A'in-i Akbari*, ed. Blochmann, 1:18. Abu'l Fazl here also makes reference to the *diwan*s Todarmal and Qulij Khan as well as Amir Fathullah Shirazi, who, as Amin al-Mulk, assisted in the regulation of the imperial revenue system.

24. Abu'l Fazl, *A'in-i Akbari*, trans. Blochmann, 1:28; Abu'l Fazl, *A'in-i Akbari*, ed. Blochmann, 23.

25. Abu'l Fazl, *A'in-i Akbari*, trans. Blochmann, 1:120; Abu'l Fazl, *A'in-i Akbari*, ed. Blochmann, 1:125.

26. On Mughal imperial attitudes toward books, on the other hand, see Lefèvre, "Recovering a Missing Voice," 481–82; and on the library of 'Abd al-Rahim Khan-i Khanan (1556–1627), see Seyller, *Workshop and Patron*, 24–38.

27. Abu'l Fazl, *A'in-i Akbari*, trans. Blochmann, 1:109, 114; Abu'l Fazl, *A'in-i Akbari*, ed. Blochmann, 1:115, 117.

28. See, for example, Verma, *Mughal Painters and their Work*; and, more recently, Beach, Fischer, and Goswamy, *Masters of Indian Painting*. These major contributions to the study of Mughal manuscript painting draw on these inscriptional data to produce catalogues raisonnés that foreground the autonomy rather than the collective identities of workshop artists.

29. I arrived at this number by estimating the number of surviving, planned, and now-lost illustrated pages in sixteen illustrated manuscripts produced at the Mughal court between approximately 1562 and 1598.

30. Seyller, "Scribal Notes."

31. On the corporeal and tacit knowledge held by early modern—in this case European—makers, see P. Smith, *The Body of the Artisan*.

32. Bourdieu, *Outline of a Theory of Practice*, esp. 72–86.

33. I also draw on Elias, *The Court Society*, a historical study informed by sociological theory.

34. Dost Muhammad, "The Bahram Mirza Album Preface," trans. Thackston, 11–12. The album that contains Dost Muhammad's preface now resides in the Topkapı Saray Museum, Istanbul, where it bears the shelfmark H.2154. On the album and its afterlife, see Roxburgh, "Disorderly Conduct?"; and Roxburgh, *The Persian Album*, esp. 245–308. On references to the "chest of witnessing" in the *Tarikh-i alfi* (Millennial history), composed at Akbar's court between 1582 and 1588, see Moin, *The Millennial Sovereign*, 297n53.

35. Roxburgh, "Concepts of the Portrait," 120.

36. K. Singh, *Real Birds in Imagined Gardens*, 71.

37. Dost Muhammad, "The Bahram Mirza Album Preface by Dost-Muhammad," trans. Thackston, 12. According to Roxburgh, Dost Muhammad here draws on the *Rawzat al-Safa'* (Gardens of purity) by Mir Khwand (1433–98) (*Prefacing the Image*, 175).

38. Roxburgh, "Concepts of the Portrait," 120–21.

39. Gruber, "In Defense and Devotion," 106.

40. Gruber, "In Defense and Devotion," 112–17. For illustrations of these pictorial manipulations in the manuscript (Topkapı Palace Library, B.282), see figs. 4.10–4.13.

41. Gruber, "In Defense and Devotion," 117–18. For reproductions of the illustration (Museum of Islamic Art, Berlin, I.44/68), see figures 4.14 and 4.15.

42. Leach, *Paintings from India*, 221–27; Farhad and Bağci, *Falnama*.

43. On the life and career of Mir Sayyid 'Ali, see Brend, "Another Career for Mirza 'Ali?" On 'Abd al-Samad, see Soucek, "'Abd-al-Ṣamad Šīrāzī"; and Soucek, "Persian Artists in Mughal India."

44. Abu'l Fazl, *A'in-i Akbari*, trans. Blochmann, 1:103, with my own modifications; and Abu'l Fazl, *A'in-i Akbari*, ed. Blochmann, 1:111.

45. Abu'l Fazl, *A'in-i Akbari*, ed. Blochmann, 1:111. It is unlikely that the production of figural painting enjoyed undivided support among Mughal elites, particularly the *'ulama*. Mughal royalty's extensive patronage of illustrated manuscripts, as well as murals, attests to the central place that painting nevertheless occupied in the imperial milieu.

46. For several exemplary studies of this kind, see Seyller, *The Adventures of Hamza*; Seyller, "Model and Copy"; and Seyller, *Pearls of the Parrot*.

47. Art-historical scholarship's undue emphasis on pristine manuscript copies, along with the concomitant neglect of damaged, dirty, and altered specimens, has recently been redressed in Rudy, *Piety in Pieces*; Gruber, "In Defense and Devotion"; and, regarding the use of later seventeenth-century Mughal portraiture in devotional contexts, Mumtaz, "Contemplating the Face of the Master."

48. The mode of analysis advanced here finds a kinship with Wu Hung's approach to the study of the Chinese painted screen, which he characterizes as "an image-bearing object *and* as a pictorial image" (*The Double Screen*, 9). For a more recent study of the play between surface and pictorial plane, with respect to plastic arts in the medieval Islamic world, see also Graves, *Arts of Allusion*.

49. Thackston, trans., in Wright, *Muraqqa'*, 290, 294.

50. For the most recent overviews of the Gulshan (or Jahangir) Album, see Beach, "Jahangir's Album"; Beach, "*Muraqqa'-i Gulshan*: The Inscriptions"; Eslami, "Golšan Album"; and Stronge, "The Gulshan Album." Regarding the number of leaves that this now largely dispersed album originally held, see Stronge, "The Gulshan Album," 80.

51. On the utility of the *muraqqa'* as a social and socializing object, see especially Roxburgh, *The Persian Album*.

1. Inner Visions

1. This group of roughly contemporaneous paintings, all associated with Jahangir's patronage and reproduced in this volume, also includes Bichitra's depiction of Jahangir seated on an hourglass throne (Freer Gallery of Art, Smithsonian Institution, Washington, DC, F1942.15a); Bichitra's double-page portraits of Jahangir and a Sufi saint (Chester Beatty Library, Dublin, In 07A.5, In 07A.14); a depiction of Jahangir seated with Shah 'Abbas I, likely executed by Bishandas (Freer Gallery of Art, Smithsonian Institution, Washington, DC, F1942.16a); a depiction of Jahangir shooting a personification of poverty, probably completed by Abu'l Hasan (Los Angeles County Museum of Art, M.75.4.28); and Abu'l Hasan's depiction of Jahangir shooting Malik 'Ambar (Chester Beatty Library, Dublin, In.07A.15.10).

2. The Persian reads: *Shah-i ma dar khwab amad pas mara khushvaqt kard / dushman-i khwab-i manast ankas ki az khwabam rubud.*

3. Chashma-yi Nur (Spring of Light) was a pleasure palace Jahangir erected near a spring in the hills west of Ajmer, Rajasthan. An inscription on the complex's *pishtaq* (rectangular frame around a vault) dates its construction to AH 1024 (1615). For photographs of the now-ruined palace, as well as a full translation of the inscriptions located on its *pishtaq*, see Koch, "My Garden Is Hindustan," 164, figs. 8, 9.

4. Jahangir never met Shah 'Abbas, but he did send a diplomatic mission, which included the royal artist Bishandas, to the Safavid court in 1613 to negotiate the rival courts' shared claims over Qandahar. It was during this visit that Bishandas produced the portraits of Shah 'Abbas that Abu'l Hasan later consulted to create his depiction of the ruler in his painting of Jahangir's dream.

5. Other writings also reflect the idea that there are three types of dreams: those received from God, those borne by the devil, and those that originate in the dreamer. For one example that postdates Ibn Khaldun, see Abdalghani al-Nabulusi (1641–1731), *Ta'fir al-anam fita'bir al-manam*, cited in Von Grunebaum, "Introduction," 7–8. In Rosenthal's translation of the *Muqaddimah*, this passage is translated as "Allegorical dream visions, which call for interpretation, are from the angels" (Ibn Khaldun, *The Muqaddimah*, trans. Rosenthal, 83).

6. Cited in Sviri, "Dreaming Analyzed and Recorded," 256. Qur'an 75:9 states that on the day of resurrection, the sun and the moon will be fused. In Abu'l Hasan's portrayal of Jahangir's dream, the solar and lunar bodies are clearly overlaid. Kunitzsch, "Sun."

7. This list is excerpted from a longer inventory provided in Fahd, "Les songes et leur interprétation," 32. Fahd adapted his own list from Abu Sa'id Nasr b. Ya'qub al-Dinawari's famous treatise *al-Qadiri fi-t-ta'bir* (written in 1006 CE), and the *Muntakhab al-kalam fi tafsir al-ahlam*, which has been attributed to the famous eighth-century oneirocritic Ibn Sirin but was more likely compiled from a variety of sources around the ninth century by Husayn b. Hasan b. Ibrahim al-Khalili al-Dari. For more on both texts, see Fahd, "The Dream in Medieval Islamic Society," 359–61.

8. On the interpretation of the prophet's dreams in hadith, see al-Bukhari, *The Translation of the Meanings of Sahih al-Bukhari*, 83–85.

9. For one such example, see the diary of the Sufi Ruzbihan Baqli (1128–1209), *The Unveiling of Secrets*.

10. Quinn, "The Dreams of Shaykh Safi al-Din," 128.

11. Cited in Quinn, "The Dreams of Shaykh Safi al-Din," 143. Prior to his tenure at the Safavid court, Khwandamir had worked as a chronicler among the royal circles of Timurid Herat. In the late 1520s he migrated to India, where he served as a scholar-administrator to both Babur and Humayun, and, at the behest of the latter, authored the *Qanun-i Humayuni* (Auspicious canons). Khwandamir, like the many other specialists who were active at the Mughal court during the sixteenth and seventeenth centuries, possessed close connections to the Persianate courts of Iran and Central Asia.

12. Cited in Quinn, "The Dreams of Shaykh Safi al-Din," 143.

13. For recent studies on the history of dreams in the Islamic world, see Knysh and Felek, *Dreams and Visions in Islamic Societies*; and Niyazioğlu, *Dreams and Lives in Ottoman Istanbul*.

14. Moin, *The Millennial Sovereign*, 174.

15. Losty, "Abu'l Hasan," 81. Here Losty draws from Skelton's earlier analysis of solar imagery in Bichitra's painting of Jahangir seated on an hourglass (Skelton, "Imperial Symbolism in Mughal Painting," 180–81).

16. Okada, *Indian Miniatures of the Mughal Court*, 55.

17. See, for example, Koch, "The Influence of the Jesuit Mission," and, more recently, Koch, "Being Like Jesus and Mary."

18. On this text, see Malti-Douglas, "Dreams, the Blind." The concept of the dream allegory originates in Greek works on dream interpretation, the most famous of which is the second-century *Oneirocritica* of Artemidorus of Ephesus. As Malti-Douglas explains, the *Oneirocritica* is largely concerned with allegorical (*allāgorikoi*) dreams, which are "encoded, usually in a symbolic manner, that is . . . the dream's significance or message is not the same as the dream narrative which must be interpreted or translated to yield this message" ("Dreams, the Blind," 145).

19. Ibn Khaldun, *The Muqaddimah*, trans. Rosenthal, 370.

20. Writing specifically on Abbasid dream narratives, Fahd points to the broader implications of this displacement of authorship: "The dream serves as a screen on which a past history is projected, a history the chroniclers were unable to write; if they were able to write it, for one reason or another, they used the dream as a subterfuge for telling it" (Fahd, "The Dream in Medieval Islamic Society," 352).

21. Sviri, "Dreaming Analyzed and Recorded," 256.

22. Moin, *The Millennial Sovereign*, 206, 210.

23. Babur, *The Baburnama*, trans. and ed. Thackston, 120.

24. Jahangir, *Jahangirnama*, trans. Thackston, 162; Jahangir, *Jahangirnamah*, ed. Hashim, 153. An album painting today housed in the Musée Guimet, Paris (n.3676 B), may depict this dream encounter between Jahangir and his father, Akbar (discussed in chapter 3).

25. Green, "Religious and Cultural Roles of Dreams," 295, 297.

26. Green, "Religious and Cultural Roles of Dreams," 298; Kinberg, "Literal Dreams and Prophetic *Hadīth*," 285–86.

27. Von Grunebaum, "Introduction," 12.

28. Brittlebank, "The Dreams of Kings," 362.

29. Nizam al-Din Awliya (1238–1325), a renowned member of the Chishti *silsila* in South Asia, recounts several such instances of Sufi oneiric encounters in the *Fawa'id al-Fu'ad* (Morals for the heart), a record of conversations between Nizam al-Din Awliya and the poet and devotee Amir Hasan Chishti (see Nizam al-Din Awliya, *Nizam Ad-Din Awliya: Morals for the Heart*, 329, for one such example).

30. Geoffroy, "*Tadjallī*."

31. The two paintings are today mounted on folios that were once part of the so-called Minto Album, which is currently divided between the Chester Beatty Library and the Victoria and Albert Museum. The Minto Album is described in detail in Stronge, "The Minto Album and Its Decoration."

32. Although Skelton, Leach, Stronge, and Ramaswamy refer to the spheres held by both figures as terrestrial globes, neither sphere bears any markings that support this identification (see Skelton, "Imperial Symbolism"; Leach, *Mughal and Other*

Indian Painting, 1:398; Stronge in "The Gulshan Album," cat. nos. 36, 37; and Ramaswamy, "Conceit of the Globe in Mughal Visual Practice," 774).

33. The wording on the two paintings differs slightly. The inscription on the image of Mu'in al-Din reads *raqm-i Bichitra banda-yi dargah* (figure by Bichitra, slave of the court), while the inscription on the Jahangir painting reads *'amal-i Bichitra banda-yi dargah* (work of Bichitra, slave of the court).

34. *Fath* here means "opening," as with a key (*kalid*) and a lock, but also "victory."

35. Another example of this type of visual "encounter" across gutter margins is the double-page composition, ascribed to Abu'l Hasan, showing Jahangir in *darbar* on one side (Freer Gallery of Art, F1946.28), and Sufis (one carrying a book) and Ottoman court figures on the other (Walters Art Museum, W. 668, fol. 37a). The use of the codex format as a means to evoke encounters across space and time finds an interesting parallel in Northern Renaissance depictions of the Virgin with a donor, with the donor portrayed on a separate panel from the Virgin and Child (e.g., the Diptych of Martin van Nieuwenhove, dated 1487, today housed in Bruges, Sint-Janshospitaal, Memlingmuseum).

36. According to Richards, Akbar had ended any pretense of devotion toward the Chishti *silsila* after 1585. Jahangir revived the Mughal dynastic connection with Mu'in al-Din Chishti (Richards, *The Mughal Empire*, 52, 105).

37. Muhammad-Hadi in Jahangir, *Jahangirnama*, trans. Thackston, 4–5.

38. Jahangir, *Jahangirnama*, trans. Thackston, 293–94; Jahangir, *Jahangirnamah*, ed. Hashim, 294.

39. Asher notes that Akbar had presented a similarly large cauldron to the *dargah* of Mu'in al-Din Chishti, and she suggests that Jahangir's donation held "dynastic significance" (Asher, *Architecture of Mughal India*, 118–19).

40. According to Asher, the railing disappeared at some point in the eighteenth century (Asher, *Architecture of Mughal India*, 119).

41. Jahangir, *Jahangirnama*, trans. Thackston, 161; Jahangir, *Jahangirnamah*, ed. Hashim, 152.

42. Jahangir, *Jahangirnama*, trans. Thackston, 162; Jahangir, *Jahangirnamah*, ed. Hashim, 153. The date for the palace's completion is provided in the chronogram *mahal-i shah Nur al-Din Jahangir* (palace of Emperor Nur al-Din Jahangir), equivalent to AH 1024, which the emperor ordered the goldsmith Sa'ida-yi Gilani to compose and engrave on a stone that was affixed to an *ayvan* (vault) in the complex (*Jahangirnama*, trans. Thackston, 162n7).

43. Mirza refers to visions that one perceives while sleeping near sacred sites as "incubation dreams" ("Dreaming the Truth," 20).

44. Mirza, "Dreaming the Truth," 20.

45. Babadžanov, Muminov, and Nekrasova, "Le mausolée de Chashma-yi 'Ayyûb."

46. On the *chashma* of Khwaja Seh Yaran, as well as a painting depicting the celebration of Akbar's circumcision at this site, see Parodi and Wannell, "The Earliest Datable Mughal Painting." I discuss this particular painting in the context of Nawruz presentation works in chapter 4.

47. See Koch, "My Garden Is Hindustan," 162–63. The complex is known as Nilkanth (the blue-throated one) because the spring is associated with the Hindu god Shiva.

48. The fully translated inscription is provided in Tirmizi, *Ajmer through Inscriptions*, 36–38. In his memoirs, Jahangir makes multiple references to parties at Chashma-yi Nur (see, e.g., Jahangir, *Jahangirnama*, trans. Thackston, 169, 173, and Jahangir, *Jahangirnamah*, ed. Hashim, 159, 161 on Nawruz offerings presented at Chashma-yi Nur by the vizier I'timad al-Dawla and the Mughal general Mahabat Khan, respectively, in 1615 for the Nawruz-*julus* celebrations). Even Sir Thomas Roe, English ambassador to the Mughal court, reportedly visited Chashma-yi Nur on at least one occasion, on 1 March 1615 (Roe, *The Embassy of Sir Thomas Roe*, 1:138).

49. Bibi Hafiz Jamal is buried in an enclosure located just south of her father's tomb in the *dargah* complex in Ajmer.

50. Moin similarly regards Jahangir's dream paintings as "both [records] of and [mediums] for the emperor's miraculous self" (*The Millennial Sovereign*, 210).

51. Pertinent in this regard is Juneja's understanding of the material construction, juxtaposition, and, especially, layering of paintings on Mughal album pages like these as suggestive of a new kind of visuality rooted in geographical and temporal passage (Juneja, "Circulation and Beyond," 73).

52. Hay, "Interventions," 435.

53. On this subject more generally, see Malecka, "Solar Symbolism"; Asher, "A Ray from the Sun"; S. A. A. Rizvi, *Religious and Intellectual History*; Richards, "The Formulation of Imperial Authority."

54. Abu'l Fazl, *The History of Akbar*, trans. Thackston, 1:174 [English], 173 [Persian].

55. Moin, "Akbar's 'Jesus' and Marlowe's 'Tamburlaine.'"

56. Suhrawardi was adviser to al-Malik al-Zahir al-Ghazi, the governor of Aleppo and son of the Ayyubid Sultan Salah al-Din. The philosopher's works thus cannot be viewed in isolation from the politics and intrigues of the day. Ziai suggests that what he calls Suhrawardi's "illuminationist political doctrine" was looked upon by the philosopher's biographers "as having such compelling practical implications that it led to al-Suhrawardi's death" (Ziai, "The Source and Nature of Authority," 343). Suhrawardi was executed in Aleppo in 1191 CE on the orders of Salah al-Din, ostensibly for corrupting the mind of the ruler's son.

57. Abu'l Fazl, *A'in-i Akbari*, trans. Blochmann, 1:3; Abu'l Fazl, *A'in-i Akbari*, ed. Blochmann, 1:2.

58. In addition to naming his palace in Ajmer the Spring of Light, Jahangir also granted his favorite wife the title of Nur Mahal (Light of the Palace) and in 1616 promoted her to the epithet Nur Jahan (Light of the World). On the depiction of *shamsa*s on Mughal thrones, see Malecka, "Solar Symbolism."

59. See Ernst, "Fayzi's Illuminationist Interpretation of Vedanta"; Asher, "A Ray from the Sun."

60. Ziai, "The Source and Nature of Authority," 314.

61. As Ziai explains, "Al-Suhrawardi discusses the special divine light called the *kharra* and distinguishes two types: simple *kharra* bestowed by the Holy Spirit (*al-ruh al-qudus*) on any human being and *kiyan kharra* bestowed upon kings. Whoever obtains this latter type of light will have manifest powers" (Ziai, "The Source and Nature of Authority," 315n29).

62. Ziai, "The Source and Nature of Authority," 325–26, 328–29.

63. Translated and cited in Ziai, "The Source and Nature of Authority," 329.

64. Schimmel, *Deciphering the Signs of God*, 63.

65. On the importance of Suhrawardi's *'alam al-mithal* for later Sufi writers on dreams, see Green, "A Brief World History of Muslim Dreams," 160–61.

66. See, for example, the numerous devotional prayers to the sun and the moon, among other celestial bodies, examined in Walbridge, "The Devotional and Occult Works." Abu Ma'shar (d. 886), a Khurasani astrologer who served at the Abbasid court in Baghdad, was another important source on astrological and celestial devotional practices, including sun worship, mined by Mughal writers of the late sixteenth century. See Moin, "Painted Rituals," 64–65.

67. Unlike many of the other dream paintings, the LACMA painting does not bear a signature or attributive inscription. Because of its close stylistic and thematic relationship with the Chester Beatty Malik 'Ambar painting, many scholars, including Skelton and Pal, have surmised that it was executed by Abu'l Hasan (Skelton, "Imperial Symbolism," fig. 5 caption; Pal, *Indian Painting*, 262–65). The date of the painting remains a subject of debate. Paintings made later in the century for Jahangir's son Shah Jahan and grandson Aurangzeb also employ solar imagery, albeit in quite different ways than in the dream paintings made for Jahangir.

68. Jahangir's blinding of *daliddar* in the LACMA painting also has disturbing parallels to the actual partial blinding of his son Khusraw in 1607, a gruesome punishment for the prince's seditious behavior. This event is not mentioned in Jahangir's memoirs but is recorded in other contemporary sources: see Beveridge, "Sultan Khusrau," 597–99. The blinding of heirs was not unique to the Mughals; it was also common at the courts of the Timurid and Byzantine rulers, among others.

According to the *Jahangirnama*, Jahangir passed an edict in 1612 that barred provincial Mughal amirs from punishing by blinding (Jahangir, *Jahangirnama*, trans. Thackston, 127; Jahangir, *Jahangirnamah*, ed. Hashim, 117); ordering this punishment was a strictly royal prerogative.

69. From Suhrawardi, *Opera II*, 134, quoted and translated in Ziai, *Knowledge of Illumination*, 160. In Walbridge and Ziai's critical translation of Suhrawardi's *Hikmat al-ishraq*, the sections on optics and vision can be found on pages 70–73 and 139–40.

70. Ziai, *Knowledge of Illumination*, 161.

71. Ziai, *Knowledge of Illumination*, 161.

72. On Suhrawardi's theory of the emanation of light, see Ziai, *Knowledge of Illumination*, 162–66.

73. Suhrawardi's Illuminationist theory takes the form of a critique of the Peripatetic epistemological approach. Ziai explains that Suhrawardi wished not to dispense with Aristotelian philosophical systems but rather to create an ideal doctrine that fused both discursive and intuitive methodologies (Ziai, *Knowledge of Illumination*, 36–37). Suhrawardi builds on Ibn 'Arabi's theories of knowledge by arguing for a correspondence between corporeal and spiritual vision. Both Suhrawardi's and al-Ghazali's epistemologies privilege mystical experience and intuition as a means of obtaining instantaneous knowledge of the divine. Al-Ghazali employs the metaphor of the heart's mirror, which "catches" images from the hidden or immaterial world, whereas Suhrawardi likens spiritual cognition to optical seeing.

74. Ziai, *Knowledge of Illumination*, 133.

75. Suhrawardi termed this central aspect of his philosophy "knowledge by presence" (*'ilm huduri*).

76. For an illuminating analysis of this painting and its relationship with the *Jahangirnama*, see Moin, *The Millennial Sovereign*, 193–95. For the *Jahangirnama* passage in question, see Jahangir, *Jahangirnama*, trans. Thackston, 201; Jahangir, *Jahangirnamah*, ed. Hashim, 192.

77. Trans. Thackston, in *Muraqqa'*, ed. Wright, 348.

78. Malecka, "Solar Symbolism," 24; Darling, "'The Vicegerent of God,'" 424–25.

79. Trans. Thackston, in *Muraqqa'*, ed. Wright, 346.

80. The classic exemplar is Ettinghausen, "The Emperor's Choice."

81. According to Firdawsi, the eleventh-century author of the *Shahnama*, Jamshid lost his *farr* because he ceased to maintain right and just rule. The concept of *farr*, which figures in both Suhrawardi's discourse on divine light and Abu'l Fazl's history of the Mughal lineage, originated in pre-Islamic Iran, the temporal and geographic context for much of the *Shahnama*'s narrative. See Soudavar and Beach, *Art of the Persian Courts*, 410–16; and Soudavar, *The Aura of Kings*.

82. Yasht 19:31–53, translated in Humbach and Ichaporia, *Zamyād Yasht*, 37–44. The entire text of Yasht 19 is devoted to the discussion of *khwarna*, the Avestan equivalent of *farr*. Note that the Jamshid of the *Shahnama* is known in the Avesta as Yima. See also Soudavar, "Farr(ah) ii. Iconography of Farr(ah)/Xareneh."

83. According to Berlekamp, "As early as the ninth century, the mystic al-Hakīm al-Tirmidhī had described exactly this arrangement. According to his interpretation, the point is that whatever seems to serve as a foundation for the world must itself have a foundation. The successive foundations seem increasingly precarious until one finally accepts that they all rest upon God" (*Wonder, Image, and Cosmos*, 197n28). Skelton was the first scholar to make the link between Jahangir's dream paintings and Islamic cosmologies like this one ("Imperial Symbolism," 182).

84. Moin, *The Millennial Sovereign*, 195.

85. See Derrida, "Structure, Sign, and Play."

86. Ettinghausen, "The Emperor's Choice," 98–107.

87. Derrida, "Structure, Sign, and Play," 289.

88. Hermansen, "Visions as 'Good to Think,'" 31. On Ibn 'Arabi's use of dreams as cognitive tools, see Knysh, "Dreams and Visions," 1.

89. Bashir, "The World as a Hat," 344.

90. On the religious and historical discourses shared by the two empires, also see Moin, *The Millennial Sovereign*.

91. Bashir, "The World as a Hat," 362.

92. For a complementary interpretation of the unusual compositional structure of Jahangir's dream painting, see K. Singh, *Real Birds in Imagined Gardens*, 65–70. Singh argues that the unusually flat depiction of the carpet disrupts the composition's sense of spatial depth. She conjectures that painters deliberately included such pictorial and representational disjunctions to "show [their] awareness of what [their] skill produced: an illusion, marks on paper" (70).

93. For the most recent studies on this subject, see Botchkareva, "Representational Realism"; Rice, "Lines of Perception"; Gonzalez, *Aesthetic Hybridity in Mughal*

Painting; Natif, *Mughal Occidentalism*; and K. Singh, *Real Birds in Imagined Gardens*.

94. Koch, "Being Like Jesus and Mary," 209, 207.

95. For alternative interpretations of the curious tension between illusion and abstraction evidenced in manuscript paintings created at the Mughal court during the late sixteenth through the mid-seventeenth century, also see the insightful commentary in Koch, "Netherlandish Naturalism"; Minissale, *Images of Thought*, 31–36; and K. Singh, *Real Birds in Imagined Gardens*, 63–70.

96. On the transmission of knowledge in Islamicate societies through the written and spoken word, see Ernst, *Eternal Garden*; F. Robinson, "Technology and Religious Change"; Schoeler, *The Oral and the Written*; DeWeese, "Aḥmad Yasavī and the Dog-Men"; and DeWeese, "Orality and the Master-Disciple Relationship."

97. Interestingly, an illustrated manuscript of the *Nafahat al-Uns* (British Library, Or. 1362) was made for Akbar in Agra in 1604–5. It is, as far as I know, the only illustrated copy of this text made in the Persianate world up to this time. Its execution may thus point to an early interest in pictorial documentation of the visions of the fairly recently deceased. Especially remarkable are depictions of visions experienced by Abu'l Husain Qarafi (f. 142r) and Razi al-Din 'Ali Lala al-Ghaznavi (f. 271v). Other paintings in the manuscript depict miraculous events that were witnessed or effected by Sufis.

On the *Fawa'id al-Fu'ad*, see Nizam al-Din Awliya, *Nizam Ad-Din Awliya*, esp. 102 and 174, for Nizam al-Din's commentary on dreams.

98. Koch has made similar claims regarding the Mughal use of painting as an alternative medium for the articulation of political allegories that had previously been expressed only in writing (Koch, "The Influence of the Jesuit Mission"; Koch, "Being Like Jesus and Mary," 209–10).

99. Just why it was imperial painters, as opposed to writers, who depicted Jahangir's visions and dreams remains a fundamental question debated among scholars. Koch, treating the paintings as political allegories rather than as depictions of encoded dreams that bear political ramifications, argues that the Jesuits' theory of and rationale for the production of sacred, venerated images provided the primary impetus for Mughal artists' creation of what she characterizes as "a more complex category of symbolic representation" ("Being Like Jesus and Mary," 207). Moin suggests that the pictorial format allowed for the intimate consumption of Jahangir's dreams by a select group of people; textual representations would have lent themselves to wider circulation and, one presumes, scrutiny (*The Millennial Sovereign*, 210). Both theories help to explain why this significant transformation from textual to pictorial representations of imperial dreams occurred when and where it did, but neither accounts for the part that court painters played in effecting this shift, nor how the production of these works troubled the status of painting and, ultimately, of the painter.

100. On the parallel use of the Sufi dream narrative as a means of voicing one's authorial agenda, see Bashir, "Narrating Sight," 34.

101. For illuminating comments on the presence of the painter in this work, see Juneja, "On the Margins of Utopia," 240.

2. Workshop and Empire

1. On the status of this and other contemporaneous Mughal manuscript depictions of calligraphers, painters, and other book specialists on colophon pages, see Das, "Calligraphers and Painters in Early Mughal Painting"; and Rice, "Between the Brush and the Pen."

2. See, for example Das, *Mughal Painting during Jahangir's Time*, an important study that points to Jahangir's apparent preference for Iranian over Indian painters as the catalyst for these transformations.

3. Seyller, "The Walters Art Museum *Diwan*"; Seyller, "A Mughal Manuscript of the *Diwan* of Nawa'i"; Beach, "The Gulshan Album"; Carvalho, "Salim's Role as Patron"; Beach, *Muraqqaʿ-i Gulshan*," 437–46.

4. On the copious primary and secondary literature and paleographical evidence bearing on the dating of Akbar's *Hamzanama* manuscript, see Seyller, *The Adventures of Hamza*, 32–41.

5. Mulla Da'ud, a Muslim poet from Dalmau in present-day Uttar Pradesh, completed the *Chandayan* around 1377–78. Based on an older tale about the romantic trials of the hero, Laur, and his beloved, Chanda, Mulla Da'ud's rhyming text is considered to be among the earliest Sufi poems written in Hindavi (also known as Awadhi). On the fifteenth-century illustrated manuscripts of the *Chandayan*, see Losty, *The Art of the Book in India*, 37–54, cat. nos. 34, 45, 46; Adamjee, "Strategies for Visual Narration"; and Adamjee, "Artistic Agency in Painted Narratives."

6. The patronage of illustrated Persian manuscripts by northern and central Indian royalty and elites during the so-called Sultanate period—labeled by scholars "Sultanate painting"—has been a source of much debate, as many of the works that identified with the region are undated and do not bear the names of the patrons or their places of production. On this topic, see, among other works, Skelton, "The *Ni'mat nama*"; Ettinghausen and Fraad, "Sultanate Painting in Persian Style"; Digby, "Literary Evidence for Painting"; Goswamy, *A Jainesque Sultanate* Shahnama; Brend, *Perspectives on Persian Painting*, 73–100; and Brac de la Perrière, *L'art du livre*.

7. See, for example, the essays in Orsini and Sheikh, *After Timur Left*.

8. On early Mughal illustrated manuscripts and albums attributable to the patronage of Humayun, see Soucek, "Persian Artists in Mughal India," esp. 169; Canby, *Humayun's Garden Party*; Richard, "An Unpublished Manuscript"; Melikian-Chirvani, "Mir Sayyed Ali"; S. C. Welch, "Zal in the Simurgh's Nest"; Parodi et al., "Tracing the History of a Mughal Album Page"; Parodi and Wannell, "The Earliest Datable Mughal Painting"; and Parodi, "Tracing the Rise."

9. For a summary of this argument, based on both textual and codicological evidence, see Seyller, *The Adventures of Hamza*, 44–47.

10. The *Tutinama* (Cleveland Museum of Art, 1962.279) was likely illustrated during the 1560s, and the *Anvar-i Suhayli* (School of Oriental and African Studies, University of London, MS 10102) was probably completed around 1570.

11. One of the earliest uses of the term *Indo-Persian* appears in V. Smith, *A History of Fine Art in India and Ceylon*, esp. chapter 14, titled "Indo-Persian or Mughal Painting," 450–99.

12. This nineteenth- and early twentieth-century notion of style as geographically and ethnically bound should be distinguished from the sixteenth-century historiographical approach advanced by the Shirazi courtier Ja'far Beg, which saw Akbar's capacity to rule as intimately tied to his location in Hindustan (see Anooshahr, "Dialogism and Territoriality," 243–49).

13. Brown, *Indian Painting*, 72. Brown draws from eighteenth-century theories, propounded most famously by the German art historian Johannes Winckelmann (1717–1768), which posited that style emerged from an indefinable nexus of landscape, climate, and spirit. In the nineteenth century, this geographically contingent notion of style later was associated with ethnicity, nationhood, and race. See Sauerländer, "From Stilus to Style." For a more recent critique of stylistic attributions as such, see Feldman, *Communities of Style*, 11–42.

14. Coomaraswamy, "Originality in Mughal Painting," 876. In the same article, Coomaraswamy likens Mughal painting to the works of Giotto and Botticelli, for all "expressed . . . the same childlike purity of soul, the same gentle wonder at the beauty of flowers and animals, the same mysterious sweet serenity in the faces of women, the same worship of humanity as a symbol of the divine" (881).

15. On the idea of Mughal painting as an import to South Asia, see also Waraich, "Competing and Complementary Visions," 88–89.

16. Coomaraswamy, *Rajput Painting*, 1:5–6. Coomaraswamy's characterization of Mughal painting as innately secular is echoed in Brown's *Indian Painting* (45) as well as in S. C. Welch's much later *India: Art and Culture*. For a critique of Coomaraswamy's depiction of Rajput painting as mystical, see Aitken, "Introduction."

17. See, for example, Chandra, *The Tūtī-Nāma*, 1:162.

18. Fraser, "Introduction," 17.

19. Abu'l Fazl, *A'in-i Akbari*, trans. Naim, 182, with my modifications; Abu'l Fazl, *A'in-i Akbari*, ed. Blochmann, 1:116.

20. Abu'l Fazl, *A'in-i Akbari*, trans. Naim, 183; Abu'l Fazl, *A'in-i Akbari*, ed. Blochmann, 1:117.

21. De Monserrate, *The Commentary*, 201.

22. Seyller, "Scribal Notes," 277.

23. Faruqui's *Princes of the Mughal Empire* makes comparable claims about the role that subimperial actors played in the creation of an imperial politic.

24. S. C. Welch, "The Paintings of Basawan." Note, however, that V. Smith's *History of Fine Art in India and Ceylon*, originally published in 1911, spearheaded this approach by focusing on the roles of 'Abd al-Samad, Mir Sayyid 'Ali, and several other artists in shaping the formation of an imperial painting style (454–56). The revised edition of Smith's book gives even more attention to the chief painters of Akbar's manuscript atelier (*A History of Fine Art in India and Ceylon*, rev. Codrington, 206–10).

25. In contrast, Beach's *The Imperial Image*, which followed the publication of his *Grand Mogul* by only a few years, organized its contents by individual manuscripts, albums, and illustrated leaves. Beach was not the first to compile such a catalogue, however. Brown's 1924 *Indian Painting under the Mughals* includes a list of known repositories, manuscripts, and artists. Verma's *Mughal Painters and Their Work* expanded on Beach's work by providing extensive catalogues raisonnés for all of the painters

identified in the ascriptions of manuscript illustrations associated with the patronage of Akbar, Jahangir, and Shah Jahan.

26. Beach, Fischer, and Goswamy, *Masters of Indian Painting*.

27. Abu'l Fazl, *A'in-i Akbari*, trans. Naim, 183; Abu'l Fazl, *A'in-i Akbari*, ed. Blochmann, 1:117. The artists whom Abu'l Fazl identifies as forerunners are Mir Sayyid 'Ali, 'Abd al-Samad, Basavana, and Dasavanta; and the commendable artists, in order of appearance in the text, are Keshava, L'al, Mukund, Miskina, Farrukh, Madhava, Jagana, Mahesha, Khemkaran, Tara, Sanvala, Harbans, and Ram.

28. Here Naim translates *yigana-yi zamana* as "uniquely excellent" (Abu'l Fazl, *A'in-i Akbari*, trans. Naim, 184).

29. Khuda Bakhsh Library, Patna, Ms. 79. The binary division of the Mughava illustrative process hews to a paradigm canonized in fifteenth- and early sixteenth-century courtly Iran, in which the *tarh* was appraised more highly than coloring.

30. The main studies of this fragmentary manuscript are Seyller, "Codicological Aspects"; and Stronge, *Painting for the Mughal Emperor*, 36–85.

31. Basavana designed and Tara Kalan colored the illustration, which is the right-hand side of the double-page spread; according to the marginal inscriptions, Basavana also designed the composition on the left-hand page (Victoria and Albert Museum, IS.2:62-1896), but the artist Asi, not Tara Kalan, was responsible for the coloring.

32. Examples include illustrations in the manuscript copies of the Cleveland Museum of Art *Tutinama* (1962.279.33b, 1962.279.36b) and the British Library *Darabnama* (Or. 4615, f.34a).

33. Seyller, "Scribal Notations," esp. 256–60.

34. Most scholars have drawn on the artist ascriptions to generate catalogues raisonnés of select artists. One notable exception is Smart, "Paintings from the *Bāburnāma*," which uses FAMULUS, a computerized bibliographical sorting and indexing program developed in the late 1960s by the US Forest Service, to analyze the frequency of artist ascriptions from nine late sixteenth-century Mughal illustrated manuscripts.

35. These notations begin to appear with some frequency only around the early 1580s (they appear infrequently in the Cleveland *Tutinama*, and in each instance the ascription credits only one artist with executing the illustration). It is difficult to know whether such collaborations never occurred earlier or whether they did and were simply not recorded in this fashion.

36. The speculative dates offered here place the manuscript's production in the new imperial city of Fatehpur Sikri. Losty and Roy, however, contend that some or all of the manuscript was illustrated in Lahore, pointing to the presence of the "Lahori" *nisba* (suffix) in two of the artist ascriptions (*Mughal India*, 32).

37. This calculation takes into account paintings that were at some point removed from the manuscript, whose existence can be confirmed by lacunae in the sequential numbering system that a member of the Mughal atelier inscribed on every illustrated page. The excising of paintings from manuscripts by nineteenth- and twentieth-century dealers and collectors was, unfortunately, a common occurrence in British India as well as in Europe and North America. On the peregrinations and modifications made to the British Library *Darabnama*, see Sims-Williams, "The Tales of Darab."

38. Déroche et al., *Islamic Codicology*, 86–88.

39. British Library, London, Or. 4615, f. 103v.

40. This hypothesis is informed by the numerous erasures and corrections that were made to the artistic ascriptions, suggesting that the process of illustrating the *Darabnama* was fraught with irregularities.

41. On the Mughal illustrated copies of the *Razmnama* and the *Ramayana*, see Seyller, "Model and Copy"; Seyller, *Workshop and Patron*; Das, *Paintings of the* Razmnama; and Rice, "A Persian Mahabharata."

42. On the translation of the *Mahabharata* into Persian at Akbar's court, see Truschke, "The Mughal Book of War"; and Truschke, *Culture of Encounters*.

43. Victoria and Albert Museum, London, IS.2:91-1896.

44. For a fuller explanation of these methods and findings, including the histograms I created from the data, see Rice, "Workshop as Network."

45. These graphs, which I created using Gephi, an open-source network analysis and graphing software program, are also reproduced in Rice, "Workshop as Network." There I provide a more detailed interpretation of these graphs, exploring how they may bear on an understanding of manuscript workshop practices at Akbar's court during the 1580s.

46. Abu'l Fazl, *A'in-i Akbari*, trans. Naim, 183; Abu'l Fazl, *A'in-i Akbari*, ed. Blochmann, 1:117

47. Social network analysis is a method of studying social ties and larger structures using statistical analytics and graphs. See Granovetter, "The Strength of Weak Ties."

48. Victoria and Albert Museum, London, IS.2:106-1896 and IS.2:107-1896.

49. This plant also makes an appearance in another illustration for which L'al is identified as the designer (Victoria and Albert, London, IS.2:108-1896).

50. Victoria and Albert Museum, London, IS.2:42-1896, IS.2:76-1896, IS.2:102-1896, IS.2:108-1896, and IS.2:109-1896.

51. According to a marginal inscription first detected by Seyller, the left-hand painting appears to have taken around forty days to complete (Seyller, "Scribal Notes," 259n49). The inscription could also be interpreted as a deadline for the illustration's completion.

52. Interestingly, Coomaraswamy identified a similarly dichotomous appreciation of designing and outlining versus laying down color in a commentary on painting in the Sanskrit plays *Pratijnayaugandharayana* of Bhasa (fl. third or fourth century CE) and *Shakuntala* of Kalidasa (fl. fourth century CE) (*The Transformation*, 103). For example, the character Mishrakeshi in Kalidasa's *Shakuntala* differentiates between "skill 'with the brush and in outline'" (*vartika-rekha-nipunata*) and "skill 'in color and line'" (*varna-rekha*). I thank Phillip B. Wagoner for sharing this reference with me.

53. These include illustrated pages in the Jaipur *Razmnama* (no. 4), the Jaipur *Ramayana* (nos. 1920, 1925), and the Keir *Khamsa* (ff. 119a, 286b). For a full list of manuscript ascriptions associated with L'al, see Verma, *Mughal Painters*, 221–31.

54. For a more detailed discussion of this study, see Rice, "Workshop as Network."

55. These included L'al, Basavana, Dasavanta, Mukund, Tara, Jagjiwan, Kanha, Keshava, Khemkaran, Madhava, Paras, Tuksi, Anis, Jagana, Mahesha, Mukhlis, and Shankara.

56. According to the marginal inscriptions, folio 89 was designed by L'al and colored by Mukund; folio 125 was designed by Mukund and colored by L'al.

57. Bourdieu, *Outline of a Theory of Practice*, esp. 72–86.

58. Bourdieu, *Outline of a Theory of Practice*, 72.

59. Wenger and Lave, *Situated Learning*, 53.

60. Although the manuscript is fragmentary, its 116 extant illustrations nevertheless constitute a large enough number to allow speculation about patterns in the division of artistic labor.

61. In the *A'in-i Akbari*, Abu'l Fazl remarks on the progress made by the imperial *tasvir-khana* with regard to the production of colors, for which he credits Akbar: "His majesty has looked deeply into the matter of raw materials and set a high value on the quality of production. As a result, colouring has gained a new beauty, and finish a new clarity" (*A'in-i Akbari*, trans. Naim, 182–83; *A'in-i Akbari*, ed. Blochmann, 1:116).

62. Roxburgh, "Micrographia," 27.

63. Roxburgh, "Kamal al-Din Bihzad and Authorship," 136. On the subject of artistic originality and imitation in Persianate manuscript painting, see also Adamova, "Repetition of Compositions"; Lamia Balafrej, *The Making of the Artist*; in the context of later Mughal and Rajasthani painting, Aitken, "Parataxis"; and Rice, "Painters, Albums, and Pandits."

64. According to Chandra's definition, de luxe manuscripts typically have fewer than forty-five illustrations, evidence a high degree of finish, and are poetic in content (*The Tūtīnāma*, 59–60). See also Seyller, "The School of Oriental and African Studies *Anvār-i Suhaylī*"; and Seyller, *Pearls of the Parrot*, 36.

65. Notable de luxe manuscripts associated with Akbar's patronage include the *Anvar-i Suhayli* (Lights of Canopus) of circa 1570 (School of Oriental and African Studies, University of London, MS 10102), the 1588 *Divan* (Collected poems) of Anvari (Fogg Art Museum, Harvard University, 1960.177), the 1596 *Baharistan* (Spring garden) of Jami (Bodleian Library, Oxford University, MS Elliott 254), and the 1597–98 *Khamsa* (Quintet) of Amir Khusraw (Walters Art Museum, Baltimore, W. 624, and the Metropolitan Museum of Art, New York City, 13.228.26–33).

66. The manuscript (British Library, London, Or. 12208) bears forty-three illustrations in total, but one of these is Dawlat's colophon painting, which was added at the behest of Jahangir early in his tenure as emperor. With the exception of one painting (Or. 12208, f. 65r), whose ascription bears the name of two artists, each of the illustrations from the original pictorial cycle is ascribed to a single artist.

67. On *sulh-i kull* and the central role that *akhlaqi* literature played at the Mughal court, see, among others, S. A. A. Rizvi, "Dimensions of *Sulh-i-Kul*"; Alam, "Akhlaqi Norms and Mughal Governance"; Alam, *The Languages of Political Islam*; Anooshahr, "Dialogism and Territoriality"; Lefèvre, "The *Majālis-i Jahāngīrī*"; Kinra, "Handling Diversity"; Amanat, "Persian Nuqtawīs"; and Moin, "Millennial Sovereignty."

68. Rezavi, "Religious Disputations."

69. Moin, *The Millennial Sovereign*, 139–40.

70. Moin, *The Millennial Sovereign*, 134.

71. The group of coauthors, comprising both Indian and Iranian Muslims, included

Naqib Khan, Shah Fathullah Shirazi, Hakim Hamam, Hakim 'Ali Gilani, Haji Ibrahimi Sirhindi, Nizam al-Din Ahmad Heravi, 'Abd al-Qadir Bada'uni, Mullah Ahmad Tahtavi, Ja'far Beg, Asaf Khan, and Abu'l Fazl, who penned the introduction. Emperor Akbar reportedly supervised the project. See Huseini, "The First Islamic Millennium," 25.

72. Moin, *The Millennial Sovereign*, 134.

73. Kinra, "Make it Fresh," 12; Kinra, *Writing Self, Writing Empire*, esp. 201–39.

74. Truschke, *Culture of Encounters*, 101. The explosion of newly commissioned texts—especially histories—at Akbar's court during the final decades of his reign has a notable precedent in the efflorescence of dynastic chronicles at the Timurid courts during the fifteenth century. See Woods, "The Rise of Tīmūrid Historiography." A parallel phenomenon closer in time, if not place, to Akbar's court is the explosion of historiography at the Ottoman court during the sixteenth century. See Fleischer, *Bureaucrat and Intellectual*.

75. Truschke, *Culture of Encounters*, 103, 104, 110, 122.

76. Abu'l Fazl, *A'in-i Akbari*, ed. Blochmann, 1:115. According to contemporary authors, Akbar was illiterate and therefore would not have been able to enjoy the fruits of these and other related literary projects. But illiteracy was one among a number of traits associated with prophecy in the Islamic world and therefore would have actually strengthened the case for Akbar's supreme spiritual standing. See Moin, *The Millennial Sovereign*, 139.

77. As Seyller has observed, the inspection notices written on manuscript flyleaves indicate that librarian-custodians (*kitabdar*s or *tahwildar*s) stored books in the harem. See Seyller, "The Inspection and Valuation of Manuscripts," 248–49, especially the mention of several manuscripts that bear inspection notices penned by the librarian and artist Dawlat in the harem library in Lahore in 1595. Seyller also considers scribal notes that record royal viewings of select manuscripts, though he concludes that these notes provide "only a fragmentary picture of the book's use at court" (251). Abu'l Fazl further states in the *A'in-i Akbari* that the royal library was kept in several places, including the female apartments of the palace (*mashku*) (*A'in-i Akbari*, ed. Blochmann, 1:115).

78. Das, "Books and Pictures"; Sardar, Seyller, and Truschke, *The Ramayana of Hamida Banu Begum*.

79. A *nisba* is a suffix that denotes a person's geographical, professional, or ancestral origins.

80. The Timurid and Ottoman historiographic projects of the fifteenth and sixteenth centuries, respectively, also included significant illustrated components. While the relationship between Timurid and Mughal manuscript illustration practices has been well explored, the possible links between the Ottoman and Mughal historiographic enterprises remain relatively underinvestigated. On the abundance of illustrated histories produced at the Timurid courts, see Lentz and Lowry, *Timur and the Princely Vision*; and for the Ottoman court, see Fetvacı, *Picturing History at the Ottoman Court*.

81. For a succinct description of subject matter illustrated in the manuscript, see Stronge, *Painting for the Mughal Emperor*, 60–84.

82. The precise chronology of the fragmentary Victoria and Albert *Akbarnama*'s production is a subject of debate. Stronge has argued that the atelier's project team created the majority of the manuscript's paintings at the same time that Abu'l Fazl was writing and editing the text, between 1590–91 and 1597–98. She argues that the manuscript's paintings were likely completed by 1595, a date that appears on one of the leaves, and points to Abu'l Fazl's own allusion in the *Akbarnama* text to having completed an illustrated copy of that work in 1596 (*Painting for the Mughal Emperor*, 42–45). Seyller, based on stylistic and codicological study of the manuscript, argues that most of its paintings were completed around 1586–87, presumably for an earlier version of the *Akbarnama*, or a related work; the text panels that appear on most of the illustrated pages, which bear the final, edited version of the *Akbarnama*, would have been added around or after 1597 to cover up the original text for which the paintings had been ostensibly made ("Codicological Aspects"). Of the two theories, I find the former the more persuasive.

83. Abu'l Fazl, *The History of Akbar*, ed. and trans. Thackston, 3:540–41.

84. Abu'l Fazl, *The History of Akbar*, ed. and trans. Thackston, 3:540–41.

85. Mughal manuscript painters' focus on the representation of the bodies and faces of the emperors and other key court agents is attested in an ascription in the lower margin of the Victoria and Albert *Akbarnama* manuscript identifying the artist Miskina as the executor of the *chihra-yi nami* (portrait, lit. "esteemed face") in the depictions of Akbar and other key figures. On imperial painters' preoccupation with Akbar's physical form, and later Jahangir's, see chapter 3.

86. Seyller, "Model and Copy."

87. Raza Library, Rampur, P.1820. See n. 41 for additional bibliography on this manuscript.

88. I lay out this argument in greater detail in Rice, "Mughal Interventions." For an example of one of these patched illustrated pages, on which a fifteenth-century fragmentary painting is embedded in a late sixteenth-century Mughal addition to the same manuscript, see "Mughal Interventions," 154, fig. 5.

89. See Koch, "Netherlandish Naturalism."

90. On Mughal poets' innovative practices, see Kinra, "Make it Fresh," and Kinra, *Writing Self, Writing Empire*, esp. 201–39; and on a new historiographical method introduced by the Shirazi courtier Ja'far Beg to the Mughal court in the 1570s, which emphasized the uniquely ecumenical and universalist character of Akbar's reign, see Anooshahr, "Dialogism and Territoriality."

91. Minissale suggests that the image below this one may have been based on a European print of the Annunciation ("The Synthesis of European and Mughal Art").

92. Miskina also contributed to the British Library *Darabnama* of circa 1580–83 (Or. 4615).

93. The existence of numerous artist inscriptions and signatures that record parental, sibling, and avuncular relationships suggests that such connections must have been a factor in the allocation of jobs—and in rankings—among the workshop's numerous employees. For case studies, see Seyller, "The Colophon Portrait"; Soucek, "Persian Artists in Mughal India."

94. Beach has recently proposed that Mughal painters employed by Akbar may

have enjoyed enough autonomy to elect to also work in Prince Salim's manuscript workshop during the final years of Akbar's reign (Beach, "The Gulshan Album," 476). The Safavids had set a precedent for the sharing of painters and calligraphers among different royal courts some decades earlier, as Simpson's and Farhad's studies of the Safavid *kitabkhana* have established (see Simpson, "The Making of Manuscripts"; Simpson and Farhad, *Sultan Ibrahim Mirza's* Haft Awrang).

3. Forms of Knowledge

1. For recent studies on the role and presence of Akbar's artists in Salim's Allahabad workshop, see the citations provided in chapter 2, n. 3.

2. The dating of the painting's chronogram has been the subject of some disagreement. For the most recent conjectures, see S. C. Welch in Akimushkin et al., *The St Petersburg* Muraqqa', 100; Stronge, "The Sublime Thrones," 55; Brend, "Dating the Prince"; and Beach, "Mansur," 248, 257.

3. Steingass, *A Comprehensive Persian-English Dictionary*, 733 (s.v. *shabīh*), 795 (s.v. *ṣūrat*). On the variable uses of these terms in Mughal inscriptions and other texts, see Natif, *Mughal Occidentalism*, 208.

4. Franke, "Emperors of *Ṣūrat* and *Maʿnī*." On the exoteric and esoteric meanings of portraiture in early modern Persian literature, see Porter, "La forme et le sens." A number of paintings of Jahangir bear Persian inscriptions that identify him as an exemplar of both *surat* and *maʿni*, including Bichitra's well-known painting of Jahangir seated on an hourglass throne, probably completed sometime between 1615 and 1620 (see fig. I.1); and a large-scale portrait of Jahangir on cotton cloth dated 1617 and ascribed to Abu'l Hasan (*Islamic and Indian Art*, lot 322, Bonhams, London, 5 April 2011). Some have questioned the presumed seventeenth-century date of the latter painting, and indeed it may be a later copy of a work now lost or destroyed.

5. Trans. Thackston, in Beach, "Mansur," 247–48.

6. I first examined the relationship between Mughal portraiture and *ʿilm al-firasa* in my 2011 PhD dissertation, "The Emperor's Eye and the Painter's Brush," 46–50.

7. On some of the earliest evidence for Mughal patronage of portraiture, see most recently Parodi, "Tracing the Rise of Mughal Portraiture."

8. On the earliest of the three *Akbarnama* manuscripts, now in the Victoria and Albert Manuscript, see Seyller, "Codicological Aspects"; and Stronge, *Painting for the Mughal Emperor*, 42–45. For the slightly later *Akbarnama* manuscript that is divided between the Chester Beatty Library (Ms. 3) and the British Library (Or. 12988), see Leach, *Mughal and Other Indian Paintings*, 1:232–300; Titley, *Miniatures from Persian Manuscripts*, 4–5; and Losty, *Art of the Book in India*, 93–94, cat. nos. 70–71. Additional illustrated pages from the latter *Akbarnama* are also dispersed among various museum and private collections, which are listed in Leach, *Mughal and Other Indian Paintings*, 1:241–42. In the early 2000s, Leach identified thirteen illustrated manuscript pages, all dispersed to different collections, as belonging to a third *Akbarnama*, probably made for Akbar's mother, Hamida Banu Begum, around 1595–1600; see Leach, "Pages from an *Akbarnama*."

9. Other illustrations in the Victoria and Albert *Akbarnama* manuscript that lack

marginal inscriptions crediting a portraitist, but in which the face of the emperor appears to have been repainted or retouched, include IS.2:15–1896, IS.2:24–1896, IS.2:41–1896, IS.2:52–1896, IS.2:54–1896, IS.2:56–1896, IS.2:58–1896, IS.2:61–1896, IS.2:65–1896, IS.2:71–1896, IS.2:76–1896, IS.2:77–1896, IS.2:83–1896, IS.2:85–1896, IS.2:93–1896, IS.2:99–1896, and IS.2:110–896.

10. Of relevance here is an event reported by 'Abd al-Sattar ibn Qasim Lahori (d. after 1619) in his *Majalis-i Jahangiri,* in which Jahangir, displeased with the quality of the portraits of Akbar available at his court, declared that "only a limited number of artists—perhaps only three—should be allowed to make such portraits and that if anyone else attempted to do so, their fingers should be cut off" ('Abd al-Sattar ibn Qasim Lahori, *Majalis-i Jahangiri,* ed. Naushahi and Nizami, 242–43, translated and cited in Alam and Subrahmanyam, "Frank Disputations," 489).

11. On the science of physiognomy in the medieval and early modern Islamic world, see Hoyland, "Physiognomy in Islam"; and Ghaly, "Physiognomy," esp. 163, where Ghaly differentiates between the practices of *firasa* and *qiyafa,* which are often conflated in scholarship.

12. Abu'l Fazl, *The History of Akbar,* trans. Thackston, 1:151 (English), 1:150 (Persian).

13. See, for example, Kangal, *The Sultan's Portrait*; Fetvacı, "From Print to Trace"; and Lelić, "Physiognomy (*'ilm-i firāsat*) and Ottoman Statecraft."

14. On the *Physiognomy* of Pseudo-Aristotle, see Boys-Stones, "Physiognomy and Ancient Psychological Theory." The reception of this text in the Islamic world is addressed in Thomann, "La tradition arabe"; and Ghersetti, "The Semiotic Paradigm." On the medieval European context, see Power, *Windows of the Soul,* esp. 46–78.

15. The ninth-century Arabic translation of Polemon's text is the only surviving version of the work. Prior to its appearance, the practice of physiognomy was mainly limited to *qiyafa* proper, that is, the examination of animal tracks and human genealogical lines (Hoyland, "Physiognomy in Islam," 363).

16. On the *Kitab al-firasa,* see Hoyland, "The Islamic Background," 263–64; for an early twentieth-century translation of al-Razi's text, see Mourad, *La physiognomie arabe.*

17. Ghersetti, "The Semiotic Paradigm," 300–301.

18. Jahangir, *Jahangirnama,* trans. Thackston, 36, with my Persian glosses; Jahangir, *Jahangirnamah,* ed. Hashim, 20.

19. For a brief description of this text, see Renard, *Tales of God's Friends,* 80–81.

20. On Jahangir's use of Akbar, rather than Timur, as a political model, see Lefèvre, "In the Name of the Father," 426–27; and Lefèvre, "Recovering a Missing Voice," 468–69. As Lefèvre points out, the discord between father and son mattered little to Jahangir after Akbar's death; rather, Jahangir cast himself deliberately in the role of the "dutiful heir" so that he could "capture (at least part of) his father's aura and legitimacy, thereby strengthening his own authority" ("Recovering a Missing Voice," 469).

21. Among the numerous publications that discuss this work, see Kalyan, "Problems of a Portrait," 392–94; Das, *Mughal Painting during Jahangir's Time,* 147, 166, 216; Seyller, "Hashim"; Okada, *Indian Miniatures,* 27–31; Bailey, "The End of the 'Catholic Era'"; Juneja, "On the Margins of Utopia," 227; and Minissale, *Images of Thought,* 212–13.

22. According to Stchoukine (*Miniatures indiennes,* 28), the portraits of Akbar and Jahangir were executed on different paper supports.

23. Jahangir, *Jahangirnama*, trans. Thackston, 162; Jahangir, *Jahangirnamah*, ed. Hashim, 153.

24. On the shift from the three-quarter to the strict side profile portrait, see Ebba Koch, "Visual Strategies," 110; Losty, "From Three-Quarter to Full Profile"; and Losty, "The Carpet at the Window."

25. Seriality and repetition also played an important part in physiognomic representations of the Ottoman sultans produced at that court around the same time. See, for example, Necipoğlu, "Word and Image"; Roxburgh, "Concepts of the Portrait," 129–30; and Fetvacı, "From Print to Trace."

26. Bashir cautions against reading the relationship between the external and the internal in strictly binary terms: "The mutual interpenetration of the spirit and body reflects the intermixing of the interior and exterior elements of reality in Sufi thoughts; when we scrutinize Sufi literature carefully, the purportedly clear distinction looks more like a scene of shifting sands than a dichotomy" (Bashir, *Sufi Bodies*, 43).

27. Zargar, *Sufi Aesthetics*, 4.

28. According to Ibn 'Arabi, vision and hearing are not equal: "The eye witnesses forms directly, while the ear receives reports of forms depicted for it by the faculty of fantasy (*wahm*). Thus, the eye, being the most immediate of senses, is also the most prominent" (Zargar, *Sufi Aesthetics*, 25).

29. The relationship between the Naqshbandis and the Mughals was, nevertheless, complicated and sometimes contentious. See, for example, Foltz, "The Central Asian Naqshbandī Connections"; and Alam, "The Mughals."

30. Bashir, "Narrating Sight," 243. The recourse here to inner perception brings to mind al-Ghazali's own argument that *al-basira al-batina* (inner perception) was the primary means of beholding inner, as opposed to strictly external, beauty—namely the beauty associated with prophets and spiritual luminaries. See Soucek, "The Theory and Practice of Portraiture," 102.

31. On later seventeenth-century Mughal royals' devotional uses of Sufi portraits, see Mumtaz, "Contemplating the Face."

32. Moin, *The Millennial Sovereign*; Babayan, *Mystics, Monarchs and Messiahs*; Cornell H. Fleischer, "The Lawgiver as Messiah"; Subrahmanyam, "Turning the Stones Over"; Lefèvre, "Messianism, Rationalism and Inter-Asian Connections."

33. Cited in Moin, *The Millennial Sovereign*, 143.

34. Though this discipleship is known popularly and in much scholarship as the Din-i Ilahi (Divine Faith), this term, according to Lefèvre, is a misnomer, as it does not appear in any official imperial texts (Lefèvre, "*Dīn-i ilāhī*"). Included among the disciples were the Mughal princes, Abu'l Fazl, the Mughal court poet Abu'l Fath Fayzi (Abu'l Fazl's brother), and Prince Salim's boon companion, the artist Muhammad Sharif. While contemporary texts state that membership was limited to twelve disciples, it seems that the *silsila* in fact boasted many more members. In addition to Lefèvre, see S. A. A. Rizvi, *Religious and Intellectual History*; and Moin, *The Millennial Sovereign*, 131–32, 142–46 and, on the large numbers of people who reportedly wished to become Akbar's disciples, 221.

35. Lefèvre, "*Dīn-i ilāhī*."

36. Abu'l Fazl, *A'in-i Akbari*, trans. Blochmann, 1:174; Abu'l Fazl, *A'in-i Akbari*, ed. Blochmann, 1:160. On the practice of *sijda* among the members of the Chishti *silsila*, see Ernst and Lawrence, *Sufi Martyrs of Love*, 25, 94–95.

37. Abu'l Fazl, *A'in-i Akbari*, trans. Blochmann, 1:175; Abu'l Fazl, *A'in-i Akbari*, ed. Blochmann, 1:160.

38. Moin suggests that the double meanings—one overt, the other hidden—of *Allahu Akbar* and *Jalla Jalaluhu* accord with the exoteric-esoteric (*zahiri-batini*) paradigm that was foundational to Mughal political ideology (Moin, *The Millennial Sovereign*, 144).

39. Abu'l Fazl, *A'in-i Akbari*, trans. Blochmann, 1:174; Abu'l Fazl, *A'in-i Akbari*, ed. Blochmann, 1:160. I here draw mainly from Moin's translation (*The Millennial Sovereign*, 143) rather than Blochmann's.

40. Abu'l Fazl, *A'in-i Akbari*, trans. Blochmann, 1:173; Abu'l Fazl, *A'in-i Akbari*, ed. Blochmann, 1:160; and Moin, *The Millennial Sovereign*, 143. Note that where Blochmann understands *ilahi tilism* (divine talisman) to refer to the process by which Emperor Akbar healed supplicants by casting his breath on the cups of water that they brought before him, Moin correctly interprets Abu'l Fazl's allusion as a reference to the body of Akbar himself.

41. 'Abd al-Qadir Bada'uni, *Muntakhab al-tavarikh*, ed. Lees and Ali, 2:338; for the English translation of the text (slightly different from my own), see Bada'uni, *A History of India: Muntakhab-ut-Tawarikh*, trans. Ranking, Lowe, and Haig, 2:349.

42. Textual and pictorial artifacts from the early seventeenth century confirm that Akbar's discipleship survived well into Jahangir's reign. Of particular interest is the *Majalis-i Jahangiri* (Assemblies of Jahangir), a report on a series of evening gatherings at the Mughal court between 1608 and 1611, which the courtier-scholar and imperial intimate 'Abd al-Sattar Lahori wrote to serve "as a spiritual handbook (*dastūr al-ʿamal*) for the newly enrolled disciples of the emperor" (Lefèvre, "The *Majālis-i Jahāngīrī*," 261; and Lefèvre, "Messianism, Rationalism and Inter-Asian Connections"). An entry from the *Jahangirnama* from April 1606 contains the account of the promotion of a certain Shaykh Ahmad Lahori, who had been "a devoted servant [*khidmatgar*] and disciple [*murid*]" during the period of Jahangir's princehood, to chief justice (*Mir-i 'Adil*). According to the *Jahangirnama*, Lahori advised the emperor as to those to whom he should offer the hand [*dast*] and portrait [*shabih*] of discipleship (Jahangir, *Jahangirnama*, trans. Thackston, 53; Jahangir, *Jahangirnamah*, ed. Hashim, 35–36).

43. Abu'l Fazl described the integral role of *darshan* (viewing) as part of Akbar's daily audience assemblies in the *A'in-i Akbari* (Abu'l Fazl, *A'in-i Akbari*, trans. Blochmann, 1:165; Abu'l Fazl, *A'in-i Akbari*, ed. Blochmann, 1:155). The further codification of this ritual practice in the seventeenth century is attested by Jahangir's identification of its setting as the *jharoka-yi darshan* (Jahangir, *Jahangirnama*, trans. Thackston, 161; Jahangir, *Jahangirnamah*, ed. Hashim, 151). On the art-historical scholarship on *jharoka-yi darshan*, see Losty, "The Carpet at the Window"; Koch, "Hierarchical Principles"; and Koch, "Visual Strategies." On the relationship between the portrait image and the practice of the Mughal emperor presenting himself before his subjects from the *jharoka-yi darshan* as theorized in Persian poetry of the seventeenth century, see Pellò, "The Portrait," 14–15.

44. On the role of *farr-i izadi* in the formulation of Mughal political ideology and visual culture during the sixteenth and seventeenth centuries, see Asher, "A Ray from the Sun."

45. The classic study of these materials is Hodivala, *Historical Studies in Mughal Numismatics*, 147–50. For recent studies of the portrait coins, see Losty, "The Carpet at the Window"; Gulbransen, "Jahāngīrī Portrait *Shast*s"; and Bhandare, "Rituals of Power." And for a recent catalogue of the coins minted during Jahangir's reign, see Liddle, *Coins of Jahangir*.

46. This medallion is one of two types of portrait *mohur*s, both showing images of a seated Jahangir holding a cup of wine, that were issued in AH 1023 (1614–15 CE). The earlier one, bearing a *julus* (accession anniversary) date of 8, bears, like the 1611 medallion type, the *shir-u-khurshid* on its reverse. The slightly later issue, bearing a *julus* date of 9, dispensed with the leonine design in favor of a depiction of a small sun. Hodivala speculates that this change was made to free up space for longer textual inscriptions (*Historical Studies in Mughal Numismatics*, 166).

47. The function of the discipleship and its associated *shast* as agents of submission and dependence is illustrated by a report that the Bijapuri ruler Ibrahim 'Adil Shah had declared himself a member of the Tawhid-i Ilahi and even attempted to commandeer the *shast* in the possession of Asad Beg Qazwini, a Mughal envoy who was dispatched to the Bijapur court in 1603 and who documented this event in his *Nuskha-yi Ahwal-i Asad Beg*, which covers the period 1601–6. See Overton, "*Vida de Jacques de Coutre*," 242. On Asad Beg's text more generally, including his mission to Ibrahim 'Adil Shah's court, see Joshi, "Asad Beg's Mission"; and Alam and Subrahmanyam, "Witnessing Transition."

48. Cohn, *Colonialism and Its Forms of Knowledge*, 114. For the practices of gifting *khila'*, see also Stillman, "*Khil'a*"; and Gordon, ed., *Robes of Honor*. On the sociological and anthropological import of gift exchange and debt, see Mauss, *The Gift*; and, more recently, Thomas, *Entangled Objects,* esp. 7–34.

49. The gold coinage used in *tula-dana*—a ceremony originally associated with Hindu kings, which the Mughals adapted for their own uses—was later distributed to court subjects. Among the firsthand accounts of the Mughal practice is that of Sir Thomas Roe, the English ambassador to the Mughal court (see Roe, *The Embassy of Sir Thomas Roe to India, 1615–1619*, 2:411–12). On the Mughal justification for the celebration of *tulu-dana* and Nawruz, see Moin, *The Millennial Sovereign*, 221–22.

50. Abu'l Fazl, *Ai'n-i Akbari*, trans. Blochmann, 1:29, with my glosses; Abu'l Fazl, *Ai'n-i Akbari*, ed. Blochmann, 1:24. Regarding the light that impregnated Alan Goa, the progenitor of the Chingizid line, see Abu'l Fazl, *The History of Akbar*, trans. Thackston, 1:41–43.

51. An unfinished portrait (c. 1615) of the powerful Mughal nobleman Abu'l Hasan Asaf Khan (d. 1641) in the Chester Beatty Library, Dublin (In 45.2), shows the noble clasping one such medallion, worn on a chain around his neck. Persian poetry of the period similarly investigates the theme of the close physical relationship between the portrait image and its referent; see, for example, Pellò, "The Portrait," 12.

52. Khafi Khan, *Muntakhab al-lubab*, 1:272.

53. The portrait coins of Jahangir measure 20.5–24 mm in diameter, roughly the same dimensions as Mughal specie issued during the same period. According to Sir

Thomas Roe, the example he received was "as big as six pence," a reference to the British silver sixpenny coin, or tanner, which also bore images of the reigning monarch (Roe, *The Embassy of Sir Thomas Roe*, 1:244). I thank Shailendra Bhandare for clarifying why the portrait roundels are rightly classified as coins rather as medallions (email communication, 21 July 2021).

54. Richards, *The Imperial Monetary System*, 2.

55. According to Roe, Asaf Khan, a high-ranking *vakil* (administrator), presented the portrait medal on behalf of Jahangir on 17 August 1616 (Roe, *The Embassy of Sir Thomas Roe*, 1:244–45). Jahangir apparently awarded another portrait coin to Austin [Augustin] Heeryard of Bordeaux, a French jeweler and goldsmith who served at the Mughal emperor's court beginning in 1612 CE (noted in a letter translated and cited by Subrahmanyam in *Europe's India*, 12).

56. Lefèvre, "Majālis-i Jahāngīrī," 259, though Lefèvre postulates, based on the survival of only a single manuscript of the *Majalis-i Jahangiri*, that the discipleship "was restricted to a very small circle."

57. Unlike Jahangir's portrait coins, the Nicholas Hilliard medallion of Elizabeth I, dated 1589, was cast rather than stamped. At 44 mm in diameter, it is roughly twice the size of the Mughal portrait coins.

58. Sowerby, "Negotiating the Royal Image," 120.

59. Roe, *The Embassy of Sir Thomas Roe*, 1:213–14. According to William Foster, the manuscript copy of Roe's travel account provides the additional information that the painting was a "small limned picture of a woeman," possibly Roe's wife (Roe, *The Embassy of Sir Thomas Roe*, 214n1). On the art-historical import of this exchange, see, among other authors, Rice, "The Global Aspirations of the Mughal Album," 67.

60. Losty argues that both the idea of the portrait coin and the practice of wearing it on one's person were likely imports from Europe (Losty, "The Carpet at the Window").

61. On the possibilities and limitations of commensurability during the early modern era, see Subrahmanyam, "A Roomful of Mirrors"; and Subrahmanyam, *Courtly Encounters*, esp. 154–210.

62. The manuscript workshop and the mint enjoyed an affinity because they shared personnel, calligraphers especially, and practices, such as drawing and outlining. ʿAbd al-Samad, who headed Akbar's manuscript workshop from 1572 to 1577, was appointed director of the royal mint at Fatehpur Sikri immediately following his tenure in the *kitabkhana*. On his life and career, see Soucek, "Abd-al-Samad Šīrāz"; Soucek, "Persian Artists in Mughal India," 169–75; and, more recently, Canby, "Abd al-Samad."

63. Three other seventeenth-century Mughal genealogical paintings are extant: one, in a private Berlin collection, that focuses on the male relatives of Akbar is examined in Kühnel, "Eine Stammtafel der Moghulkaiser"; and the other two, the first showing members of Jahangir's family and the members of Shah Jahan's family, are in the Vatican Libraries, Rome (Ms. Barb. Or. 136), and published in Kurz, "A Volume of Mughal Drawings and Miniatures," and as a digital facsimile: https://digi.vatlib.it/view/MSS_Barb.or.136.

64. For examples of Ottoman illustrated genealogical manuscripts, see Kangal, *The Sultan's Portrait*; on the history of the genealogical tree and the genealogical table in

Islamicate historiography, see Binbaş, "Structure and Function"; and Aigle, "L'histoire sous forme graphique."

65. An ascription at the bottom of the panel bearing the name of Dhanraj, a painter who worked for Prince Salim (later Emperor Jahangir) but who served most of his time at Akbar's court, points to the possibility that the Timurid genealogy predates the Jahangir-period tree by at least a couple of decades.

66. See, in particular, the early fifteenth-century genealogical scroll now mounted in the so-called Timurid Workshop Album in the Topkapı Palace Museum (H.2152), discussed in Esin, "Hanlar Ulaki"; and Roxburgh, *The Persian Album*, 93–96.

67. A related work is the so-called Princes of the House of Timur, a large painting on cotton showing Humayun with his Timurid ancestors, now in the British Museum, London (1913,0208,0.1). It, like the Toronto genealogical tree, was executed in different painting styles, in this case because the family portrait, initially created during the latter part of Humayun's reign, was apparently repainted and revised at the direction of both Jahangir and Shah Jahan. On this enigmatic object, see the collection of essays in Canby, ed., *Humayun's Garden Party*; and Parodi and Verri, "Infrared Reflectography."

68. Jahangir, *Jahangirnama*, trans. Thackston, 99, with my glosses; Jahangir, *Jahangirnamah*, ed. Hashim, 88. On another portrait of Timur, presented to Jahangir by the English chaplain Edward Terry, Thomas Aldworthe, the chief factor at Surat, wrote to Kerridge in 1614 that Edwards "brings one picture that we think will content [Jahangir] above all, which is the picture of Tamburlaine, from whence he derives himself" (Foster, *Letters Received*, 2:138).

69. Jahangir, *Jahangirnama*, trans. Thackston, 99–100; Jahangir, *Jahangirnama*, ed. Hashim, 88. Jahangir here employs Sufi terminology to describe his ancestor's descendants and their physical appearance: *surat-i u hilya-yi awlad-i u farzandan-i silsila-yi . . .* (form and external appearance of the children and descendants of the lineage of . . .).

70. A battle scene portrait [*majlis-i jang*] featuring Timur, apparently of Timurid provenance, was acquired in Iran by the Mughal ambassador to Shah 'Abbas's court, Khan 'Alam, and then gifted to Jahangir in 1619–20. Jahangir does not seem to have doubted its accuracy as a likeness of his ancestor (Jahangir, *Jahangirnama*, trans. Thackston, 319; Jahangir, *Jahangirnamah*, ed. Hashim, 323).

71. The *Khatirat-i Mutribi Samarqandi* has been translated by Foltz as *Conversations with Emperor Jahangir by 'Mutribi' al-Asamm of Samarqand*; for the text in the original Persian, see Samarqandi, *Khatirat-i Mutribi*, ed. Mirzoev. On Mutribi's report of his encounter with Jahangir, see S. Singh, "The Indian Memoirs of Mutribi Samarqandi"; Foltz, "Two Seventeenth-Century Central Asian Travellers"; Alam and Subrahmanyam, *Indo-Persian Travels*, 120–29; and Subrahmanyam, "Early Modern Circulation."

72. Samarqandi, *Conversations with Jahangir*, trans. Foltz, 76; Samarqandi, *Khatirat-i Mutribi*, 21, with my Persian glosses.

73. Samarqandi, *Conversations with Jahangir*, 76–77, with my Persian glosses; Samarqandi, *Khatirat-i Mutribi*, 21–22.

74. Seyller, "A Mughal Code of Connoisseurship," 177. Both Stronge (*Painting for*

the Mughal Emperor, 133) and Natif (*Mughal Occidentalism*, 248) also touch on this section of Mutribi's text, but neither addresses the significance of Jahangir's ordering one of his artists to correct the portrait to better fit the poet's memory of the Shaybanid *khan*s.

75. Alam and Subrahmanyam, *Indo-Persian Travels*, 127.

76. The portrait of Ibrahim 'Adil Shah II is reproduced in Okada, *Indian Miniatures of the Mughal Court*, 151, fig. 75; and the portrait of Qutb al-Mulk of Golconda is reproduced in Seyller, "Hashim," 109, fig. 5. For an illuminating examination of these portraits as statements of political submission, see Overton, "*Vida de Jacques de Coutre.*"

77. It seems clear that this assessment was meant to serve not as commentary on the aesthetic quality of the painting but rather as confirmation that that the artist had portrayed the subject's appearance faithfully. Seyller nevertheless suggests that "these inscriptions should be understood more as tokens of imperial approbation of the formal accomplishments and suitable characterization seen in the portraits than as personal testaments to the accuracy of their likenesses" (Seyller, "Hashim," 111). This interpretation is belied by the fact that Jahangir, as the examples in this chapter make clear, made a point of assessing the accuracy of portraits that depicted individuals whom he had not met in person.

78. Jahangir, *Jahangirnama*, trans. Thackston, 319, with my Persian glosses; Jahangir, *Jahangirnamah*, ed. Hashim, 323. A precedent for sending an artist on a diplomatic mission can be found in the dispatching by the Timurid prince Baysunghur (d. 1433) of the artist Ghiyath al-Din Naqqash from his capital in Herat to the Ming court of China in 1419. See Roxburgh, "The 'Journal' of Ghiyath al-Din Naqqash."

79. Perkinson observes a similar phenomenon in the rise of physiognomic portraiture in late medieval France (*The Likeness of the King*, 257).

80. Jahangir, *Jahangirnama*, trans. Thackston, 319, with my Persian glosses; Jahangir, *Jahangirnamah*, ed. Hashim, 323.

81. On the transfer of drawings in the Timurid manuscript workshop, see Roxburgh, "Persian Drawing, ca. 1400–1450," 61–63; for the South Asian context, see Aitken, "The Laud *Rāgamālā* Album," 28–31.

82. Another portrait of Zayn Khan Koka—this one showing him on horseback—can be found in the Fondation Custodia, Paris (inv. no. 1973-T.4).

83. In an article published in 1918, for example, Coomaraswamy suggested that Mughal painting's "aims and standpoint are realistic: it is interested in passing events, and most typically in the exact delineation of individual character in the portraiture of men and animals ("Mughal Painting [Akbar and Jahangir], 2)." Recent studies have continued to echo these sentiments, characterizing Mughal portraiture of the period as "accurate [and] observed" (Branfoot, "Introduction," 10) and further arguing that the goal of the early seventeenth-century Mughal portrait was to "render a lifelike representation of the sitter" (Natif, *Mughal Occidentalism*, 206).

84. In art history, this idea seems to find its genesis in the work of Jacob Burckhardt: see *Jacob Burckhardt-Gesamtausgabe*, 12:143–291. For a critique of this perspective, bearing on the study of medieval European sculpture, see Dale, "The Individual."

85. Belting, *An Anthropology of Images*, 77.

86. Soucek writes of Persianate portraiture more generally: "Under the proper conditions a portrait could express such an 'inner reality,' revealing significant aspects of the subject's personality, especially those with connections to underlying universal principles" ("The Theory and Practice of Portraiture," 101).

87. For a more recent study that characterizes Mughal portraiture as fundamentally serial in nature, see Botchkareva, "Representational Realism," esp. 324–29. Botchkareva draws productively from Necipoğlu's "Word and Image" on the serial nature of Ottoman genealogical portraiture.

88. O'Hanlon, "Manliness and Imperial Service," 56; O'Hanlon, "Kingdom, Household, and Body." Some members of the administration resisted these norms, among them the polymath historian 'Abd al-Qadir Bada'uni (d. 1615), whose *Muntakhab al-tavarikh* (Selection of chronicles), an unofficial and critical history of Akbar's reign, sought to subvert the rules of comportment promulgated in official texts like Abu'l Fazl's *Akbarnama* and *A'in-i Akbari* (O'Hanlon, "Kingdom, Household and Body," 910–11).

89. Richards, "Norms of Comportment."

90. Koch, "Hierarchical Principles," 138.

91. Wright has proposed the dates of 1600–1605 for the production of the Salim Album folios (*Muraqqa'*, 55). Her argument is based on the existence of three folios that bear references to "Shah Salim," a salient point that does not preclude the possibility that the album continued to be compiled after Jahangir's accession to the throne.

92. O'Hanlon, "Kingdom, Household and Body," 914–16.

93. Abu'l Fazl reports that this event took place on 22 April 1578 (Abu'l Fazl, *The Akbarnama of Abu-l-Fazl*, trans. Beveridge, 3:345).

94. O'Hanlon, "Manliness and Imperial Service," 64.

95. Both paintings are ascribed to Manohar and today housed in an album that was probably assembled in Iran in the nineteenth century (Walters Art Museum, Baltimore, W.668, ff. 28b–29a). The death date for Madhava Singh is recorded as VS 1667 (1610 CE) in the *Kurma-Vilas*, a history of the Kachhwaha line (personal e-mail communication with Rima Hooja, via Aparna Andhare, 15 November 2019).

96. Not surprisingly, depictions of stock types were subjected to the same scheme. A page from the Salim Album (Museum of Fine Arts, Boston, 14.658), for example, bears a painting of a rotund falconer wearing a snugly tied *patka* (sash) that emphasizes the figure's compact build and thus his masculine, battle-ready physique.

97. Mukhia, *The Mughals of India*, 92.

98. These directives appear in a'in 74, titled *a'in-i kurnish u taslim* (Abu'l Fazl, *A'in-i Akbari*, trans. Blochmann, 1:166–68; Abu'l Fazl, *A'in-i Akbari*, ed. Blochmann, 1:156).

99. Depending on when the album page was completed, Madhava Singh, who died in 1610, may also have been deceased, making Jahangir the only living subject in the composition.

100. O'Hanlon, "Kingdom, Household and Body," 891. On Akbar as a regulating ruler, see also Moin, *The Millennial Sovereign*, 150; in the context of Jahangir's reign, see Lefèvre, "Recovering a Missing Voice," 471–72. As Lefèvre underscores, this rhetoric drew heavily from Nasirean ethics.

101. Jahangir, *Jahangirnama*, trans. Thackston, 24; Jahangir, *Jahangirnamah*, ed. Hashim, 5.

102. The Mughals, however, were not innovators in this regard. The idea of the ruler as an impartial judge in possession of keen insight and reason was foundational to statecraft in the Persianate world, especially during the medieval period. The *Siyasat-nama* (Book of government) of Nizam al-Mulk (1018–1092), an intellectual who served as vizier under the Seljuk sultans Arp Aslan and Malik Shah, stresses the importance of justice over right religion (i.e., the acceptance of Sunnism as the true path). Justice, according to Nizam al-Mulk's administrative manual, was critical to maintaining social order (Lambton, "The Dilemma of Government," 56). Other important texts on statecraft and government include the *Nasihat al-muluk* (The book of counseling of kings) written by al-Ghazali (1058–1111) and the *Akhlaq-i Nasiri* (Nasirean Ethics) by Nasir al-Din al-Tusi (1201–1274).

The Mughals were of course familiar with many of these works. Akbar even commissioned an illustrated copy of the *Akhlaq-i Nasiri*, which is today part of the collections of the Aga Khan Museum, Toronto (AKM 288). On the currency of Nasirean ethics across the Mughal empire, see, in particular, Alam, "*Akhlaqi* Norms"; on the production of politico-ethical texts of this kind in and around the Jahangir court, see Alvi, "Religion and State."

103. Lefèvre, "Recovering a Missing Voice," 471–72; Alam, "*Akhlaqi* Norms," 67–95; Moin, *The Millennial Sovereign*, 150–52.

104. Gülru Necipoğlu has examined the role that the gaze (and the architectural controlling of the gaze) played in Mughal court ceremony and architectural design ("Framing the Gaze," 312–18).

105. The imperial enthronement ritual, in particular the emphasis on the emperor's revealing his visage to his subjects, resonates with the Hindu devotional practices of *darshan*—that is, the exchanging of gazes between the worshipper and the deity. The correspondence is not coincidental. Abu'l Fazl states explicitly that "the mode of showing himself [Akbar] is called, in the language of the country, *darsan*" (Abu'l Fazl, *A'in-i Akbari*, trans. Blochmann, 1:165; Abu'l Fazl, *A'in-i Akbari*, ed. Blochmann, 1:155).

106. Abu'l Fazl, *The Akbarnama of Abu-1-Fazl*, trans. Beveridge, 3:373.

107. Abu'l Fazl, *The Akbarnama of Abu-1-Fazl*, trans. Beveridge, 3:914.

108. The *A'in-i Akbari* includes a description of Akbar's court of justice that emphasizes the emperor's keen faculties of observation: "From his knowledge of the character of the times, though in opposition to the practice of kings of past ages, His Majesty looks upon the smallest details as mirrors capable of reflecting a comprehensive outline; he does not reject that which superficial observers [*zahir-binan*] call unimportant, and counting the happiness of his subjects as essential to his own, never suffers his equanimity to be disturbed" (Abu'l Fazl, *A'in-i Akbari*, trans. Blochmann, 1:165, with my Persian glosses; Abu'l Fazl, *A'in-i Akbari*, ed. Blochmann, 1:155–56).

109. Abu'l Fazl, *The Akbarnama of Abu-1-Fazl*, trans. Beveridge, 3:393.

110. On Akbar's strained relationship with the *'ulama'*, see Minault, "Akbar and Aurangzeb."

111. Bada'uni, *Muntakhab-ut-Tawarikh*, trans. Elliot and Dowson, 532.

112. Johansen, "Signs as Evidence," 188, 189. According to Johansen, Ibn Qayyim stresses the involuntary and almost mechanical quality of bodily functions, which would make concealing or falsifying them nearly impossible. Speech, on the other hand, can be controlled and harnessed for various reasons and intents. On the status of the legal witness, see also Shaham, *The Expert Witness*, 27–55.

113. As translated by Moin, "*Sulh-i Kull*," 22; and Melvin-Koushki, "*Taḥqīq* vs. *Taqlīd*," 194.

114. Moin, "*Sulh-i Kull*," 22, 23.

115. Jahangir, *Jahangirnama*, trans. Thackston, 268, with my Persian glosses; Jahangir, *Jahangirnamah*, ed. Hashim, 266–67.

116. Of course, to exercise connoisseurship is itself a political act. On connoisseurship as a central aspect of princely behavior in later seventeenth-century Mughal texts, for example, see O'Hanlon, "Manliness and Imperial Service," 70–84.

117. Similarly, Jahangir's collections of rare and precious objects, like a jade tankard associated with the Timurid prince Ulugh Beg (1394–1449), today housed in the Calouste Gulbenkian Museum, Lisbon (inv. 328), could register the emperor's truly phenomenal visual and intellectual judgment and thus provide proof of his aptitude for *tahqiq*. On Jahangir's collections as an expression of his universal grasp, see Lefèvre, "Recovering a Missing Voice," 479–80.

118. The foundational study of these phenomena is Das, *Wonders of Nature*.

119. Jahangir, *Jahangirnama*, trans. Thackston, 133.

120. Jahangir, *Jahangirnama*, trans. Thackston, 133, with my Persian glosses; Jahangir, *Jahangirnamah*, ed. Hashim, 123.

121. Even though the text affirms the author's intention that the memoirs be reproduced and circulated widely, Moin underscores the calculated "modesty" of its contents (Moin, *The Millennial Sovereign*, 179–85).

122. Moin, *The Millennial Sovereign*, 184.

123. Lefèvre, "Recovering a Missing Voice," 480, 477.

124. Jahangir, whose court was often mobile, traveled frequently with painters, in addition to calligraphers and other craft specialists, thus underscoring the fundamental part that artists and images played in courtly life (Stronge, "Jahangir's Itinerant Masters," 127). On the role that the *Jahangirnama*'s illustrations played in reinforcing "the effect of the text's language," see Lefèvre, "Recovering a Missing Voice," 484.

125. Jahangir, *Jahangirnama*, trans. Thackston, 360, with my adjustments; Jahangir, *Jahangirnamah*, ed. Hashim, 372.

126. Since the *Jahangirnama*'s mention of the zebra occurs in a section of the text concerning the Nawruz festivities of March 1621, it can be inferred that Mir Ja'far likely presented the animal to Jahangir as a Nawruz gift. On the significance of Nawruz and Nawruz gift presentations, see chapter 4.

127. Jahangir, *Jahangirnama*, trans. Thackston, 360, with my adjustments; and Jahangir, *Jahangirnamah*, ed. Hashim, 372.

128. Jahangir, *Jahangirnama*, trans. Thackston, 133; Jahangir, *Jahangirnamah*, ed. Hashim, 123.

4. World in a Book

1. On the cultural and political significance of the costumes of Jahangir and Shah 'Abbas, see Houghteling, "The Emperor's Humbler Clothes."

2. The solar Ilahi calendar fell out of use during the reign of Shah Jahan and was later wholly abandoned by Aurangzeb. See Blake, "Nau Ruz in Mughal India," 129–31.

3. On the gifting of paintings during Mughal celebrations of Nawruz, see Soucek, "Persian Artists"; Stronge, "Jahangir's Itinerant Masters"; Parodi and Wannell, "The Earliest Datable Mughal Painting"; and Parodi, "Tracing the Rise of Mughal Portraiture."

4. Abu'l Hasan, for example, enjoyed the sobriquet Nadir al-Zaman (Rarity of the Age), a reward granted him by Jahangir. The painter's epithet appears in a passage in Jahangir's memoirs dated 24 Tir of the thirteenth accession year (4 July 1618) (Jahangir, *Jahangirnama*, trans. Thackston, 267; Jahangir, *Jahangirnamah*, ed. Hashim, 266), and the artist himself alludes to the title in an epigraph on his painting of Jahangir's dream of Shah 'Abbas, which was probably completed several years earlier.

5. On the reception of this and related Mughal album paintings in eighteenth-century Iran, see Akimushkin et al., *The St Petersburg* Muraqqa' *Album*; and Botchkareva, "Topographies of Taste."

6. According to Boyce, the appeal of Nawruz to Islamic rulers likely lay in its focus on the splendors and "divinely bestowed power" of kingship; the presentation of gifts, moreover, provided a means of "affirming and enhancing their power and prestige through a predominantly non-Islamic channel" (Boyce, "Nowruz i. In the Pre-Islamic Period").

7. Lambton, "Pīshkash," 148.

8. Zahir al-Din Muhammad Babur, *Baburnama*, trans. Beveridge, 236. The Safavids even constructed special halls for the annual festivities associated with Nawruz. On these, see, for example, Floor, "The Talar-i Tavila," esp. 151. Another fascinating insight into the Safavid preoccupation with Nawruz can be found in the *Bihar al-Anwar* (Sea of lights), a compendium of poetry written by the Safavid scholar Muhammad Baqir al-Majlisi (1628–1699/1700), which features a discussion of the practice, history, and legality (in an Islamic framework) of Nawruz. The sections dealing with Nawruz in al-Majlisi's *Bihar al-Anwar* are examined in Walbridge, "A Persian Gulf."

9. Zain Khan, *Tabaqat-i Babur*, xxxiii; Hasan, *Babur*, 162.

10. Blake, "Nau Ruz," 123–24.

11. On this episode, see Blake, "Nau Ruz," 124.

12. Gulbadan Begam, *The History of Humayun*, 179–80.

13. Bada'uni, *Muntakhab-ut-Tawarikh*, trans. and ed. Ranking, 2:175.

14. For a description of these, see *The Akbarnamah of Abu-l-Fazl*, trans. Beveridge, 3:644.

15. The date for Akbar's original accession to the throne was even recalculated to coincide with Nawruz. Hence the new date of accession for the first Ilahi year was proclaimed to be 28 Rabi' II, AH 963 (10 March 1556).

16. Jahangir, *Jahangirnama*, trans. Thackston, 46–48; Jahangir, *Jahangirnamah*, ed. Hashim, 29. According to the *Akbarnama*, Akbar established this practice in AH 990 (1582), having decreed that "every year from the time of the equinox until the exaltation would be celebrated, and every day one of the court servants would be in charge of the regal celebration" (Abu'l Fazl, *The History of Akbar*, ed. and trans. Thackston, 6:442 [Persian]–443 [English]).

17. Jahangir, *Jahangirnama*, trans. Thackston, 169; Jahangir, *Jahangirnamah*, ed. Hashim, 159. Note that Thackston here mistakenly renders Jahangir's valuation of Asaf Khan's *pishkash*—*hashtad u panj hazar*—as eighty thousand rupees.

18. Under Akbar, all *mansabdars* (rank holders) were expected to recruit, command, and recompense a set number of soldiers, expressed as *zat*, and armed cavalry, expressed as *suwar*, to serve in the imperial army.

19. Jahangir, *Jahangirnama*, trans. Thackston, 169; Jahangir, *Jahangirnamah*, ed. Hashim, 159.

20. These "gifts" to the Mughal emperor are better termed *pishkash*, a type of presentation akin to tribute or payment. As Mauss explains, a gift—whether in the form of an object, a marriage alliance, a political office, or even an invitation to dine—is seldom voluntary and never devoid of further contractual obligations (*The Gift*, 39–41). Thus the gift constitutes social relations not only by bonding the giver to the recipient—often in an asymmetrical arrangement—but also by formulating the terms by which one individual is economically and socially positioned in relation to another.

21. Jahangir, *Jahangirnama*, trans. Thackston, 129; Jahangir, *Jahangirnama*, ed. Hashim, 118.

22. This fact was most baldly demonstrated on a courtier's death. According to the laws of escheat, any titles, gifts, land, or other assets awarded to or earned by a Mughal courtier during his career at the Mughal court reverted to the royal treasury, not to the courtier's family.

23. On the relational and social operations entailed in the valuation of things, see Appadurai, "Introduction."

24. See, for example, Simpson and Farhad, *Sultan Ibrahim's* Haft Awrang, regarding two *qit'a*s mounted in an album made for Shah Tahmasp (Istanbul University Library, F.1422, f. 70v): "Both poems address the shah, praising his justice and leadership; the second also invokes blessings on his life and rule. It may be that Rustam Ali wrote these formulaic pieces for or on a special occasion, such as Nawruz (the Persian new year), for direct presentation to Tahmasp" (Farhad and Simpson, *Sultan Ibrahim's* Haft Awrang, 271, fig. 170).

25. Sperl, "Islamic Kingship."

26. Seyller's important study of the valuation of manuscripts inventoried in the Mughal royal library thus warrants further evaluation, taking into consideration "hidden" values associated with ceremonial gifting (Seyller, "The Inspection and Valuation of Manuscripts," esp. 278).

27. Early textual evidence for the practice can be found in a letter written by Humayun and recorded by Bayazid Bayat in his *Tarikh-i Humayun* (History of Humayun). It states that among the gifts that the emperor sent to Rashid Khan

(r. 1533–1560), ruler of Kashgar, in 1552 (AH 959) was "a page of one of the works of Mawlana 'Abd al-Samad that was made on Nawruz" (*yik safha-yi az kar-ha-yi mawlana 'Abd al-Samad ki ruz-i Nawruz sakhta*) (*Three Memoirs of Homayun*, ed. and trans. Thackston, 2:39). Note my emendation to Thackston's translation of the text, which reads "a scene by Mawlana Abdul-Samad depicting the celebration of Nawruz."

28. Parodi and Wannell, "The Earliest Datable Mughal Painting." The artist ascription identifying Dost Muhammad as the work's maker was likely added only during the early seventeenth century, possibly when the painting was mounted for inclusion in the Jahangir Album.

29. For discussion of a parallel phenomenon—the presentation of clever, thought-provoking New Year's gifts at the fifteenth-century French Valois court—see Buettner, "Past Presents."

30. Soucek, "Persian Artists," 170.

31. *'Amal-i Nawruz-i mawlana 'Abd al-Samad ki dar nim ruz sakhta sana 958.*

32. The inscription, according to the former Golestan Palace librarian Atabay, reads: *hazrat makhdumi ra mashq khast* [*khost/khas*] *musavvir* [*ki*] ([special/choice?] painted exercise belonging to/made for His Highness) (Atabay, *Fihrist-i muraqqa'at-i kitabkhana-yi saltanati*, 351). For a slightly different translation of the inscription, see Skelton, "Iranian Artists," 36.

33. Interestingly, in her survey of Persian-language primary source texts from the premodern period, Lambton found that the most common terms used to refer to public and private gifts presented during the Persian New Year were *nawruzi* and *pishkash-nawruzi* ("Pīshkash,'" 145).

34. *'Amal-i Nawruz-i mawlana 'Abd al-Samad ki dar ruz az sabah ta vaqt-i istiva' sakhta sana 965.*

35. Seyller, "Scribal Notes."

36. Seyller, "The Inspection and Valuation of Manuscripts."

37. Roxburgh, for example, identifies a *qasida* (panegyric poem) written by Mir 'Ali Shir Nava'i for Sultan Husayn Mirza on the occasion of 'Id al-Fitr, as well as another poetic work also composed by Mir 'Ali Shir Nava'i for 'Abd al-Rahman Jami, the poet's spiritual guide, on Jami's return from a trip to the Hijaz (see Roxburgh, *Prefacing the Image*, 68).

38. None definitively linked to Nawruz, however, have yet been uncovered.

39. Welch, "Painting as Performance," 28, 32.

40. For recent overviews of the Jahangir Album, see Beach, "Jahangir's Album"; Beach, "*Muraqqa'-i Gulshan*"; Eslami, "Golšan Album"; and Stronge, "The Gulshan Album."

41. On the binary nature of this album, and of seventeenth-century Mughal albums more broadly, see Rice, "The Brush and the Burin."

42. On the later inheritance of these operations by eighteenth-century Mughal artists, see Aitken, "Parataxis." On the copying and rehashing of pictorial compositions in early modern court painting from Rajasthan, see Aitken, *The Intelligence of Tradition*.

43. Roxburgh, *Prefacing the Image*, 158–59; see also Şahin, "Staging an Empire." On

the topos of painting as the centerpiece of a courtly competition in Nizami Ganjavi's *Khamsa* and in the manuscript illustrations of that literary episode, see Soucek, "Nizāmī on Painters and Painting"; and Graves, "Beyond the Beholder's Share." In Nizami's telling of this tale, as in other iterations of the story credited to other authors, painting is understood as a durational and performative activity.

44. Roxburgh, *Prefacing the Image*, 45, 51. On the comparable, though sometimes quite different, uses of albums at the seventeenth-century Ottoman court, see Fetvacı, "The Album of Ahmed I," and Fetvacı, *The Album of the World Emperor*.

45. As one point of comparison, Roxburgh speculates that the courtly albums that circulated during the Timurid period could accommodate a maximum of six viewers simultaneously (*The Persian Album*, 11).

46. Beach ("Jahangir's Album," 117) and Pal (*Indian Painting*, 219) both date the painting's extensions to the early seventeenth century. Parodi et al. ("Tracing the History of a Mughal Album Page") have more recently corroborated their suppositions and provided compelling evidence that the extension of the paintings' edges likely dates to a single period. They suggest that the underlying painting was executed by 'Abd al-Samad nearly four decades earlier for a now-lost or largely dispersed Humayuni *Shahnama* manuscript. The authors cite evidence of another mid-sixteenth-century *Shahnama* illustration, attributed by S. C. Welch to Mir Sayyid 'Ali, that matches the original dimensions of this album page painting.

47. The painting's signature reads *suwwarahu 'Abd al-Samad Shirin Qalam* ("'Abd al-Samad 'Sweet-Pen' painted it"). Skelton notes an additional inscription just below the artist's name that reads *fi kabir sin* (in advanced age), presumably referring to the artist, who would then have been around seventy years old (Skelton, "Iranian Artists," 38).

48. Soucek was the first to suggest that 'Abd al-Samad may have made this work on Nawruz ("Persian Artists," 170; Soucek, "Solomon's Throne," 122). Skelton suggests that it was completed between 2 December 1587 and 9 March 1588 ("Iranian Artists," 38).

49. According to the historian and theologian al-Tabari (838–923 CE), it was the miracle of Jamshid's ascension in a demon-driven chariot that inspired the establishment of the first Nawruz celebration (al-Tabari, *Tarikh al-rusul wa'l muluk*, 1: 349–50). On the relationship between Mughal iconography, ideologies of kingship, and Suleyman (Solomon), with whom Jamshid was frequently conflated, see Koch, "The Baluster Column"; Koch, *Shah Jahan and Orpheus*; Koch, "The Mughal Emperor as Solomon"; and Koch, "The Mughal Audience Hall."

50. Parodi et al., "Tracing the History of a Mughal Album Page."

51. *'Amal-i murid dar chahar martaba-yi ikhlas pay bar ja Sharif*. A similarly worded inscription accompanies Muhammad Sharif's painting of Farhad carrying Shirin in the Keir *Khamsa*, f. 73b (illustrated c. 1585–90), which reads: *'amal-i ibtada-yi mashq-i murid az chahar martaba-yi ikhlas pay bar ja Sharif* (the work of the disciple of the beginning of the practice of the four stages of sincerity, with foot in place, Sharif).

52. On this devotional cult, also see chapter 3, especially the references in n. 34.

53. Abu'l Fazl, *A'in-i Akbari*, trans. Blochmann, 1:174; Abu'l Fazl, *A'in-i Akbari*, ed. Blochmann, 1:160.

54. Jahangir, *Jahangirnama*, trans. Thackston, 28.

55. Seyller, "Manohar," 148. Manohar was the son of Basavana, whose career in Akbar's manuscript atelier is discussed in chapter 2.

56. Jahangir, *Jahangirnama*, trans. Thackston, 29; Jahangir, *Jahangirnamah*, ed. Hashim, 9.

57. On the idea of the Mughal painter as a deliberate melder of artistic styles, see the illuminating arguments in K. Singh, *Real Birds in Imagined Gardens*.

58. Roe, *The Embassy of Sir Thomas Roe*, 142–43. On Roe's accounts of the exchange and presentation of paintings at Jahangir's court, see Pinch, "Same Difference in India and Europe," esp. 400–405; and Stronge, "Portraiture," 29.

59. There likely exist other paintings of Nawruz ceremonies that lack inscriptions identifying them as such; their subject matter must be inferred through other means. Skelton, for example, has speculated that a painting in the Keir collection, which he dates to circa 1620, may depict a Nawruz scene ("Indian Painting of the Mughal Period," cat. no. V.70, 259–60, color plate 37, pl. 127). He bases his theory on the presence in the painting of an ornate throne, which may have been the one made by Austin of Bordeaux and presented to Jahangir by 'Itimad al-Daula during the Nawruz celebrations of 1619 (Jahangir, *Jahangirnama*, trans. Thackston, 298; Jahangir, *Jahangirnamah*, ed. Hashim, 301). According to a letter written by Austin of Bordeaux on April 27, 1625, to the baron du Tour, this throne was used only on the occasion of Nawruz (Maclagan, "Four Letters of Austin of Bordeaux," 13). Another candidate is an image of Shah Jahan receiving Shah Shuja' in *durbar*, from the St. Petersburg Album (E-14, f. 34r), which may depict a gifting ceremony that took place during the Nawruz festivities of 1630 (Akimushkin et al., *The St Petersburg* Muraqqa', 1:pl. 125).

60. On the Mughal *darbar* portrait as a state representation of the imperial corporate body, see Koch, "Hierarchical Principles," and Koch, "Visual Strategies."

61. See, for example, Seyller, "Manohar," 152n33, where he conjectures that Manohar's painting depicts actual European works on canvas that had arrived at Jahangir's court in 1608.

62. Bailey originated this theory, as related by S. C. Welch in Akimushkin et al., *The St Petersburg* Muraqqa', 2:106.

63. In a related vein, Payne, writing about the nexus of visuality, vision, and epistemology in early modern Europe, characterizes Filippo Brunelleschi's famous experiment with linear perspective before the Baptistery in Florence in 1413 as "the moment of [linear perspective's] public performance, of the presentation of vision as an event" ("Introduction," 3).

64. I draw here from Daston, "Epistemic Images," but see also P. Smith, *The Body of the Artisan*; and Marr, "Knowing Images." For a foundational art-historical study of the history of vision and visuality, again focusing on early modern Europe, see Alpers, *The Art of Describing*.

65. Littlefield, "The Object in the Gift," 101.

66. Jahangir, *Jahangirnama*, trans. Thackston, 108, 143; Jahangir, *Jahangirnamah*, ed. Hashim, 96, 135.

67. An allusion in one of the calligraphed cartouches situated just above the painting to the *jam-i jam* (world-revealing goblet), a divinatory vessel associated with the legendary Persian ruler Jamshid, incidentally hints at this work's possible status as a Nawruz presentation piece. Bishandas's painting was probably mounted in an impe-

rial album made for Jahangir. However, since it was taken, probably as loot, to Iran in the mid-eighteenth century, where it was mounted and bound in an Asfsharid album today known as the St. Petersburg Album, the original context of the work remains obscure.

68. For one such example, see Krahl, Erbahar and Ayers, *Chinese Ceramics,* 2:828, cat. no. 1679. Das was the first scholar to correctly identify the cup in the painting as a specific type of Ming porcelain ware; he also suggests that the vessel was one among others that Shah 'Abbas may have gifted to Jahangir (see Das, "Chinese Porcelain," 391).

69. The workshops of Augsburg produced a number of Diana drinking automata, two examples of which can be found in the collections of the Metropolitan Museum of Art (17.190.746) and the Liechtenstein Museum (Inv.-No. SI261). On the circulation and adaptation of European automata at the Mughal court, see Keating, "Metamorphosis."

70. Abu'l Fazl, *A'in-i Akbari,* trans. Blochmann, 1:103; Abu'l Fazl, *A'in-i Akbari,* ed. Blochmann, 1:111–12. The special status accorded writing for its capacity to record speech and ideas has a long history in Persian and Arabic discourses on the arts of the pen. See Rosenthal, "Abū Ḥaiyān al-Tawḥīdī on Penmanship"; and Roxburgh, "'The Eye is Favored,'" 279–80.

71. Abu'l Fazl, *A'in-i Akbari,* ed. Blochmann, 1:111, 114.

72. On the idea of the Mughal painter as a self-conscious, even hesitant, creator of illusionistic images, see also K. Singh, *Real Birds in Imagined Gardens,* 70.

73. Compare, for example, this image with two other late sixteenth-century portraits (most likely self-portraits) of Keshava Das, one in the Jahangir Album and today housed in the Staatsbibliothek zu Berlin, Preussischer Kulturbesitz (Libri picturati A 117, f. 25r), and the other in the collections of the Williams College Museum of Art (81.44).

74. Bahadur Khan Uzbek was also known as Abu'l Baqa: see Shahnawaz Khan Aurangabadi, *Ma'athir al-'umara,* 157.

75. Wensinck and Fahd, *Encyclopaedia of Islam, Second Edition,* s.v. ṣūra. On the creative agency and authority of the artist in the Islamic world, see, among others, Bürgel, *The Feather of Simurgh*; Roxburgh, *Prefacing the Image*; and Balafrej, *The Making of the Artist.*

76. Abu'l Fazl, *A'in-i Akbari,* trans. Naim, 184, with my minor adjustments; Abu'l Fazl, *A'in-i Akbari,* ed. Blochmann, 1:117.

77. On this subject, also see Juneja, "Circulation and Beyond," esp. 73–74. Whereas Juneja examines court artists' use of album frames, or borders, as a form of commentary on pictorial creation that she contrasts with the illusionism of the main album panel's painted surface, I argue that artists' meditations on these themes entered into the main panel of the album page as well.

78. Barthes, *Camera Lucida,* 27, 42, 55.

79. On Mughal attitudes (artistic and otherwise) toward the Virgin Mary during the reigns of Akbar and Jahangir, see Bailey, "The Indian Conquest"; Weis, "Maryam—Maria"; Moin, "Akbar's 'Jesus' and Marlowe's 'Tamburlaine'"; and Koch, "Being Like Jesus and Mary."

80. Previously published in Canby, "'Abd al-Samad," cat. no. 2, fig. 3, 102–5; Me-

likian-Chirvani, *Le chant du monde*, cat. no. 174, 436–37; Canby, "The Horses of 'Abd us-Samad," fig. 4; Binyon, Wilkinson, and Gray, *Persian Miniature Painting*, pl. 104b; and Verma, *Mughal Painters*, 41, 45.

81. *Shabih-i Shah Humayun u Akbar ra nigasht khama-yi 'Abd al-Samad [zi ruy-i hunar] numud tasvir anki tamam-i in majlis ba-safha-yi ki numayad ba-shah Akbar* (The pen of 'Abd al-Samad, who made the painting of the entire composition that is on the page that Akbar shows to the shah, painted the portrait of Shah Humayun and Akbar).

82. Melikian-Chirvani reads the inscription slightly differently (*Le chant du monde*, 436). From photographic details, it appears that Canby's reading of the inscription is the more accurate ("'Abd al-Samad," 98).

83. Binyon, Wilkinson, and Gray, *Persian Miniature Painting*, 147.

84. Abu'l Fazl, *The History of Akbar*, trans. Thackston, 3:127, 129 [English]; 126, 128 [Persian].

85. Soucek, "'Abd-Al-Ṣamad Šīrāzī."

86. The letter, which was addressed to the king of Kashgar, Rashid Khan, was later given to Bayazid Bayat by 'Abd al-Samad to record in his *Tarikh-i Humayun* of 1591 (*Three Memoirs of Homayun*, trans. Thackston, 2:28; Bayazid Bayat, *Tazkira-yi Humayun u Akbar*, ed. Hosain, 67–69). Bada'uni employed a similar trope in his characterization of 'Abd al-Samad's son, Muhammad Sharif, Mughal painter and boon companion of Jahangir, whom he described as having "bored in one poppy seed eight small holes, and passed wires through them, and . . . drew, on a grain of rice, a picture of an armed horseman, preceded by an outrider, and bearing all the things proper to a horseman such as a sword, a shield, a polo stick, etc." (Bada'uni, *A History of India*, trans. and ed. Haig, 3:430; Bada'uni, *Muntakhab al-Tavarikh*, ed. Sahib, 3:213). Whether 'Abd al-Samad or Muhammad Sharif in fact executed such miniature paintings is unknown. The topos of an artist executing a masterpiece on a grain of rice originated in discourses on the arts of Arabic and Persian calligraphy (see, e.g., Roxburgh, *Prefacing the Image*, 113).

87. According to Bada'uni, 'Abd al-Samad copied the four verses of Surat al-Ikhlas (Q112) on one side of a poppy seed and then inscribed its commentary (*tafsir*) on the reverse (*A History of India*, trans. and ed. Haig, 3:430; Bada'uni, *Muntakhab al-Tavarikh*, ed. Sahib, 3:213).

88. Coffey, "Between Amulet and Devotion," 95.

89. Abu'l Fazl, *A'in-i Akbari*, trans. Naim, 184; Abu'l Fazl, *A'in-i Akbari*, ed. Blochmann, 1:117.

90. On Mughal murals from the period, see Koch, "Jahangir and the Angels"; Koch, "Notes on the Painted and Sculptured Decoration"; Koch, "Mughal Palace Gardens"; Bailey, "The Indian Conquest"; and Stronge, "Jahangir's Itinerant Masters," 127–28.

91. For a similar argument, advanced in the context of depictions of idols in Ilkhanid illustrated manuscripts, see Roxburgh, "Concepts of the Portrait," esp. 118.

92. For a list of gifts exchanged at the courts of Akbar and Jahangir, as well as examples of paintings depicting scenes of courtly gifting, see Littlefield, "The Object in the Gift," appendix A, parts 3 and 4; and appendix B, parts 6 and 7. Littlefield does

not include the *'amal-i Nawruz* paintings discussed in this chapter among the objects that were presented to the Mughal emperors.

93. See Seyller, "The Inspection and Valuation of Manuscripts," 278.

94. Abu'l Fazl, *A'in-i Akbari*, trans. Blochmann, 1:445.

95. Jahangir, *Jahangirnama*, trans. Thackston, 182; Seyller, "The Inspection and Valuation of Manuscripts," 278.

Epilogue

1. Dadlani, *From Stone to Paper*, observes a parallel phenomenon in architecture and architectural practice. On the canonization of seventeenth-century Mughal paintings during the eighteenth century, see also Rice, "Painters, Albums, and Pandits."

2. See, for example, and Beach, *Rajput Painting*, 6–10; Skelton, "Shaykh Phul"; Dehejia, "The Treatment of Narrative"; Aitken, *The Intelligence of Tradition*; Glynn, "A Rājasthānī Princely Album"; and Beach, "The Masters of the Chunar *Ragamala*." On early Mughal responses to Rajput painting, see Aitken, "The Laud *Rāgamālā* Album."

3. Botchkareva, "Topographies of Taste."

BIBLIOGRAPHY

Abu'l Fazl. *A'in-i Akbari* [Regulations of Akbar]. Translated in part by C. M. Naim. In *The Tūtī-nāma of the Cleveland Museum of Art*, by Pramod Chandra, vol. 1. Graz: Akademische Druck-u. Verlagsanstalt, 1976.

———. *A'in-i Akbari* [Regulations of Akbar]. 2 vols. Edited by Heinrich Blochmann. Osnabrück: Biblio Verlag, 1985. First published 1877 by the Asiatic Society of Bengal.

———. *A'in-i Akbari* [Regulations of Akbar]. 2 vols. Translated by Heinrich Blochmann. Delhi: Low Price, 2006. First published 1927.

———. *The Akbarnama of Abu-l-Fazl: History of the Reign of Akbar, Including an Account of his Predecessors*. 3 vols. Translated by Henry Beveridge. Delhi: M. L. Chopra for Rare Books, 1973. First published in 1897 by the Asiatic Society of Bengal.

———. *The History of Akbar*. 8 vols. Translated and edited by Wheeler M. Thackston. Cambridge, MA: Harvard University Press, 2017–22.

Adamjee, Qamar. "Artistic Agency in Painted Narratives: The Case of the *Chandayan* Manuscripts." In *A Magic World: New Visions of Indian Painting, in Tribute to Ananda Coomaraswamy's* Rajput Painting of 1916, ed. Molly Emma Aitken, 116–29. Mumbai: Marg, 2017.

———. "Strategies for Visual Narration in the Illustrated *Chandayan* Manuscripts." PhD diss., Institute of Fine Arts, 2011.

Adamova, Adel T. "The Hermitage Manuscript of Nizami's *Khamsa* Dated 835/1431." *Islamic Art* 5 (2001): 53–132.

———. "Repetition of Compositions in Manuscripts: The *Khamsa* of Nizami in Leningrad." In *Timurid Art and Culture*, ed. Lisa Golombek and Maria Subtleny, 67–75. Leiden: Brill, 1992.

Adamova, Adel T., and J. M. Rogers. "The Iconography of *A Camel Fight*." *Muqarnas* 21 (2004): 1–14.

Ahmad, Aziz. "Safawid Poets and India." *Iran* 14 (1976): 117–32.

Aigle, Denise. "L'histoire sous forme graphique en arabe, persan et turc ottoman: Origines et function." *Bulletin d'études orientales* 58 (2008–2009): 11–49.

Aitken, Molly Emma. *The Intelligence of Tradition in Rajput Court Painting*. New Haven: Yale University Press, 2010.

———. "Introduction." In *A Magic World: New Visions of Indian Painting, in Tribute to Ananda Coomaraswamy's* Rajput Painting of 1916, ed. Molly Emma Aitken. Mumbai: Marg, 2017.

———. "The Laud *Rāgamālā* Album, Bikaner, and the Sociability of Subimperial Painting." *Archives of Asian Art* 63, no. 1 (2013): 27–58.

———. "Parataxis and the Practice of Reuse, from Mughal Margins to Mīr Kalān Khān." *Archives of Asian Art* 59 (2009): 81–103.

Akimushkin, Oleg, Francesca von Habsburg, Anatoly Ivanov, Yury A. Petrosyan, and Stuart Cary Welch. *The St Petersburg* Muraqqa': *Album of Indian and Persian Miniatures from the 16th through the 18th Century and Specimens of Persian Calligraphy by Imad Al-Hasani*. 2 vols. Milan: Leonardo Arte, 1996.

Alam, Muzaffar. "*Akhlaqi* Norms and Mughal Governance." In *The Making of Indo-Persian Culture: Indian and French Studies*, ed. Muzaffar Alam, Françoise Nalini Delvoye, and Marc Gaborieau, 67–98. New Delhi: Manohar, 2000.

———. *The Languages of Political Islam: India, 1200–1800*. Chicago: University of Chicago Press, 2004.

———. "The Mughals, the Sufi Shaikhs, and the Formation of the Akbari Dispensation." *Modern Asian Studies* 43, no. 1 (2009): 135–74.

Alam, Muzaffar, and Sanjay Subrahmanyam. "Frank Disputations: Catholics and Muslims in the Court of Jahangir (1608–11)." *Indian Economic and Social History Review* 46, no. 4 (2009): 457–511.

———. *Indo-Persian Travels in the Age of Discoveries, 1400–1800*. Cambridge: Cambridge University Press, 2007.

———. "Witnessing Transition: Views on the End of the Akbari Dispensation." In *The Making of History: Essays Presented to Irfan Habib*, ed. K. N. Panikkar, Terrence J. Byres, and Utsa Patnaik, 104–40. London: Anthem, 2002.

Alpers, Svetlana. *The Art of Describing: Dutch Art in the Seventeenth Century*. Chicago: University of Chicago Press, 1983.

Alvi, Sajida. "Religion and State during the Reign of Mughal Emperor Jahangir (1605–27): Nonjuristical Perspectives." *Studia Islamica* 69 (1989): 95–119.

Amanat, Abbas. "Persian Nuqtawīs and the Shaping of the Doctrine of 'Universal Conciliation' (*ṣulḥ-i kull*) in Mughal India." In *Norm, Transgression and Identity in Islam: Diversity of Approaches and Interpretations*, ed. O. Mir-Kasimov, 367–92. Leiden: Brill, 2014.

Anooshahr, Ali. "Dialogism and Territoriality in a Mughal History of the Islamic Millennium." *Journal of the Economic and Social History of the Orient* 55 (2012): 220–54.

Appadurai, Arjun. "Introduction: Commodities and the Politics of Value." In *The Social Life of Things: Commodities in Cultural Perspective*, ed. Arjun Appadurai, 3–63. Cambridge: Cambridge University Press, 1986.

Arnold, Sir Thomas W. *The Library of A. Chester Beatty: A Catalogue of the Indian Miniatures*. Revised and edited by James Vere Stewart Wilkinson. London: Emery Walker, 1936.

Asher, Catherine. *Architecture of Mughal India*. Cambridge: Cambridge University Press, 1992.

———. "A Ray from the Sun: Mughal Ideology and the Visual Construction of the Divine." In *The Presence of Light: Divine Radiance and Religious Experience*, ed. Matthew T. Kapstein, 161–94 . Chicago: University of Chicago Press, 2004.

Atabay, Badri. *Fihrist-i muraqqa'at-i kitabkhana-yi saltanati* [Catalogue of albums from the imperial library]. Tehran, 1974.

Babadžanov, Bahtijar, Aširbek Muminov, and Elizaveta Nekrasova. "Le mausolée de Chashma-yi 'Ayyûb à Boukhara et son prophète." *Cahiers d'Asie Centrale* 5–6 (1998): 63–94.

Babayan, Kathryn. *Mystics, Monarchs and Messiahs: Cultural Landscapes of Early Modern Iran.* Cambridge, MA: Harvard University Press, 2003.

Babur, Zahir al-Din Muhammad. *The* Baburnama*: Memoirs of Babur, Prince and Emperor.* Translated and edited by Wheeler M. Thackston. New York: Modern Library, 2002. First published 1996.

———. *Baburnama.* Translated by Annette S. Beveridge. New Delhi: Oriental Books Reprint Corp., 1970. First published 1922.

Bada'uni, 'Abd al-Qadir . *A History of India: Muntakhabu-ut-Tawarikh.* 3 vols. Translated by George S. A. Ranking, W. H. Lowe, and T. W. Haig. New Delhi: Atlantic, 1990.

———. *Muntakhab al-Tavarikh* [Selection of chronicles]. 3 vols. Edited by Mawlavi Ahmad 'Ali Sahib. Tehran: Anjaman-i Asar va Muvakhir-i Farhangi, 2000.

———. *Muntakhab al-Tavarikh* [Selection of chronicles]. 3 vols. Edited by W. N. Lees and Mawlavi Ahmad Ali. Calcutta: Asiatic Society of Bengal, 1865–69.

———. *Muntakhab-ut-Tawarikh* [Selection of chronicles]. 2 vols. Translated and edited by George S. A. Ranking. Karachi: Karimsons, 1976. First published 1884–1925 by the Asiatic Society of Bengal.

———. *Muntakhab-ut-Tawarikh* [Selection of chronicles]. Translated by H. M. Elliot and J. Dowson in *The History of India as Told by Its Own Historians,* vol. 5, *The Muhammad Period.* Frankfurt am Main: Institute for the History of Arabic-Islamic Science, 1997. First published 1873 by Trübner.

Bağci, Serpil. "A New Theme of the Shirazi Frontispiece Miniatures: The *Dīvān* of Solomon." *Muqarnas* 12 (1995): 101–11.

———. "Old Images for New Texts and Contexts: Wandering Images in Islamic Book Painting." *Muqarnas* 12 (2004): 21–32.

Bailey, Gauvin Alexander. *Art on the Jesuit Missions in Asia and Latin America.* Toronto: University of Toronto Press, 2001.

———. "Counter Reformation Symbolism and Allegory in Mughal Painting." PhD diss., Harvard University, 1996.

———. "The End of the 'Catholic Era' in Mughal Painting: Jahangir's Dream Pictures, English Painting, and the Renaissance Frontispiece." *Marg* 53, no. 2 (2001): 46–59.

———. "The Indian Conquest of Catholic Art: The Mughals, the Jesuits, and Imperial Mural Painting." *Art Journal* 57, no. 1 (Spring 1998): 24–30.

———. *The Jesuits and the Grand Mogul: Renaissance Art at the Imperial Court of India, 1580–1630.* Washington, DC: Freer Gallery of Art, Arthur M. Sackler Gallery, Smithsonian Institution, 1998.

———. "The *Truth-Showing Mirror*: Jesuit Catechism and the Arts in Mughal India." In *The Jesuits: Cultures, Sciences, and the Arts, 1540–1773*, ed. John W. O'Malley, Gauvin Alexander Bailey, Steven J. Harris, and T. Frank Kennedy, 380–401. Toronto: University of Toronto Press, 1999.

Balabanlilar, Lisa. "Lords of the Auspicious Conjunction: Turco-Mongol Imperial Identity on the Subcontinent." *Journal of World History* 18, no. 1 (March 2007): 1–39.

Balafrej, Lamia. *The Making of the Artist in Late Timurid Painting*. Edinburgh: Edinburgh University Press, 2019.

Baqli, Ruzbihan. *The Unveiling of Secrets: Diary of a Sufi Master*. Translated by Carl W. Ernst. Chapel Hill, NC: Parvardigar, 1997.

Barasch, Moshe. *Theories of Art: From Winckelmann to Baudelaire*. New York: New York University Press, 1985.

Barrett, Douglas, and Basil Gray. *Painting of India*. Geneva: Skira, 1963.

Barthes, Roland. *Camera Lucida: Reflections on Photography*. Translated by Richard Howard. New York: Hill and Wang, 1981.

Bashir, Shahzad. "Narrating Sight: Dreaming as Visual Training in Persianate Sufi Hagiography." In *Dreams and Visions in Islamic Societies*, ed. Özgen Felek and Alexander D. Knysh, 233–49. Albany: State University of New York Press, 2012.

———. *Sufi Bodies: Religion and Society in Medieval Islam*. New York City: Columbia University Press, 2011.

———. "The World as a Hat: Symbolism and Materiality in Safavid Iran." In *Unity in Diversity: Mysticism, Messianism and the Construction of Religious Authority in Islam*, edited by Orkhan Mir-Kasamov, 343–66. Leiden: Brill, 2014.

Bayat, Bayazid. *Tārīkh-i Humāyūn* (History of Humayun). Translated and edited by Wheeler M. Thackston. In *Three Memoirs of Homayun*. Vol. 2. Costa Mesa, CA: Mazda, 2009.

———. *Tazkira-yi Humayun u Akbar* [Biography of Humayan and Akbar]. Edited by Muhammad Hidayat Hosain. Calcutta: Royal Asiatic Society of Bengal, 1941.

Beach, Milo Cleveland. "The Context of Rajput Painting." *Ars Orientalis* 10 (1975): 11–17.

———. *The Grand Mogul: Imperial Painting in India, 1600–1660*. Williamstown, MA: Sterling and Francine Clark Art Institute, 1978.

———. "The Gulshan Album and the Workshops of Prince Salim." *Artibus Asiae* 73, no. 2 (2013): 445–77.

———. *The Imperial Image: Paintings for the Mughal Court*. Washington, DC: Freer Gallery of Art, Smithsonian Institution, 1981.

———. "Jahangir's Album: Some Clarifications." In *Arts of Mughal India: Studies in Honour of Robert Skelton*, ed. Rosemary Crill, Susan Stronge, and Andrew Topsfield, 111–18. Ahmedabad: Mapin, 2004.

———. "Mansur." In *Masters of Indian Painting, 1100–1900*, vol. 1, ed. Milo Cleveland Beach, Eberhard Fischer, and B. N. Goswamy, 247–48. Zurich: Artibus Asiae, 2011.

———. "The Masters of the Chunar *Ragamala* and the Hada Master." In *Masters of Indian Painting, 1100–1900*, vol. 1, ed. Milo Cleveland Beach, Eberhard Fischer, and B. N. Goswamy, I: 291–304. Zurich: Artibus Asiae, 2011.

———. *Mughal and Rajput Painting*. The New Cambridge History of India, vol. 1, part 3. Cambridge: Cambridge University Press, 1992.

———. "The Mughal Painter Abu'l Hasan and Some English Sources for His Style." *Journal of the Walters Art Gallery* 38 (1980): 6–33.

———. "The Mughal Painter Kesu Das." *Archives of Asian Art* 30 (1976–77): 34–52.

———. "*Muraqqaʿ-i Gulshan*: The Inscriptions." In *No Tapping around Philology: A Festschrift in Honor of Wheeler McIntosh Thackston Jr.'s 70th Birthday*, ed. Alireza Korangy and Daniel J. Sheffield, 437–46. Wiesbaden: Harrassowitz, 2014.

———. *Rajput Painting at Bundi and Kotah*. Ascona, Switzerland: Artibus Asiae, 1974.

Beach, Milo Cleveland, Eberhard Fischer, and B. N. Goswamy, eds. *Masters of Indian Painting, 1100–1900*. 2 vols. Zurich: Artibus Asiae, 2011.

Bean, Susan. "The Unfired Clay Sculpture of Bengal in the Artscape of Modern South Asia." In *Companion to Asian Art and Architecture*, ed. Rebecca M. Brown and Deborah S. Hutton, 604–28. London: Wiley-Blackwell, 2011.

Belting, Hans. *An Anthropology of Images: Picture, Medium, Body*. Princeton: Princeton University Press, 2011.

Berlekamp, Persis. *Wonder, Image, and Cosmos in Medieval Islam*. New Haven: Yale University Press, 2011.

Beveridge, Henry. "Sultan Khusrau." *Journal of the Royal Asiatic Society of Great Britain and Ireland* 39 (1907): 597–609.

Bhandare, Shailendra. "Rituals of Power: Coinage, Court Culture and Kingship under the Mughals." In *Power, Presence and Space: South Asian Rituals in Archaeological Context*, ed. Henry Albery, Jens-Uwe Hartmann, and Himanshu Prabha Ray, 39–82. London: Routledge, 2020.

Binbaş, İlker Evrim. "Structure and Function of the 'Genealogical Tree' in Islamic Historiography." In *Horizons of the World: Festschrift for Isenbike Togan*, ed. İlker Evrim Binbaş and Nurten Kılıç-Schube, 465–544. Istanbul: Ithaki, 2011.

Binyon, Laurence, J. V. S. Wilkinson, and Basil Gray. *Persian Miniature Painting, Including a Critical and Descriptive Catalogue of the Miniatures Exhibited at Burlington House, January–March, 1931*. 1933. Reprint, New York: Dover Publications, 1971.

Blake, Stephen. "Nau Ruz in Mughal India." In *Rethinking a Millennium: Perspectives on Indian History from the Eighth to the Eighteenth Century. Essays for Harbans Mukhia*, ed. Rajat Datta, 121–35. New Delhi: AAKAR, 2008.

Botchkareva, Anastassiia Alexandra. "Representational Realism in Cross-Cultural Perspective: Changing Visual Cultures in Mughal India and Safavid Iran, 1580–1750." PhD diss., Harvard University, 2014.

———. "Topographies of Taste: Aesthetic Practice in 18th-Century Persianate Albums." *Journal18* 6 (Fall 2018), www.journal18.org/3245.

Bourdieu, Pierre. *Outline of a Theory of Practice*. Translated by Richard Nice. Cambridge: Cambridge University Press, 1977.

Boyce, Mary. "Nowruz i. In the Pre-Islamic Period." In *Encyclopaedia Iranica*, ed. Ehsan Yarshater. Published online 2016, www.iranicaonline.org/articles/nowruz-i.

Boys-Stones, George. "Physiognomy and Ancient Psychological Theory." In *Seeing*

the Face, Seeing the Soul: Polemon's Physiognomy from Classical Antiquity to Medieval Islam*, ed. Simon Swain, 19–124. Oxford: Oxford University Press, 2007.

Brac de la Perrière, Eloïse. *L'art du livre dans l'Inde des sultanats*. Paris: Presses universitaires de Paris-Sorbonne, 2008.

Brand, Michael and Glenn Lowry. *Akbar's India: Art from the Mughal City of Victory*. New York: The Asia Society Galleries, 1985.

Branfoot, Crispin. "Introduction: Portraiture in South Asia." In *Portraiture in South Asia since the Mughals: Art, Representation and History*, ed. Crispin Branfoot, 1–32. London: I. B. Tauris, 2018.

Brend, Barbara. "Another Career for Mirza 'Ali?" In *Society and Culture in the Early Modern Middle East: Studies on Iran in the Safavid Period*, ed. A. J. Newman, 213–35. Leiden: Brill, 2003.

———. "Dating the Prince: A Picture in the St Petersburg Mughal Album." *South Asian Studies* 24, no. 1 (2008): 91–6.

———. *The Emperor Akbar's* Khamsa *of Nizāmī*. London: The British Library, 1995.

———. *Perspectives on Persian Painting: Illustrations to Amir Khusrau's* Khamsah. London: Routledge, 2002.

———. "A Sixteenth-Century Manuscript from Transoxiana: Evidence for a Continuing Tradition in Illustration." *Muqarnas* 11 (1994): 103–16.

Brittlebank, Kate. "The Dreams of Kings: A Comparative Discussion of the Recorded Dreams of Tipu Sultan of Mysore and Peter the Great of Russia." *Journal of Early Modern History* 13, no. 5 (2009): 359–74.

Brookshaw, Dominic Parviz. "Palaces, Pavilions and Pleasure-gardens: The Context and Setting of the Medieval *Majlis*." *Middle Eastern Literatures* 6, no. 2 (2003): 199–223.

Brown, Percy. *Indian Painting*. Calcutta: Association Press, 1930.

———. *Indian Painting under the Mughals*. Oxford: Clarendon Press, 1924.

Buettner, Brigitte. "Past Presents: New Year's Gifts at the Valois Court, ca. 1400." *Art Bulletin* 83 (2001): 598–625.

Bukhari, Sahih al-. *The Translation of the Meanings of Sahih al-Bukhari*. Edited and translated by Muhammad Muhsin Khan. Vol. 9. Chicago: Kazi Bashir, 1976.

Burckhardt, Jacob. *Jacob Burckhardt-Gesamtausgabe*, vol. 12. Edited by Heinrich Wölfflin. Stuttgart: Deutsche Verlags-Anstalt, 1930.

Bürgel, Johann Christoph. *The Feather of Simurgh: The 'Licit Magic' of the Arts in Medieval Islam*. New York: New York University Press, 1988.

Campbell, Stephen J., ed. *Artists at Court: Image-Making and Identity, 1300–1500*. Boston: Isabella Stewart Gardner Museum, 2002.

Canby, Sheila, R. "'Abd al-Samad." In *Masters of Indian Painting: 1100–1900*, vol. 1, ed. Milo Cleveland Beach, Eberhard Fischer, and B. N. Goswamy, 97–110. Zurich: Artibus Asiae, 2011.

———. "The Horses of 'Abd us-Samad." In *Mughal Masters: Further Studies*, edited by Pratapaditya Pal. Mumbai: Marg, 1998.

———, ed. *Humayun's Garden Party: Princes of the House of Timur and Early Mughal Painting*. Bombay: Marg, 1994.

———. *Princes, Poets, and Paladins: Islamic and Indian Paintings from the Collection of

Prince and Princess Sadruddin Aga Khan. London: Trustees of the British Museum, 1998.

———. *The* Shahnama *of Shah Tahmasp: The Persian Book of Kings*. New York: Metropolitan Museum of Art, 2014.

Carvalho, Pedro Moura. "Salim's Role as Patron of Mughal Painting at Allahabad (1600–1604): Four Newly Identified Miniatures from a Dispersed Copy of the *Mir'at al-Quds*, a Life of Christ, for Emperor Akbar." In *No Tapping around Philology: A Festschrift in Honor of Wheeler McIntosh Thackston Jr.'s 70th Birthday*, ed. Alireza Korangy and Daniel J. Sheffield, 381–94. Wiesbaden: Harrassowitz, 2014.

Chagatai, M. A. "'Abd-al-Rahīm 'Anbarīn-Qalam." In *Encyclopaedia Iranica*, ed. Ehsan Yarshater. Published online 2011, www.iranicaonline.org/articles/abd-al-rahim-anbarin-qalam.

Chandra, Pramod. *The Tūtī-nāma of the Cleveland Museum of Art*. 2 vols. Graz: Akademische Druck- u. Verlagsanstalt, 1976.

Chann, Naindeep Singh. "Lord of the Auspicious Conjunction: Origins of the Ṣāḥib-Qirān." *Iran and the Caucasus* 13, no. 1 (2009): 93–110

Chittick, William C. "Ibn Arabi." In *The Stanford Encyclopedia of Philosophy* (2014), ed. Edward N. Zalta. Published online 2008, revised 2014, http://plato.stanford.edu/archives/spr2014/entries/ibn-arabi/.

———. *The Self-Disclosure of God: Principles of Ibn al-'Arabī's Cosmology*. Albany: State University of New York Press, 1998.

———. *The Sufi Path of Knowledge: Ibn al-'Arabī's Metaphysics of Imagination*. Albany: State University of New York Press, 1989.

Coffey, Heather. "Between Amulet and Devotion: Islamic Miniature Books in the Lilly Library." In *The Islamic Manuscript Tradition: Ten Centuries of Book Arts in Indiana University Collections*, ed. Christiane J. Gruber, 78–115. Bloomington: Indiana University Press, 2009.

Cohn, Bernard. *Colonialism and Its Forms of Knowledge*. Princeton: Princeton University Press, 1996.

Coomaraswamy, A. K. *Catalogue of the Indian Collection in the Museum of Fine Arts, Boston*. Boston: Museum of Fine Arts, 1923.

———. "Mughal Painting (Akbar and Jahangir)." *Museum of Fine Arts Bulletin* 16, no. 93 (1918): 2–8.

———. "Originality in Mughal Painting." *Journal of the Royal Asiatic Society of Great Britain and Ireland* (July 1910): 874–81.

———. *Rajput Painting*. 2 vols. London: Humphrey Milford, Oxford University Press, 1916.

———. *The Transformation of Nature in Art*. New York: Dover, 1934.

Crill, Rosemary, and Kapil Jariwala, eds. *The Indian Portrait, 1560–1860*. London: National Portrait Gallery Publications, 2010.

Crill, Rosemary, Susan Stronge, and Andrew Topsfield, eds. *Arts of Mughal India: Studies in Honour of Robert Skelton*. Ahmedabad: Mapin, 2004.

Dadlani, Chanchal. *From Stone to Paper: Architecture as History in the Late Mughal Empire*. New Haven: Yale University Press, 2019.

Dale, Thomas E. A. "The Individual, the Resurrected Body, and Romanesque

Portraiture: The Tomb of Rudolf von Schwaben in Merseburg." *Speculum* 77, no. 2 (2002): 707–43.

Darling, Linda T. "'The Vicegerent of God, from Him We Expect Rain': The Incorporation of the Pre-Islamic State in Early Islamic Political Culture." *Journal of the American Orientalist Society* 134, no. 3 (2014): 407–29.

Das, Asok Kumar. "Books and Pictures from the Zenana Mahal: The Collection of Manuscripts of Hamida Banu Begam." In *The Diverse World of Indian Painting: Vichitra-Viśva: Essays in Honour of Dr. Vishwa Chander Ohri*, ed. Usha Bhatia, Amar Nath Khanna, and Vijay Sharma, 20–28. New Delhi: Aryan Books International, 2009.

———. "Calligraphers and Painters in Early Mughal Painting." In *Chhavi-2*, ed. Anand Krishna, 92–97. Varanasi: Bharat Kala Bhavan, 1981.

———. "Chinese Porcelain at the Mughal Court." *Silk Road Art and Archaeology* 2 (1991–92): 383–409.

———. *Mughal Painting during Jahangir's Time*. Calcutta: Asiatic Society, 1978.

———. *Paintings of the Razmnama: The Book of War*. Ahmedabad: Mapin, 2005.

———. "Salim's Taswirkhana." In *Allahabad: Where the Rivers Meet*, ed. Neelum Saran Gour, 57–71. Mumbai: Marg, 2009.

———. *Wonders of Nature: Ustad Mansur at the Mughal Court*. Mumbai: Marg, 2012.

Das, Asok Kumar, ed. *Mughal Masters: Further Studies*. Mumbai: Marg, 1998.

Daston, Lorraine. "Epistemic Images." In *Vision and Its Instruments: Art, Science, and Technology in Early Modern Europe*, ed. Alina Payne, 13–35. University Park: Pennsylvania State University Press, 2015.

De Boer, T. J., and L. Gardet. "'Ālam." In *Encyclopaedia of Islam, Second Edition*, ed. P. Bearman, T. Bianquis, C. E. Bosworth, E. van Donzel, and W. P. Heinrichs. Published online 2012, http://dx.doi.org/10.1163/1573-3912_islam_COM_0041.

Dehejia, Vidya. "The Treatment of Narrative in Jagat Singh's *Rāmāyaṇa*: A Preliminary Study." *Artibus Asiae* 56, nos. 3–4 (1996): 303–24.

De Laet, Johannes. *The Empire of the Great Mogol: A Translation of De Laet's "Description of India and Fragment of Indian History."* Translated by John S. Hoyland. Bombay: D. B. Taraporevala Sons, 1928.

Déroche, François, Anne Berthier, Marie-Geneviève Guesdon, Bernard Guineau, Francis Richard, Annie Vernay-Nouri, Jean Vezin, and Muhammad Isa Waley. *Islamic Codicology: An Introduction to the Study of Manuscripts in Arabic Scripts*. London: Al-Furqān Islamic Heritage Foundation, 2005.

Derrida, Jacques. "Structure, Sign, and Play in the Discourse of the Human Sciences." In *Writing and Difference*, translated by Alan Bass, 278–93. Chicago: University of Chicago Press, 1978.

Desai, Vishakha N. "Painting and Politics in Seventeenth-Century North India: Mewār, Bikāner, and the Mughal Court." *Art Journal* 49, no. 4 (1990): 370–78.

Desai, Z. A. "Inscription on the Mausoleum of Mir Abdullah Mushkin-Qalam at Agra." In *Islamic Heritage in South Asian Subcontinent*, vol. 1, ed. Nazir Ahmad and I. H. Siddiqui. Jaipur: Publication Scheme, 1998.

———. "Inscriptions from the Khusraw Bagh, Allahabad." In *Epigraphia Indica, Arabic and Persian Supplement* (1959–61): 64–68. New Delhi: Director General, Archaeological Survey of India, 1987.

DeWeese, Dewin. "Ahmad Yasavī and the Dog-Men: Narratives of Hero and Saint at the Frontier of Orality and Textuality." In *Theoretical Approaches to the Transmission and Edition of Oriental Manuscripts: Proceedings of a Symposium Held in Istanbul, March 28–30, 2001*, ed. Judith Pfeiffer and Manfred Kropp, 147–73. Würzburg: Ergon-Verlag, 2007.

———. "Orality and the Master-Disciple Relationship in Medieval Sufi Communities (Iran and Central Asia, 12th–15th centuries)." In *Oralité et lien social au Moyen Âge (Occident, Byzance, Islam): Parole donnée, foi jurée, serment*, ed. Marie-France Auzépy and Guillaume Saint-Guillain, 293–307. Paris: Collège de France—CNRS, 2008.

Digby, Simon. "Literary Evidence for Painting in the Delhi Sultanate." *Bulletin of the American Academy of Benares* 1 (1967): 47–58.

Dost Muhammad. "The Bahram Mirza Album Preface by Dost-Muhammad." Translated and edited by Wheeler M. Thackston. In *Album Prefaces and Other Documents on the History of Calligraphers and Painters*, 4–17. Leiden: Brill, 2001.

Dye, Joseph, III. *The Arts of India: Virginia Museum of Fine Arts*. Richmond: Virginia Museum of Fine Arts, 2001.

Eaton, Richard. *A Social History of the Deccan, 1300–1761: Eight Indian Lives*. Cambridge: Cambridge University Press, 2005.

Elias, Norbert. *The Court Society*. Translated by Edmund Jephcott. New York: Pantheon, 1983.

Ernst, Carl W. *Eternal Garden: Mysticism, History, and Politics at a South Asian Sufi Center*. Albany: State University of New York Press, 1992.

———. "Fayzi's Illuminationist Interpretation of Vedanta: The *Shariq al-ma'rifa*." *Comparative Studies of South Asia, Africa, and the Middle East* 30, no. 3 (2010): 356–64.

Ernst, Carl W., and Bruce B. Lawrence. *Sufi Martyrs of Love: The Chishti Order in South Asia and Beyond*. London: Palgrave Macmillan, 2002.

Esin, Emil. "Hanlar Ulaki (The Succession of Kings): On the illustrated genealogy, with Uygur inscriptions, of Mongol and Temürid dynasties, at the Topkapı Library." In *Gedanke und Wirkung: Festschrift zum 90. Geburtstag von Nikolaus Poppe*, ed. W. Heissig and K. Sagaster, 113–27. Wiesbaden: O. Harrassowitz, 1989.

Eslami, Kambiz. "Golšān Album." In *Encyclopaedia Iranica*. Published online 2012, www.iranicaonline.org/articles/golsan-album.

Ettinghausen, Richard. "The Emperor's Choice." In *De artibus opuscula XL: Essays in Honor of Erwin Panofsky*, vol. 1, ed. Millard Meiss, 98–120. New York: New York University Press, 1961.

Ettinghausen, Richard, and I. L. Fraad. "Sultanate Painting in Persian Style, Primarily from the First Half of the Fifteenth Century: A Preliminary Study." In *Chaavi: Golden Jubilee Volume*, ed. Anand Krishna, 48–66. Varanasi: Bharat Kala Bhavan, Benares Hindu University, 1971.

Fahd, Toufy. "The Dream in Medieval Islamic Society." In *The Dream and Human Societies*, ed. Gustav E. von Grunebaum and Roger Caillois, 351–63. Berkeley: University of California Press, 1966.

———. "Les songes et leur interprétation selon l'Islam." In *Les songes et leur interprétation: Egypte ancienne, Babylone, Hittites, Canaan, Israël, Islam, peuples*

altaïques, Persans, Kurdes, Inde, Cambodge, Chine, Japon, ed. Anne-Marie Esnoul, 175–87. Paris: Éditions du Seuil, 1959.

Farhad, Massumeh, ed., with Serpil Bağci. *Falnama: Book of Omens*. London: Thames & Hudson, 2009.

Faruqui, Munis. *The Princes of the Mughal Empire, 1504–1719*. Cambridge: Cambridge University Press, 2012.

Feldman, Marian. *Communities of Style: Portable Luxury Arts, Identity, and Collective Memory in the Iron Age Levant*. Chicago: University of Chicago Press, 2014.

Fetvacı, Emine. "The Album of Ahmed I." *Ars Orientalis* 42 (2012): 127–38.

———. *The Album of the World Emperor: Cross-Cultural Collecting and the Art of Album-Making in Seventeenth-Century Istanbul*. Princeton: Princeton University Press, 2019.

———. "From Print to Trace: An Ottoman Imperial Portrait Book and Its Western European Models." *Art Bulletin* 95, no. 2 (2013): 243–68.

———. *Picturing History at the Ottoman Court*. Bloomington: Indiana University Press, 2013.

Flatt, Emma J. *The Courts of the Deccan Sultanates: Living Well in the Persian Cosmopolis*. Cambridge: Cambridge University Press, 2019.

Fleischer, Cornell H. *Bureaucrat and Intellectual in the Ottoman Empire: The Historian Mustafa Ali (1541–1600)*. Princeton: Princeton University Press, 1986.

———. "The Lawgiver as Messiah: The Making of the Imperial Image in the Reign of Süleymān." In *Soliman le magnifique et son temps*, ed. Gilles Veinstein, 159–77. Paris: La Documentation Française, 1992.

Floor, Willem. "The Talar-i Tavila or Hall of Stables, a Forgotten Safavid Palace." *Muqarnas* 19 (2002): 149–63.

Foltz, Richard. "The Central Asian Naqshbandī Connections of the Mughal Emperors." *Journal of Islamic Studies* 7, no. 2 (1996): 229–39.

———. "Two Seventeenth-Century Central Asian Travellers to Mughal India." *Journal of the Royal Asiatic Society of Great Britain and Ireland* 6, no. 3 (1996): 367–77.

Foster, William, ed. *Letters Received by the East India Company from Its Servants in the East*. 6 vols. London: S. Low, Marston, 1896–1902.

Franke, Heike. "Emperors of *Ṣūrat* and *Maʿnī*: Jahangir and Shah Jahan as Temporal and Spiritual Rulers." *Muqarnas* 31 (2014): 123–49.

Fraser, Simon. "Introduction: Painting, Patronage, and Propaganda in Mughal India." In *Mughal Paintings: Art and Stories*, ed. Sonya Rhie Quintanilla, 15–40. London: D. Giles, 2016.

Gacek, Adam. *Arabic Manuscripts: A Vademecum for Readers*. Leiden: Brill Academic, 2009.

Geoffroy, E. "*Tadjallī*." In *Encyclopaedia of Islam*, 2nd edition, ed. P. Bearman, T. Bianquis, C. E. Bosworth, E. van Donzel, and W. P. Heinrichs. Published online 2012, http://dx.doi.org/10.1163/1573-3912_islam_SIM_7275.

Ghaly, Mohammed M. "Physiognomy: A Forgotten Chapter of Disability in Islam, the Discussions of Muslim Jurists." *Bibliotheca Orientalis* 66, nos. 3–4 (2009): 162–98.

Ghersetti, Antonella. "The Semiotic Paradigm: Physiognomy and Medicine in Medieval Islam." In *Seeing the Face, Seeing the Soul*, ed. Simon Swain, 281–308. Oxford: Oxford University Press, 2007.

Glynn, Catherine. "Early Painting in Mandi." *Artibus Asiae* 44, no. 1 (1983): 21–64.

———. "A Rajasthani Princely Album: Rajput Patronage of Mughal-Style Painting." *Artibus Asiae* 60, no. 2 (2000): 222–64.

Godard, Yedda. "Les marges du Murakka' Gulshan." *Athar-e Iran* 1 (1936): 11–33.

Gonzalez, Valerie. *Aesthetic Hybridity in Mughal Painting, 1526–1658*. Farnham, UK: Ashgate, 2015.

Gordon, Stewart, ed. *Robes of Honour: Khil'at in Pre-colonial and Colonial India*. New Delhi: Oxford University Press, 2003.

Goswamy, B. N. *A Jainesque Sultanate* Shahnama *and the Context of Pre-Mughal Painting in India*. Zurich: Museum Rietberg, 1988.

———. "Pahari Painting: The Family as the Basis of Style." *Marg* 21, no. 4 (1968): 17–62.

Goswamy, B. N., and Eberhard Fischer. *Wonders of a Golden Age: Painting at the Court of the Great Mughals*. Zurich: Museum Rietberg, 1987.

Gould, Rebecca. "How Gulbadan Remembered: The *Book of Hūmayūn* as an Act of Representation." *Early Modern Women: An Interdisciplinary Journal* 6 (2011): 187–93.

Grabar, Oleg, and Mika Natif. "The Story of Portraits of the Prophet Muhammad." *Studia Islamica* 96 (2004): 19–37.

Granovetter, Mark. "The Strength of Weak Ties." *American Journal of Sociology* 78, no. 6 (1973): 1360–80.

Graves, Margaret. *Arts of Allusion: Object, Ornament, and Architecture in Medieval Islam*. Oxford: Oxford University Press, 2018.

———. "Beyond the Beholder's Share: Painting as Process." In *Fruit of Knowledge, Wheel of Learning: Essays in Honour of Carole and Robert Hillenbrand*, vol. 2, ed. Ali M. Ansari and Melanie Gibson, 66–97. London: Gingko, 2022.

Green, Nile. "A Brief World History of Muslim Dreams." *Islamic Studies* 54, nos. 3–4 (2015): 143–67.

———. "The Religious and Cultural Roles of Dreams and Visions in Islam." *Journal of the Royal Asiatic Society of Great Britain and Ireland* 13 (2003): 287–313.

Gruber, Christiane J. "Between Logos (*Kalima*) and Light (*Nūr*): Representations of the Prophet Muhammad in Islamic Painting." *Muqarnas* 26 (2009): 229–62.

———. *The Ilkhanid Book of Ascension: A Persian-Sunni Prayer Manual*. London: Tauris Academic Studies, 2009.

———. "In Defense and Devotion: Affective Practices in Early Modern Turco-Persian Manuscript Paintings." In *Affect, Emotion, and Subjectivity in Early Modern Muslim Empires: New Studies in Ottoman, Safavid, and Mughal Art and Culture*, ed. Kishwar Rizvi, 95–123. Leiden: Brill, 2017.

———. "The Prophet Muhammad's Ascension (*Mi'rāj*) in Islamic Art and Literature, ca. 1300–1600." PhD diss., University of Pennsylvania, 2005.

———. *The Timurid Book of Ascension (Mi'rājnama): A Study of Text and Image in a Pan-Asian Context*. Valencia: Patrimonio Ediciones, 2008.

Gruber, Christiane J., and Frederick Colby, eds. *The Prophet's Ascension: Cross-Cultural*

Encounters with the Islamic Mi'raj Tales. Bloomington: Indiana University Press, 2010.

Grunebaum, Gustav E. von. "Introduction: The Cultural Function of the Dream as Illustrated by Classical Islam." In *The Dream and Human Societies*, ed. Gustave E. von Grunebaum and Roger Caillois, 3–21. Berkeley: University of California Press, 1966.

Gulbadan Banu Begam. *The History of Humayun*. Translated by Annette S. Beveridge. Delhi: Idarah-i Adabiyat-i Delli, 1972.

Gulbransen, Krista. "Jahāngīrī Portrait *Shast*s: Material-Discursive Practices and Visuality at the Mughal Court." *Postmedieval* 11 (2020): 68–79.

Hasan, Mohibbul. *Babur: Founder of the Mughal Empire in India*. New Delhi: Manohar, 1985.

Hay, Jonathan. "Interventions: The Mediating Work of Art." *Art Bulletin* 89, no. 3 (2007): 435–59.

Hermansen, Marcia K. "Visions as 'Good to Think': A Cognitive Approach to Visionary Experience in Islamic Sufi Thought." *Religion* 27, no. 1 (1997): 25–43.

Hodivala, S. H. *Historical Studies in Mughal Numismatics*. Bombay: Numismatic Society of India, 1976.

Houghteling, Sylvia. "The Emperor's Humbler Clothes: Textures of Courtly Dress in Seventeenth-Century South Asia." *Ars Orientalis* 47 (2017): 91–116.

Hoyland, Robert. "The Islamic Background to Polemon's Treatise." In *Seeing the Face, Seeing the Soul*, ed. Simon Swain, 227–80. Oxford: Oxford University Press, 2007.

———. "Physiognomy in Islam." *Jerusalem Studies in Arabic and Islam* 30 (2005): 361–402.

Humbach, Helmut, and Pallan R. Ichaporia. *Zamyād Yasht: Yasht 19 of the Younger Avesta; Text, Translation, Commentary*. Wiesbaden: Otto Harrassowitz, 1998.

Huseini, Said Reza. "The First Islamic Millennium and the Making of the *Tarikhi Alfi* in the Sixteenth Century Mughal India." MA thesis, University of Leiden, 2017.

Ibn 'Arabi. *Fusus al-hikam* [Seals of wisdom]. Translated by R. W. J. Austin. New York: Paulist Press, 1980.

———. *Fusus al-hikam* [Seals of wisdom]. Translated by William C. Chittick. In *The Sufi Path of Knowledge: Ibn al-'Arabi's Metaphysics of Imagination*. Albany: State University of New York Press, 1989.

———. *al-Futuhat al-makkiyya* [Meccan openings]. Translated by William C. Chittick. In *The Self-Disclosure of God: Principles of Ibn al-'Arabi's Cosmology*. Albany: State University of New York Press, 1998.

Ibn Khaldun. *The Muqaddimah: An Introduction to History*. Translated by Franz Rosenthal. Edited and abridged by N. J. Dawood. Princeton, NJ: Princeton University Press, 1967.

Jahangir, Nur al-Din. *The Jahangirnama: Memoirs of Jahangir, Emperor of India*. Translated by Wheeler M. Thackston. Washington, DC: Smithsonian Institution, 1999.

———. *Jahangirnamah, Tuzuk-i Jahangiri*. Edited by Muhammad Hashim. Tehran: Intisharat-i Bunyad-i Farhang-i Iran, 1980.

Jariwala, Kapil. "Introduction." In *The Indian Portrait, 1560–1860*, ed. Rosemary Crill and Kapil Jariwala, 11–16. Ahmedabad: Mapin, 2010.

Johansen, Baber. "Signs as Evidence: The Doctrine of Ibn Taymiyya (1263–1328) and Ibn Qayyim al-Jawziyya (d. 1351) on Proof." *Islamic Law and Society* 9, no. 2 (2002): 168–93.

Joshi, P. M. "Asad Beg's Mission to Bijapur, 1603–4." In *Mahamahopadhyaya Prof. D.V Potdar Sixty-First Birthday Commemorative Volume*, ed. S. N. Sen, 184–96. Pune: M. M. Potdar Sixty-First Birthday Celebration Committee, 1950.

Juneja, Monica. "Circulation and Beyond: The Trajectories of Vision in Early Modern Eurasia." In *Circulations in the Global History of Art*, ed. Thomas DaCosta Kaufmann, Catherine Dossin, and Béatrice Joyeux-Prunel, 59–78. London: Routledge, 2016.

———. "On the Margins of Utopia: One More Look at Mughal Painting." *Medieval History Journal* 4 (2001): 203–40.

———. "Translating the Body into Image: The Body Politic and Visual Practice at the Mughal Court during the Sixteenth and Seventeenth Centuries." *Paragrana* 18, no. 1 (2009): 243–66.

Kangal, Selmin, ed. *The Sultan's Portrait: Picturing the House of Osman*. Istanbul: Işbank, 2000.

Keating, Jessica. "Metamorphosis at the Mughal Court." *Art History* 38, no. 4 (2015): 732–47.

Khafi Khan, Muhammad Hashim. *Muntakhab al-lubab* [Selection of essential matters], parts 1 and 2. Edited by Mawlavi Kabir al-Din Ahmad. Calcutta: Asiatic Society of Bengal, 1869.

Kinberg, Leah. "Literal Dreams and Prophetic *Hadīth* in Classical Islam: A Comparison of Two Ways of Legitimation." *Der Islam* 70, no. 2 (1993): 279–300.

Kinra, Rajeev. "Fresh Words for a Fresh World: *Tāza-Gū'ī* and the Poetics of Newness in Early Modern Indo-Persian Poetry." *Sikh Formations: Religion, Culture, Theory* 3 (2007): 125–49.

———. "Handling Diversity with Absolute Civility: The Global Historical Legacy of Mughal *Ṣulḥ-i Kull*." *Medieval History Journal* 16, no. 2 (2013): 251–95.

———. "Make It Fresh: Time, Tradition, and Indo-Persian Literary Modernity." In *Time, History and the Religious Imaginary in South Asia*, ed. Anne Murphy, 12–39. Abingdon: Routledge, 2011.

———. *Writing Self, Writing Empire: Chandar Bhan Brahman and the Cultural World of the Indo-Persian State Secretary*. Berkeley: University of California Press, 2015.

Knysh, Alexander. *Ibn 'Arabi in the Later Islamic Tradition: The Making of a Polemical Image in Medieval Islam*. Albany: State University of New York Press, 1999.

Knysh, Alexander, and Özgen Felek, eds. *Dreams and Visions in Islamic Societies*. Albany: SUNY Press, 2012.

Koch, Ebba. "The Baluster Column: A European Motif in Mughal Architecture and Its Meaning." *Journal of the Warburg and Courtauld Institutes* 45 (1982): 251–62.

———. "Being Like Jesus and Mary: The Jesuits, the Polyglot Bible and Other Antwerp Print Works at the Mughal Court." In *Transcultural Imaginations of the Sacred*, ed. Klaus Krüger and Margit Kern, 197–230. Leiden: Brill, 2019.

———. "Hierarchical Principles of Shah-Jahani Painting." In *King of the World: The Padshahnama, an Imperial Mughal Manuscript from the Royal Library, Windsor Castle*, ed. Milo Cleveland Beach, Ebba Koch, and Wheeler Thackston, 131–43. London: Thames and Hudson, 1997.

———. "The Influence of the Jesuit Mission on Symbolic Representations of the Mughal Emperors." In *Islam in India: Studies and Commentaries*, vol. 1, ed. C. W. Troll, 14–29. New Delhi: Vikas, 1982.

———. "Jahangir and the Angels: Recently Discovered Wall Paintings under European Influence in the Fort of Lahore." In *India and the West*, ed. Joachim Deppert, 173–95. New Delhi: Manohar, 1983.

———. *Mughal Art and Imperial Ideology: Collected Essays.* New Delhi: Oxford University Press, 2001.

———. "The Mughal Audience Hall: A Solomonic Revival of Persepolis in the Form of a Mosque." In *Royal Courts in Dynastic States and Empires: A Global Perspective*, ed. Metin Kunt, Tülay Artan, and Jeroen Duindam, 313–38. Leiden: Brill, 2011.

———. "The Mughal Emperor as Solomon, Majnun and Orpheus, or the Album as a Think-Tank for Allegory." *Muqarnas* 27 (2010): 278–311.

———. "Mughal Palace Gardens from Babur to Shah Jahan." *Muqarnas* 14 (1997): 143–65.

———. "My Garden Is Hindustan: The Mughal Padshah's Realization of a Political Metaphor." In *Middle East Garden Traditions: Unity and Diversity*, ed. Michel Conan, 158–75. Washington, DC: Dumbarton Oaks, 2007.

———. "Netherlandish Naturalism in Imperial Mughal Painting." *Apollo* 152 (2000): 29–37.

———. "Notes on the Painted and Sculptured Decoration at Nur Jahan's pavilions in the Ram Bagh (Bagh-i Nur Afshan) at Agra." In *Facets of Indian Art: A Symposium Held at the Victoria and Albert Museum*, ed. Robert Skelton, Andrew Topsfield, Susan Stronge, and Rosemary Crill, 51–65. New Delhi: Heritage Publishers, 1987.

———. *Shah Jahan and Orpheus: The Pietre Dure Decoration and the Programme of the Throne in the Hall of Public Audiences at the Red Fort of Delhi.* Graz: Akademische Druck- und Verlaganstalt, 1988.

———. "Visual Strategies of Imperial Self-Representation: The Windsor *Pādshāhnāma* Revisited." *Art Bulletin* 99, no. 3 (2017): 93–124.

Komaroff, Linda, and Stefano Carboni, eds. *The Legacy of Genghis Khan: Courtly Art and Culture in Western Asia, 1256–1353.* New Haven: Yale University Press, 2002.

Krahl, Regina, Nurdan Erbahar, and John Ayers. *Chinese Ceramics in the Topkapi Saray Museum, Istanbul, A Complete Catalogue.* Vol. 2. London: Sotheby's, 1986.

Krishna, Kalyan. "Problems of a Portrait of Jahangir in the Musée Guimet, Paris." In *Chhavi: Golden Jubilee Volume*, ed Anand Krishna, 392–94. Banaras: Bharat Kala Bhavan, 1971.

Krishna, Naval. "Bikaneri Miniature Painting Workshops of Ruknuddin, Ibrahim, and Nathu." *Lalit Kala* 21 (1990): 23–37.

Kühnel, Ernst. "Eine Stammtafel der Moghulkaiser." *Berliner Museen* 62, no. 3 (1941): 30–33.

Kühnel, Ernst, and Hermann Goetz. *Indian Book Painting from Jahangir's Album in the State Library in Berlin*. London: Kegan Paul, Trench, Trubner, 1926.

Kunitzsch, Paul. "Sun." In *Encyclopaedia of the Qurʾān*, ed. Jane Dammen McAuliffe. Published online 2005. http://dx.doi.org/10.1163/1875-3922_q3_EQSIM_00407.

Kurz, Otto. "A Volume of Mughal Drawings and Miniatures." *Journal of the Warburg and Courtauld Institutes* 30 (1967): 251–71.

Lambton, Ann K. S. "The Dilemma of Government in Islamic Persia: The *Siyāsat-nāma* of Niẓām al-Mulk." *Iran* 22 (1984): 55–66.

———. "*Pīshkash*: Present or Tribute?" *Bulletin of the School of Oriental and African Studies* 57, no. 1 (1994): 145–58.

Landau, Amy. "From Poet to Painter: Allegory and Metaphor in a Seventeenth-Century Persian Painting by Muhammad Zaman, Master of *Farangī-Sazī*." *Muqarnas* 28 (2011): 101–31.

Lange, Christian. "'On That Day When Faces Will Be White or Black' (Q3:106): Towards a Semiology of the Face in the Arabo-Islamic Tradition." *Journal of the American Oriental Society* 127, no. 4 (2007): 429–45.

Langermann, Y. Tzvi. "Arabic Cosmology." *Early Science and Medicine* 2, no. 2 (1997): 185–213.

Leach, Linda York. *Mughal and Other Indian Paintings from the Chester Beatty Library*. Vol. 1. London: Scorpion Cavendish, 1995.

———. "Pages from an *Akbarnama*." In *Arts of Mughal India: Studies in Honour of Robert Skelton*, ed. Rosemary Crill, Susan Stronge, and Andrew Topsfield, 43–55. London: Victoria and Albert Museum, 2004.

———. *Paintings from India*. London: Nour Foundation in association with Azimuth Editions and Oxford University Press, 1998.

Lefèvre, Corinne. "*Dīn-i ilāhī*." In *Encyclopaedia of Islam*, 3rd edition, ed. Kate Fleet, Gudrun Krämer, Denis Matringe, John Nawas, and Everett Rowson. Published online 2015. http://dx.doi.org/10.1163/1573-3912_ei3_COM_26038.

———. "In the Name of the Father: Mughal Genealogical Strategies from Bābur to Shāh Jahān." *Religions of South Asia* 5, no. 1 (2012): 409–42.

———. "The *Majālis-i Jahāngīrī* (1608–11): Dialogue and Asiatic Otherness at the Mughal Court." *Journal of the Economic and Social History of the Orient* 55, nos. 2–3 (2012): 255–86.

———. "Messianism, Rationalism and Inter-Asian Connections: The *Majalis-i Jahangiri* (1608–11) and the Socio-intellectual History of the Mughal 'Ulama." *Indian Economic and Social History Review* 54, no. 3 (2017): 317–38.

———. "Recovering a Missing Voice from Mughal India: The Imperial Discourse of Jahāngīr (r. 1605–1627) in His Memoirs." *Journal of the Economic and Social History of the Orient* 50, no. 4 (2007): 452–89.

Lelić, Emin. "Physiognomy (*ʿilm-i firāsat*) and Ottoman Statecraft: Discerning Morality and Justice." *Arabica* 64, nos. 3–4 (2017): 609–46.

Lentz, Thomas W., and Glenn D. Lowry. *Timur and the Princely Vision: Persian Art and Culture in the Fifteenth Century*. Los Angeles: Los Angeles County Museum of Art, 1989.

Liddle, Andrew V. *Coins of Jahangir: Creations of a Numismatist*. New Delhi: Manohar, 2013.

Littlefield, Sharon. "The Object in the Gift: Embassies of Jahangir and Shah Abbas." PhD diss., University of Minnesota, 1999.

Losensky, Paul. *Welcoming Fighānī: Imitation and Poetic Individuality in the Safavid-Mughal Ghazal*. Costa Mesa, CA: Mazda Publishers, 1998.

Losty, Jeremiah. "Abu'l Hasan." In *Mughal Masters of the Imperial Mughal Court*, ed. Pratapaditya Pal, 69–104. Bombay: Marg, 1991.

———. *Art of the Book in India*. London: British Library Reference Division Publications, 1982.

———. "The 'Bute Hafiz' and the Development of Border Decoration in the Manuscript Studio of the Mughals." *Burlington Magazine* 127, no. 993 (1985): 855–71.

———. "The Carpet at the Window: A European Motif in the Mughal *Jharokha* Portrait." In *Indian Painting: Themes, History and Interpretation: Essays in Honour of B. N. Goswamy*, ed. Mahesh Sharma and Padma Kaimal, 52–64. Ahmedabad: Mapin, 2013.

———. "From Three-Quarter to Full Profile in Indian Painting: Revolutions in Art and Taste." In *Das Bildnis in der Kunst des Orients*, ed. Martin Kraatz, Jürgen Meyer zur Capellen, and Dietrich Seckel, 153–66. Stuttgart: Franz Steiner Verlag, 1990.

Losty, Jeremiah, and Malini Roy. *Mughal India: Art, Culture, and Empire*. London: British Library, 2014.

Maclagan, Edward. "Four Letters of Austin of Bordeaux." *Journal of the Panjab Historical Society* 4 (1918): 3–17.

Malecka, Anna. "Solar Symbolism of the Mughal Thrones, A Preliminary Note." *Arts Asiatiques* 54 (1999): 24–32.

Malti-Douglas, Fedwa. "Dreams, the Blind, and the Semiotics of the Biographical Notice." *Studia Islamica* 51 (1980): 137–62.

Marr, Alexander. "Knowing Images." *Renaissance Quarterly* 69, no. 3 (2016): 1000–1013.

Mauss, Marcel. *The Gift: Form and Functions of Exchange in Archaic Societies*. Translated by Ian Cunnison. Eastford, CT: Martino Fine Books, 2011. First published in French in 1923 by L'Année Sociologique.

Melikian-Chirvani, Assadullah Souren. *Le chant du monde: L'art de l'Iran safavide, 1501–1736*. Paris: Musée du Louvre, 2007

———. "Mir Sayyed Ali: Painter of the Past and Pioneer of the Future." In *Mughal Masters: Further Studies*, ed. Asok Kumar Das, 30–51. Mumbai: Marg, 1998.

Melvin-Koushki, Matthew. "Early Modern Islamicate Empire: New Forms of Religiopolitical Legitimacy." In *The Wiley-Blackwell History of Islam*, ed. Armando Salvatore, Roberto Tottoli, and Babak Rahimi, 353–75. Hoboken, NJ: Wiley-Blackwell, 2018.

———. "*Taḥqīq* vs. *Taqlīd* in the Renaissances of Western Early Modernity." *Philological Encounters* 3 (2018): 193–249.

Minault (Graham), Gail. "Akbar and Aurangzeb: Syncretism and Separatism in Mughal India: A Re-examination." *Muslim World* 59, no. 2 (1969): 106–26.

Minissale, Gregory. *Images of Thought: Visuality in Islamic India, 1550–1750*. Newcastle: Cambridge Scholars Publishing, 2009.

———. "The Synthesis of European and Mughal Art in the Emperor Akbar's *Khamsa* of Nizami." October 13, 2000. http://www.asianart.com/articles/minissale.

Mirza, Sarah. "Dreaming the Truth in the *Sīra* of Ibn Hishām." In *Dreams and Visions in Islamic Societies*, ed. Özgen Felek and Alexander D. Knysh, 15–30. Albany: State University of New York Press, 2012.

Mitter, Partha. *Art and Nationalism in Colonial India, 1850–1922*. Cambridge: Cambridge University Press, 1995.

Moin, Ahmed Azfar. "Akbar's 'Jesus' and Marlowe's 'Tamburlaine': Strange Parallels of Early Modern Sacredness." *Fragments* 3 (2013–14). http://hdl.handle.net/2027/spo.9772151.0003.001

———. "Islam and the Millennium: Sacred Kingship and Popular Imagination in Early Modern Iran and India." PhD diss., University of Michigan, 2010.

———. *The Millennial Sovereign: Sacred Kingship and Sainthood in Islam*. New York: Columbia University Press, 2012.

———. "Millennial Sovereignty, Total Religion, and Total Politics." *History and Theory* 56, no. 1 (2017): 89–97.

———. "Painted Rituals: The Sacred Art of Jahangir." In *Muslim Voices: Community and the Self in South Asia*, ed. Sandria B. Freitag, David Gilmartin, and Usha Sanyal, 37–66. New Delhi: Yoda, 2013.

———. "Partisan Dreams and Prophetic Visions: Shi'i Critique in al-Mas'ūdī's History of the Abbasids." *Journal of the American Oriental Society* 127, no. 4 (2007): 415–27.

———. "Peering through the Cracks in the *Baburnama*: The Textured Lives of Mughal Sovereigns." *Indian Economic and Social History Review* 49, no. 4 (2012): 493–526.

———. "*Sulh-i Kull* as an Oath of Peace: Mughal Political Theology in History, Theory, and Comparison." Unpublished essay.

Monserrate, António de. *The Commentary of Father Monserrate*. Translated by J. S. Hoyland, S.J. Calcutta: Oxford University Press, 1922.

Mourad, Yusef. *La physiognomie arabe et le Kitab al-firasa de Fakhr al-Dīn al-Rāzī*. Paris: Geuthner, 1939.

Mukhia, Harbans. *The Mughals of India*. Malden, MA: Blackwell Publishing, 2004.

Mumtaz, Murad Khan. "Contemplating the Face of the Master: Portraits of Sufi Saints as Aids to Meditation in Seventeenth-Century Mughal India." *Ars Orientalis* 50 (2020): 106–28.

Natif, Mika. *Mughal Occidentalism: Artistic Encounters between Europe and Asia at the Courts of India, 1580–1630*. Leiden: Brill, 2018.

Necipoğlu, Gülru. "Framing the Gaze in Ottoman, Safavid, and Mughal Palaces." *Muqarnas* 23 (1993): 303–42.

———. "Persianate Images between Europe and China: The 'Frankish Manner' in the Diez and Topkapı Albums, c. 1350–1450." In *The Diez Albums: Contexts and Contents*, ed. Julia Gonnella, Friederike Weis, and Christoph Rauch, 531–91. Leiden: Brill, 2016.

———. "Word and Image in Portraits of the Ottoman Sultans: A Comparative

Perspective." In *The Sultan's Portrait: Picturing the House of Osman*, ed. Selmin Kangal, 22–59. Istanbul: İşbank, 2000.

Niyazioğlu, Aslı. *Dreams and Lives in Ottoman Istanbul: A Seventeenth-Century Biographer's Perspective*. Abingdon, UK: Routledge, 2007.

Nizam al-Din Awliya. *Nizam Ad-Din Awliya: Morals for the Heart*. Translated by Bruce Lawrence. New York: Paulist Press, 1991.

O'Hanlon, Rosalind. "Kingdom, Household, and Body: History, Gender and Imperial Service under Akbar." *Modern Asian Studies* 41, no. 5 (2007): 887–923.

———. "Manliness and Imperial Service in Mughal North India." *Journal of the Social and Economic History of the Orient* 42, no. 1 (1999): 47–93.

Okada, Amina. *Indian Miniatures of the Mughal Court*. Translated by Deke Dusinberre. New York: H. N. Abrams, 1992.

Orsini, Francesca, and Samira Sheikh, eds. *After Timur Left: Culture and Circulation in Fifteenth-Century North India*. Oxford: Oxford University Press, 2014.

Ortner, Sherry. "On Key Symbols." *American Anthropologist* 75, no. 5 (1973): 1338–46.

Overton, Keelan. "Book Culture, Royal Libraries, and Persianate Painting in Bijapur, circa 1580–1630." *Muqarnas* 33 (2016): 91–154.

———. "*Vida de Jacques de Coutre*: A Flemish Account of Bijapuri Visual Culture in the Shadow of Mughal Felicity." In *The Visual World of Muslim India: The Art, Culture and Society of the Deccan in the Early Modern Era*, ed. Laura E. Parodi, 233–64. London: I. B. Tauris, 2014.

Pal, Pratapaditya. *Indian Painting: A Catalogue of the Los Angeles County Museum of Art Collection*. Los Angeles: Los Angeles County Museum of Art, 1993.

Pal, Pratapaditya, ed. *Master Artists of the Imperial Mughal Court*. Bombay: Marg, 1991.

Parodi, Laura E. "Of Shaykhs, Bībīs and Begims: Sources on Early Mughal Marriage Connections and the Patronage of Babur's Tomb." In *Mediaeval and Modern Iranian Studies: Proceedings of the 6th European Conference of Iranian Studies (Vienna, 2007)*, ed. Maria Szuppe, Anna Krasnowolska, and Claus Pedersen, 121–38. Leuven: Peeters, 2011.

———. "Tracing the Rise of Mughal Portraiture: The Kabul Corpus, c. 1545–55." In *Portraiture in South Asia since the Mughals: Art, Representation and History*, ed. Crispin Branfoot, 49–71. London: I.B. Taurus, 2018.

Parodi, Laura E., Jennifer H. Porter, Frank D. Preusser, and Yosi Pozeilov. "Tracing the History of a Mughal Album Page in the Los Angeles County Museum of Art." *Asianart.com* (March 2010). http://www.asianart.com/articles/mughal/index.html#1.

Parodi, Laura E., and Giovanni Verri. "Infrared Reflectography of the Mughal Painting 'Princes of the House of Timur' (British Museum, 1913,0208,0.1)." *Journal of Islamic Manuscripts* 7, no. 1 (2016): 36–65.

Parodi, Laura E., and Bruce Wannell. "The Earliest Datable Mughal Painting: An Allegory of the Celebrations for Akbar's Circumcision at the Sacred Spring of Khwaja Seh Yaran near Kabul (1546 AD) [Staatsbibliothek zu Berlin—Preussischer Kulturbesitz, Libr. Pict. A117, fol. 15a]." Asianart.com (November 2011). www.asianart.com/articles/parodi/index.html.

Payne, Alina. "Introduction." In *Vision and Its Instruments: Art, Science, and Technology in Early Modern Europe*, ed. Alina Payne, 1–12. University Park: Pennsylvania State University Press, 2015.

Pedersen, Johannes. *The Arabic Book.* Translated by Geoffrey French and edited by Robert Hillenbrand. Princeton, NJ: Princeton University Press, 1984.

Pellò, Stefano. "The Portrait and Its Doubles: Nasir 'Ali Sirhindi, Mirza Bidil and the Comparative Semiotics of Portraiture in Late Seventeenth-Century Indo-Persian Literature." *Eurasian Studies* 15, no. 1 (2017): 1–35.

Perkinson, Stephen. *The Likeness of the King: A Prehistory of Portraiture in Late Medieval France.* Chicago: University of Chicago Press, 2009.

Pinch, William. "Same Difference in India and Europe." *History and Theory* 38, no. 3 (1999): 389–407.

Porter, Yves. "La forme et le sens: À propos portrait dans la littérature persan classique." In *Pand-o Sokhan: Mélanges offerts à Charles-Henri de Fouchécour*, ed. Christophe Balaÿ, Claire Kappler, and Živa Vesel, 219–31. Tehran: Institut Français de Recherche en Iran, 1995.

———. "From the 'Theory of the Two *Qalams*' to the 'Seven Principles of Painting': Theory, Terminology, and Practice in Persian Classical Painting." *Muqarnas* 17 (2000): 109–18.

Power, Martin. *Windows of the Soul: Physiognomy in European Culture 1470–1780.* Oxford: Oxford University Press, 2005.

Qazi Ahmad. *Gulistan-i Hunar* [Rose garden of arts]. Translated by Vladimir Minorsky. In *Calligraphers and Painters, a treatise by Qāzī Ahmad, son of Mīr Munshī, circa A.H. 1015/A.D 1606.* Washington, DC: Freer Gallery of Art, 1959.

Quinn, Sholeh. "The Dreams of Shaykh Safi al-Din and Safavid Historical Writing." *Iranian Studies* 29, nos. 1–2 (1996): 127–47.

Ramaswamy, Sumathi. "Conceit of the Globe in Mughal Visual Practice." *Comparative Studies in Society and History* 49, no. 4 (2007): 751–82.

Renard, John. *Tales of God's Friends: Islamic Hagiography in Translation.* Berkeley: University of California Press, 2009.

Rezavi, Syed Ali Nadeem. "Religious Disputations and Imperial Ideology: The Purpose and Location of Akbar's *Ibadatkhana*." *Studies in History* 24, no. 2 (2008): 195–209.

Rice, Yael. "Between the Brush and the Pen: On the Intertwined Histories of Mughal Painting and Calligraphy." In *Seeing the Past: Envisioning Islamic Art and Architecture; Essays in Honor of Renata Holod*, ed. David J. Roxburgh, 151–78. Leiden: Brill, 2014.

———. "The Brush and the Burin: Mogul Encounters with European Engravings." In *Crossing Cultures: Conflict, Migration, and Convergence: The Proceedings of the 32nd International Congress of the History of Art*, ed. Jaynie Anderson, 305–10. Melbourne: Miegunyah Press, 2009.

———. "The Emperor's Eye and the Painter's Brush: Artists and Agency at the Mughal Court, c. 1546–1627." PhD diss., University of Pennsylvania, 2011.

———. "The Global Aspirations of the Mughal Album." In *Rembrandt and the Inspiration of India*, ed. Stephanie Schrader, 61–77. Los Angeles: J. Paul Getty Museum, 2018.

———. "Lines of Perception: European Prints and the Mughal *Kitābkhāna*." In *Prints in Translation, 1450–1750: Image, Materiality, Space*, ed. Suzanne Karr Schmidt and Edward Wouk, 202–23. London: Routledge, 2017.

———. "Mughal Interventions in the Rampur *Jāmiʿ al-tavārīkh*." *Ars Orientalis* 42 (2012): 150–64.

———. "'One Flower from Each Garden': Contradiction and Collaboration in the Canon of Mughal Painters." In *Canons and Values: Ancient to Modern*, ed. Larry Silver and Kevin Terraciano, 138–62. Los Angeles: Getty Research Institute, 2019.

———. "Painters, Albums, and Pandits: Agents of Image Reproduction in Early Modern South Asia." *Ars Orientalis* 51, published online 2021, https://doi.org/10.3998/ars.13441566.0051.002.

———. "A Persian Mahabharata: The 1598–99 *Razmnama*." *Manoa* 22, no. 1 (2010): 125–31.

———. "Workshop as Network: A Case Study from Mughal South Asia." *Artl@s Bulletin* 6, no. 3 (2017): 50–65.

Richard, Francis. "An Unpublished Manuscript from the Workshop of Emperor Humāyūn, the *Khamsa* Smith-Lessouëf 216 of the Bibliothèque Nationale." In *Confluence of Cultures: French Contributions to Indo-Persian Studies*, ed. Francoise "Nalini" Delvoye, 37–53. New Delhi: Manohar, 1994.

Richards, John F. "The Formulation of Imperial Authority under Akbar and Jahangir." In *Kingship and Authority in South Asia*, ed. John F. Richards, 252–85. Madison: South Asian Studies, University of Wisconsin, Madison, 1978.

———. *The Imperial Monetary System of Mughal India*. Oxford: Oxford University Press, 1988.

———. *The Mughal Empire*. Cambridge: Cambridge University Press, 1993.

———. "Norms of Comportment among Imperial Mughal Officers." In *Moral Conduct and Authority: The Place of* Adab *in South Asian Islam*, ed. Barbara Daly Metcalf, 255–89. Berkeley: University of California Press, 1984.

Rizvi, Kishwar. "Introduction: Affect, Emotion, and Subjectivity in the Early Modern Period." In *Affect, Emotion, and Subjectivity in Early Modern Muslim Empires: New Studies in Ottoman, Safavid, and Mughal Art and Culture*, ed. Kishwar Rizvi, 1–20. Leiden: Brill, 2017.

———. "The Suggestive Portrait of Shah 'Abbas: Prayer and Likeness in a Safavid *Shahnama*." *Art Bulletin* 94:2 (2012): 226–50.

Rizvi, Saiyid Athar Abbas. "Dimensions of *Ṣulḥ-i-Kul* (Universal Peace) in Akbar's Reign and the *Ṣūfī* Theory of Perfect Man." In *Akbar and His Age*, ed. Iqtidar Alam Khan, 3–20. New Delhi: Northern Book Centre. 1999.

———. *Religious and Intellectual History of the Muslims in Akbar's Reign, with special Reference to Abu'l Fazl, 1556–1605*. New Delhi: Munshiram Manoharlal, 1975.

Robinson, B. W. *Persian and Mughal Art*. London: P. & D. Colnaghi, 1976.

Robinson, Cynthia. *In Praise of Song: The Making of Courtly Culture in al-Andalus and Provence, 1005–1134 A.D.* Leiden: Brill, 2002.

Robinson, Francis. "Technology and Religious Change: Islam and the Impact of Print." *Modern Asian Studies* 27, no. 1 (1993): 229–51.

Roe, Thomas. *The Embassy of Sir Thomas Roe to the Court of the Great Mogul, 1615–19*,

edited by William Foster. Liechtenstein: Nendel, 1967. First published 1899 by the Hakluyt Society.

Rosenthal, Franz. "Abū Haiyān al-Tawḥīdī on Penmanship." *Ars Islamica* 13–14 (1947): 1–30.

Roxburgh, David J. "Baysunghur's Library: Questions Related to Its Chronology and Production." *Journal of Social Affairs* 18, no. 72 (2001): 11–39.

———. "Concepts of the Portrait in the Islamic Lands, c. 1300–1600." In *Dialogues in Art History, from Mesopotamian to Modern: Readings for a New Century*, ed. Elizabeth Cropper, 119–38. Washington, DC: National Gallery of Art, 2009.

———. "Disorderly Conduct? F. R. Martin and the Bahram Mirza Album." *Muqarnas* 15 (1998): 32–57.

———. "'The Eye Is Favored for Seeing the Writing's Form': On the Sensual and the Sensuous in Islamic Calligraphy." *Muqarnas* 25 (2008): 275–98.

———. "The 'Journal' of Ghiyath al-Din Naqqash: Timurid Envoy to Khan Balïgh, and Chinese Art and Architecture." In *The Power of Things and the Flow of Cultural Transformations: Art and Culture between Europe and Asia*, ed. Lieselotte E. Saurma-Jeltsch and Anja Eisenbeiß, 90–113. Munich: Deutscher Kunstverlag, 2010.

———. "Kamal al-Din Bihzad and Authorship in Persianate Painting." *Muqarnas* 17 (2000): 119–46.

———. "Micrographia: Toward a Visual Logic of Persianate Painting." *Res: Anthropology and Aesthetics* 43 (2003): 12–30.

———. *The Persian Album, 1400–1600: From Dispersal to Collection*. New Haven: Yale University Press, 2005.

———. "Persian Drawings, ca. 1400–1500: Materials and Creative Procedures." *Muqarnas* 19 (2002): 44–77.

———. *Prefacing the Image: The Writing of Art History in Sixteenth-Century Iran*. Leiden: Brill, 2000.

Roxburgh, David J., and Mary McWilliams. *Traces of the Calligrapher: Islamic Calligraphy in Practice, c. 1600–1900*. Houston: Museum of Fine Arts, 2007.

Rudy, Kathryn M. *Piety in Pieces: How Medieval Readers Customized Their Manuscripts*. Cambridge: Open Book Publishers, 2016.

Sadiqi Beg Afshar. *Qanun al-Suvar* [Canons of painting]. Translated by Martin Dickson. In Martin Dickson and Stuart Cary Welch, *The Houghton Shahnamah*, 1:259–69. Cambridge, MA: Harvard University Press, 1981.

Şahin, Kaya. "Staging an Empire: An Ottoman Circumcision Ceremony as Cultural Performance." *American Historical Review* 123, no. 2 (2018): 463–92.

Samarqandi, Mutribi al-Asamm. *Conversations with Emperor Jahangir by 'Mutribi' al-Asamm of Samarqand*. Translated by Richard C. Foltz. Costa Mesa, CA: Mazda, 1998.

———. *Khatirat-i Mutribi: Musahibah'ha ba Jahangir Padishah* [Memoirs of Mutribi: Conversations with Jahangir Padshah]. Edited by A. M. Mirzoev. Karachi: Muassasah-i Tahqiqat-i Asiya-yi Miyanah va Gharbi, Danishgah-i Karachi, 1977.

Sardar, Marika, John Seyller, and Audrey Truschke, eds. *The Ramayana of Hamida Banu Begum: Queen Mother of Mughal India*. Milan: Silvana Editoriale, 2020.

Sauerländer, Willibald. "From Stilus to Style: Reflections on the Fate of a Notion." *Art History* 6, no. 3 (1983): 253–70.

Schimmel, Annemarie. *Deciphering the Signs of God: A Phenomenological Approach to Islam.* Albany: State University of New York Press, 1994.

Schmitz, Barbara and Ziyaud-Din A. Desai, eds. *Mughal and Persian Paintings and Illustrated Manuscripts in the Raza Library, Rampur.* New Delhi: Indira Gandhi National Centre for the Arts, 2006.

Schoeler, Gregory. *The Oral and the Written in Early Islam.* Translated by Uwe Vagelpohl and edited by James E. Montgomery. New York: Routledge, 2006.

Schrieke, B., J. Horovitz, J. E. Bencheikh, J. E. Knappert, and B. W. Robinson. "*Mi'rādj.*" In *Encyclopedia of Islam, Second Edition,* ed. P. Bearman, T. Bianquis, C. E. Bosworth, E. van Donzel, and W. P. Heinrichset. Published online 2012, http://dx.doi.org/10.1163/1573-3912_islam_COM_0746.

Seyller, John. *The Adventures of Hamza: Painting and Storytelling in Mughal India.* Washington, DC: Arthur M. Sackler Gallery, Smithsonian Institution, 2002.

———. "Codicological Aspects of the Victoria and Albert *Akbarnāma* and Their Historical Implications." *Art Journal* 49, no. 4 (1990): 379–87.

———. "The Colophon Portrait of the Royal Asiatic Society *Gulistan* of Saʻdi." *Artibus Asiae* 68, no. 2 (2008): 333–42.

———. "Hashim." In *Master Artists of the Imperial Mughal Court,* ed. Pratapaditya Pal, 105–18. Bombay: Marg, 1991.

———. "The Inspection and Valuation of Manuscripts in the Imperial Mughal Library." *Artibus Asiae* 57, nos. 3–4 (1997): 243–349.

———. "Manohar." In *Masters of Indian Painting: 1100–1900,* vol. 1, ed. Milo Cleveland Beach, Eberhard Fischer, and B. N. Goswamy, 135–52. Zurich: Artibus Asiae, 2011.

———. "Model and Copy: The Illustration of Three *Razmnāma* Manuscripts." *Archives of Asian Art* 38 (1985): 37–66.

———. "A Mughal Code of Connoisseurship," *Muqarnas* 17 (2000): 178–203.

———. "A Mughal Manuscript of the *Diwan* of Nawa'i." *Artibus Asiae* 71, no. 2 (2011): 325–34.

———. "Overpainting in the Cleveland *Ṭūṭīnāma.*" *Artibus Asiae,* vol. 52, nos. 3–4 (1992): 283–318.

———. "Painter's Directions in Early Indian Painting," *Artibus Asiae* 59, nos. 3–4 (2000): 303–18.

———. *Pearls of the Parrot of India: The Walters Art Museum Khamsa of Amir Khusraw of Delhi.* Baltimore, MD: Trustees of the Walters Art Gallery, 2001.

———. "Recycled Images: Overpainting in Early Mughal Art." In *Humayun's Garden Party: Princes of the House of Timur and Early Mughal Painting,* ed. Sheila Canby, 49–80. Bombay: Marg, 1994.

———. "The School of Oriental and African Studies *Anvār-i Suhaylī:* The Illustration of a *De Luxe* Manuscript." *Ars Orientalis* 16 (1986): 119–51.

———. "Scribal Notes on Mughal Manuscript Illustrations." *Artibus Asiae* 48, nos. 3–4 (1987): 247–77.

———. "The Walters Art Museum *Diwan* of Amir Hasan Dihlawi and Salim's

Atelier at Allahabad." In *Arts of Mughal India*, ed. Rosemary Crill, Susan Stronge, and Andrew Topsfield, 95–110. Ahmedabad: Mapin, 2004.

———. *Workshop and Patron in Mughal India: The Freer Ramayana and Other Illustrated Manuscripts of 'Abd al-Rahim*. Zurich: Museum Rietberg, 1999.

Shaham, Ron. *The Expert Witness in Islamic Courts: Medicine and Crafts in the Service of Law*. Chicago: University of Chicago Press, 2010.

Shahnawaz Khan Aurangabadi. *Ma'athir al-'umara* [Biography of nobles]. Translated by Henry Beveridge and Baini Prashad. Reprint, Patna: Janaki Prakashan, 1979.

Simpson, Marianna Shreve. "The Making of Manuscripts and the Workings of the *Kitab-khana* in Safavid Iran." In *The Artist's Workshop*, ed. Peter M. Lukehart, 104–21. Washington, DC: National Gallery of Art, 1993.

Simpson, Marianna Shreve, and Massumeh Farhad. *Sultan Ibrahim Mirza's* Haft Awrang: *A Princely Manuscript from Sixteenth-Century Iran*. New Haven: Yale University Press, 1997.

Sims-Williams, Ursula. "The Tales of Darab: A Medieval Persian Prose Romance." British Library African and Asian Studies Blog, March 4, 2014. http://blogs.bl.uk/asian-and-african/2014/03/the-tales-of-darab-a-medieval-persian-prose-romance.html.

Singh, Kavita. *Real Birds in Imagined Gardens: Mughal Painting between Persia and Europe*. Los Angeles: Getty Publications, 2017.

Singh, Surinder. "The Indian Memoirs of Mutribi Samarqandi." *Proceedings of the Indian History Congress*, 55th Session, Aligarh, 1994, 345–54. Delhi: Indian History Congress, 1995.

Skelton, Robert. "Imperial Symbolism in Mughal Painting." In *Content and Context of Visual Arts in the Islamic World*, ed. Priscilla Soucek, Carol Bier, and Richard Ettinghausen, 177–91. University Park: Pennsylvania State University Press, 1988.

———. "Indian Painting of the Mughal Period." In *Islamic Painting and the Arts of the Book Indian Painting: The Keir Collection*, ed. B. W. Robinson, 233–74. London: Faber and Faber, 1976.

———. "Iranian Artists in the Service of Humayun." In *Humayun's Garden Party: Princes of the House of Timur and the Origins of Mughal Painting,* ed. Sheila Canby, 33–48. Bombay: Marg, 1994.

———. "The *Ni'mat nama*: A Landmark of Malwa Painting." *Marg* 12, no. 3 (1959): 44–48.

———. "Shaykh Phul and the Origin of Bundi Painting." In *Chhavi-2: Rai Krishnadasa Felicitation Volume*, ed. Anand Krishna, 123–29. Banaras: Bharat Kala Bhavan, 1981.

Smart, Ellen. "Paintings from the *Bāburnāma*: A Study of Sixteenth Century Mughal Historical Manuscript Illustrations." PhD diss., School of Oriental and African Studies, University of London, 1977.

Smith, Pamela H. *The Body of the Artisan: Art and Experience in the Scientific Revolution*. Chicago: University of Chicago Press, 2004.

Smith, Vincent. *A History of Fine Art in India and Ceylon*. Revised by K. de B. Codrington. Oxford: Clarendon Press, 1930.

———. *A History of Fine Art in India and Ceylon: From the Earliest Times to the Present Day*. Oxford: Clarendon Press, 1911.

Soucek, Priscilla. "Abd-al-Samad Šīrāzī." In *Encyclopaedia Iranica*, ed. E. Yarshater, vol. 1, fasc. 2, 162. London: Routledge & Kegan Paul, 1982–.

———. "Nizāmī on Painters and Painting." In *Islamic Art in the Metropolitan Museum of Art*, ed. Richard Ettinghausen, 9–21. New York: Metropolitan Museum of Art, 1972.

———. "Persian Artists in Mughal India: Influences and Transformations." *Muqarnas* 4 (1987): 166–81.

———. "Solomon's Throne/Solomon's Bath: Model or Metaphor?" *Ars Orientalis* 23 (1993): 109–34.

———. "The Theory and Practice of Portraiture in the Persian Tradition." *Muqarnas* 17 (2000): 97–108.

Soudavar, Abolala. *The Aura of Kings: Legitimacy and Divine Sanction in Iranian Kingship*. Costa Mesa, CA: Mazda, 2003.

———. "Between the Safavids and the Mughals: Art and Artists in Transition." *Iran* 37 (1999): 49–66.

———. "Farr(ah) ii: Iconography of Farr(ah)/Xareneh." In *Encyclopaedia Iranica*, ed. Ehsan Yarshater. Accessed online 29 May 2018.

Soudavar, Abolala, and Milo Cleveland Beach. *Art of the Persian Courts: Selections from the Art and History Trust Collection*. New York: Rizzoli, 1992.

Sowerby, Tracey A. "Negotiating the Royal Image: Portrait Exchanges in Elizabethan and Early Stuart Diplomacy." In *Early Modern Exchanges: Intercultural Exchanges and Dialogues, 1550–1750*, ed. Helen Hackett, 119–41. Aldershot: Ashgate, 2013.

Sperl, Stefan M. "Islamic Kingship and Arabic Panegyric Poetry in the Early 9th Century." *Journal of Arabic Literature* 8 (1979): 20–35.

Stchoukine, Ivan. *Les Miniatures indiennes de l'époque des Grands Moghols au Musée du Louvre*. Paris: Ernest Leroux, 1929.

———. *Peinture indienne à l'epoque des Grands Moghols*. Paris: Ernest Leroux, 1929.

———. "Portraits Moghols, IV: La collection du Baron Maurice de Rothschild." *Revue des arts asiatiques* 9 (1935): 192–208.

Steinfels, Amina. "His Master's Voice: The Genre of Malfūẓāt in South Asian Sufism." *History of Religions* 44, no. 1 (2004): 56–69.

Steingass, Francis Joseph. *A Comprehensive Persian-English Dictionary*. Delhi: Asian Educational Services, 1992.

Stillmann, Norman A. "Khil'a." In *Encyclopaedia of Islam,* 2nd edition, ed. P. Bearman, T. Bianquis, C. E. Bosworth, E. van Donzel, and W. P. Heinrichset. Published online 2012, http://dx.doi.org/10.1163/1573-3912_islam_COM_0507.

Stronge, Susan. "The Gulshan Album, c. 1600–1618." In *Muraqqa': Imperial Mughal Albums from the Chester Beatty Library, Dublin*, ed. Elaine Wright, 76–81. Alexandria, VA: Art Services International, 2008.

———. "Jahangir's Itinerant Masters." In *Indian Painting: Themes, History and Interpretations; Essays in Honour of B. N. Goswamy*, ed. Mahesh Sharma and Padma Kaimal, 125–35. Ahmedabad: Mapin, 2013.

———. "The Minto Album and Its Decoration, c. 1612–1640." In *Muraqqa': Imperial*

Mughal Albums from the Chester Beatty Library, Dublin, ed. Elaine Wright, 82–105. Alexandria, VA: Art Services International, 2008.

———. *Painting for the Mughal Emperor: The Art of the Book, 1560–1660.* London: Victoria and Albert Publications, 2002.

———. "Portraiture at the Mughal Court." In *The Indian Portrait, 1560–1860*, ed. Rosemary Crill and Kapil Jariwala, 23–32. London: National Portrait Gallery Publications, 2010.

———. "The Sublime Thrones of the Mughal Emperors of Hindustan." *Jewellery Studies* 10 (2004): 52–67.

Subrahmanyam, Sanjay. *Courtly Encounters: Translating Courtliness and Violence in Early Modern Eurasia.* Cambridge, MA: Harvard University Press, 2012.

———. "Early Modern Circulation between Central Asia and India and the Question of 'Patriotism.'" In *Writing Travel in Central Asian History*, ed. Nile Green, 69–88. Bloomington: Indiana University Press, 2014.

———. *Europe's India: Words, People, Empire, 1500–1800.* Cambridge, MA: Harvard University Press, 2017.

———. "Iranians Abroad: Intra-Asian Elite Migration and Early Modern State Formation." *Journal of Asian Studies* 51, no. 2 (May 1992): 340–63.

———. "A Roomful of Mirrors: The Artful Embrace of Mughals and Franks, 1550–1700." *Ars Orientalis* 39 (2010): 38–83.

———. "Turning the Stones Over: Sixteenth-Century Millenarianism from the Tagus to the Ganges." *Indian Economic and Social History Review* 40, no. 2 (2003): 129–61.

Suhrawardi, Shihab al-Din. *The Philosophy of Illumination: A New Critical Edition of the Text of Hikmat al-ishrāq.* Translated and edited by John Walbridge and Hossein Ziai. Provo, UT: Brigham Young University Press, 1999.

Sviri, Sara. "Dreaming Analyzed and Recorded: Dreams in the World of Medieval Islam." In *Dream Cultures: Explorations in the Comparative History of Dreaming*, ed. David Shulman and Guy G. Stroumsa, 252–73. New York: Oxford University Press, 1999.

Swallow, Deborah and John Guy, eds. *Arts of India: 1550–1900.* London: Victoria and Albert Publications, 1990.

———. *The Arts of the Sikh Kingdoms.* London: Victoria and Albert Publications, 1999.

Tabari, Muhammad ibn Jarir al-. *Tarikh al-rusul wa'l muluk* [History of the prophets and kings]. Translated and annotated by Franz Rosenthal. In *The History of al-Tabari*, vol. 1. Albany: State University of New York Press, 1989.

Tanındı, Zeren. "Additions to Illustrated Manuscripts in Ottoman Workshops." *Muqarnas* 17 (2000): 147–61.

Thackston, Wheeler M., translator. *Album Prefaces and Other Documents on the History of Calligraphers and Painters.* Leiden: Brill, 2001.

———. *Three Memoirs of Homayun.* 2 vols. Costa Mesa, CA: Mazda, 2009.

Thomann, J. "La tradition arabe de la physiognomonie d'Aristote." In *Dictionnaire des philosophes antiques, supplément*, ed. Richard Goulet, 496–98. Paris: CNRS Editions, 2003.

Thomas, Nicholas. *Entangled Objects: Exchange, Material Culture, and Colonialism in the Pacific.* Cambridge, MA: Harvard University Press, 1991.

Tirmizi, S. A. I. *Ajmer through Inscriptions.* New Delhi: Indian Institute of Islamic Studies, 1968.

Titley, Norah. *Miniatures from Persian Manuscripts: A Catalogue and Subject Index of Paintings from Persia, India and Turkey in the British Library and British Museum.* London: British Museum, 1977.

Topsfield, Andrew. *Paintings from Mughal India.* Oxford: Bodleian Library, 2008.

———. "Sahibdin's Illustrations to the *Rasikapriya.*" *Orientations* 17, no. 3 (1986): 18–31.

Truschke, Audrey. *Culture of Encounters: Sanskrit at the Mughal Court.* New York City: Columbia University Press, 2016.

———. "The Mughal Book of War: A Persian Translation of the Sanskrit Mahabharata." *Comparative Studies of South Asia, Africa and the Middle East* 31, no. 2 (2011): 506–20.

Verma, Som Prakash. *Mughal Painters and Their Work: A Biographical Survey and Catalogue.* Delhi: Oxford University Press, 1994.

Walbridge, John. "The Devotional and Occult Works of Suhrawardī the Illuminationist." In *Ishraq: Islamic Philosophy Yearbook,* no. 2, ed. Yanis Eshots, 80–97. Moscow: Vostochnaya Literatura, 2011.

———. "A Persian Gulf in a Sea of Lights: The Chapter on *Naw-Rūz* in the *Bihār al-Anwār.*" *Iran* 35 (1997): 83–92.

Waraich, Saleema. "Competing and Complementary Visions of the Court of the Great Mogor." In *Seeing across Cultures in the Early Modern Period,* ed. Dana Leibsohn and Jeanette Favrot Peterson, 73–94. Burlington, VT: Ashgate, 2012.

Warnke, Martin. *The Court Artist: On the Ancestry of the Modern Artist.* Cambridge: Cambridge University Press, 1993.

Weis, Friederike. "Maryam—Maria: Bilder aus dem Marienleben aus einer Mer'ât-al Qods-Handschrift des Moghulhofes." In *Image Match: Visueller Transfer, 'Imagescapes' und Intervisualität in globalen Bildkulturen,* ed. Martina Baleva, Ingeborg Reichle, and Oliver Lerone-Schultz, 64–95. Munich: Fink Wilhelm, 2012.

Welch, Anthony, and Stuart Cary Welch. *Arts of the Islamic Book: The Collection of Prince Sadruddin Aga Khan.* Ithaca, NY: Cornell University Press, 1982.

Welch, Evelyn. "Painting as Performance in the Italian Renaissance Court." In *Artists at Court: Image-Making and Identity, 1300–1550,* ed. Stephen J. Campbell, 9–18. Boston: Isabella Stewart Gardner Museum, 2004.

Welch, Stuart Cary. *The Art of Mughal India: Painting and Precious Objects.* New York: Distributed by H. N. Abrams, 1963.

———. *India: Art and Culture, 1300–1900.* New York: Metropolitan Museum of Art, 1985.

———. "The Paintings of Basawan." *Lalit Kala* 10 (1961): 7–17.

———. "Zal in the Simurgh's Nest: A Painting by Mir Sayyid 'Ali for a *Shahnama* Illustrated for Emperor Humayun." In *Arts of Mughal India: Studies in Honour of Robert Skelton,* ed. Rosemary Crill, Susan Stronge, and Andrew Topsfield, 36–41. London: Victoria and Albert Museum; Bombay: Mapin, 2004.

Welch, Stuart Cary, and Anthony Welch. *Arts of the Islamic Book: The Collection of Prince Sadruddin Aga Khan*. Ithaca, NY: Cornell University Press, 1982.

Wenger, Etienne, and Jean Lave. *Situated Learning: Legitimate Peripheral Participation*. Cambridge: Cambridge University Press, 1991.

Wensinck, A. J., and T. Fahd. "Ṣūra." *Encyclopaedia of Islam*, 2nd edition, ed. P. Bearman, T. Bianquis, C. E. Bosworth, E. van Donzel, and W. P. Heinrichs. Published online 2012. http://dx.doi.org/10.1163/1573-3912_islam_COM_1125.

Woods, John E. "The Rise of Tīmūrid Historiography." *Journal of Near Eastern Studies* 46, no. 2 (1987): 81–108.

Wright, Elaine. *Muraqqaʿ: Imperial Mughal Albums from the Chester Beatty Library, Dublin*. Alexandria, VA: Art Services International, 2008.

Wu Hung. *The Double Screen: Medium and Representation in Chinese Painting*. Chicago: University of Chicago Press, 1997.

Zargar, Cyrus Ali. *Sufi Aesthetics: Beauty, Love, and the Human Form in the Writings of Ibn ʿArabi and ʿIraqi.* Columbia: University of South Carolina Press, 2011.

Zayn Khan. *Tabaqat-i Babur* [Biography of Babur]. Translated by S. Hasan Askari. Delhi: Idarah-i Adabiyat-i Dilli, 1982.

Ziai, Hossein. *Knowledge of Illumination: A Study of Suhrawardi's* Hikmat al-Ishrāq. Athens, GA: Scholars Press, 1990.

———. "The Source and Nature of Authority: A Study of al-Suhrawardi Illuminationist Political Doctrine." In *The Political Aspects of Islamic Philosophy, Essays in Honor of Muhsin S. Mahdi*, ed. Charles E. Butterworth, 304–44. Cambridge, MA: Harvard University Press, 1992.

INDEX

Page numbers in *italics* refer to illustrations.

'Abd al-Rahim 'Anbarin Qalam, 51, *53*
'Abd al-Rahim Khan-i Khanan, 123, 183n26
'Abd al-Samad: in Akbar's atelier, 98; Akbar's elevation of, 61; canonical practices of, 151; downplaying of creative agency by, 175; gift of painting by, 212n27; and Muhammad Sharif's royal hunt painting, 154, 213n46; Nawruz paintings and images of Majnun, 163, 213n48; painting skill of, 176, 216nn86–87; role in Mughal style formation, 60, 193n24; as workshop director and mentor, 58, 68, 75, 204n62
'Abd al-Samad, paintings by: festivities at the court of Humayun, 170–72, *171*, 175; Jamshid writing on a rock, *153*, 154; Nawruz paintings by, 144, *146*, 146–49, *147*, *150*, 151
'Abd al-Sattar ibn Qasim Lahori, *Majalis-i Jahangiri* (Assemblies of Jahangir), 114, 200n10, 202n42
Abu Bakr and dreams, 24
Abu'l Fath Fayzi (Abu'l Fazl's brother), 87, 112, 182n22, 201n34; *Shariq al-ma'rifa* (The illuminator of gnosis), 35
Abu'l Fazl: discipleship of Akbar, 108, 201n34; and ideology of total peace, 85–86; work on *Akbarnama* by, 88, 198n82
Abu'l Fazl, *A'in-i Akbari* (Regulations of Akbar): on Akbar and Mughal manuscript painting, 7–8, 61, 196n61; on Akbar's healing power, 108, 202n40; on Akbar's insight, 182n21; on Akbar's observational faculties, 208n108; and Akbar's supreme status, 87; defense of image making in, 167–68, 172; and discipleship, 108; and independence in pursuit of truth, 134; and just rule, 190n81; on kingship, 35; list of forerunners of Mughal painting, 8, 62–63, 94, 194n27; on management and training of artists, 74, 81; on manuscript storage, 197n77; on the Mughals' progenitor, 34; on Mughal workshops, 63; on painting masters, 62; on poses and gestures of imperial subjects, 127; on truth in paintings, 14; on the utility of writing and painting, 163; on the viewing of Akbar, 208n105. *See also* Akbar, Jalal al-Din Muhammad
Abu'l Fazl, *Akbarnama* (Book of Akbar): about, 5; Akbar as mystical Persianate king, 88; and Akbar's supreme status, 87; Basavana and, 62, *64–65*, 95; chronology in Victorian and Albert copy, 198n82; commissioned copies of, 88; contextualization of Akbar in illustrations in, 20; corrections of illustrations in Victoria and Albert copy, 102; designer-colorists on, 81, 198n85; design work in, 78, *79*; dreams in, 24; enthronement scene from, *21*, 47–48; inscriptions in, *64–65*; invention in illustrating, 90; locations of the three manuscripts of, 199n8; Miskina's work in, 94; on the significance of Akbar's smile, 103; teams of painters for, 68. *See also* Victoria and Albert Museum, *Akbarnama* copy in
Abu'l Fazl, *Akbarnama* (Book of Akbar), paintings in: Akbar being weighed, 99, *100*; Akbar commanding his army, 75, *76–77*, *102*, 104, 195n51; Akbar greeting

Abu'l Fazl (*continued*)
 Rajput royals, *83*; Akbar observing a battle, 62, *64–65*, 194n31; Akbar receiving Azim Khan, *101*; Akbar receiving news of Salim's birth, *21*; Akbar slays a tiger, *82*; Akbar supervising construction of Fatehpur Sikri, 69, *70*; execution of Akbar's *koka* (milk brother), 89, *90*

Abu'l Hasan: as painter-bureaucrat-disciple, 54, 95; sobriquet given to, 210n4

Abu'l Hasan, paintings by: depiction of politics of court spectatorship in, 157, *158*; double portrait of Jahangir and Akbar, 105–8, *106*, 112; epigraphs about witnessing dreams in, 22; inscription on Nawruz painting by, 174–75; Jahangir dispensing justice, *133*; Jahangir shooting the head of Malik 'Ambar, 40–42, *41*, *176*, 177, *178*; Jahangir vanquishing poverty, 36–37, *38–39*, 40, 42, 43, 44, 189nn67–68; and knowledge transmission through, 156; and visual encounters across page gutters, 187n35. *See also* Jahangir embracing Shah 'Abbas I in a dream

Abu Nu'aym al-Isfahani, *Hilyat al-awliya' wa tabaqat al-asfiya'* (The adornment of the saints and the ranks of the elite), 104–5

Abu Tahir Tarsusi, Muhammad ibn Hasan, *Darabnama* (Book of Darab), 66–68, *67*, 194nn36–37, 195n40, 198n92

Adham Khan, 89, *90*

Afsharid album (later, the Leningrad Album, the St. Petersburg Album), 178, 215n67

Aga Khan Museum (Toronto), 118, *119*, *133*, 208n102

Agra, 30, 63, 97, 131, 173, 191n97

A'in-i Akbari. *See* Abu'l Fazl, *A'in-i Akbari*

Ajmer, 22, 26, 29–33, 110, 116, 142, 188n49, 188n58

Akbar, Jalal al-Din Muhammad: as accommodator of diversity, 87, 92; artist-teachers of, 170; atelier of, 9, 52, 54, 98; capacity to rule, 193n12; date of accession to the throne, 210n15; as discoverer of truth, 4, 134; explosion of commissioned texts under, 197n74; as illiterate, 197n76; influence on colonial administration, 7; influence on manuscript painting, 7–8, 60–62, 172; involvement in workshops, 61, 81, 196n61; as *mujtahid*, 4, 86–87, 132; new age of social harmony under, 2, 4, 86, 91; painters' advancement of, 1, 54; physical appearance and facial features, 99, *100–101*, 104, 127; portraits of, *130*, *131*; and reading of manuscripts during royal assemblies, 87; and select group of disciples, 95; smile of, 103; as supreme judge, 132, 134; and water features, 32. *See also* Abu'l Fazl, *A'in-i Akbari*; Abu'l Fazl, *Akbarnama*; Chishtiyya lineage; Nawruz and Nawruz gifting

Akbarnama. *See* Abu'l Fazl, *Akbarnama*

'alam al-mithal (world of images): iconography and depictions of dreams in, 44–45, 49; as intermediary zone, 19, 20, 27, 36

Alan Goa, 34, 112

albums (*muraqqa's*), Mughal: arrangement of paintings in, 33, 188n51; and artists' defense of the painting craft, 173; audience viewings of, 151, 168, 213n45; bricolage of images and, 164; dream portraits in, 27–28, *29*; form of, 140; four-part grid layouts in, 164; and painting's multiple potentialities, 16; punctums in, 168; role in preservation of paintings, 179; significance of painters' work in, 140–41; signification in, 150–51; and visual encounters across page gutters, 28, 187n35. *See also* Afsharid album; Jahangir Album; Kevorkian Album; Laud *Ragamala* Album; Minto Album; Persianate albums; Salim Album; St. Petersburg Album; Wantage Album

'Ali Ahmad, 8

Allahabad, 98, 105, 149, 199n1

Allahu Akbar (God is the greatest): on coins, 110; double meaning in, 202n38; signification of, 155; as talisman, 108, *109*

allegory, 25, 48, 186n18, 191nn98–99

'amal (coloring, literally "work"; also *rang-amizi*), 22, 23, 50, 62, 69

Amir Hasan Chishti, *Fawa'id al-Fu'ad* (Morals for the heart), 49

Amir Khusraw Dihlavi, *Khamsa* (Quintet), 83, 94, 196n65

Antonius Polemon, 103, 200n14

Anvar-i Suhayli (Lights of Canopus), 60, 94, 192n10

Artemidorus of Ephesus, *Oneirocritica*, 186n18

art history: and Abu'l Hasan's painting of Jahangir and Shah 'Abbas I, 139; allegorical structures in Mughal paintings, 25; and analysis of individual paintings, 14; characterization of Mughal painting in, 60; and continuity between Akbar and Jahangir's ateliers, 52; interpretation through oneiric frameworks in, 25; and Jahangir as an art connoisseur, 135, 209nn116–17; and Jahangir's interest in visual accuracy, 121; and naturalistic portraiture, 125–26, 206n84; and pristine examples, 184n47; reception of *A'in-i Akbari* by, 9. *See also* iconography; pictorial representation

Asaf Khan, 142–43, 161, 203n51, 204n55, 211n17

Asi, *64*, 194n31

Ataga Khan, 89

Aurangzeb 'Alamgir, 177

'Aziz Khan (Khan Azam), 26

Babu Naqqash, *77*, 78, *79*, 102

Babur, Zahir al-Din Muhammad, 24, 26, 27, 32, 118, 135, 141

Baburnama (Book of Babur), 5, 68, 87, 90; Osh inhabitants repelling invaders, 91, *92*

Bada'uni, 'Abd al-Qadir, 172; *Muntakhab al-tavarikh* (Selection of chronicles), 108–9, 207n88, 216n87

Bahadur Khan Uzbek, 167, 215n74

Bahram Mirza, album of, 11–12

Bandi, 69, *70*

Barthes, Roland, 168

Basavana: as collaborator, *73–74*, 73–75, 95; and the *Darabnama*, 68; as designer, 62, 79–80, *82*, 194n31; as master painter, 62, 194n27; paintings ascribed to, *64–65*, *67*; son of, 98, 214n55; work in deluxe manuscripts, 83

Bashir, Shahzad, 45, 47, 201n26

Bayazid Bayat *Tazkira-yi Humayan* (History of Humayan), 211n27, 216n86

Beach, Milo Cleveland, 198n94, 213n46; *The Grand Mogul*, 62, 193n25

Beatty, Alfred Chester, 178

Belting, Hans, 126

Bhagavata Purana (Story of Krishna), 58

Bhura, 81

Bibi Hafiz Jamal, 32, 188n49

Bichitra: portraits of Jahangir by, *3*, 19, 28, *29*; portraits of Mu'in al-Din by, 16, 28, *29*, 33; self-effacement of, 17, 50. *See also* Jahangir seated on an hourglass throne

Bishandas: in Akbar's workshop, 95; on diplomatic mission, 121–23; Jahangir's appointment of, 168; and knowledge transmission of paintings, 156; painting of Jahangir entertaining Shah 'Abbas I, 161–63, *162*, 214n67; portraits of court servants by, 126–27, *128*; portraits of Jahangir by, 19; portraits of Shah 'Abbas I by, 185n4

books and bookmaking: Akbar's extensive investment into, 9, 183n29; design and planning of *muraqqa*'s, 9–10; as primary vehicles of knowledge, 1. *See also* albums (*muraqqa*'s), Mughal; codices (stitched books) and manuscripts

Bourdieu, Pierre, 10, 80

British Library (London): manuscripts and albums in, 66, 92, 94; paintings in, *15*, *53*, *84*, *85*, *93*, 123, *124*

British Museum (London), *111*, *114*, *115*, 205n67

Brown, Percy, 60, 193n13; *Indian Painting under the Mughals*, 193n25

Bukhara, 32, 149

calligraphy and precedent, 181n7

chain of justice, 37, 131–32

Chandra, Pramod, 196n64

Chashma-yi Nur (palace), *31*, 31–32, 33, 185n3, 187n42

Chester Beatty Library (Dublin): *Akbarnama* in, 94, 100; Minto album paintings in, *29*, 40, *41*, 178, 186n31; painting of Jahangir shooting Malik 'Ambar, 40, *41*, 43, 48; Salim Album paintings in, *128*; unfinished paintings in, 203n51

Chishtiyya lineage, 28, *29*, 116, 187n36

Christianity: and illusionist techniques, 12, 14; influence on paintings, 92; and Keshava Das's paintings, 164, 169

Cleveland Museum of Art, *57*, 60, *116*

codices (stitched books) and manuscripts: decorated bindings of, 1; de luxe manuscripts, 82–83, 196nn64–65; and dynastic authority, 1; excision of paintings from, 194n37; inspection notices on, 197n77; and instrumentality of the painted page, 16, 184n48; Mughal albums as, 140;

codices (*continued*)
performances of the canon in, 149–55. *See also* albums (*muraqqa*'s), Mughal; inscriptions; *Ramayana*; *Razmnama*

coins, imperial portrait (*shast*s): associations with money, 114, 203n53; design details on, 109–10, *111*, *114*, 203n46; and discipleship, 203n47; and distinguished lineage of emperors, 137; gifting of, 112, 203n49; gold and the imperial body, 112; images of wine cups on, 112; Jahangir's presentation to Thomas Roe of, 114, 204n55; models for, 116; protective power in, 112; wearing of, 114, 203n51, 204n60

color, use of, 4, 7, 75, 78, 91

coloring (*'amal* or *rang-amizi*), 22, 23, 50, 62, 69

colorists, role of, 79, 81–82

Coomaraswamy, Ananda Kentish, 60–61, 193n14, 195n52, 206n83

Critz, John de, the Elder, 20; portrait of James I, *46*

curatorial cropping of images, 14

Daniyal, Prince, portraits of, 127, *129–30*, 131, 137, 207n95

Darabnama. *See* Abu Tahir Tarsusi, Muhammad ibn Hasan, *Darabnama*

Das, Asok Kumar, 215n68

Da'ud, Mulla, *Chandayana* (Tale of Chanda), 57, *57*, 58, 192n5

Dawlat: colophon image of, *53*, 54, 196n66; depiction in codex of, 51–52; and inspection notices, 197n77; in Jahangir's workshop, 95

decorated margins: in the Minto Album, 28, *29*, *41*, *113*, *122*, *136*; for painting of Jahangir and Shah 'Abbas I, 140; in the Shah Jahan Album (Kevorkian Album), *122*; in the St. Petersburg Album, *3*, *18*, *96*, *158*, *162*

design (*tarh*): appraisal of, 194n27; color's role in, 81–82; concealing of, 78; line and contour in, 180

designers: advancement to work in, 94; collaboration with colorists, 75, 78–79; and departures from convention, 168, 215n77; in depicting subjects' character, 129; inspiration from older manuscripts, 91; and inventiveness, 82, 85, 91, 92, 95. *See also* Basavana; L'al

detail: in Abu'l Hasan's painting of Jahangir and Shah 'Abbas I, 139, 140; in Persianate painters' work, 4, 181n6; writing and painting on a poppy seed metaphor, 172, 216n86

Dhanraj, *119*

Dharmdas, 83

Din-i Ilahi (Divine Faith), 201n34. *See also* Tawhid-i Ilahi

discipleship: imperial, 109, 114–15, 201n34, 204n56; inscriptions showing, 213n51; under Jahangir's reign, 202n42; poetry's allusion to, 155; rituals in, 108; and wearing of portraits, 108–9. *See also* coins, imperial portrait

Dost Muhammad, 11–14, 144, *145*, 148, 212n28

dreams: and allegory, 25, 186n18; as cognitive tools, 45; and divine truth, 27; encounters with the dead in, 26–33; and history, 186n20; incubation dreams, 187n43; painters' roles in depicting, 26; paintings' signifiers of, 23–24; and politics, 24, 25; springs and water sources and, 32; types of, 185n5

Dublin painting. *See* Chester Beatty Library: painting of Jahangir shooting Malik 'Ambar

Dulwich Picture Gallery (London), *46*

emperors: and dreams as messages from God, 19; and enlightenment, 35; gold and the imperial body, 112; as messiahs of a new heterogenous era, 6; physical appearance and inner character of, 89, 107, 137, 201n26; ritual viewing of, 109, 202n43, 208n105. *See also* Akbar, Jalal al-Din Muhammad; Jahangir

empirical observation and truth, 4, 131–34, 208n102

epistemic images, 160–63

Ettinghausen, Richard, 44

European visual arts: coronation medallions, 115, *115*, 204n57; engravings' influence on artists, 48–49; Keshava Das's use of European subjects, 164, 169; and Mughal painters' work, 5–6, 20, 91–92, 181n9, 182n11, 198n91, 214n61. *See also* Christianity

facial features: clean-shaven faces, 127, *128*; comparison of Jahangir and Akbar, 107;

Index
250

divine auras from, 109; and inner character, 99; moles, 104, 105, 107; and Mughal behavioral and bodily ideals, 126–27; painters' attention to, 102; of the Prophet Muhammad, 13, 104

Fakhr al-Din al-Razi, *Kitab al-firasa* (Book of physiognomy), 103, 104

Fakhr al-Din Ibrahim 'Iraqi, 107

Falnama (Book of divination) (Ja'far al-Sadiq), 13

FAMULUS, 194n34

Fatehchand, *117*

Fatehpur Sikri, 61, 69, 86, 148, 173, 194n36, 204n62

Fayzi. *See* Abu'l Fath Fayzi

Firdawsi, Abu'l Qasim, *Shahnama* (Book of kings), 55, 58, 141, 152, 190n81, 213n46; wedding of Siyavash and Firangis in, *56*

gazes: court subjects and, 167; in the imperial enthronement ritual, 208n105; the imperial gaze, 99, 132, 157; of nobles in Nawruz celebration, 157; role in architectural design, 208n104

genealogical paintings: dynastic connections made through, 123; examples of, 204n63; importance of painting style in, 120–21; visual distinctions between Miran Shah's and Jahangir's issues in, 118–20, *119*, 205n69

Ghazali, Abu Hamid al-, 23, 201n30

Ghulam 'Ali Khan, Jahangir shooting the head of Malik 'Ambar, *176*, 177

gifting: in Mughal society, 139–40, 142–43, 160–61, 173–74, 211n22; power and prestige through, 210n6; and social relationships, 211n20. *See also* Nawruz and Nawruz gifting; poetry

Gita Govinda (Song of Govinda), 58

Golestan Palace Library (Tehran), *146*, *147*, *150*, *171*, 212n32

Govardhan, 95

Gulbadan Banu Begam, *Humayunnama* (Book of Humayun), 142

Gulshan Album. *See* Jahangir Album

habitus, 10, 80

Hafiz-i Abru, *Kulliyat al-tavarikh* (Collection of histories), 13

Hamida Banu Begum, 34, 88, 199n8

Hamzanama (Tale of Hamza), 9, 52, 55, *55*, 57–58, *59*, 60

Harbans, 194n27

Harvard Art Museums/Arthur M. Sackler Museum, *101*

Hashim: double portrait of Jahangir and Akbar, 105–8, *106*, 112, 200n22; portraits of Deccani rulers by, 121, *122*

Herat, 11, 99, 142, 149, 182n18, 185n11, 206n78

Hermansen, Marcia, 45

Hindu texts, Persian translation and illustration of, 87–88

Hodivala, S. H., 203n46

Humayun, Nasir al-Din Muhammad, 32, 58, 141–42, 144, *145*, 205n67, 211n27, 216n86

Ibn 'Arabi, 36, 86, 107, 189n73, 201n28; *Kitab al-futuhat al-makkiyya* (Book of the Meccan revelations), 27, 103–4

Ibn Khaldun, *Muqaddimah* (Introduction), 23, 25, 185n5

Ibn Qayyim al-Jawziyya, 134, 209n112

Ibn Taymiyya, 134

Ibrahim 'Adil Shah II, portrait of, 121, *122*

iconography: of Bichitra painting, 44; and decoding of paintings, 43–44; limitations of analyses of, 44; and mediation between the physical and metaphysical, 45; and the oneiric realm, 45

'ilm al-firasa (science of physiognomy). *See* physiognomy

inscriptions: and Akbar's facial details, 101; on coins, 110; on companion portraits, 28, 33, 187n33; couplets with portrait of Prince Salim, 98–99; details crediting artists, *64–65*; and *Jahangirnama*, 40; and Jahangir's sacred authority, 33, 42; marginal instructions and record-keeping, 63, 66, 195n51; on Nawruz paintings, 146–47, 148, 212n32; and painter's creative agency, 22–23; on painting of Jahangir vanquishing poverty, 37; to protect painters from evaluation, 22–23

ishraqi (Illuminationist) philosophy, 35–36, 39, 42, 43, 110, 188n56, 189n73

Islam: and illiteracy, 197n76; Islamic cosmologies, 43, 190n83; and the second millennium, 86–87

Islamic dream interpretation, 23, 45

Islamic painting, portrayal of inner essences in, 12–13

Ja'far al-Sadiq, 105, 150
Ja'far Beg, 193n12, 198n90
Jagana, *101*, 194n27
Jahangir, Nur al-Din Muhammad: atelier of, 9, 52, 95, 97; authority and connection to Akbar, 51, 200n20; chain of justice of, 131–32; and Chishti shrine, 29–30, *31*, 32, 33, 187nn39–40; continuance of cult of discipleship by, 109; as creator of the cosmos, 43; depiction of enlightened status of, 28; as discoverer of truth, 4; displeasure with portraits, 200n10, 206n74; dreams of, 26, 30–31 (*see also* Jahangir, Nur al-Din Muhammad, dream paintings of); ear piercing of, 33; execution of Abu'l Fazl ordered by, 151; as exemplar of *surat*, 98, 199n4; in genealogical chart, 118–20, *119*; as Islam's redeemer and savior, 34; Nawruz gifts and allegiances under, 142–43; and a new harmonious age, 137–38; as Nur al-Din (Light of Faith), 25, 35, 110; observational powers of, 134–35; painters' advancement of, 1; partial blinding of his son, 189n68; patronage of sacred springs by, 32; physiognomy of, 98, 120; portraits of, *130*, 131; portrait with pearl earrings of, *116*; as Prince Salim, 28–29, *96*, 97–98, 149, 154; proclamation as emperor, 97, 98; as Savarni Manu, 43; spiritual transformation of, 33; status as Mujaddid-i Alf-i Thani, 99; and zone between earthly and spiritual worlds, 20, 22, 36. *See also* portraiture
Jahangir, Nur al-Din Muhammad, dream paintings of: dense iconography of, 44–45; encounter with deceased Akbar, 26–27; focus on foreground in, 48, *49*; *ishraqi* philosophy in paintings of, 36–37; as mediational objects, 42; Moin on, 188n50; overview of, 19, 184n1; and painters' roles as servants and creators, 50; textual analogues to, 49. *See also* Jahangir embracing Shah 'Abbas I in a dream
Jahangir Album (Gulshan Album): construction of, 9, 17; contents of, 16, 149; format and signification in, 151; importance of, 175; overview of, 16; portraits in, 215n73; translocation beyond South Asia of, 178; viewers of, 173
Jahangir Album (Gulshan Album), paintings in: by 'Abd al-Samad, *146*; four-painting amalgams, 164–69, *165*–*66*, *169*, 215n73; four-portrait painting with Madhava Singh in, *130*, 131, 207n99; of Jamshid writing on a rock, *153*, 154; Nawruz paintings, *145*, *146*, *147*, 149, *150*, 151, *152*; of Prince Akbar presenting a painting to Humayun, 170, *171*; of a prince hunting on horseback, *152*, 154
Jahangir embracing Shah 'Abbas I in a dream (Abu'l Hasan): allegorical structure in, 25; artist's haste in completing, 22–23, 139–40; and artist's title, 210n4; description of, 19–20; figure of, *18*; gold ground for poetry in, 34, *34*; oneiric dream setting of, 23–25, 26; and Qureshi's *Considerate Flying Objects I*, 180; spatial treatment in, 48; translocation to Iran of, 178, 185n4
Jahangirnama (Book of Jahangir): and the authenticity of portrait of Timur, 120; commentary on 'Abd al-Samad in, 155; description of Akbar in, 104, 105; dream accounts in, 24, 105; enlightenment of Jahangir reflected in, 138; on gift exchange, 173–74; and gifts presented to the emperor, 160–61, 215n68; illustrated manuscript of, 48; Jahangir's identification of artists, 134–35; modesty in, 209n121; and offers of discipleship, 202n42; readership of, 26; relationship of painting of Malik 'Ambar painting to, 40; strange and natural wonders in, 135; text as propaganda in, 135–36; on value of images, 168
Jahangirnama (Book of Jahangir), paintings in: Jahangir dispensing justice, 131–32, *133*; Jahangir distributing alms, 116, *117*; Muhammad Sharif in Nawruz painting in, 155, *159*; zebra presented to Jahangir, *136*, 136–37, 209n126
Jahangir seated on an hourglass throne (Bichitra): about, 1–3, *3*; Bichitra's autograph on, 10, 17, 50; completion of, 199n4; oneiric context of, 6; portrait of James I in, 20, 44, 45, *47*; signs and symbols in, 44; treatment of space in, 48
James I, 20, 45, *46*, 49, 115, *115*

Jami, Nur al-Din 'Abd al-Rahman, 27; *Baharistan* (Spring garden), 83, 94, 196n65; *Nafahat al-Uns* (Breaths of fellowship), 49
Jami'al-tavarikh (Compendium of chronicles) (Rashid al-Din), 69, 91
Jamshid: Jahangir compared to, 44, 98; loss of *farr* by, 43, 190n81; and Nawruz, 141, 213n49; painting of, *153*, 154; wine cups and, 110, 214n67; as Yima, 190n82
Jesuit missionaries, 48
Jesuit theories, 191n99
Juneja, Monica, 188n51, 215n77

Kabul, 20, 32, 58, 61, 142, 143, 144
Kanha, *128*
Keshava, 194n27
Keshava Das, 164, *165*, 169, *169*, 215n73
Kevorkian Album (Shah Jahan Album), *122*, 179
Khafi Khan, Muhammad Hashim, *Muntakhab al-lubab* (Selection of essential matters), 112, 114
Khemkaran, 81, 194n27
Khizr, communication with, 27, 185n5
Khuda Bakhsh Library (Patna), 62
Khurram (Prince; the future Shah Jahan), 26, 118, 157
Khwandamir, Ghiyas al-Din Muhammad, 185n11; *Habib al-siyar* (Beloved of biographies), 24
kingship, sacred: discipleship and, 54; and gifts, 210n6; *ishraqi* philosophy and, 35–36, 43, 50, 110; the king as God's shadow, 42; portraits as proof of, 137; rituals and motifs of, 108; special divine light and, 188n61; and Sufism, 106–7
Kinra, Rajeev, 87
Kishan Das Tunwar, portrait of, *126*, *128*
kitabkhana (library-atelier, literally "book house"), 5, 182n18, 194n94, 204n62. See also Mughal manuscript workshops
knowledge: art and the transmission of, 1; direct perception and, 39–40; dissemination in the Islamic world of, 173; inner perception and, 107, 201n30; and Jahangir's discerning eye, 135–37; writing and painting as fundamental to transmission of, 163, 215n70
Koch, Ebba, 48–49, 126, 191nn98–99

LACMA painting. *See* Abu'l Hasan, paintings by: Jahangir vanquishing poverty
Lahore, 63, 120, 173, 194n36, 197n77
L'al: as collaborator, 73–75; as colorist, 83; as designer, 75–78, *76–77*, 79, 83, 195n49; and Mughal painting style, 194n27; repainting by, 102; and supervision, 95
Laud *Ragamala* Album, *125*
Leach, Linda York, 199n8
Lefèvre, Corinne, 201n34, 204n56
light: and darkness, 42; rulers and divine light, 35–36, 39, 188n61; and vision, 37, 39
linear perspective, 5
lion and sun symbol, 110
Los Angeles County Museum of Art (LACMA), 37, *38–39*, 40; Nasli and Alice Heeramaneck Collection, *152*
Losty, Jeremiah, 25, 194n36, 204n60

Madhava, 83, *83*, 101, 194n27
Madhava Khurd, 69, *70*
Madhava Singh, portraits of, 127, *129–30*, 137, 207n95, 207n99
Mahabharata, 5, 69, 87
Mahesha, 81, 194n27
Majnun, paintings and poetry about, 149, 151, 154–55, 163
Malik 'Ambar (1548–1626), 40, 42; Jahangir shooting the head of (paintings), 40–43, *41*, 48, *176*, 177, 178
Malti-Douglas, Fedwa, 186n18
Mam'un, al-, 27
Mani, 12, 14, *15*, 16
ma'ni (inner meaning or essence), 22, 45, 98, 103, 107, 199n4
Manichaeism, 12
Manohar: father of, 214n55; imperial patronage of, 98; Jahangir's recruitment of, 95; and knowledge transmission of paintings, 156; portrayal of Pencz's work in Nawruz painting, 157, *159*, 214n62
Manohar, paintings by: Jahangir receiving Prince Parviz, *113*; Jahangir's first *darbar*, 155, *159*, 160; of King Anushirvan, 83–85, *84*; of Madhava Singh, 127, *129*, 129–31, 137, 207n95; of Prince Daniyal, 127, *129*, 137, 207n95; of Prince Salim, *96*, 97, 98
Mansur, *96*, 97, 98, *136*, 137
manuscript paintings: assessment of value

manuscript paintings (*continued*) of, 147–48; challenge to status of writing, 1; close attention to faces in, 69, 198n85; constructed nature of, 168; and deception, 12, 14; depiction of truth by, 14, 168, 172; and disassociation from textual contexts, 14; documentation of emperor's dreams and visions in, 10–11; double meanings in, 16; emphasis on visual apprehension in, 40; as imitation of God's creative activity, 167, *169*; and Islamic rivalries, 13; prophecy and knowledge transmitted by, 11–12; as representation of emperors' illumined state, 4, 34; representation of paintings within, 168, 172; representation of prophets and the supernatural in, 13; as signifiers of dynastic connections, contact and celebration, 149–55; sun and moon in, 23–24, 25, 185n6; and supernal conversions, 33; use of space in, 47–48, 91, 190n92; the Virgin Mary and the nature of painting, 169. *See also* dreams; genealogical paintings; iconography; Nawruz paintings; Nizami Ganjavi, *Khamsa*; pictorial representation; portraiture

manuscript painting style: and use of space, 47–48, 91, 190n92

Masters of Indian Painting, 1100–1900, 62

Mauss, Marcel, 211n20

Mawlana Maqsud of Herat, 8

Metropolitan Museum of Art (New York City), 56, 94, *122*, 179

micrographia, 82

Minneapolis Institute of Art, *160*

Minto, Lord, 178

Minto Album: compilation of, 28; museums holding portions of, 178–79, 186n31; paintings in, *41*, 112, *113*, *122*, *136*; provenance of paintings in, 178–79

Mir 'Abdullah (Mushkin Qalam), 98

Mir 'Ali Shir Nava'i, 212n37

Miran Shah, 118

Mir Khwand, *Rawzat al-safa'* (Garden of purity), 13

Mir Musavvir, 85

Mir Sayyid 'Ali, 58, 60, 85, 170, 193n24, 194n27, 213n46

Mirza, Sarah, 187n43

Mirza Muhammad Hakim, 61

Miskina: as collaborator, 73, *73*, *75*; as colorist, 94; and the *Darabnama*, 198n92; debating philosophers, 93, 94; as designer, *83*, 90, 92, *93*, 95; and Mughal painting style, 194n27; and portrait of Akbar, 198n85; work on de luxe manuscripts by, 83, 94

Moin, A. Azfar, 24, 26, 188n50, 191n99, 202n37, 202n40, 209n121

Mongol courts of Iran, 4

Monserrate, Antonio, 61

Mughal Empire: blinding as punishment in, 189n68; connection to Stuart England, 115; cosmopolitan status and heterogeneity in, 86, 87–88, 94, 141; court subjects and archetypes in, 125, 126, 207n88; evolving imperial identity of, 87; gifting and tributes in, 139–40, 142–43, 173–74, 211n22; independent inquiry in the discovery of truth in, 3, 4, 134, 135; justice in, 131–34, 208n102, 208n108; light and divine origins of, 34; map of, *xiv*; and novel forms of expression, 6, 182n13; place of painting in, 54, 184n45; use of money in, 114; and Western culture, 5–6. *See also* gifting; kingship, sacred; knowledge; vision

Mughal manuscript workshops: affinities with the mint, 204n62; allocation of jobs in, 198n93; artist ascriptions and processes in, 63, 66, 67–69, 71–75, 79, 81, 88, 194nn34–35, 195n40; artistic influences of other workshops, 58; and artists' betweenness centrality, 73–75; and becoming an artist in, 54; collaboration in, 63, 66, 69–75, 73–75, 79, 94; collective subjectivity in, 54; as communities of practice, 81–82; and de luxe manuscripts, 82, 196nn64–65; Humayun's workshop, 58, 60; increased size and diversification of, 60, 63, 88; organization of, 66, 68; and painter-bureaucrat-disciple roles, 95; processes revealed in marginal instructions, 66, 195n51; record keeping in, 63, 194n37; relocation of Akbar's atelier, 63; sharing of artists among, 198n94; status of painters in, 54. *See also* Akbar, Jalal al-Din Muhammad; inscriptions; Jahangir, Nur al-Din Muhammad

Mughal painters: agency of, 10, 16–17, 129, 138, 165, 167, 169, *169*, 175; apperception of, 116–25; and calligraphers, 51–52; central task of, 10–11; collective and courtly identity of, 10, 52, 54, 80, 94, 183n28; competition for royal favor by, 174; copying of canonic works, 149;

design-colorists, 81, 82–83, 95; as devoted slaves, 10, 11, 28, 50, 75, 170, 187n33; epistemic images in paintings by, 156, 160–63; fictional images and worlds in paintings, 163; and figural and spatial distinction from *Akbarnama* illustrations, 47–48; formation of, 17; imperial status of, 8–9, 52, 155, 170, 209n124; murals and public profile of, 173; new illustrations to older texts, 91; new repertoires of subjects and motifs used by, 5; objectives of, 2, 206n83; and painting as divine gift, 50; paintings and judgment of rulers, 137; precedents for, 49, 191n97; role in emperors' kingship status, 1, 11; role in fashioning Mughal empire's vision, 141; self-effacement by, 22, 174–75; separation of tasks among, 69; skill of, 78, 81–82; social network analysis of, 73–75, 79, 195n45; status of, 173; testimonies of visual authenticity by, 121–23; and transcendence of work by, 6–7; translation work of, 88; use of dense iconography by, 45; use of institutional memory for paintings, 160; use of micrographic mode of representation by, 4; use of non-Persianate sources by, 6, 49, 182n11. *See also* 'Abd al-Samad; Abu'l Hasan; art history; Basavana; Bichitra; Bishandas; Dawlat; European visual arts; Hashim; Jahangir, Nur al-Din Muhammad, dream paintings of; Manohar; Mansur; Miskina; Nawruz and Nawruz gifting; painters' training; Persianate manuscript painters and paintings; physiognomy; Sufi master/disciple (*pir*/*murid*) relationship

Mughal painting style: canonization of, 177, 179; Coomaraswamy on, 193n14, 193n16; design *versus* coloring, 194n27; *Hamzanama*'s stylistic shifts in, 57–58, 60; Indo-Persian influences on, 60–61; master artists' impact on, 62–63, 193n24; origins of, 54–65; and style as process, 80. *See also* art history; color, use of; decorated margins; design; detail; European visual arts; facial features; gazes; manuscript paintings; signs and symbols

Muhammad Baqir Najm-i Sani, *Maw'iza-yi Jahangiri* (Admonitions of Jahangir), 127

Muhammad ibn 'Abd Allah al-Kisa'i, *Qisas al-anbiya'* (Stories of the prophets), 43

Muhammad Qutb Shah, portrait of, 121, *122*

Muhammad Sadiq, 2, *18*, *162*

Muhammad Sharif: as disciple, 201n34; historical lineages in Nawruz paintings of, 156; inscription of discipleship on painting by, 213n51; poetry by, 154–55; poppy seed trope and, 216n86; title granted by Jahangir to, 155; update of Nawruz painting by, *152*, 154, 213nn46–47

Mu'in al-Din Chishti, 27, 28, *29*, 29–31

Mu'in al-Din Chishti, shrine of, 29–30, *30*, 32

Mujaddid-i Alf-i Thani. *See* Jahangir, Nur al-Din Muhammad

Mukund, 79, 83, *100*, 194n27

mural paintings, 173

muraqqa's. *See* albums (*muraqqa*'s), Mughal

Musée Guimet (Paris), *106*

Museum of Fine Arts (Boston), *59*

musicians and poets, 174. *See also* poetry

Mutribi Samarqandi, Muhammad, *Khatirat-i Mutribi Samarqandi* (Memoirs of Mutribi Samarqandi), 120–21, 123

Nadir Shah, 178

Nasir al-Din Tusi, 134

Nawruz and Nawruz gifting: appeal to Islamic rulers, 210n6; and the emperor's munificence, 174; establishment of, 213n49; gifting during, 173–74; gifts offered to Jahangir, 161, 209n126; history of observance of, 141–42; by Mughal nobles, 140, 142; and painters' gifts, 139–40, 148, 161; and the royal calendar, 139; and social visibility, 156–57; terms for gifting, 212n33

Nawruz paintings: and the artist's loyalty, 143; celebration after Akbar's circumcision, 143, *145*, 212n28; genealogies of affiliation and affection produced by, 151; historical function of, 156; horse with a groom, 146, *147*, 149, *150*; identification of, 214n59; Jahangir's first Nawruz celebration, 156–57, *159*; meeting between Jahangir and Shah 'Abbas I, 161–63, *162*, 214n67; musician with princely scribe, 144, 146, *146*, 149, *150*; and painters' value to the court, 174; and the politics of courtly spectatorship, 157, *158–59*; prince hunting on horseback, *152*, 154; signifying devotion to Akbar, 155; time to complete, 146, 147, 148

Necipoğlu, Gülru, 182n10

Nicholas II, 178

Index

255

Ni'matnama (Book of delicacies), 58
Nizam al-Din Awliya, 49, 186n29
Nizami Ganjavi, *Khamsa* (Quintet): artists' names in, 69, 71, 72, 196n66; color and design artists for, 79; on deception in, 12, 14; and history of workshops, 58; numbers of paintings in, 51; solo production of illustrations in, 83; tale of Majnun in poetry of, 149, 213n43
Nizami Ganjavi, *Khamsa* (Quintet), paintings in: colophon with Dawlat in, 51–52, *53*; debating philosophers in, 92, *93*, 94; Mani painting a dead dog, 14, *15*, 16; Manohar's painting of Anushirvan, *84*; paintings of Anushirvan in, 83, 85, *85*
Nur Jahan, 173, 188n58

"occasional art," 148
Okada, Amina, 25
oneiric frameworks, 23–26
Oxford University Bodleian Libraries, 94, *125*

painters' training: coloring as means of learning, 79, 94; fluidity of roles and, 81; learning from one another, 80; of novices, 75; shared habitus in, 80
painting style as geographically bound, 60, 193nn12–13
Pal, Pratapaditya, 213n46
Parodi, Laura E., 213n46
Payne, Alina, 214n63
Pencz, Georg, engraving of Tobias and archangel, 157, *159–60*
Persianate albums, 66, 164, 168
Persianate manuscript painters and paintings, 5, 6, 83, 182n10, 191n97
physiognomy, 89; analyses and authenticity of likenesses, 123; and emperor's divinity, 110; goal of, 126; and inner character, 11, 107, 132, 201n26; Jahangir and, 135; Mughals' interest in, 89, 103; Polemon's effect on practice of, 200n14; portraiture and, 99; prognostication from, 103; rulers' ideal forms and cosmic status, 99
Physiognomy (attr. Aristotle), 103
pictorial representation: as challenge to God's creative authority, 174–75; constructed nature of, 167–70; invention in, 90, 163–64; new modes used by Mughal painters, 5; Rajput princes' preference for Mughal modes of, 178
Platonic ideals, 134
poetry: "fresh-speaking" (*taza-gu'i*), 6, 87; during Nawruz, 143–44, 174, 211n24; with Nawruz paintings, 151, 154; "occasional poetry," 148, 212nn37–38; and precedent, 181n7
Porta, Giambattista della, *De humana physiognomonia*, 103
portraiture: amalgam of, *165–66*, 167; authenticity of, 120–23, 205n70, 206n77; canon of types in, 125–31, 207n96; companion portraits of Jahangir and a Sufi shaykh, 27–28, *29*, 186n31; and emperors' dreams and visions, 6; the emperor's form in, 99–108; epistemic value of, 137, 206n83; gestures and poses in, 127, *128*; and inner essences, 207n86; narrow waists in, 127, *129*; and physiognomy, 99; three-quarter and side profiles in, 97, 107, 110, 126; and truth, 137; on wearable coins, 11, 33; wearing of portraits, 108–9; and the workshops' archives of images, 123. *See also* coins, imperial portrait
precedence and tradition: Mughal departure from, 2, 4–5; traditions and discovery of truth, 2, 134
Prophet Muhammad, physiognomy of, 104

Qiyafat al-insaniyya fi şama'il al-'Osmaniye (Human physiognomy and the disposition of the Ottomans), 103
Qiyafatname (Book of physiognomy), 103
Qur'an: surah 12:3, 23; surah 75:9, 185n6; writing verses on a poppy seed, 172
Qureshi, Nusra Latif, *Considerate Flying Objects I*, *179*, 180

Raisal Darbari, portrait of, 126, *128*
Rajput princes, 178
Ram, 194n27
Ramayana (Story of Rama): artists' collaborating on, 69, 71, *72*, 73, *73*; Basavana and, 95; color and design artists for, 79, 94; copies of, 88; invention in illustrating copies of, 90; and Mughal imperial identity, 87
Rana Karan Singh II, *166*, 167

rang-amizi. See 'amal
Raza Library (Rampur), paintings in, *31*, *117*
Razmnama (Book of war): artists collaborating on, 71, 73; artists names in, 69, 71, *71*, *74*; Basavana and, 95; color and design artists for, 79–80, 94, 195n55, 196n56; copies of, 88; invention in illustrating copies of, 90; and the *Mahabharata*, 5; and Mughal imperial identity, 87
Richards, John F., 114, 187n36
Roe, Thomas, 11, 114–15, 156, 203n49, 203n53, 204n55
Roxburgh, David J., 82, 148, 150, 151n6, 212n37, 213n45
Royal Polyglot Bible, *Pietas Regis* image in, 48
Russian Academy of Sciences (St. Petersburg), Institute of Oriental Manuscripts, *96*, *158–59*
Rustam Ali, 211n24

Safadi, al-, *Nakt al-himyan fi nukat al-'umyan* (Outpourings from the purse, anecdotes about the blind), 25
Safavids: founder of empire, 24; Mughal's affiliation with cultural practices and specialists of, 13–14; and Nawruz, 210n8; symbolism of the turban to, 47
"Safi," 'Ali ibn Husayn Kashifi, *Rashahat-i 'ayn al-hayat* (Dewdrops from the elixir of life), 107
Safi al-Din Ishaq Ardabili, 24
Salim (Prince). See Jahangir, Nur al-Din Muhammad
Salim Album, *126–27*, *128*, 207n91, 207n96
Salim Chishti, 28, 29
San Diego Museum of Art, Edwin Binney III collection, *176*
Sangha, *90*
Sanvala, *76*, *78*, 79, 83, 194n27
Sarwan, 81, *82–83*
Savarni Manu, 43
School for Oriental and African Studies, 60
Seyller, John: on artists' collaboration, 63, 66; on completion of *Akbarnama* paintings, 198n82; on inspection notices, 197n77; and marginal inscription, 195n51; on paintings' inscriptions, 206n77; on payment to poets, 174; and valuation of manuscripts, 211n26; on workshops' production volume, 61

Shah Isma'il, 24
Shah Jahan (Shihab al-Din Muhammad Khurram). See Khurram
Shah Jahan Album. See Kevorkian Album
Shahnama. See Firdawsi, Abu'l Qasim, *Shahnama*
Shahrukh Shah, 178
Shah Tahmasp, 55, 58
Sharaf al-Din 'Ali Yazdi, *Zafarnama* (Book of victory), 49, 99, *101*
Shihab al-Din Suhrawardi: on divine light, 188n61; Jahangir and philosophy of, 50; political connections of, 188n56; theory of knowledge, 39–40, 189n73, 190n75; theory of optical perception, 37, 39, 40. See also *ishraqi* (Illuminationist) philosophy
Shiraz, 58
signs and symbols: in Bichitra's painting of Jahangir on an hourglass throne, 44; encoding of oneiric vision through, 47; as mediators between the physical and metaphysical, 45, 47; of the Safavid turban, 47; as triggers of visionary experience, 45
Singh, Kavita, 182n11, 190n92
Skelton, Robert, 190n83, 213n47, 214n59
Smart, Ellen, 194n34
Smithsonian Institution, paintings in: Arthur M. Sackler Gallery, *55*; Freer Gallery of Art, *3*, *18*, *34*, *47*, *153*, *162*, *176*, *177*, *178*
social network analysis, 195n45, 195n47
Soucek, Priscilla, 207n86, 213n48
South Asia: influence on Mughal painting style, 59–60; links with Persianate world, 58
Staatsbibliothek zu Berlin, *130*, *145*, *165–66*, *169*, 215n73
St. Petersburg Album, *158–59*, *162*, 178, 215n67
Stronge, Susan, 198n82
Subrahmanyam, Sanjay, 115
Sufi master/disciple (*pir/murid*) relationship: and Akbar learning about painting arts, 170; careful observation in, 107; prostration before the master, 108; rite of succession, 109; workshops' mirroring of, 30
Sufi masters' dreams, 23–24, 26, 27
Sufism: and devotional cults, 108; and dream encounters with saints, 27; inner essence and external form in, 201n26; Jahangir and, 28; Naqshbandis, 107, 201n29; proximity to saint's bodies, 32

sulh-i kull (total peace), ethos of, 86, 87, 108
Sultanate painting, 192n6
Suraj Singh Rathor, *166*, 167
Surat, 161, 205n68
surat (outer or sensory form), meaning and significance of, 22, 45, 98, 103, 107, 135, 199n4
Sur Das, *101*
Sur Gujarati, 14, 16
Sutton Gallery (Melbourne), *179*

Tabari, Muhammad ibn Jarir, al-, 213n49
Tabriz, 55, 58
tahqiq (independent inquiry), 2, 86, 134–35, 137, 209n117
taqlid (imitation of tradition), 2, 86, 134
Tara, 194n27
Tara Kalan ("the Elder"), 62, *65*
tarh. *See* design
Tarikh-i alfi (Millennial history), 69, 86, 87, 88, 91
Tarikh-i Khandan-i Timuriyya (History of the family of Timur): artistic collaboration in, 71; artists' collaborating on, *72*, 74, *74*; Basavana's work on, 62; and cultural inclusion, 87; inspiration from, 91; Miskina and, 94; paintings in, 68–69
tasvir-khana (literally "picture house"). *See* Mughal manuscript workshops
Tawhid-i Ilahi, 95, 155, 201n34, 203n47
Timur, 2, 99, 101, *101*, 205n68, 205n70
Timurid historiographic projects, 197n74, 197n80
Timurid lineage, 118, 205n65, 205n67
Timurid painters, 5
Tipu Sultan, 27
Truschke, Audrey, 87
Tulsi, 69, *70*
Tutinama (Book of the parrot), 60, 192n10

Vaivasvata Manu, 37, 43
Varma, Raja Ravi, 7
Victoria and Albert Museum (London): Minto Album pages held by, *113*, *122*, *136*, *178*, *179*, 186n31; painting of Adham Khan being thrown from the palace, *90*; portrait of Zayn Khan Koka, *123*, *124*
Victoria and Albert Museum (London), *Akbarnama* copy in: Akbar greeting Rajput royals, *83*; Akbar receiving Azim Khan, *101*; Akbar slays a tiger, *82*; Akbar supervising construction of his capital, *70*; Akbar watching a battle, *64–65*; artists that worked on, 95; battle at Sarnal, *76–77*, *102*; an emperors' physical characteristics, 137; inscriptions in, 63, *64–65*, 69; Miskina's work on, 94; revisions in illustrations of, 102
Virginia Museum of Fine Arts (Richmond), Nasli and Alice Heeramaneck Collection, *128*
Virgin Mary, images of, 169
vision: compared to hearing, 201n28; and Jahangir's discerning eye, 131–34, 208n102; and knowledge, 39–40, 189n73; linear perspective and, 214n63; paintings and illumination of vision, 50; and perception of the divine, 107; theories of, 37, 39

Walters Art Museum (Baltimore), 94, 127, *129*, 137
Wantage Album, *179*
Welch, Stuart Cary, 62, 213n46
Western worldviews, South Asian artists in, 7
Williams College Museum of Art (Williamstown, MA), 215n73
World's Columbian Exposition, 7
Wright, Elaine, 207n91

Zakariya' al-Qazwini, *'Aja'ib al-makhluqat wa ghara'ib al-mawjudat* (Wonders of creation and oddities of existence), 43
Zamana Beg (Mahabat Khan), *166*, 167
Zayn Khan Koka, portraits of, 123, *124–25*, 206n82
Ziai, Hossein, 39, 188n56, 188n61, 189n73